DAVID HOCKNEY
A BIGGER EXHIBITION

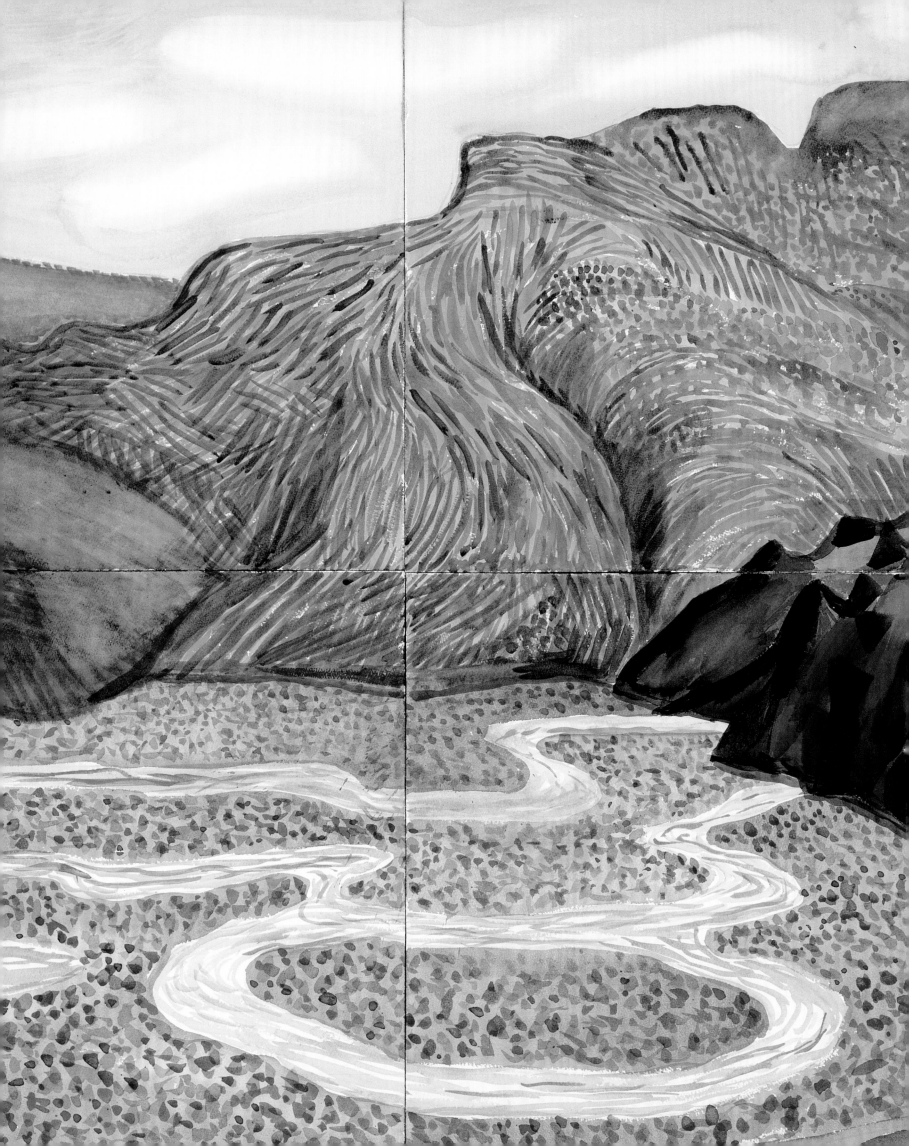

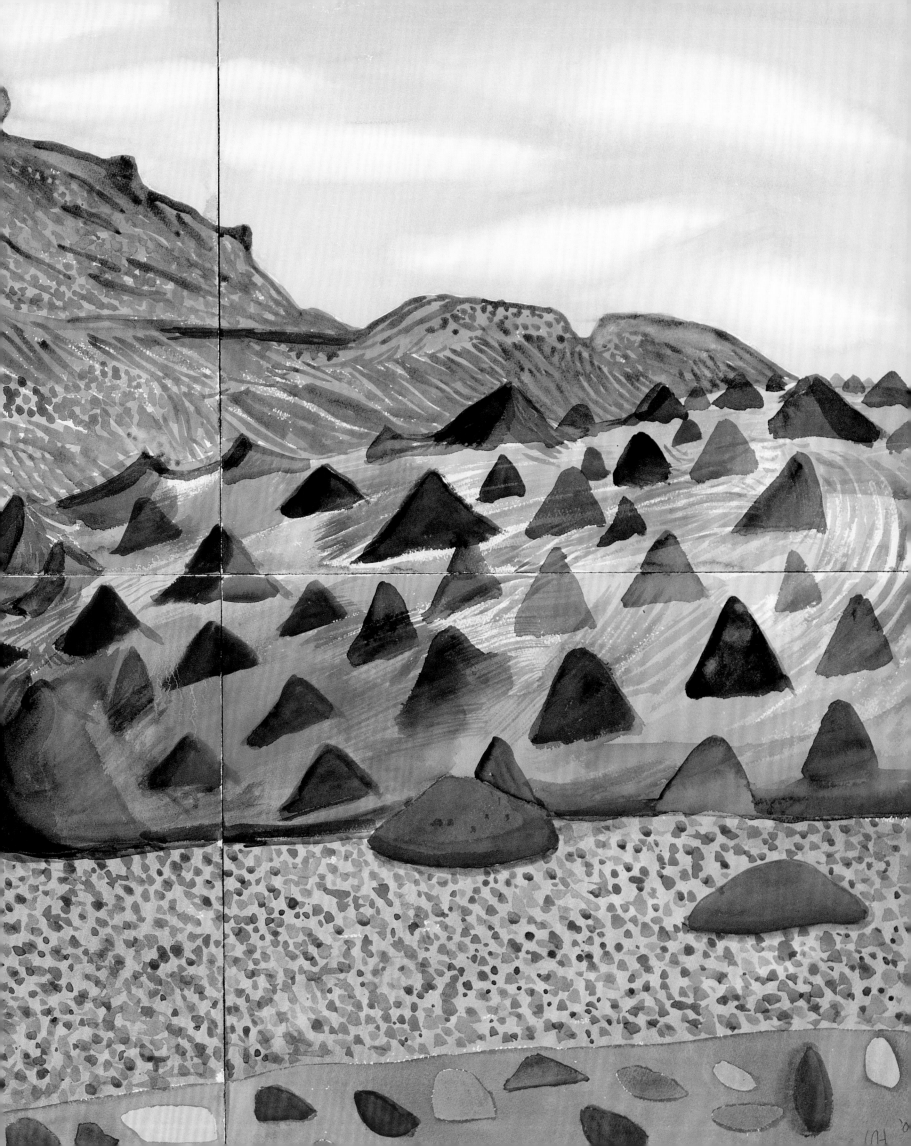

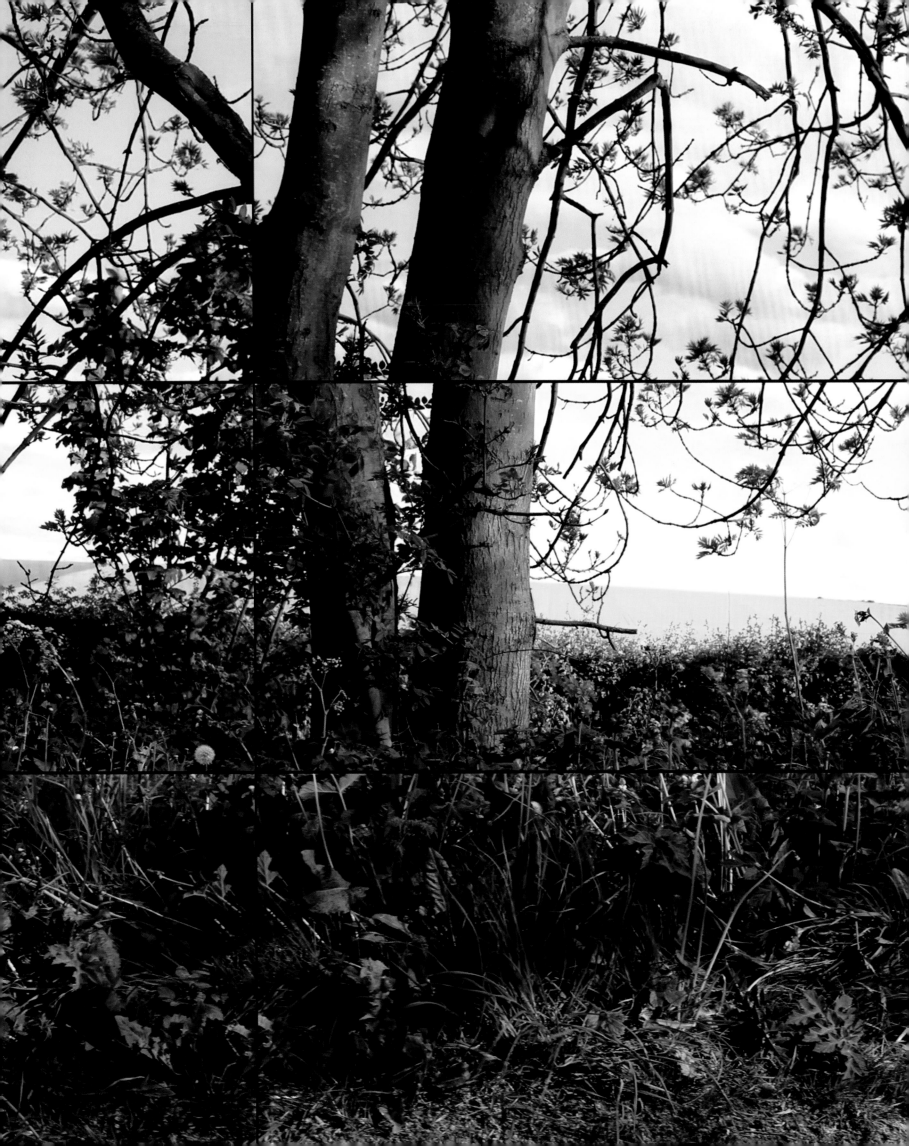

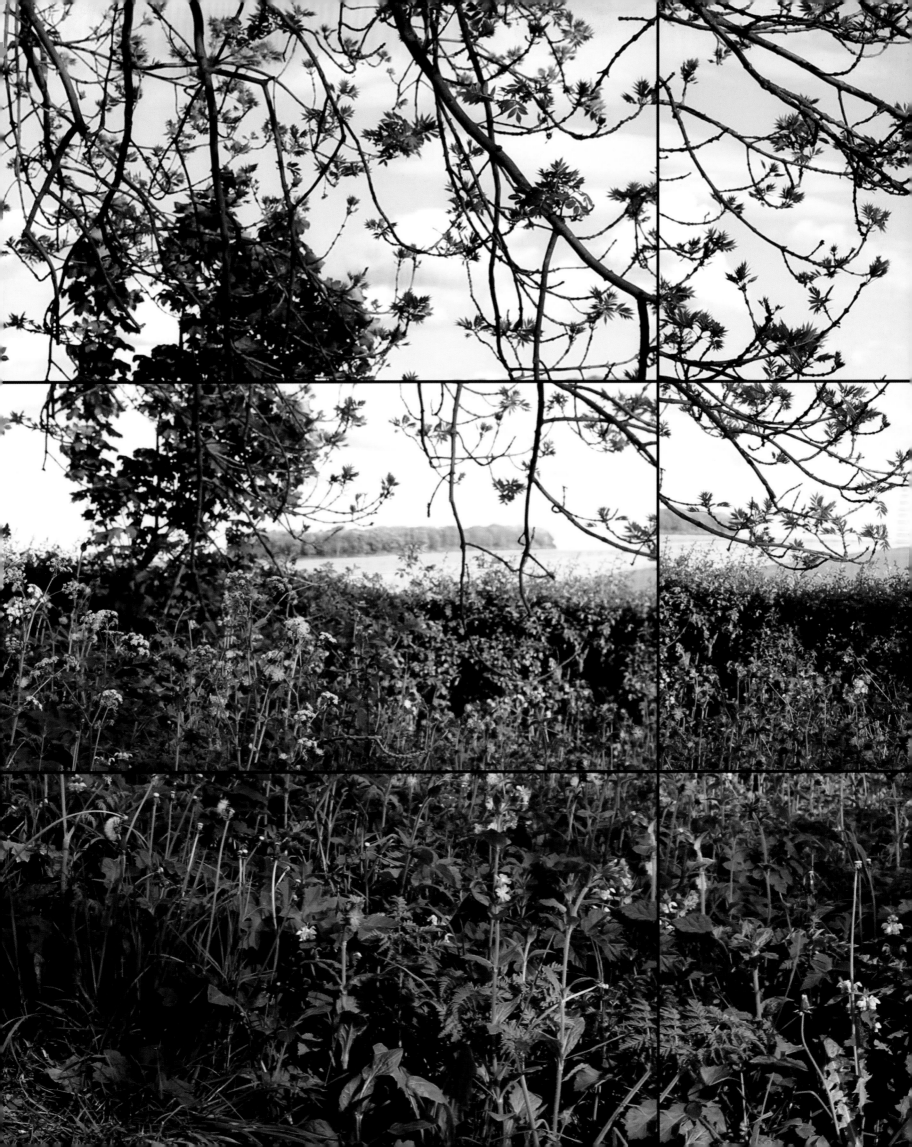

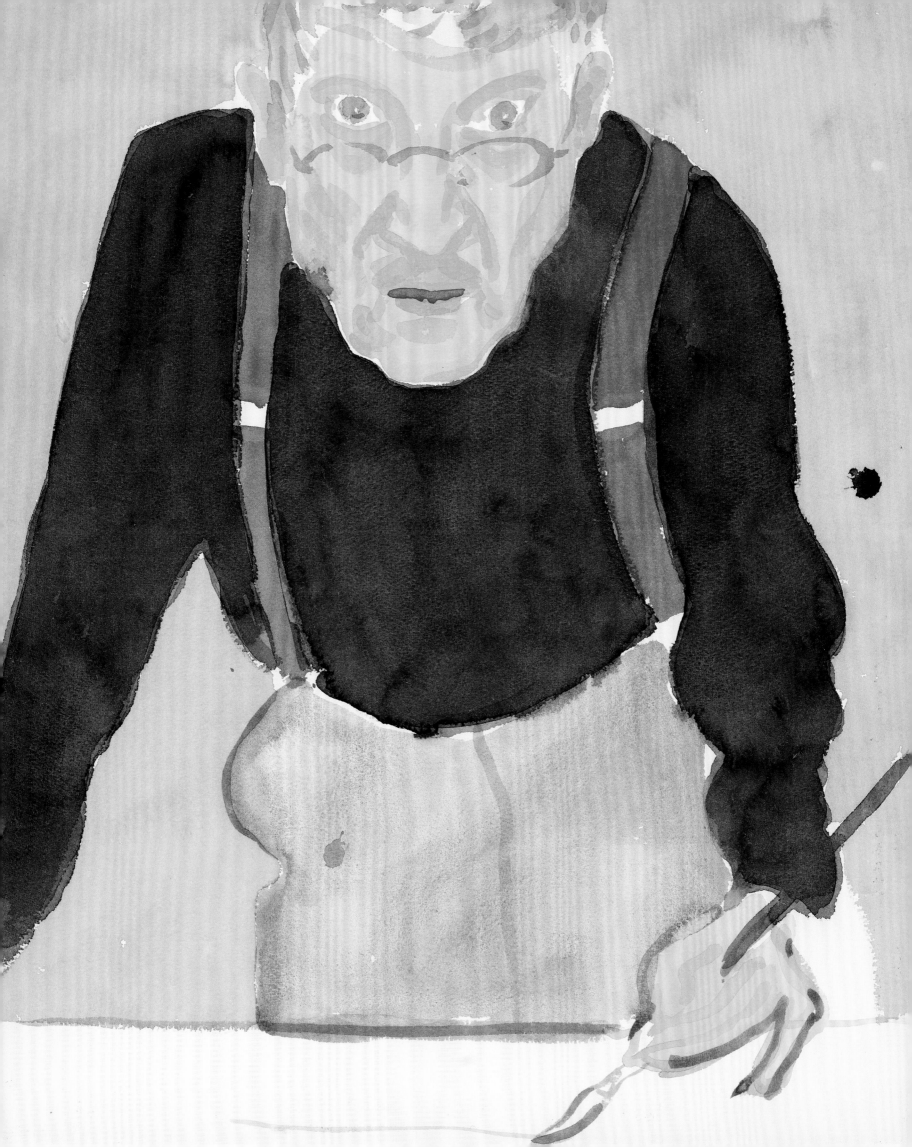

DAVID HOCKNEY
A BIGGER EXHIBITION

RICHARD BENEFIELD
LAWRENCE WESCHLER
SARAH HOWGATE
DAVID HOCKNEY

CURATED BY
GREGORY EVANS

Fine Arts Museums of San Francisco

DelMonico Books · Prestel
Munich London New York

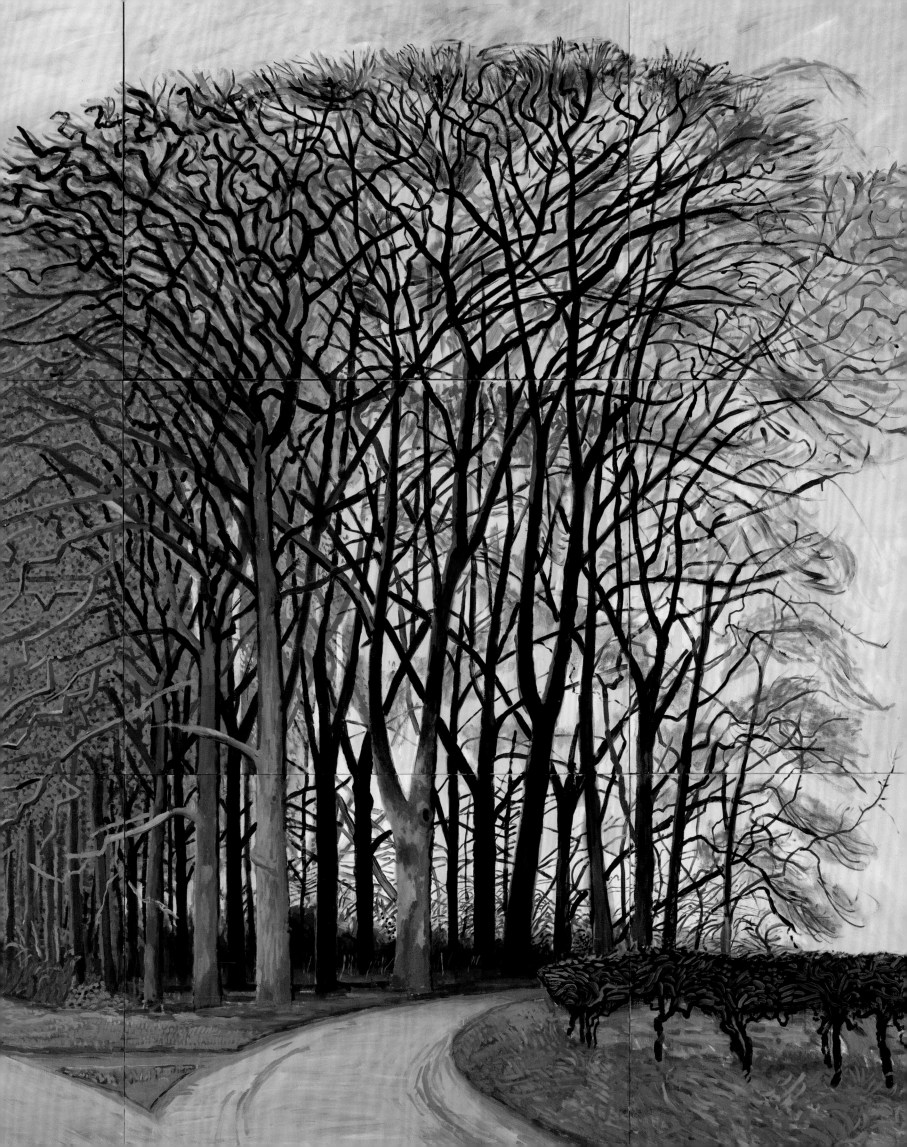

CONTENTS

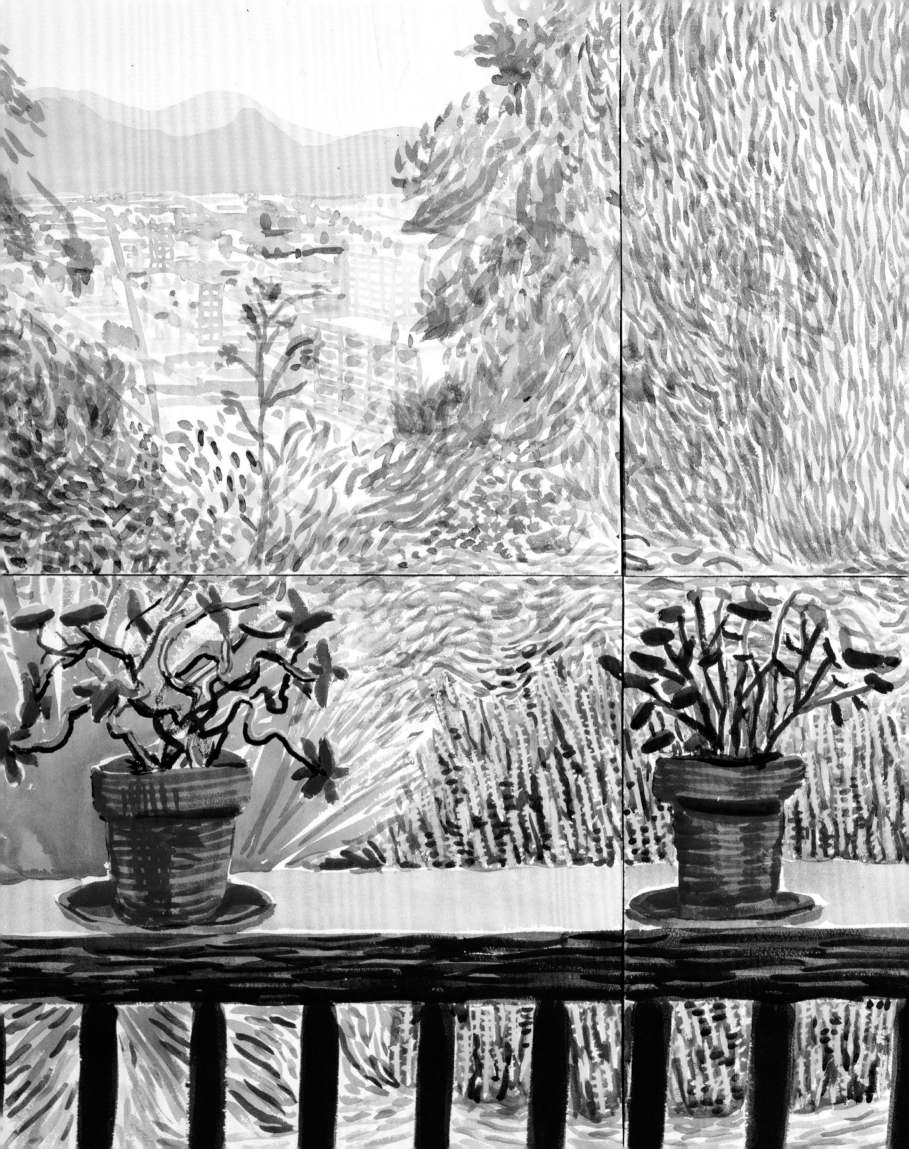

COLIN B. BAILEY

DIRECTOR'S FOREWORD

THE PRESENTATION OF A MAJOR EXHIBITION OF A LIVING ARTIST'S
work is always a special occasion for any museum, and it is no less so for the Fine Arts Museums of San Francisco in organizing this survey of David Hockney's oeuvre since 2002. Ever prolific, the artist has arguably made the past decade one of the most productive of his career, working in a staggering array of media, old and new—from watercolor to iPad, charcoal to computer, and oil paint to digital movie.

David Hockney: A Bigger Exhibition is the first major presentation of his work since the critical and popular success of David Hockney: A Bigger Picture, which was shown in London, Bilbao, and Cologne. Our show, the largest in the history of the de Young, features more than 250 works of art, including landscapes, still lifes, portraits, and digital movies. The monumental canvases, A Bigger Message (pl. 105) and The Arrival of Spring in Woldgate, East Yorkshire in 2011 (twenty eleven), Version 3 (pl. 178), as well as the five iPad drawings Bigger Yosemite (pls. 197–201), are shown here for the first time in North America.

We are proud to be the first museum to exhibit and publish the artist's most recent output, spanning a year in which he has worked exclusively in charcoal. In fact, a special place was reserved in this catalogue for a work Hockney was excited about completing. The twenty-five drawings The Arrival of Spring in 2013 (twenty thirteen) (pls. 231–255), were finished in May of this year and are now accorded a special place in this volume. These remarkable works, made with the most basic of materials, underscore the fact that Hockney is, without question, one of our greatest draftsmen.

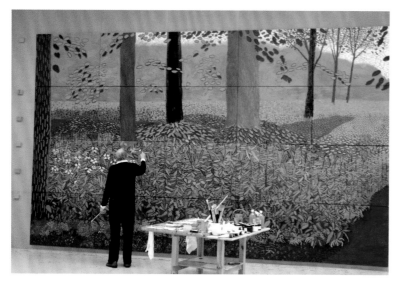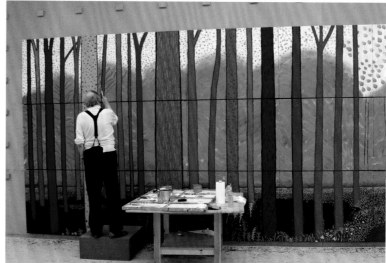

David Hockney working on *Under the Trees, Bigger* (2010–2011, pl. 100), 2011, and *The Arrival of Spring in Woldgate, East Yorkshire in 2011 (twenty eleven)* (2011–2013, pl. 178), 2011

The Fine Arts Museums of San Francisco wish to thank the Board of Trustees and President Diane B. Wilsey for their unconditional support of this project. Our deputy director, Richard Benefield, brought his years of experience working with living artists to the organization of the exhibition and catalogue, working directly with the artist and his associates at the Hockney studios in Los Angeles and Bridlington, England.

Through their astute essays for this volume, both Lawrence Weschler and Sarah Howgate have shared important insights into Hockney's work, made all the richer by their years of association and friendship with him. A special mention is given to Leslie Dutcher, director of publications, and her staff for overseeing the editing and production of this catalogue. We thank Ann Heath Karlstrom for her deft editing, Bob Aufuldish for his elegant design, Roberto Conti and his colleagues at Conti Tipocolor for their beautiful printing of this book, and Mary DelMonico and Karen Farquhar at DelMonico Books | Prestel for their partnership. This catalogue is published with the assistance of the Andrew W. Mellon Foundation Endowment for Publications, for which we are grateful.

Thanks are also due to the Museums' exhibitions team and its leaders: Krista Brugnara, director of exhibitions; Therese Chen, director of collections management; Craig Harris, manager of installation and preparation; Rich Rice, manager of audiovisual services; and Bill Huggins, lighting designer. We also thank Suzy Peterson, executive assistant, for overseeing the myriad details of this undertaking. Our further thanks are given to the members of the Museums' extended staff, including the entire marketing, development, design, education, public programs, and member and visitor services teams.

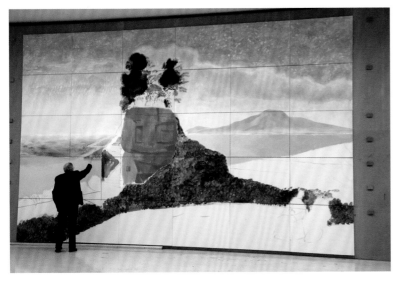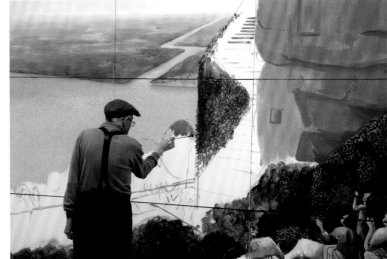

Two views of the artist painting *A Bigger Message* (2010, pl. 105), 2010

Our donors and sponsors make it possible for the Museums to bring major exhibitions to San Francisco. We are grateful to those who provided leadership support for this particular exhibition: David Davies and Jack Weeden, the bequest of Dr. Charles L. Dibble, Ray and Dagmar Dolby, Marissa Mayer and Zachary Bogue, the Michael Taylor Trust, and Diane B. Wilsey.

Numerous individuals and institutions deserve our thanks for their assistance in the development of this project. These include Peter Goulds and Kimberly Davis at L.A. Louver, David Juda at Annely Juda Fine Art, and Sylvia Weber at the Würth Collection. We also thank the National Portrait Gallery, London, and the Art Gallery of New South Wales, Sydney, Australia, and other private lenders for sharing their artworks with us.

We extend the deepest gratitude to Gregory Evans, curator and designer of the exhibition, for his insights into David Hockney's biography, creative processes, and working methods. This exhibition and catalogue would not have been possible without his gracious partnership. We also thank his colleagues at the David Hockney studios: Erik Arnesen, Julie Green, Shannan Kelly, Greg Rose, Richard Schmidt, and George Snyder in Los Angeles; and Jean-Pierre Gonçalves de Lima and Jonathan Wilkinson in Bridlington, England.

Our greatest debt, of course, is to David Hockney, whose extraordinarily diverse and critically acclaimed art we are proud to share with our audiences. It has been a pleasure and an honor to collaborate with him on the presentation of this luminous chapter of his life's work.

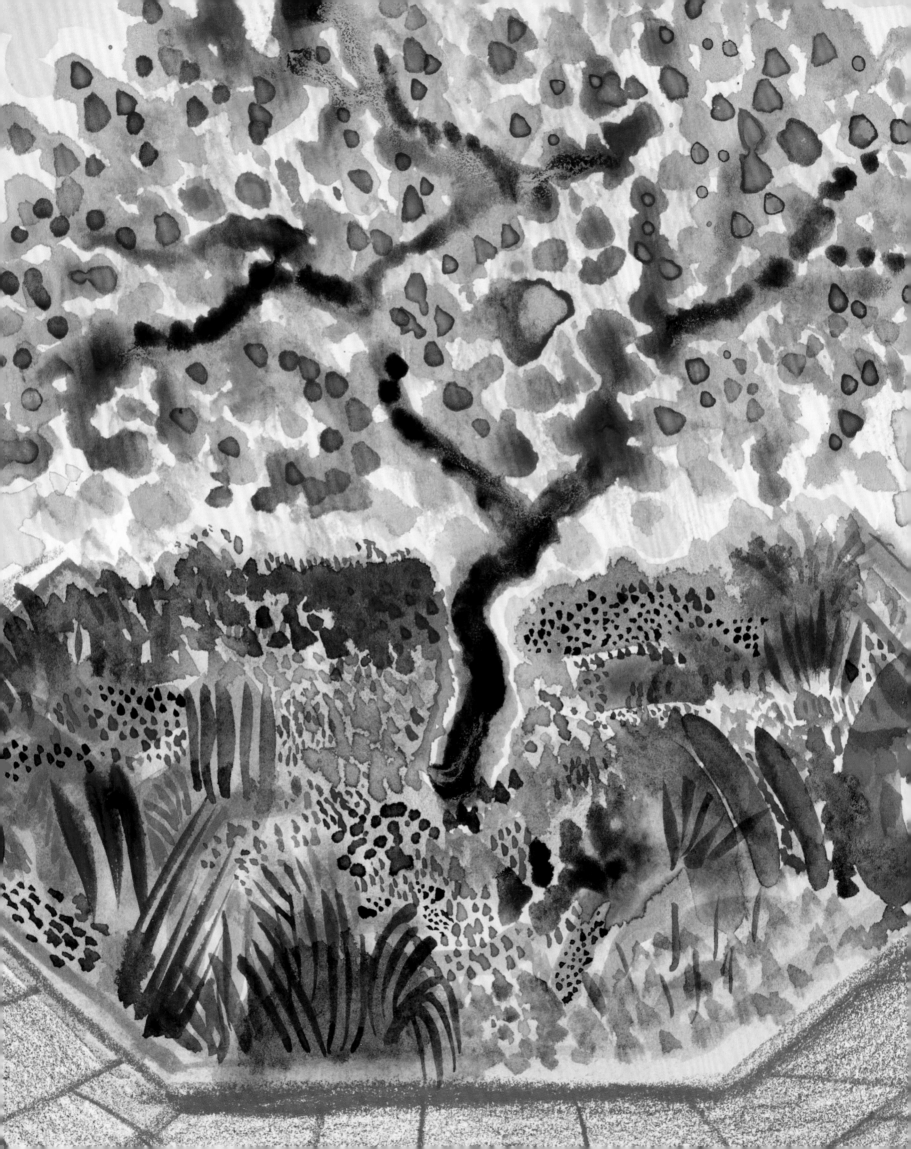

ESSAYS

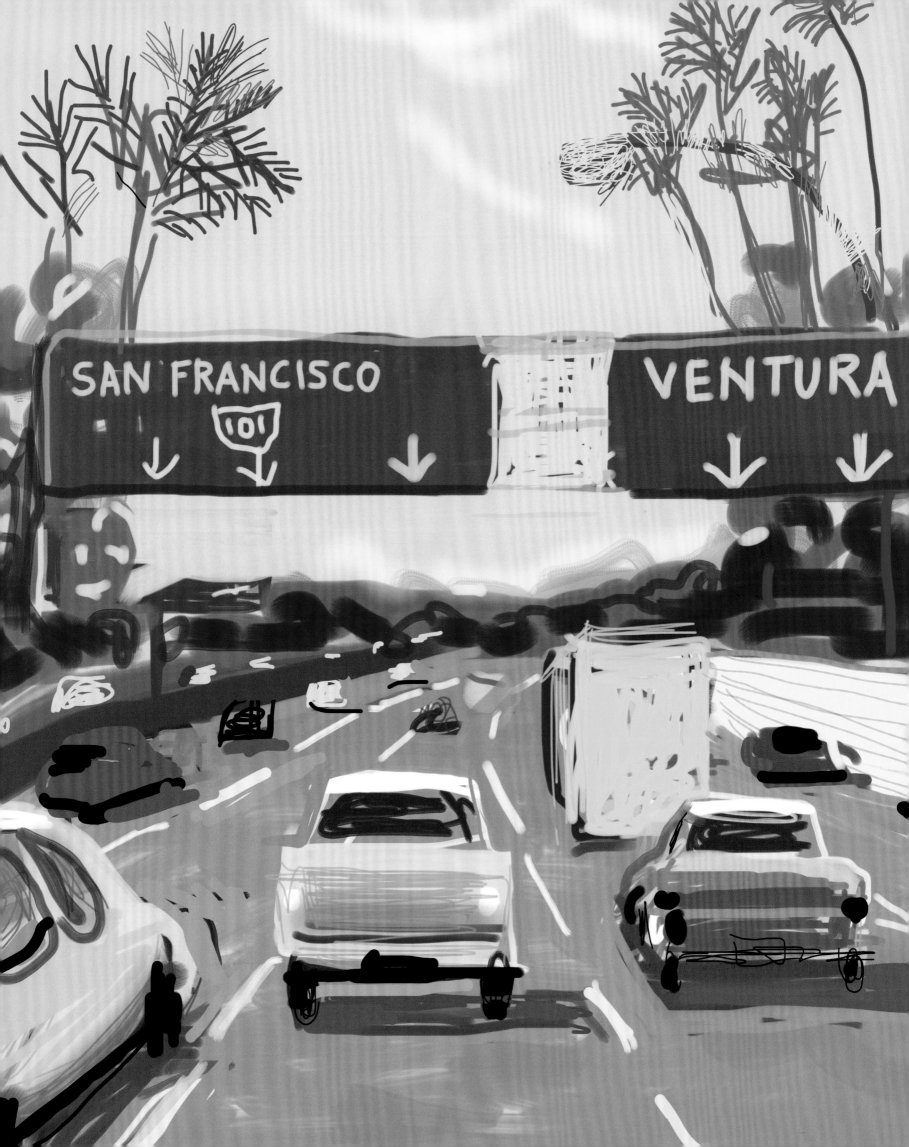

RICHARD BENEFIELD

DAVID HOCKNEY IN SAN FRANCISCO

DAVID HOCKNEY FIRST VISITED THE NEW DE YOUNG MUSEUM IN

2011. He was in town for a San Francisco Opera performance of Puccini's *Turandot*, for which he was scenic designer (see fig. 1).[1] At the de Young, he saw the exhibition *Picasso: Masterpieces from the Musée National Picasso, Paris*. Hockney has always held Picasso in high regard. During his art school days, when Hockney saw that Picasso really could draw, other students as well as faculty regarded Picasso as a philistine. Hockney was a music lover from his youth, when he regularly served as an usher in exchange for a seat to hear the likes of Schubert, Wagner, and other classical masters. This deep knowledge and love of music, combined with his own observations of Picasso's understanding and mastery of chiaroscuro, led Hockney to the conclusion that the Spanish master must have been tone-deaf—increasing capacity in one of the senses with diminished acuity in another.[2]

In those same months that Hockney visited the Picasso exhibition at the de Young, he was in the midst of developing his ideas for the multicamera digital movies. These movies are made using as many as eighteen separate digital cameras, mounted on a grid, recording the action simultaneously (see figs. 2–4).[3] They are shown using just as many video monitors, mounted on the wall in an equivalent grid, playing simultaneously. Because each camera has its own single-point perspective, one movie ends up having as many as eighteen perspectives. The foci of the cameras do not line up exactly to present one continuous view, hence, the Cubist movie. Hockney is not only in his post-Pop, post-minimal, and post-conceptual mode, he has come full circle, back to his earlier and lifelong fascination with Cubism.

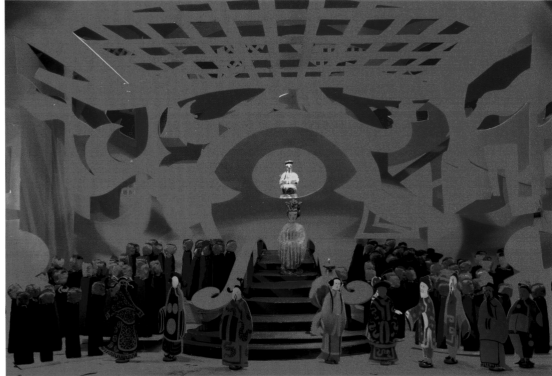

FIG. 1 David Hockney
Stage design for *Turandot*, act 3,
scene 2, 1990

FIG. 2 David Hockney directing nine
cameras, April 2010

FIG. 3 David Hockney
863, 2011
iPad drawing

FIG. 4 David Hockney
580, 2010
iPad drawing

FIG. 1

On my first visit in August 2012 to David Hockney's Hollywood Hills home and his two Los Angeles studios, I was treated to a viewing of his multicamera digital movies. I was seated next to him and he offered a number of comments: "There are so many more options to look at"; "We have conquered the tyranny of one-point perspective"; and "Imagine the ramifications this may have for the movies." However, what I remember more than anything from my first meeting with him was this: "One hundred years ago Cubism was invented, and this may be the first Cubist movie."

Hockney continually investigates aspects of time relative to the image. From his own observations of the development of Cubism in the early twentieth century, he surmises that what we see in a single painting are multiple perspectives of the artist, which could happen only over time. In other words, the artist paints one perspective, he looks again and paints another, then another, and so on. Hockney has famously said that one drawback of photography is that it does not capture time. For him, a photograph becomes uninteresting after about thirty seconds. By making the photographic collages, however, Hockney has conveyed multiple perspectives as well as elapsed time. Each individual photograph in a collage has its own perspective, and the photographs used in a collage are taken in sequence over a period of minutes, hours, or days. With the digital movies, Hockney has taken this process one step further, capturing multiple perspectives simultaneously to record time-based performance: acrobats juggling, dancers rehearsing, or trees blowing in the wind (see pls. 210–215).

After the wildly successful exhibition at London's Royal Academy of Arts, *David Hockney: A Bigger Picture*, we wondered whether the time was right for a major Hockney exhibition in San Francisco. There had not been a major Hockney museum exhibition in the United States since the 2006 portrait show at the Los Angeles County Museum of Art and the Museum of Fine Arts, Boston. When I asked several of my colleagues what they thought of the idea of bringing a Hockney exhibition to this museum, they raised doubts about how a Bay Area audience might respond to paintings of the East Yorkshire countryside. After all, the Royal Academy exhibition was focused for the most part on East Yorkshire, England, landscapes, albeit landscapes writ large (the "bigger picture"). Nevertheless, the Museums' board president, Diane B. Wilsey, encouraged me to keep alive the idea of a Hockney exhibition at the de Young.

I approached David Hockney about a San Francisco exhibition through his longtime friend and curator, Gregory Evans. After the two of them discussed the idea, Gregory got back to me quickly: "Yes, David likes the idea of doing a big exhibition in San Francisco, but it won't be the same show that was held at the Royal Academy." That exhibition actually went on to the Guggenheim Museum in Bilbao, Spain, and then to the Ludwig Museum in Cologne, Germany.

As we discussed the exhibition at the de Young, Evans hit on the brilliant idea of doing a comprehensive retrospective from 2002 to the present day. At first I thought to myself, "This artist is making art at a breakneck pace. What will that mean? Will we have a final checklist in time to create a catalogue of the exhibition? What if he makes something brand new at the last minute?" Even at the time of this writing, Hockney is still making art that will likely make it onto the walls of this exhibition.

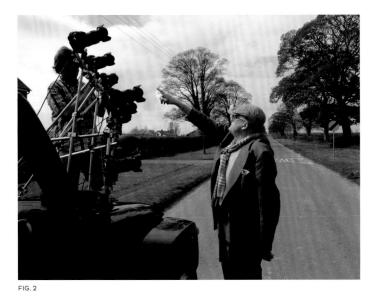

car with nine cameras

FIG. 2 FIG. 3 FIG. 4

This, of course, is something like a high-wire act for museum professionals. We are accustomed to commissioning individual works of art, but in this case, we have commissioned an entire exhibition from one of our most prolific living artists.

The year 2002 was particularly significant for Hockney, as Lawrence Weschler points out in his main essay for this catalogue. That was the year that Hockney returned to making art full-time following an intense period of research on the development of portrait making. Something—a certain line? a photographic quality?—had caught his eye, and Hockney began the process of gathering reproductions of hundreds of portraits, which led to building *The Great Wall* (see figs. 27 and 32). Using high-quality color photocopies, he arranged the portraits chronologically on a horizontal axis (early to late, left to right) and geographically on a vertical axis (transitioning from Northern European works at the top to those from Southern Europe at the bottom). With the *Wall* constructed, he continued his discussions with scientists and art historians around the globe to study his theory that artists had, indeed, for centuries used optical devices as aids in their drawings. With the *Wall* assembled, he was able to pinpoint the moment in time, circa 1430, when artists began using optical devices in their working processes. His methodology and findings were communicated in his book *Secret Knowledge: Rediscovering the Lost Techniques of the Old Masters.*[4] Evans has said that Hockney was liberated by the fact that he had discovered that artists across a period of centuries had used optical devices as aids in portrait making—aids, but not crutches. Experimenting with the camera lucida himself to make a series of portraits, Hockney confirmed that to use such a

device, one had to be a very good draftsman. "It's not that easy. The truth is, if you need the device in order to be able to draw, it won't be of much use at all. On the other hand, if you don't, it can be immensely useful."[5]

That feeling of liberation manifested itself in an explosion of activity over the next decade: watercolor, painting *en plein air*, experimentation with the iPhone, iPad drawings, oil paintings on the grandest scale imaginable, digital movies, and, more recently, charcoal on paper. Throughout his life, Hockney has explored new technologies, new ways of making pictures, various ways of, to borrow a word he uses often, "depicting." This post–*Secret Knowledge* period has seen an explosion of experimentation and creativity, as well as productivity.

David Hockney: A Bigger Exhibition, with more than 250 works of art displayed in roughly 18,000 square feet of gallery space, is the largest exhibition in the history of the de Young, and it includes some of Hockney's grandest works both in terms of size and concept. Several of the groups of paintings in the exhibition are considered as single works of art, and some works actually comprise as many as thirty-two canvases. The show also illustrates the fact that Hockney has, over the last decade, concentrated on two genres: portraiture and landscape (though Weschler makes a very good case in this volume for considering the landscapes as portraits). These two genres encompass many media, from the complex technologies used to make the movies to the simplest technology of all, the pencil and paper. Like an artist alchemist, in one minute Hockney uses a fancy digital device to make a colorful iPad drawing (see pls. 138–165); in the next he shows us that he is one of our greatest draftsmen by rendering

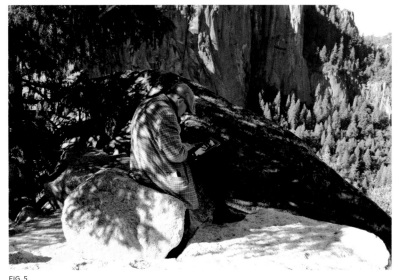

FIG. 5

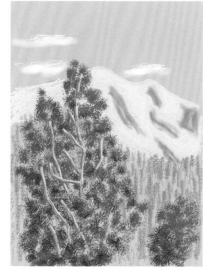

FIG. 6

an exactingly detailed charcoal drawing of a forest scene in East Yorkshire, England (see pls. 231–255).

As Gregory Evans, curator of the exhibition, began to discuss his ideas for its organization, we both felt that it was important to make several distinctions. For the most part, the work since 2002 is shown in roughly chronological order. This points to the fact that over the past decade Hockney has been making landscapes and portraits essentially simultaneously, although he went through periods where he would focus on one or the other. Sarah Howgate, in her essay in this volume, has made her own observations about his portraits, which have arisen in several intense periods devoted to the genre. She describes the intimacy of the portraits in scale, media, and choice of subject—almost always a close friend, relative, or colleague.

The landscapes are also grouped in several distinct sections. The watercolors from 2002 to 2004 represent a period in which Hockney used the medium exclusively and intensively for the first time (see pls. 1–56). In 2004 he began a rather lengthy stint, which continues today, of painting and drawing *en plein air*, first using watercolor, then moving to oil on canvas, the iPad, the movies, and charcoal on paper. In many cases, he recorded the start and end times of each piece, pointing again to the importance of time in his work.

The landscapes also largely factor in his use of digital technologies. In particular, he used the iPad to draw landscapes of the East Yorkshire countryside as well as the spectacles of Yosemite National Park. In fact, after the first Yosemite drawings in 2010 (see pls. 179–196) and the subsequent printing of those works, he realized that to capture the grandeur of Yosemite,

the prints needed to be larger, an aspect he was not considering on his first Yosemite trip. Hence, *Bigger Yosemite*, comprising those five drawings made on that subsequent sojourn in 2011, each made with the intention of being printed as large as twelve feet high (pls. 197–201). His continuing uses of digital technologies also include a period of portrait making on the computer (see pls. 93–97) and on the iPad (see pls. 139, 141, 143, 145, 147, 151, and 159), as well as a series of iPad self-portraits (see pls. 202–209).

Particular groups in the exhibition deserve special explanatory mentions. The four nine-camera digital movies documenting the four seasons in Woldgate, England (pls. 211–214), are considered by the artist to be one work. The same is true for the thirty-two-canvas painting and its accompanying twelve iPad drawings entitled *The Arrival of Spring in Woldgate, East Yorkshire in 2011 (twenty eleven), Version 3* (pls. 166–178).

A Bigger Message (pl. 105), consisting of thirty canvases, grew out of the artist's interest in the Baroque-era French artist Claude Lorrain's *Sermon on the Mount* in the Frick Collection, New York. At the time, the painting was very dark and needed cleaning. Hockney did his own "restoration" of the painting, working with a photograph on the computer and cleaning it digitally. He then copied in oils both the dark and brightened versions. Fascinated by the topic, he then painted several reinterpretations of the work (see pls. 101–104). Each of his versions became progressively more abstract or, better, Cubist, before he completed the larger piece. This group of paintings is not considered a single work as are several of his other groups or series; rather it visually documents Hockney's thinking and rethinking the Lorrain painting over time.

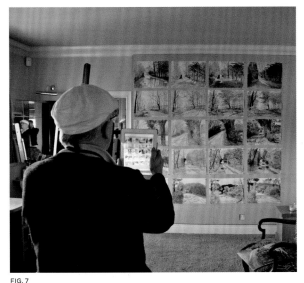

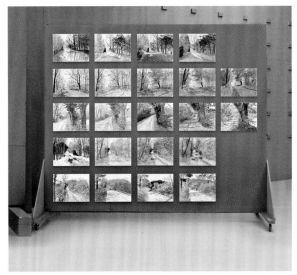

FIG. 7 David Hockney photographing *The Arrival of Spring in 2013 (twenty thirteen)* in progress, 2013

FIG. 8 *The Arrival of Spring in 2013 (twenty thirteen)* in progress, 2013

Only by seeing *The Great Wall* and understanding the scope and scale of this enormous undertaking can one ultimately have any sense of the freedom it gave the artist going forward. Hockney invested more than a year of initial research into Western portraiture and his assembly of the *Wall*. Along with this rare showing of *The Great Wall*, the exhibition includes a selection of Hockney's camera lucida drawings, his own experiments with using an optical device as an aid.

Hockney continues to generate new ideas and methods, and his work remains fresh and remarkable. Since the opening of *David Hockney: A Bigger Picture* in Cologne in October 2012, he has worked exclusively with charcoal on paper, and the exhibition displays a considerable number of these drawings. Making portraits of loved ones and those who have worked closely with him (see pls. 221–230), alongside his continuing documentation of his beloved East Yorkshire countryside, Hockney has not turned away from color so much as he has begun to lavish upon his work an extraordinarily generous amount of detail about what he sees. As has happened again and again when Hockney turns his attention to a different medium, he proceeds to mastery. Then, it is as though he cannot keep up with all the things that he wants to get down. This foray into drawing with charcoal has all the intensity of his work on the multicanvas paintings, the iPad drawings, and the movies.

Finding himself in East Yorkshire in January 2013, Hockney realized that he had the opportunity to capture the arrival of spring once again. Without the use of the iPad and those colorful drawings that led to the monumental multicanvas fantasy painting chronicling the arrival of spring in 2011, he has mastered the medium of charcoal to make twenty-five drawings (pls. 231–255) that capture the event on paper in staggering, almost breathtaking detail. There is no color, yet in them "you can see the bleakness of the winter and its exciting transformation to the summer."[6] Without the aid of an optical device to render such levels of intricacy, with these most recent works, Hockney has proven that he is, above all, a consummate virtuoso of draftsmanship.

NOTES

1 It was also on this trip that Hockney revisited Yosemite, where he made the second suite of iPad drawings that are known as *Bigger Yosemite*.

2 Lawrence Weschler, *True to Life: Twenty-Five Years of Conversations with David Hockney* (Berkeley: University of California Press, 2008), 90.

3 By 2011 he had used only as many as nine cameras.

4 David Hockney, *Secret Knowledge: Rediscovering the Lost Techniques of the Old Masters*, rev. ed. (London: Thames and Hudson, 2006).

5 Weschler, *True to Life*, 146.

6 E-mail from David Hockney to the author, May 17, 2013.

LAWRENCE WESCHLER

LOVE LIFE: DAVID HOCKNEY'S TIMESCAPES

ON THE TRAIN OUT OF LONDON'S KING'S CROSS STATION TOWARD
Bridlington, via Doncaster, one cold gray morning this past January—on my way to visit with David Hockney once

again, this time regarding his upcoming San Francisco show of portraits and landscapes—I was watching the snug small

towns and winter-idled fields stream by, punctuated by the occasional copse of bare trees, and I found myself recalling

some lines of Auden's that David used to cite when we were first getting to know each other (around the time of his

Polaroid collages in the early eighties). A crisp vivid stanza from W. H. Auden's "Letter to Lord Byron," to be exact:

> *To me Art's subject is the human clay,*
>
> *And landscape but a background to a torso;*
>
> *All Cézanne's apples I would give away*
>
> *For one small Goya or a Daumier.*

How he loved decanting those lines as he splayed out the Polaroid tiles into yet another portrait of this or that

other fond dear friend—his studio assistants David Graves and Richard Schmidt and Gregory Evans, for example, or

his longtime sidekicks Christopher Isherwood and Don Bachardy, or Billy Wilder and his wife, or Stephen Spender

by himself (see fig. 9)—commenting on the amount of time and focus it took to work out that room-wide backdrop

if he were going to succeed in bringing out the piece's true subject and his heart's true passion, which was to say, all

that human clay.

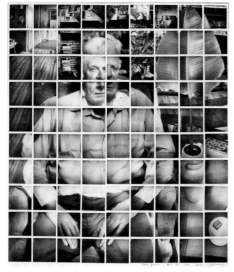

FIG. 9

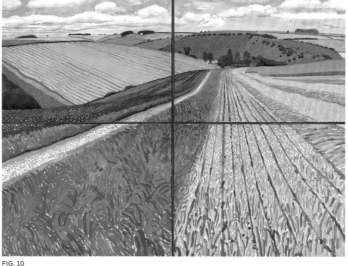

FIG. 10

FIG. 9 David Hockney
Stephen Spender April 9th 1982
Composite Polaroid
34 ¾ × 30 in. (88.3 × 76.2 cm)

FIG. 10 David Hockney
*Vista near Fridaythorpe,
Aug, Sept 2006*
Oil on 4 canvases
72 × 96 in. (182.9 × 243.8 cm)

FIG. 11 David Hockney
More Felled Trees on Woldgate
(detail, pl. 87), 2008
Oil on 2 canvases
60 × 96 in. (152.4 × 243.8 cm)

FIG. 12 Felled Woldgate Totem, 2012

FIG. 13 Front page of the *Guardian*,
November 19, 2012

How remarkable, I found myself thinking, that over the past ten years, the culmination in many ways of a passionate journey of aesthetic inquiry that had really begun with those gridded Polaroid collages, so much of the work had come to focus on an engagement with landscapes entirely emptied of any people (see, for example, fig. 10).

As the train now began to home in on its coastal East Yorkshire Bridlington terminus, the thus far relatively bland landscape began to take on character. It began, that is, to look like "a Hockney." And no wonder—scores of David's watercolors and paintings and blown-up iPad drawings of these very wheat fields and sloping wolds and tight-grouped trees and blowsy cloudscapes had recently held center stage at the Royal Academy of Arts in London. (A record 650,000 rapt visitors had traipsed through the gallery-wide exhibition, which then went on to draw similarly unprecedented crowds in both Bilbao and Cologne.) Someone in London had commented that Hockney had managed to turn this previously ignored corner of East Yorkshire into a virtual national park, so familiar had people become with this particular vantage or that particular view, and so treasured had those views become. Indeed thousands of people had started making pilgrimages to the environs of this otherwise fairly dilapidated onetime summer coastal resort situated across the North Sea from northernmost Holland. Having been noticed, the landscape sliding by—the dendrite-spreading trees, the sky-reflecting puddles, the dense brambly hedgery—began to look *worthy of notice*. No longer bland, it seemed to take on promise, veritably to breathe it out. Look at me, it seemed to boast (not unlike certain fields outside Arles, on other hillscapes in the lee of

the Montagne Sainte-Victoire east of Aix), look at me, *for I have been seen*.

DAVID WAS THERE to greet me in the parking lot at the Bridlington station, all bundled up, smoking, snug in the driver's seat of his Lexus sedan. He was, as I had been forewarned, somewhat less voluble than usual. Granted, over the years he has seemed to follow a regular, almost tidal, pattern: five or six years of intense and evermore intense activity (and the past half-dozen years had seen perhaps his most intense productivity ever), followed by several months of almost prostrate collapse. Only this time, as I was now given to understand, things had been a bit more serious than that. In fact, within weeks of each other he'd suffered a minor stroke that had initially left him almost unable to speak, though his thinking and ability to draw had gone largely unscathed, and then four nights in a hospital for a substantial operation to clear some arteries in his neck (the first time in his seventy-five years that he'd ever undergone anesthesia, or even spent the night in a hospital!). His ability to speak seemed to be filling back in, and doctors were predicting he'd soon recover completely, but his discourse that weekend was still somewhat more halting than usual, and the experience—a brush, after all, with mortality—had clearly left him fairly shaken.

But what had really upset him, I now came to understand as he took me on a short side trip down Woldgate Road just outside town (the undulating, tree-dappled two-mile country lane that constitutes the spine, as it were, of Hockney National Park), was something altogether more savagely unexpected. As I say, those of us who have been following Hockney's landscape passion over the past decade, or else have re-experienced it across

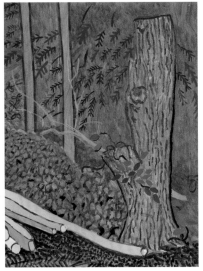
FIG. 11

FIG. 12

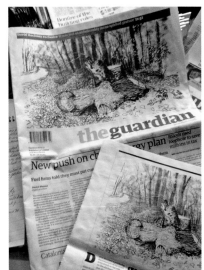
FIG. 13

the recent museum shows, have gotten to know many of these swerves and swells almost by heart. We recognize this thistle-choked hedgerow along the roadside here, for example, or right over there, the leaf-tramped paths perpendicularly bisecting the road, the spot where David used to set up his easels season after season back in 2006–2007 as he built up the nine separate six-canvas combines portraying the changing play of air and light month by month across the spreading forest floor. And then, coming up here, the stretch of timberland thicket that was thinned out the following year, in 2008, the felled logs dragged out onto the roadside and stacked in piles, subject of countless drawings (indeed some of the most poignant drawings of Hockney's entire career, especially a sequence capturing the hauntingly emptied expanse once the felled trees had been removed [see pls. 85–86]), as well as a whole suite of epic color-besotted oil paintings (see pl. 87). And now, round this next bend, yes, we'd doubtless see the Totem (see fig. 11), as David called it, the person-tall magisterial tree stump by the side of the road that Hockney had convinced the foresters to leave standing and that over the years had become one of his favorite subjects. Only wait, where was it? It wasn't there! Where had it gone?

David pulled the sedan to a stop and lit up a cigarette, allowing me to take in the full dimensions of what had happened: somebody, probably more than one somebody, had come along and simply toppled the thing, sawn the main body clean through a foot or two from the ground, abandoning the felled bole where it had come crashing down (see fig. 12). "Vandals," David muttered, exhaling a drag. "I mean, the sheer *meanness* of it all."

He restarted the car engine and we headed back toward town, David

relating how shortly after his little stroke, while he'd been down in London getting checked out, a group of pranksters one night had apparently defaced the famous Totem, slathering graffiti all across its flanks in gaudy, bright pink paint—the image of an erect phallus at waist height, the word "CUNT" in a sloppy scrawl. David's own crew had been hesitant even to tell him, though in the event he hadn't proven all that upset, figuring that the coming rains would wash the vileness away. But then a few weeks later, in the period following his operation while he was in the hospital, the hooligans had apparently come back in the middle of another night to chop the whole thing down. "You could see," he now said, "it can't have been an easy thing to do. It was quite thick there at the base. Must have taken a good hour and involved at least two of them." Again David's crew had hesitated to tell him; he only found out on the Monday of his return. Shattered, he withdrew to his bed and didn't get up for two whole days. "Very dark," he now intoned. "I felt about as bad as I have in many years. Why would anyone do something so spiteful?" That Thursday, though, he'd climbed out of bed, newly resolved, and headed back to the scene, sketch pad in hand. "I couldn't really speak still," he now recalled as we turned onto his side street. "But I could draw, and I could even concentrate." And over the next few weeks of intense concentration, he proceeded to produce five charcoal drawings of his felled hero (pls. 216–220).

He now eased the sedan into the garage of the onetime bed-and-breakfast he'd originally bought as a residence for his then-nonagenarian mother (and into which he and his studio crew had moved in the wake of her passing, back in 1999), and we made our way into the lodging's cozy

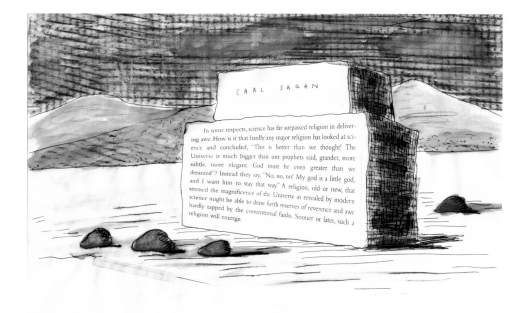

In some respects, science has far surpassed religion in delivering awe. How is it that hardly any major religion has looked at science and concluded, "This is better than we thought! The Universe is much bigger than our prophets said, grander, more subtle, more elegant. God must be even greater than we dreamed"? Instead they say, "No, no, no! My god is a little god, and I want him to stay that way." A religion, old or new, that stressed the magnificence of the Universe as revealed by modern science might be able to draw forth reserves of reverence and awe hardly tapped by the conventional faiths. Sooner or later, such a religion will emerge.

FIG. 14

FIG. 14 David Hockney
Carl Sagan Quote, 1995
Crayon, Uni-ball pen, and collage on
xerographic print
11 × 17 in. (27.9 × 43.2 cm)

FIG. 15 David Hockney
My Parents, 1977
Oil on canvas
72 × 72 in. (182.9 × 182.9 cm)
Tate, London

FIG. 16 David Hockney
Le Parc des Sources, Vichy, 1970
Acrylic on canvas
84 × 120 in. (213.4 × 304.8 cm)
Private collection

kitchen ("cozy" having been a favorite word of Auden's as well), where David showed me reproductions of the five drawings. "The people at the *Guardian* heard about the tree's having been chopped down—word of the event made it down to London" (the Totem had been one of the standout stars, after all, of the previous year's Royal Academy show, its image plastered all over town) "and they called up to ask if I had any comment. In response, I e-mailed them images of some of the drawings"—David rummaged around piles of old papers, spearing a copy of the daily—"and, see, they put it on the cover" (fig. 13). Indeed they had, and above the fold at that, with a whole other spread on the inside. *Major news.* Hard to imagine anything like that happening in the United States. Who was it—Pound?—who described poetry as news that stays new? On the other hand, famously, conversely, as William Carlos Williams noted in his "Asphodel," "It is difficult to get the news from poems," continuing, "yet men die miserably every day for lack of what is found there."

Mortality, of course, being of the essence here. Surely Hockney's brush with his own mortality must have intensified the pall of his response to the assassination of that Totem, whose resolute survival after the thinning out of all the other logs piled there by the side of the road, piled and then hauled away, must over the years have come to stand, in no small measure, for his own unflagging productivity. His drawings and paintings of the Totem across the ensuing seasons hadn't been landscapes at all, I found myself thinking later that evening as I prepared for bed, recalling the Auden riddle I'd thrummed at on the train ride up; if anything, they'd been portraits. And *self*-portraits at that. How else to account for the uncanny

power of those drawings of the Totem felled, drawn in the wake of his own near brush with death?

Still later, falling off to sleep, I came to realize that, in fact, the distinction between landscape and portrait at the heart of this coming show, at least as it pertains to Hockney's work of the past several years, might itself constitute a kind of mischaracterization. For Hockney's weren't landscapes in any conventional sense. Rather, they were portraits of the land, and not just any land—land that David himself had worked as a teenager on summer stints out of nearby Bradford, land across which his mother's very ashes had been scattered. They were careful studies of the way light and the seasons played across the face of the land, rendering the vistas ever more familiar and cherished. And for that matter, conversely, the more conventional portraits in this coming show, repeated returns year after year to gaze upon the same dear friends, might in their way be seen as landscapes—careful, care-saturated studies of the weathering of face, bearing, and posture across the years (of course the tradition of portrait as landscape goes a long way back in the Western tradition; think of the great wide horizonscape of Velázquez's *Rokeby Venus*). Indeed, the landscapes and portraits alike might better be understood as *timescapes*, studies of time's passing, and as such, evocations of the evanescent preciousness of life.

AT ONE POINT, sometime in the early nineties, Hockney took a paragraph from the astronomer Carl Sagan's book *Pale Blue Dot*, photocopied it, embedded the text in a simple color drawing of a plinthlike monolith dominating a rock-strewn plain, and proceeded, as was his frequent wont,

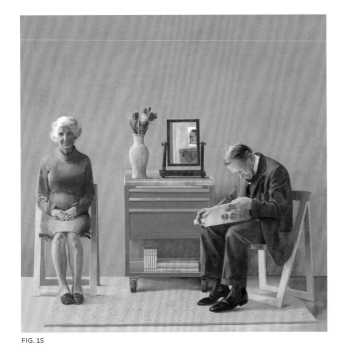

FIG. 15

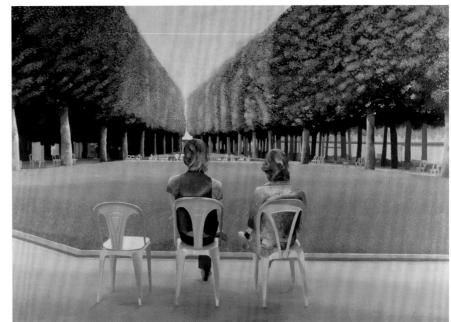

FIG. 16

to mail copies of the image to several friends (fig. 14). "In some respects," the plinth's text reads:

> *Science has far surpassed religion in delivering awe. How is it that hardly any major religion has looked at science and concluded, "This is better than we thought! The Universe is much bigger than our prophets said, grander, more subtle, more elegant. God must be even greater than we dreamed"? Instead they say, "No, no, no! My god is a little god, and I want him to stay that way." A religion, old or new, that stressed the magnificence of the universe as revealed by modern science might be able to draw forth reserves of reverence and awe hardly tapped by the conventional faiths. Sooner or later, such a religion will emerge.*

Across the bottom of the version he sent me, he'd hand scrawled, in the lower right-hand corner of the image, a simple injunction: *"Love life!"*

I say timescapes, but what I mean, of course, are *lovescapes*.

NOW, I'M NOT in any way suggesting that Hockney fancies himself Moses-like, the founding prophet of some new age religion. But the thing that stands out in that Sagan passage, looking back on it now, is the precision of its characterization of the challenge—the need to break free from impinging orthodoxies, to reach for bigger and grander ways of being in the world; the way in which, as Hockney himself soon started insisting with ever-greater urgency, *wider vantages are called for now.*

As it happens, Sagan died just a few years after penning those lines, and what might have initially read, in Hockney's rendition, as a rousing

monolithic assertion came, with the passage of time, to seem more like a tolling memorial headstone. Likewise, I've recently come to feel, with the whole sweep of Hockney's production across the latter half of his career, starting in the early eighties with those Polaroid collages. Elsewhere I've attempted to evoke the dead end before which David had seemed to arrive toward the end of the seventies: how two Golden Boy decades in which he had seemed incapable of doing any wrong had culminated in that series of extraordinarily successful double portraits—from Henry Geldzahler and Christopher Scott in 1969 (fig. 70), Celia and Ossie with their cat in 1970 (fig. 69), and Peter Schlesinger gazing down on that swimmer poolside in that 1972 hillscape, on through the remarkable portrait of his parents from 1977 (his mother to one side, peering intently out at him, his father hunched off to the other, seemingly lost in the perusal of an art book spread across his lap) (fig. 15). Hockney could have easily gone on knocking off that heightened realist sort of thing for the rest of his life, and doubtless his dealers would have loved him for it; they were instant classics. But something was gnawing at him all the while, already discernible in one of the first in the series, *Le Parc des Sources, Vichy* of 1970 (in which two friends seen from behind on plastic chairs, a third empty chair by their side from which David had presumably only just risen, gaze into a pair of vertiginously tapering tree colonnades to either side of the canvas) (fig. 16), and then all the way through the ridiculously ambitious and presently abandoned view out across the street from the inside of his studio as depicted in *Santa Monica Blvd.* (1978–1980) (fig. 17). The problem being, as he would come to see it, the tyranny of one-point perspective. Thus Hockney's increasing fascination,

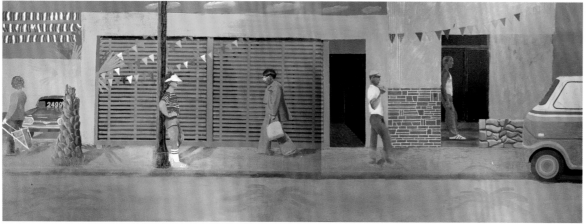

FIG. 17

FIG. 17 David Hockney
Santa Monica Blvd., 1978–1980
Acrylic on canvas
86 × 240 in. (218.4 × 609.6 cm)
Collection of the David Hockney Foundation

FIG. 18 David Hockney
George Lawson and Wayne Sleep Pembroke Studios London W8, 2 May 1982
Composite Polaroid
56 × 30 in. (142.2 × 76.2 cm)

FIG. 19 David Hockney
Celia Making Tea, N.Y., Dec. 1982
Photographic collage
An edition of 20
25 × 21 in. (63.5 × 53.3 cm)

FIG. 20 David Hockney
Dog Painting 34, 1995
Oil on canvas
18 × 25 ½ in. (45.7 × 64.8 cm)
Private collection

there toward the end of the seventies, with Cubism in general and Picasso in particular (especially the late Picasso)—the way those artists too had been wrestling with the same problem. And thus, also, the origins of that Polaroid passion, starting in February 1982, in which he was consciously trying to break the picture plane into multiple one-point perspectives, the goal, already there, being to reach out toward wider and wider vantages.

But the thing of it was, I now realized with a start, what else had been going on in the early eighties? Googling, I confirmed that April 24, 1980, had seen the recognition of the first case of AIDS in the United States, when Ken Horne, a San Francisco resident, was reported to the Center for Disease Control as presenting with a previously rare cancer known as Kaposi's sarcoma. On July 3, 1981, the *New York Times* ran an article headlined "Rare Cancer Seen in 41 Homosexuals," the first such piece on the subject; by the end of 1981, 121 people had died of the disease. Hockney fashioned his first Polaroid collage, a tour of his Hollywood Hills home, on February 26, 1982, going on to assemble dozens more such collages, mainly portraits, over the next several months (see fig. 18). On July 27 of that same year, just around the time Hockney was beginning to make the transition from those gridded Polaroid combines to the more seemingly *pêle-mêle* borderless Pentax photocollages, the term AIDS (Acquired Immune Deficiency Syndrome) was first proposed at a meeting of gay leaders and federal health bureaucrats in Washington, DC, as a replacement for the previous term GRID (Gay Related Immune Deficiency), as evidence was beginning to percolate that the illness was not confined entirely to gay men. And indeed, on December 10, 1982, a baby in California became ill with the first known case of AIDS

contracted from a blood transfusion. That same month, Hockney crafted a major photocollage documenting a visit to the New York City apartment of his longtime friend and model, Joe MacDonald, who had recently fallen mysteriously ill. And soon thereafter he made another one, showing their mutual friend Celia in hauntingly backlit dark silhouette preparing a cup of tea for Joe, who is seated on his bed, one of the first such combines in which Hockney tries to interject the experience of movement: Celia's arm pulling the tea bag out of the cup and shaking out its last drips (fig. 19).

By the following year, Hockney, still fancying himself young and blithe at age forty-five, would start seeing close, dear friends from his young blithe cohort dying all about him: Joe, Nathan, René, Charles, Mario, Larry, Nick…. And not just of AIDS. Over the ensuing years he would lose two of his closest friends, Henry Geldzahler and Jonathan Silver, to savagely premature deaths by cancer, and then, by century's end (albeit at the other age extreme), his mother.

The point is that Hockney's entire production over the three decades since 1982 has been shadowed by death and in many ways can be seen as a direct response to all of that dying—a defiant celebration of life ("Love life!") in the face of annihilation, the assertion of an almost aching tenderness in the very craw of mortality. (Think for instance of that remarkable suite of paintings and pencil sketches from the late eighties and early nineties of his beloved dachshunds, Stanley and Boodge, as they lie there lolling and lazing and nuzzling voluptuously [see fig. 20], this at a time when it was no longer really possible to render similarly uncontaminated vantages of young male nudes.) Life against Death. *Light* against Death (that glorious

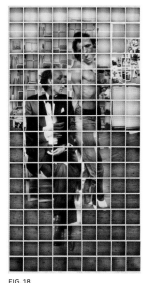

FIG. 18

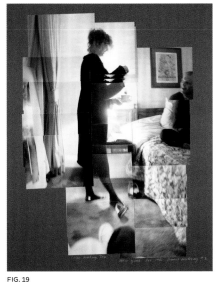

FIG. 19

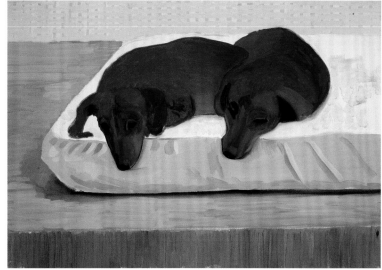

FIG. 20

soaring final exaltation of pure blue light, cresting and cresting at the climax of the "Liebestod" in Hockney's late staging of Wagner's *Tristan und Isolde*). And finally, really, simply love ("*Love* life!")—love against death.

But it's also clear that across the past three decades, the assertion of life and love against death has become synonymous in Hockney's mind with breaking that constrictive, tapering, ever-narrowing stranglehold of one-point perspective. In retrospect one begins to notice intimations of that coming passion already in the seventies. See the way, for instance, he chose to portray Bedlam in his 1975 production of the Stravinsky/Auden *Rake's Progress* at Glyndebourne—not as in virtually every other production of the opera or any other such representation of an insane asylum you've ever likely seen (from Hogarth through Tennessee Williams, from *Cuckoo's Nest* through *Sweeney Todd*), as a seething, roiling mass of demented humanity, but rather as a grid of nested cells, each containing an isolate inmate, tapering relentlessly to the back of the hall. Perspective itself, that is, as a form of madness. With Hockney's subsequent delving into Chinese painting (with its moving focus) and quantum physics (with its liberating tolerance for ambiguity), his critique of the dead hand, the death grip (as he was now coming to see it) of one-point perspective, started becoming more and more overt.

The same goes for his entire photocollage adventure, which, far from being a celebration of photography (as some took it at the time, a retreat from painting into the higher potentialities of the photographic), constituted one long attack on ordinary photography, pervasive as its presence had become (everywhere from billboards to magazines to television and the movies), or at any rate on its standard hackneyed claims to being capable

of representing lived experience in any meaningful way. "Photography is all right," Hockney liked to say, "if you don't mind looking at the world from the point of view of a paralyzed Cyclops, for a split second." He'd pause, waiting for the image to sink in. "But that's not what the world is like, and it's not what actually experiencing the world is like."

Trying to depict the world as it is actually experienced, or, more precisely, to capture the experience of advancing into all that space, now became the animating focus of Hockney's work. At first a series of climactic photocollages allowed, encouraged—frankly, even compelled—viewers to break free from the constraining vise of one-point perspective and instead to let their eyes wander across multiple simultaneous vantages: *Pearblossom Hwy.* (fig. 21), for example, with the seamless interweaving of its attention both to the close-up and the far-off; or *The Desk* (fig. 22), wherein, by following the Cubists' lead and *reversing* perspective, Hockney was able to bid the viewer to move all about the object of regard, seeing it from one side and then the other or both sides at the same time. These were in turn the sorts of effects Hockney explored further when in January 1986 the editors of French *Vogue* gave him free rein of their pages as guest editor. And they likewise circulated back into his paintings of the period, as, for instance, in *A Visit with Christopher & Don, Santa Monica Canyon* (fig. 23) of 1984 (in which the viewer is invited, as it were, to drive up to the house, park the car, descend the steps, enter the home, and walk about from room to room, repeatedly glimpsing the same and yet not quite the same vista from different windows). All of this culminating in that sequence of evermore ambitious depictions of the view out over the Grand Canyon (see fig. 24)

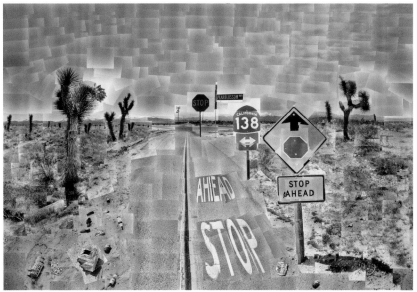

FIG. 21

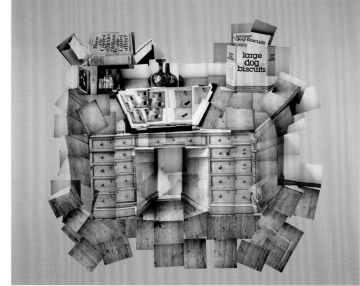

FIG. 22

from the very edge of its rim (way out across to the other side, down into the abyss, and then back up the near flank across a sequence of various side croppings)—*talk about space!*

This layering of space upon space, the stacking of horizon upon horizon in the same image, in turn seemed to reach a further crescendo in the series of paintings Hockney embarked upon some years after that, when he was back in England for the first extended period in years. Traveling back and forth between his aging mother's place in Bridlington and his ailing friend Jonathan Silver's final sickbed in a hospital in York, he now began portraying the land and villagescapes of East Yorkshire for the first time—in *The Road across the Wolds*, for example, or *The Road to York through Sledmere* (fig. 25). Perhaps most impressive of these early efforts is the view in *Garrowby Hill* (fig. 26), where as the highway crests the peak, the sudden vista of the entirety of the York valley suddenly heaves into view, in soaring reverse perspective (you can almost feel how, though the back wheels of the car have yet to quite make it over the hilltop, the front wheels are already barreling forward into the downsloping view).

At the time of its completion, painted from memory back in California several months, actually, after Silver's passing, I'd thought *Garrowby Hill* might betoken Hockney's overtopping, his overcoming of his own period of grieving, with a renewed open field of painterly opportunity spreading out there before him. But in retrospect I realize that, even more, it foreshadowed the descent into another phase of more or less pure research. For it had been just around the same time, a few months earlier in 1999, that, visiting an Ingres retrospective at the Royal Academy in London and closely examining

several of the great French master's extraordinarily accomplished early pencil drawings of English aristocrats on their grand tours through Rome (from around 1815) (see fig. 28), Hockney became convinced that he'd seen that sort of seemingly effortless, confidently assured line before, but where?—oh wait, that was it, in Andy Warhol's drawings of common household utensils (see fig. 29), of all places! Now, Warhol's assurance arose from the fact that he was tracing off of slide-projected photographs, but how could Ingres have been doing it? In the first of a dazzling series of leapfrogging insights, Hockney became convinced that Ingres must have been using a then-only-recently invented camera lucida, a tiny prism held horizontally steady by a stick more or less at eye level above the flat sketching surface, looking down through which the artist could see the, as it were, periscoped image of the subject sitting in front of him, seemingly overlain atop the empty sketching surface below. Taking advantage of the effect, the artist could then block in with great speed and accuracy the location of key features (the pupils of the eyes, say, and the corners of the lips and nostrils, the lie of the ears and the line of the hair, the flow of the enveloping garments, and so forth), thereby greatly facilitating the drafting process.

In the wake, a few months later, of his mother's passing, at age ninety-nine, David procured a camera lucida of his own and launched into a fresh suite of pencil portraits. (It was becoming increasingly the case, following the deaths of close friends and relatives, that David would pull back in, surrounding himself once more with the company of his closest friends and taking a careful "inventory" of all the love that might still be seen to abide.) Meanwhile, he started noticing (Hockney is one of the great noticers in the

FIG. 23

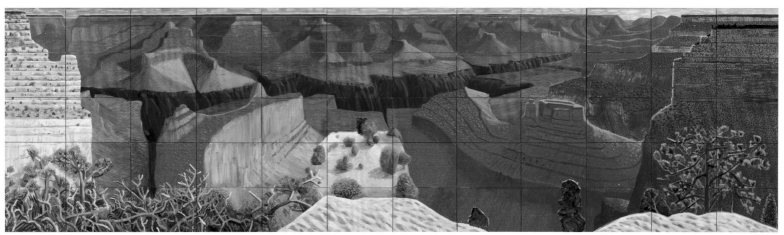

FIG. 24

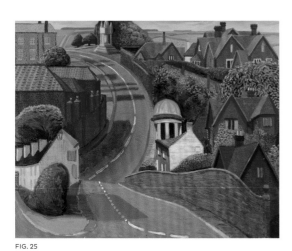

FIG. 25

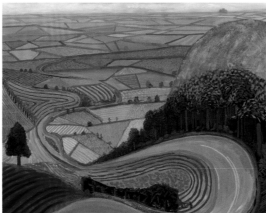

FIG. 26

FIG. 21 David Hockney
Pearblossom Hwy., 11–18th April 1986 (Second Version), 1986
Photographic collage
71 ½ × 107 in. (181.6 × 271.8 cm)
J. Paul Getty Museum, Los Angeles, 97.XM.39

FIG. 22 David Hockney
The Desk, July 1st 1984
Photographic collage
An edition of 20
48 × 46 in. (121.9 × 116.8 cm)

FIG. 23 David Hockney
A Visit with Christopher & Don, Santa Monica Canyon, 1984
Oil on 2 canvases
72 × 240 in. (182.9 × 609.6 cm)
Museum Ludwig, Cologne, Germany

FIG. 24 David Hockney
A Closer Grand Canyon, 1998
Oil on 60 canvases
81 ½ × 293 in. (207 × 744.2 cm)
Louisiana Museum of Modern Art, Humlebæk,
Denmark, acquired with funding from The A. P.
Moeller and Chastine Mc-Kinney Moeller Foundation

FIG. 25 David Hockney
The Road to York through Sledmere, 1997
Oil on canvas
48 × 60 in. (121.9 × 152.4 cm)

FIG. 26 David Hockney
Garrowby Hill, 1998
Oil on canvas
60 × 76 in. (152.4 × 193 cm)
Museum of Fine Arts, Boston, Juliana Cheney Edwards
Collection, Seth K. Sweetser Fund, and Tompkins
Collection—Arthur Gordon Tompkins Fund, 1998.56

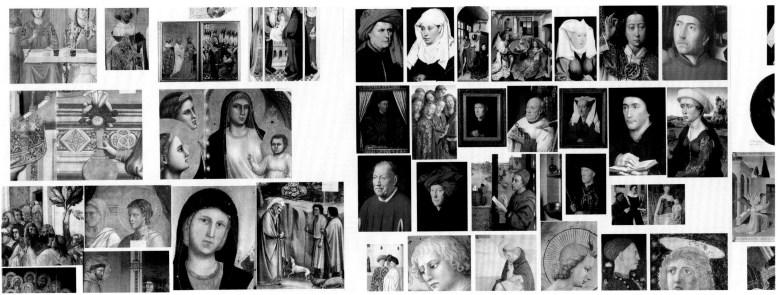

FIG. 27

FIG. 27 David Hockney
The Great Wall (detail, ca. 1400–1500), 2000
Color laser copies on 18 panels
96 × 864 in. (243.8 × 2194.6 cm)
Collection of the David Hockney Foundation

FIG. 28 Jean-Auguste-Dominique Ingres
Portrait of Madame Louis-François Godinot,
née Victoire-Pauline Thiollière de l'Isla, 1829
Graphite
8½ × 6½ in. (21.9 × 16.5 cm)
Collection of André Bromberg, Paris

FIG. 29 Andy Warhol
Still Life (detail), 1975
Graphite on TH Saunders paper
26⅞ × 40½ in. (68.3 × 102.9 cm)
The Andy Warhol Foundation for the Visual Arts

FIG. 30 Jan van Eyck
Portrait of Giovanni(?) Arnolfini
and His Wife, 1434
Oil on oak
32⅜ × 23⅝ in. (82.2 × 60 cm)
The National Gallery, London, bought, 1842, NG186

FIG. 31 Lorenzo Lotto
Husband and Wife, 1523–1524
Oil on canvas
38 × 45½ in. (96 × 116 cm)
The State Hermitage Museum, Saint Petersburg

FIG. 32 David Hockney
The Great Wall (detail, ca. 1830–1890), 2000
Color laser copies on 18 panels
96 × 864 in. (243.8 × 2194.6 cm)
Collection of the David Hockney Foundation

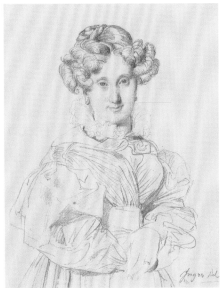

FIG. 28

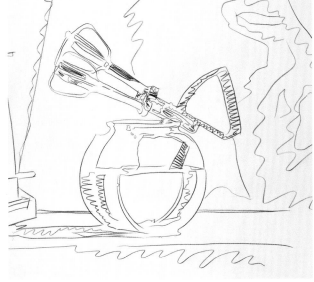

FIG. 29

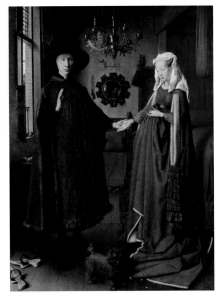

FIG. 30

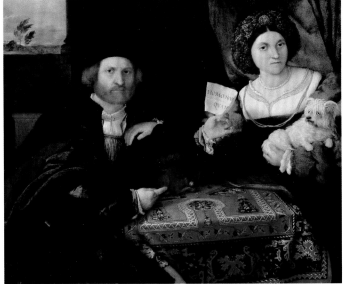

FIG. 31

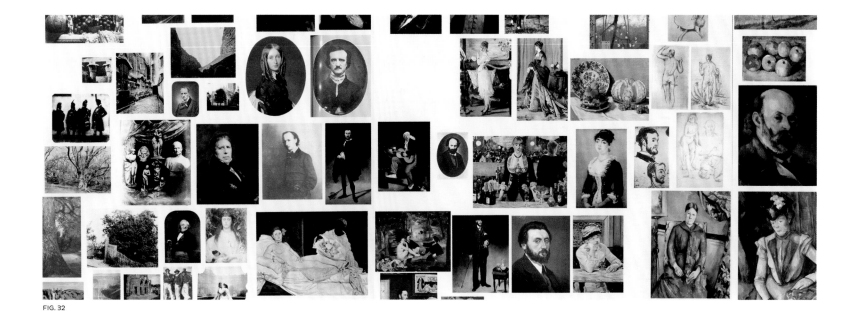

FIG. 32

art world) evidence of the same sort of "look" in the work of artists going back long before Ingres, past Vermeer, and all the way to Caravaggio, who, Hockney now became convinced, must have been deploying some similar sort of optical aid, in his case more likely some sort of pinhole in a wall, perhaps amplified by a simple focusing lens, which is to say a primitive camera obscura.

Clearing the long wall of the studio above his Hollywood Hills home (a studio with a wall the length of the tennis court over which it had been built, and two stories high), Hockney now began photocopying color images from the history of Western art, drawing on his formidable personal library of such books, and shingling the copies all across the wall in chronological order—1350 to one side, 1900 to the other, Northern Europe above and Southern Europe below (see details, figs. 27 and 32). Where and when, he'd wonder, as he perused what his team had taken to calling *The Great Wall*, did that optical look make its first appearance? In such exercises it's often a matter of determining the right question, and in this instance, with that wide swath of the history of European image-making spread across the wall like that, the question almost answered itself. It was obvious: roughly five years to either side of 1430—first apparently in Bruges with van Eyck (see fig. 30) and his followers—and then hard on in Florence with Brunelleschi and his, it was as if Europe had simply put on its spectacles. All at once, *like that*, what had previously seemed halting and awkward, and with no apparent struggle whatsoever to get there, suddenly became vivid and exact—albeit vivid and exact *in a particular way*.

But how, Hockney now wondered, could van Eyck possibly have

accomplished such a remarkable leap, since there was no evidence that lenses had yet come into existence? The next breakthrough came when Charles Falco, a visiting physicist from the University of Arizona who specialized in quantum optics, informed Hockney of something known to any first-year physics student, though apparently unknown to almost every art historian: the fact that concave mirrors (the obverse of all the convex mirrors that had mysteriously begun appearing in Northern European paintings at that very moment) are capable of projecting images of outside reality onto a darkened flat surface, images that can be traced, in exactly the same way as a focusing lens. (Try it yourself some morning in your darkened bathroom using a shaving mirror. The concave reflective surface doesn't even have to be particularly polished or smooth: the effect works equally well with a common aluminum kitchen sieve.) Reviewing the images arrayed along *The Great Wall*, the two, side by side, seemed like intent generals inspecting their troops. Falco now speared one in particular—the Lorenzo Lotto *Husband and Wife* of 1523–1524 (fig. 31)—the geometrical patterning of whose foregrounded Persian carpet table covering and the way it seemed to go in and out of focus at particular intervals, he was subsequently able to deploy in a mathematical proof that optical devices of some sort would have *had* to have been used.

Response to Hockney's and Falco's new discoveries and speculations, once they began publicizing them, proved decidedly mixed. Conventional art historians seemed to take particular umbrage. (The gall of this common bird, talking back like that to such distinguished ornithologists!) Where, they demanded, was the hard evidence, the testimonies or manuals or letters or sketches? (As it happened, Hockney's studio assistant David Graves was

FIG. 33 David Hockney drawing with the aid of a camera lucida, 1999

FIGS. 34-35 David Hockney painting the landscape in East Yorkshire, England, 2006

FIG. 33

able to dig up a good deal of such contemporary evidence, which Hockney included as appendices in a sumptuously illustrated, carefully argued volume laying out the whole theory, *Secret Knowledge: Rediscovering the Techniques of the Old Masters*, 2001.) More generally, people seemed offended that Hockney was suggesting that the Old Masters had somehow cheated. Hockney countered that he wasn't suggesting anything of the sort—that he was speaking of a time, at least at the outset, when the gap between the arts and sciences had yet to open, when Michelangelo and Leonardo and the like would have been omnivorously curious and omnidirectionally engaged. Image makers, positively captivated by such projective effects, would have immediately started putting them to good use (though, given both the Inquisitional tenor of the times and the competitive nature of their vocations, probably in strict secret). Nor was Hockney suggesting, as some of his more literal-minded critics took to caricaturing his position, that every artist had traced every line of every painting. Just to witness such projections, Hockney countered, was to use them; they cast a spell, they left an indelible impression. To the extent that the projections were used, it was to lock in certain proportions and contours, after which the artist could return to more conventional types of direct observational painting, though certain effects (accurate reflections on glass and metal, the sheen of silk) couldn't have been achieved without them. (In the case of reflected armor, for example, the projected reflection would stay still even while the painter's head bobbed and wove, which would not have been possible otherwise; just look at the stylized awkwardness in the treatment of such reflections in paintings before 1430.) Still, the techniques were hardly easy, and some artists were obviously much better at it

than others. "These are the sort of aids," Hockney commented at one point, "that if you aren't already a sophisticated artist won't be of much help; but if you are, they could be of remarkable assistance." And to be sure, he went on, with the passage of time, certain conventions based on extended study of such projected images began to gain a pedagogical currency of their own, delinked from the projections themselves.

But what was most striking across the years of controversy that followed was the way people seemed intent on missing Hockney's main point: that his was a critique of the *limitations* of that kind of painting and of the look—"the optical look"—that enforced it, the insistent misprision that held sway for more than four centuries; that this was what reality actually looked and felt like. Because what he was really critiquing, though he never used the term, was the hegemony of the *cycloptic* look: the paralyzed one-eyed, perspective-pinched vantage, which, it now turned out, had long preceded the invention of photography. Or rather, he argued, the "photographic look" had come into the world all the way back in the fifteenth century when painters began deploying single curved mirrors or lenses or prisms and surrendering to the perspectival imperatives that such devices all but dictated.

In that sense, the year 1839 merely saw the invention of a method for chemically fixing onto paper a way of seeing that had already held sway for centuries. And ironically *that* was the very moment, as Hockney would now be only too happy to show you, his hand sweeping to the far end of his *Wall*, when European painting began falling away from the optical (see fig. 32). "Awkwardness returns!" he would announce triumphantly. Artists once again began looking with two eyes, trying to capture all the things a standard

FIG. 34

FIG. 35

chemical photograph couldn't. Impressionists, expressionists, Cézanne, and presently the Cubists were no longer trying to aspire to "objective" truth, in the chemical-photographic sense; rather, they were endeavoring to fashion a way of seeing that was "true to life." And in that sense, in a world progressively more saturated (and by our own time, supersaturated) with conventional photographic imagery, the Cubist project was far from over.

And Hockney seemed ready once again to take up the gauntlet.

"OH DEAR, I truly must get back to painting." How many times over the previous twenty years, after one such new extended side-passion or another (the photocollages, the fax combines and the handmade prints, the prolonged investigations into physics or Chinese art, the operas, the camera lucida drawings, and now this all-consuming multiyear art historical excursus) had I heard that phrase tripping off David's lips? The fact is that the twenty years since 1980 had seen far fewer paintings than the two preceding decades. But now, in the first years of the new millennium, David seemed freshly resolved. Now he was really going to pour himself back into painting.

Except that instead he took up watercolors (actually he'd begun to explore the medium a few years earlier, in London, and then ever more assuredly in Norway and Iceland) (see pls. 15–18). In part, he'd now explain the attraction, they allowed him to work *en plein air* and as such really to explore the staging grounds surrounding his new Bridlington home base. (He'd told the folks back in Los Angeles that he hadn't permanently left, he was just "on location," a concept he figured they could relate to. But, in fact, he'd grown weary of the heightened post–9/11 immigration security regime

permeating the United States, which was making it much more difficult for his English friends to visit; and he was also constantly exasperated, almost beside himself, with California's variously compounding antismoking initiatives.) But in addition, watercolors by their very nature, with the immediacy of their application, precluded any sort of "optical" approach. Furthermore, the unforgiving nature of the medium (the way one couldn't easily cover over one's mistakes) forced him to look deeper the first time (for example, at the profuse varieties of plant material making up a seemingly random roadside hedge, each genus specifically distinct, and each individual specifically distinct within the genus) — to look deeper and hence see more. Over just a few months from the late summer of 2004 through the end of the year, Hockney produced well over a hundred such watercolor studies.

But he was just getting started, and the year 2005 would indeed finally see his return to painting in a big way, starting with a relentless outpouring that summer — sometimes a full painting a day, occasionally even two or three — retracing some of his favorite sites from those earlier watercolor excursions. All the while he kept trying to widen his vantages, not only deploying some of the reverse perspective tricks he'd honed during the earlier photocollage experiments, but presently contriving methods as well for mounting multiple canvases on easels, one beside the next, and then six at a time (two high and three wide), creating vistas that were not just bigger and wider but that featured multiple overlapping vanishing points, pulling the viewer ever more actively into the scene (see figs. 34–35). The effect was all the more striking in several of the paintings in that Hockney would have repeated recourse to the trope of a road receding toward the horizon

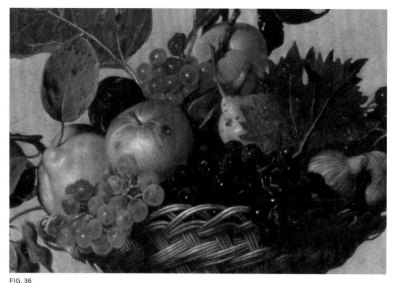

FIG. 36

FIG. 37

(sometimes under a virtual tunnel of overarching trees)—the very epitome of the traditional one-point perspective effect—only, in his versions, the roads would be veering slightly off-center, and the viewer's gaze drawn equally powerfully to all the vantages peeling off to its sides.

"How do you like my latest figure paintings?" he asked me, impishly, one day around this time, as I stood gazing at one of those combines on the wall of the big studio he'd established in the hangar of an industrial park just outside town. "But," I decided to take the bait, "there *are* no figures." At which point, smiling wryly, he corrected me, emphatically insisting, "*You—you* are the figure." Indeed, perusing some of those combines, you couldn't help it: your eyes would up and go for a walk, perhaps nowhere more so than with the fifty-canvas winterscape, his vastest and most staggering combine yet, *Bigger Trees near Warter*, which took up the entirety of the far wall in the long hall of the Royal Academy's summer 2007 group invitational (see fig. 38).

Throughout this period, Hockney took particular delight in how vividly the resultant paintings read from across the room, in direct contradistinction from those fashioned under the more conventional "optical" approach. He'd enjoy tacking the color reproduction of, say, the detail of a Caravaggio still life on the far side of the studio (see fig. 36), right up next to the reproduction of a similarly themed Cézanne, with the fruit in question exactly the same size (see fig. 37). "Not to diminish the exquisite mastery of Caravaggio's rendering," he'd say, "but just look: the Caravaggio from this distance virtually disappears, while the Cézanne almost pops off the wall." This, he was convinced, was because the Carvaggio had a certain distancing, receding

perspective *built into* the composition (the cycloptic recess, occasioned by the way it had been produced, persisting in an abstractly frozen present), whereas Cézanne's apples had been seen with both eyes and across time.

Indeed, time itself and its passage now began to take up more and more of Hockney's concern. Wider and wider vantages continued to be needed, but whereas at the Grand Canyon, for instance, Hockney had been after bigger and bigger spaces, around Bridlington he was instead becoming intent on incorporating greater and greater extensions of time, and not just the time involved in becoming the figure and taking those visual ambles all about the painting. ("And some time make the time to drive out west / Into County Clare," as Seamus Heaney urges us to do at the outset of his poem "Postscript" at the end of his *Spirit Level* volume. Take the time, that is, to render yourself aware of all the life unfurling even past the corner of your eye, the things that come at us "sideways / And catch the heart off guard and blow it open.") Hockney was also becoming more and more sensitive to the passage of time *between* paintings, the play of the seasons with their very specific barometric shifts. Time and again he would return to the same sites—those intersecting paths in the Woldgate Woods, for example, which he ended up depicting no fewer than nine times in six-canvas combines across 2006; or the trio of trees near Thixendale, rendered twice the following year, the first time in August when they presented themselves almost like great green breathing lungs, the second in December, by which time they'd been stripped to an almost dessicated anatomical cross section (figs. 39–40). The seasons had been something he'd nearly come to forget in Southern California (since in Los Angeles, famously, there hardly are any), and their

FIG. 38

FIG. 36 Michelangelo Merisi da Caravaggio
Basket of Fruit (detail), ca. 1599
Oil on canvas
18 ½ × 78 ¾ in. (47 × 200 cm)
Biblioteca Pinacoteca Accademia Ambrosiana,
Milan, donazione cardinal Federico Borromeo
1618, inv. 151 1984 000151

FIG. 37 Paul Cézanne
Apples (detail), 1877–1878
Oil on canvas
7 ½ × 10 ⅝ in. (19 × 27 cm)
On loan to the Fitzwilliam Museum, Cambridge
from King's College, Cambridge, England

FIG. 38 David Hockney and friends
looking at *Bigger Trees near Warter or/
ou Peinture sur le Motif pour le Nouvel
Âge Post-Photographique* at the London
Royal Academy of Arts Summer
Exhibition, 2007

OVERLEAF:

FIG. 39 David Hockney
Three Trees near Thixendale, Summer 2007
Oil on 8 canvases
72 ¼ × 192 ¾ in. (183.5 × 489.6 cm)
Private collection

FIG. 40 David Hockney
Three Trees near Thixendale, Winter 2007
Oil on 8 canvases
72 ¼ × 192 ¾ in. (183.5 × 489.6 cm)
Private collection

passage week by week now constituted for Hockney one of the special savors of this return to his boyhood haunts. Indeed he came to feel that it wasn't until you'd seen a tree winter-bare and all dendrite-spread late in the fall—and preferably across two or three such falls—that you could ever hope to capture its true essence come the following leaf-full, blowsy summer.

SO IT WAS painting, painting, painting virtually all the time those days from 2005 onward at l'Atelier Hockney Bridlington. Except that, in typical fashion, actually, it wasn't; for at the very same time (at least after 2008), David began to be ensorcelled by a whole new, and virtually diametrically opposite, technology altogether, one that he now took to pursuing with almost as much verve and fascination.

A striking openness to new technologies has long been a feature of Hockney's career. There was a time when the people at Canon photocopiers used to ply him with experimental cartridges, long before they went to market, just to see what he'd come up with (he came up with those "handmade prints"). Likewise fax machines in the time of their impending ubiquity, and the long-distance, widely broadcast collages he managed to wrest out of those. For that matter, he was one of the first people I knew who had tape and then CD players installed in his cars—the better to choreograph elaborately prescored drives through the Santa Monica and San Gabriel mountains, soaring and swooping hours-long affairs, alternating between composers, that almost invariably culminated as one came hurtling over the last pass heading back toward the coast, Wagner at full throttle, with a transcendent vantage of the setting sun just as it went slipping into the sea.

(Such openness to new technologies in part explains why, for all his relatively advanced years, Hockney remains one of the youngest artists around.)

Now it was the turn of the iPhone, whose dazzling potential as a color drawing device, by way of its Brushes application, Hockney was one of the first artists fully to exploit. He'd spend hours noodling around on its touchscreen, and further hours away from the phone itself, just thinking about how he might achieve certain effects, before returning to try them out: the effect of white porcelain, for example, or cut glass or polished brass; the effect of cut flowers or bonsai or cacti; or the effect of sun rising slowly over the sea (see pls. 106–137). This last challenge proved especially engrossing for Hockney. An inveterate visual chronicler of sunsets back in California, he'd long wanted to introduce sunrises into his repertory, but prior to the iPhone had never been able to do so. Either it was too dark to make out the paints and colored pencils, let alone the blank surface before him, or if he turned on an indoor light to be able to see such things at all, he'd drown out the dawn. But since with the iPhone light itself was the very medium, this was no longer a problem; he could chronicle the most subtle transitions starting out from the pitchest dark. Suddenly his friends all around the world began receiving two, three, or four such drawings a day on *their* iPhones—each of the incoming dispatches, incidentally, for all intents and purposes, "originals," since there were no other versions that were digitally more complete. "People from the village," he told me one day, "come up and tease me, 'We hear you've started drawing on your telephone.' And I tell them, 'Well, no, actually, it's just that occasionally I speak on my sketch pad.'" And indeed, the iPhone was proving a much more compact

DAVID HOCKNEY'S NEW iPHONE PASSION

AFTER TWO DECADES OF REGULARLY FINDING HIMSELF ENTRAMMELED by all sorts of seemingly extraneous side-passions (photocollages, operatic stage design, fax extravaganzas, homemade photocopier print runs, a controversial revisionist art historical investigation, a watercolor idyll), David Hockney, now age seventy-two, has finally taken to *painting* once again, doing so, over the past three or four years, with a delight and a vividness and a sheer productivity perhaps never before seen in his career. This recent body of work consists almost entirely of seasonal landscapes of the rolling hills, hedgerows, tree stands, valley wolds, and farm fields surrounding the somewhat déclassé onetime summer seaside resort of Bridlington, on the North Sea coast, where he now lives. Some are intimately scaled, but many others are among the largest, most ambitious canvases of his entire career.

The paintings have been widely exhibited—in London (at the Tate and the Royal Academy of Arts), in Los Angeles, a broad overview in a small museum in Germany this past summer—though not yet in New York, a situation that will be rectified come late October by a major show, his first there in ten years, slated to take up both the uptown and downtown spaces at the Pace gallery. The buildup toward these shows has found him busier than ever (he is still in the process of completing a dozen fresh canvases as I write), but not so busy that he hasn't managed to become fascinated by yet another new (and virtually diametrically opposite) technology, one that he is pursuing with almost as much verve and fascination—drawing on his iPhone.

FIG. 44

FIG. 45

FIG. 46

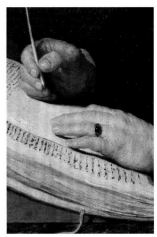
FIG. 47

HOCKNEY first became interested in iPhones about a year ago (if truth be told, he grabbed the one I happened to be using right out of my hands). Soon he had acquired one of his own and began deploying it as a high-powered reference tool, searching out paintings on the web and cropping appropriate details as part of the occasional polemics or appreciations with which he is wont to shower his friends. At one point, for example, he zeroed in on the achingly poignant way a blind man in a Blue Period painting by Picasso reaches to touch a clay vase by a tin bowl, and the way in turn that his unseeing touch heightens our own visual appreciation of the tactility of Picasso's rendering of the vase and bowl (figs. 44–45). At another point he summoned up the uncanny solidity of the way a pair of hands by Rembrandt lay on an open book (figs. 46–47). (Striking, the way the handheld device was refocusing Hockney's attention specifically on hands.)

But soon he discovered one of those new-fangled iPhone applications, entitled Brushes, which allows the user digitally to smear, or draw, or finger-paint (it's not yet entirely clear what the proper verb should be for this novel activity), to render highly sophisticated full-color images directly onto the device's screen, and then to archive or send out the resultant images. Essentially, the Brushes application affords the user a full color-wheel spectrum, from which he can choose a specific color. He can then modify that color's hue along a horizontal range, darker or lighter, and go on to fill in the entire backdrop of the screen in that color, or else fashion subsequent brushstrokes, variously narrower or thicker, and more or less transparent, according to need, dragging his finger across the screen, progressively layering the emerging image with as many such daubings as he desires.

Over the past six months, Hockney has fashioned literally hundreds, probably more than a thousand, such images, sending out as many as four or five a day to a group of about a dozen friends, and not really caring what happens to them after that. (He assumes the friends pass them along through the digital ether.) These are, mind you, not second-generation digital copies of images that exist in some other medium: their digital expression constitutes the sole (albeit multiple) original of the image.

The flood of images has more or less resolved itself into three main streams. To begin with, portraits, and mainly self-portraits at that (see fig. 48)—perhaps playing off the way that an iPhone's blackened screen, when off, already functions as a sort of Claude Lorrain–style darkened glass, reflecting back a ghostly image of the user's face. (Intriguingly, the reflected face in the blackened screen is approximately twice the size of the same face if one turns the iPhone around to snap a photographic self-portrait. "But that's how it always is with photography," Hockney points out. "It inevitably pushes the world away. That's just one of its many problems." Hockney's drawings, as it were, bring the face back to full scale.)

Early on, however, Hockney became much more interested in bunches of cut flowers and plants arranged in brick pots, ceramic vases, and glass jars. These became the occasion for his extensive investigations into the types of effects possible in this new medium. "Although the actual drawing, when I do it, goes quite quickly," he explains, "some days it might be preceded by hours and hours of thinking through just how one might achieve a certain play of light, texture, or color." Indeed, the range of results is dazzlingly various, mouthwateringly colorful, and instantaneously evocative (see figs. 49–53).

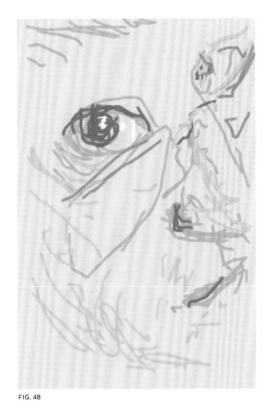

FIG. 48

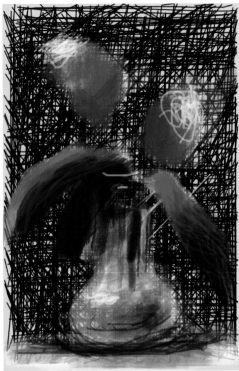

FIG. 49

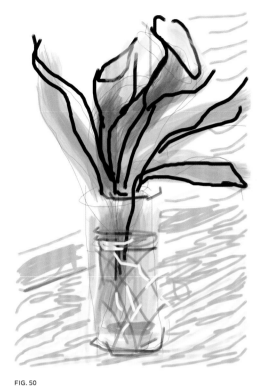

FIG. 50

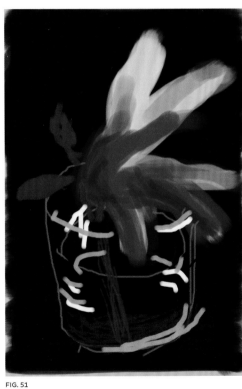

FIG. 51

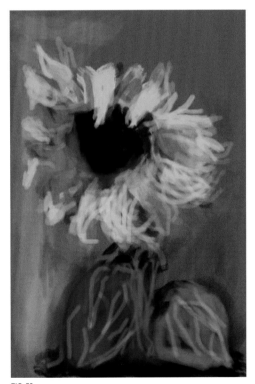

FIG. 52

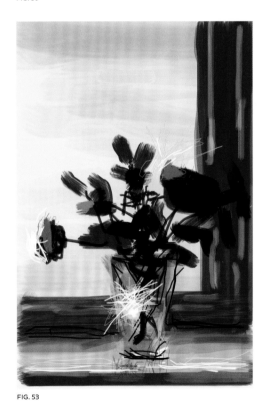

FIG. 53

FIG. 44 Pablo Picasso
The Blind Man's Meal, 1903
Oil on canvas
37 ½ × 37 ¼ in. (95.3 × 94.6 cm)
The Metropolitan Museum of Art,
New York, purchase, Mr. and Mrs. Ira
Haupt Gift, 1950, 50.188

FIG. 45 Detail of fig. 44

FIG. 46 Rembrandt van Rijn
Portrait of a Scholar, 1631
Oil on canvas
41 ½ × 36 ¼ in. (104.5 × 92 cm)
The State Hermitage Museum, Saint
Petersburg, inv. no. GE-744

FIG. 47 Detail of fig. 46

FIG. 48 David Hockney
IP–0622, 2006
iPhone drawing

FIG. 49 David Hockney
367, 2009
iPhone drawing

FIG. 50 David Hockney
360, 2009
iPhone drawing

FIG. 51 David Hockney
158, 2009
iPhone drawing

FIG. 52 David Hockney
IP–0602, 2009
iPhone drawing

FIG. 53 David Hockney
400, 2009
iPhone drawing

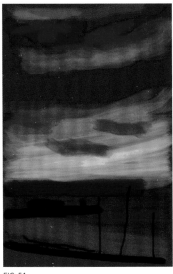

FIG. 54

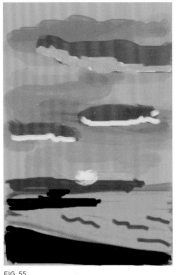

FIG. 55

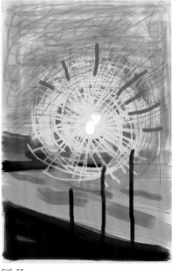

FIG. 56

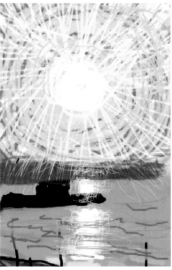

FIG. 57

FIG. 54 David Hockney
IP–0652, 2009
iPhone drawing

FIG. 55 David Hockney
IP–0653, 2009
iPhone drawing

FIG. 56 David Hockney
IP–0655, 2009
iPhone drawing

FIG. 57 David Hockney
IP–0656, 2009
iPhone drawing

FIG. 58 Lawrence Weschler
David Hockney Drawing on His iPhone, 2006
iPhone photograph

FIG. 59 David Hockney
543, 2009
iPhone drawing

Increasingly, over the past several months, however, it is the summer dawn rising over the sea bay outside his bedroom window that has been capturing Hockney's attention. "I've always wanted to be able to paint the dawn," Hockney explains. "After all, what clearer, more luminous light are we ever afforded? Especially here where the light comes rising over the sea, just the opposite of my old California haunts. But in the old days one never could, because, of course, ordinarily it would be too dark to see the paints; or else, if you turned on a light so as to be able to see them, you'd lose the subtle gathering tones of the coming sun. But with an iPhone, I don't even have to get out of bed, I just reach for the device, turn it on, start mixing and matching the colors, laying in the evolving scene."

He has now accomplished dozens of such sequential studies, sending them out in real time, such that his friends in America wake to their own account of the Bridlington dawn—two, five, sometimes as many as eight successive vantages, sent out minutes apart, one after the next (see figs. 54–57).

I've noticed how most users of the Brushes application tend to trace out their brushstrokes with their pointer finger. As I discovered on a recent visit, Hockney limits his contact with the screen exclusively to the pad of his thumb. (The screen is heat-sensitive, such that it will not register any sort of artificial stylus.) "The thing is," Hockney explains as he takes to drawing my face, "if you are using your pointer or other fingers, you actually have to be working from your elbow. Only the thumb has the opposable joint which allows you to move over the screen with maximum speed and agility, and the screen is exactly the right size; you can easily reach every corner with

FIG. 58

FIG. 59

your thumb." He goes on to note how people used to worry that computers would one day render us "all thumbs," but it's incredible the dexterity, the expressive range, lodged in "these not-so-simple thumbs of ours."

Hockney, who has carried small notebooks in his pockets since his student days, along with pencils, crayons, pastel sticks, ink pens, and water-color bottles—and smudged clean-up rags—is used to working small, but he delights in the simplicity of this new medium. "It's always there in my pocket, there's no thrashing about, scrambling for the right color. One can set to work immediately, there's this wonderful impromptu quality, this freshness, to the activity; and when it's over, best of all, there's no mess, no clean-up. You just turn off the machine. Or, even better, you hit Send, and your little cohort of friends around the world gets to experience a similar immediacy. There's something, finally, very intimate about the whole process."

I asked Hockney whether he'd mind my sharing some of these images with a wider audience across a printed medium like this, and he said, not really, he more or less assumed the pictures would one by one find their way into the world. "Though it is worth noting," he adds, putting down the device and lighting one of his perennial cigarettes, "that the images always look better on the screen than on the page. After all, this is a medium of pure light, not ink or pigment, if anything more akin to a stained-glass window than to an illustration on paper.

"It's all part of the urge toward figuration," he continues. "You look out at the world and you're called to make gestures in response. And that's a primordial calling: goes all the way back to the cave painters. May even have preceded language. People are always asking me about my ancestors,

and I say, well, there must have been a cave painter back there somewhere. Him scratching away on his cave wall, me dragging my thumb over this iPhone's screen. All part of the same passion."

He laughs, stubs out his cigarette, snaps off the iPhone, and, wiping the virtual smudge off his thumb by rubbing it against his spotless coat pocket, heads back over to a vast painted canvas arrayed against the far wall of his hangarlike studio: a view of a forest road, lined with felled trees, a gridded combine of fifteen canvases, three high and five long. He daubs a long paintbrush with fresh glops of creamy paint, and begins working *from his shoulder*. "People from the village," he says, craning back over that shoulder, "come up and tease me, 'We hear you've started drawing on your telephone.' And I tell them, 'Well, no, actually, it's just that occasionally I speak on my sketch pad.'"

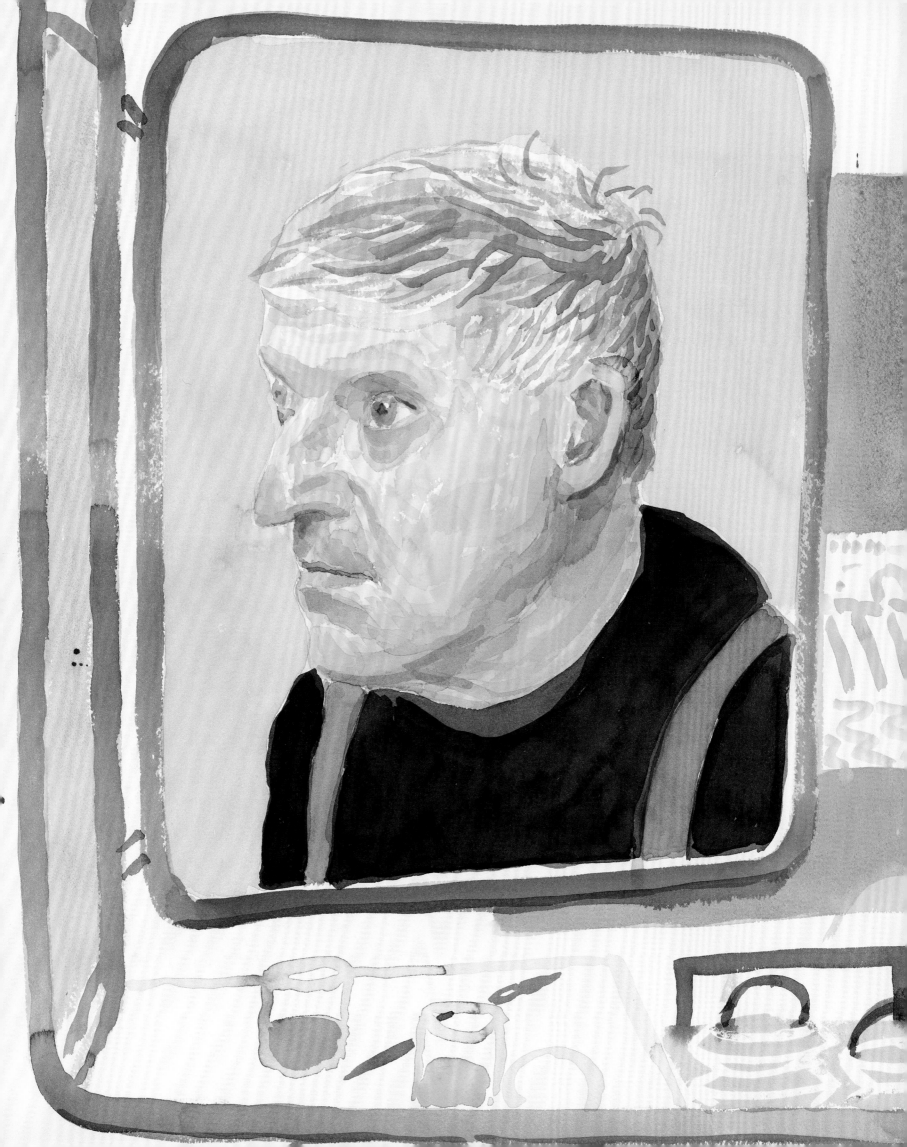

SARAH HOWGATE

EXPLORING THE LANDSCAPE OF THE FACE

FOR THE PAST TEN YEARS, THE ENGLISH LANDSCAPE HAS BEEN THE headline news for David Hockney. Literally, that is—his latest drawings heralding the turning of the seasons on Woldgate or the felling of his beloved Totem have taken the center spread in Britain's leading liberal newspaper, the *Guardian* (see fig. 13). It has been an intense period of multimedia landscape depiction, and the vista has grown ever wider. The culmination of this activity was titled, appropriately enough, *A Bigger Picture*, an exhibition at London's Royal Academy of Arts in 2012. Seen there by a record-breaking audience of 650,000, it went on to Bilbao and Cologne, where the bigger picture got even bigger. But alongside these expansive and vibrant landscapes has been a quieter side to the artist's work—a portrait thread running through.

This is the story of the portraits Hockney has made since the publication of *Secret Knowledge: Rediscovering the Lost Techniques of the Old Masters* in 2001, and how the research and writing of this book, and his experiments with the camera lucida, had a profound effect on the artist's practice. This more technical story runs alongside the romantic one about the artist's return from his adopted home in California to his Yorkshire roots. As always with Hockney, it's a many-layered story. Just when there appear to be no more media to explore, he discovers a new one and pushes it to its limits with characteristic self-belief and boundless enthusiasm. Unafraid of change, he constantly reinvents his approach. The medium may change, but the artist's genres—portraits, still lifes, and landscapes—have remained constant. In recent years the making of portraits has often followed a period of large-scale activity and energy working *en plein air*. The "portrait periods," involving fewer assistants, are generally calmer, more intense and introspective, perhaps,

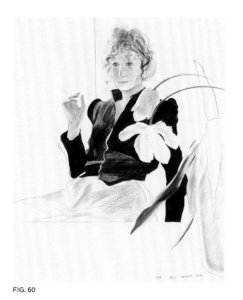

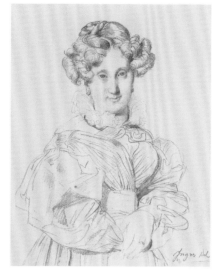

FIG. 60

FIG. 61

and they almost always take place indoors — in the studio or in a domestic setting.

THE CAMERA LUCIDA DRAWINGS

Hockney has always made exquisite line drawings; he is widely recognized as one of the greatest draftsmen of the second half of the twentieth century. Indeed, some critics wish he had never moved on from the seductive colored-pencil drawings of the early 1970s. These were made when he escaped to Paris, having felt trapped by his own naturalistic approach to painting, which had reached its peak with a series of large-scale double portraits (see figs. 69–70). His newfound freedom and Left Bank lifestyle were reflected in the loosening up of his drawing. For the most part he concentrated on making portraits of those he knew well. The drawings, particularly the ones of his close friend and muse, Celia Birtwell, are ravishing in their delicacy of touch (see fig. 60). Around the time he made this drawing, he said of his portraits of Celia:

Portraits aren't just made up of drawings, they are made up of other insights as well. Celia is one of the few girls I know really well. I've drawn her so many times and knowing her makes it always slightly different. I don't bother about getting the likeness in her face because I know it so well. She has many faces and I think if you looked through all the drawings I've done of her, you'd see that they don't look alike.[1]

Nearly thirty years later, in 1999, his portrait drawings underwent a significant transformation. For the first time he began making portraits of people outside his intimate circle in earnest. This came about through his looking at the portrait drawings of Jean-Auguste-Dominique Ingres in an exhibition at the National Gallery in London that spring. Hockney was struck by how Ingres, thirty years before the invention of photography, managed to achieve an accurate likeness in one short sitting, even when his models were unfamiliar to him (see fig. 61). Scouring the exhibition catalogue for clues as to how this might have happened, he could find no technical evidence. Hockney realized that the drawings reminded him of some Andy Warhol drawings he had seen recently, which had been traced from projected photographs. It was through this scientific approach that he concluded that Ingres might have used an optical device called a camera lucida to make his pencil portraits. (The camera lucida, patented in 1807, which would have made it readily available to Ingres, is a small prism, which is mounted at the end of a metal arm, through which an image can be refracted; see Weschler, "Love Life," this volume.) To prove his point, Hockney set about using one, and as he became more proficient, like Ingres, he was able to make likenesses of less familiar faces using this same device. Over the next ten months he made two hundred drawings, which demonstrated his openness to experimentation and innovation. Many of them were exhibited in 2000 at the Hammer Museum, University of California, Los Angeles.

His drawing *Lindy. Marchioness of Dufferin and Ava. London. 17th June 1999* (fig. 62) is a striking example of a portrait of a friend, which links nicely with the sitters in Ingres's drawings. Although Lindy is wearing a casual jacket and a baseball cap, she has the deportment of an aristocrat. Hockney pays the same attention to the details of the fabrics she wears as Ingres did

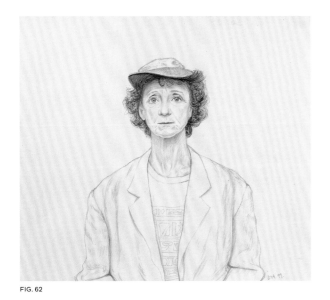

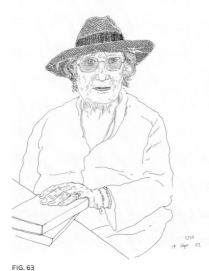

FIG. 62

FIG. 63

FIG. 62 David Hockney
Lindy, Marchioness of Dufferin and Ava, London, 17th June 1999
Pencil on gray paper using a camera lucida
15 × 16 ⅞ in. (38.1 × 42.3 cm)
Collection of the David Hockney Foundation

FIG. 63 David Hockney
Drue with Blue Hat, 2002
Ink on paper
16 ¼ × 12 ¼ in. (41.3 × 31.1 cm)
National Portrait Gallery, London, purchased, 2004, NPG 6674

to his sitter's finery. The subject looks directly at the artist; as a fellow artist she has a great interest in observing how Hockney works.

Also in 2000, the National Gallery in London invited Hockney to participate in *Encounters: New Art from Old*. Rather than look to the art on the walls as a source of inspiration, as other artists participating in the exhibition had done, he chose to make a series of portraits of the guards who looked after the paintings on the walls of the Gallery (see fig. 64). In portraying a range of characterful subjects, young and old, cheeky and morose, he was amused by the notion that the visitor to the exhibition might come face-to-face with some of the sitters depicted in these drawings. Hockney had previously shied away from depicting subjects he did not know well, so in this case the sitters were selected by the Gallery. With the help of the camera lucida, he quickly established reference points for facial features before moving on to direct observation, safe in the knowledge that naturalistic accuracy would be assured. He was always quick to point out, however, that the camera lucida was no more than a technical device that enabled him, as it had many of his predecessors, to make reference points when initially mapping out a face or landscape. He came across disapproval from some art historians and critics who felt that an artist using optical aids was cheating, "that somehow I was attacking the idea of innate artistic genius. Let me say here that optics do not make marks, only the artist's hand can do that."[2]

EYEBALLING

Following the artist's close scrutiny of the face using the camera lucida, he returned to making pen-and-ink drawings based on direct observation, or "eyeballing," as he likes to call it: "By this, I mean the way an artist sits down in front of a sitter and draws or paints a portrait by using his hand and eye alone and nothing else, looking at the figure and then trying to re-create the likeness on the paper or canvas. By doing this, he 'gropes' for the form he sees before him."[3] These were the first pen-and-ink line drawings Hockney had made in a considerable time. He began carrying small sketchbooks around in specially designed pockets in his suits (these were later replaced by "iPad pockets") wherever he went and recording the minutiae of his life—a visual diary that included lightning sketches of the passersby as he traveled on the top of the number 9 bus from his home in Kensington to the West End; a bowl of soup served up by Karen Wright, former editor of *Modern Painters*; and an exhibition of sculpture at Tate Modern. He drew his sister, Margaret, an avid photographer and lover of technology, holding her camera and sitting alongside her partner, Ken. He depicted his friend, the great patron of the arts Drue Heinz at a summer party she hosted on the shores of Lake Como (fig. 63). All these drawings reflect a release after the strictures of the camera lucida drawings. The line, as always, is controlled, spare, and apparently effortless. In 1978 the artist wrote of line drawing:

> *To reduce things to line I think is really one of the hardest things. I never talk when I'm drawing a person, especially if I'm making line drawings. I prefer there to be no noise at all so I can concentrate more. You can't make a line too slowly, you have to go at a certain speed; so the concentration needed is quite strong. If you make two or three line drawings, it's very tiring in the head, because you have to do it all at one go, something you've no need*

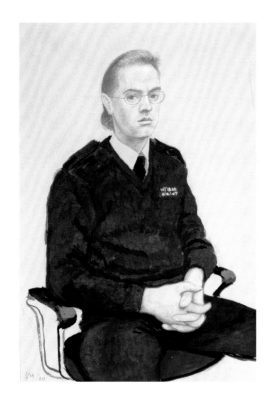
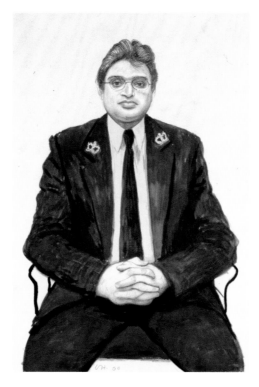
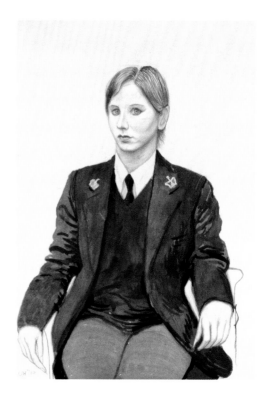
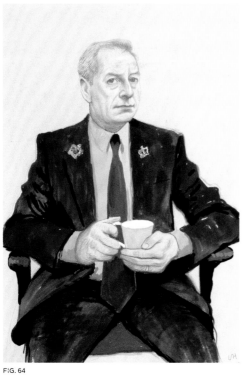
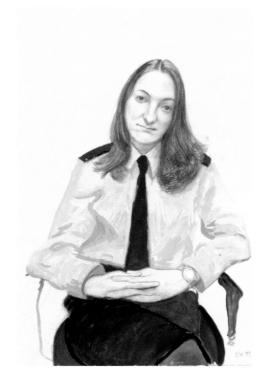
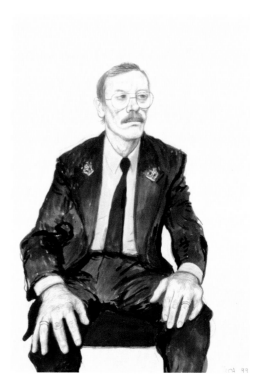

FIG. 64

52

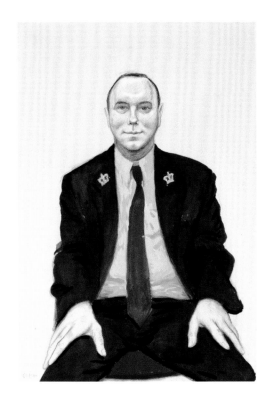
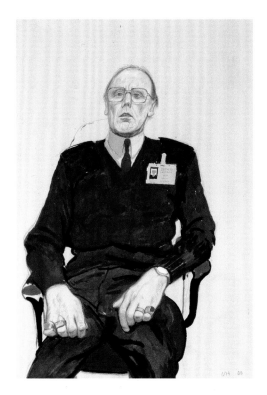
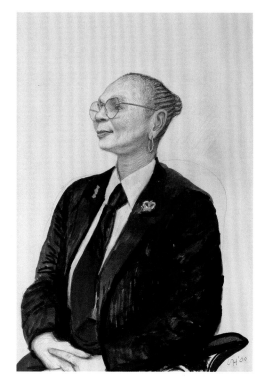
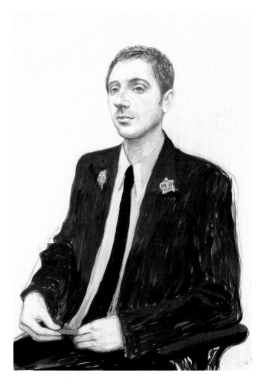
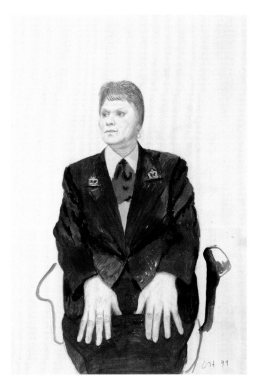
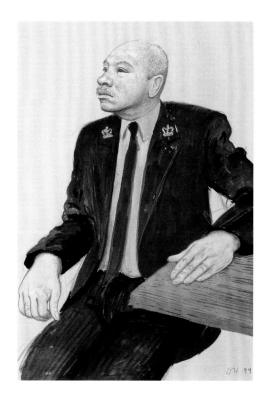

FIG. 64 David Hockney
12 Portraits after Ingres in a Uniform Style, 1999–2000
Pencil, crayon, and gouache on 12 sheets of gray paper using a camera lucida
EACH: 22 ⅛ × 15 in. (56.2 × 38.1 cm)
OVERALL: 44 ¼ × 90 in. (112.4 × 228.6 cm)
Private collection

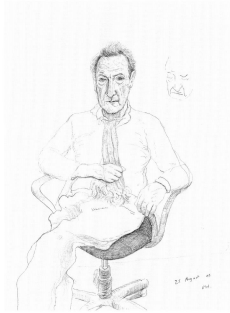

FIG. 65

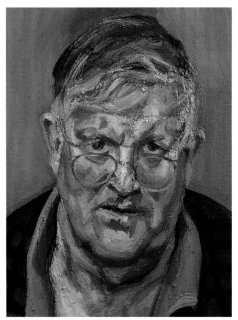

FIG. 66

to do with pencil drawings. . . . You can't rub out line, mustn't do it. It's exciting doing it and I think it's harder than anything else; so when they succeed they're much better drawings.[4]

These drawings reveal a great attention to detail and a fondness for the subjects, as does the drawing of his friend and fellow artist Lucian Freud (fig. 65). He drew him once, with attention to his wiry frame and sense of style, and then in the top right-hand corner of the sheet he drew him again, as he had fallen asleep while sitting. The occasion for this portrait had been Freud painting a portrait of Hockney (fig. 66). Freud had asked Hockney to sit for him before, but Hockney had never been able to give him the time he required to make a portrait from life. However, in the spring of 2002 Hockney spent more time in England than usual, so he was able to commit to a rigorous sitting regime. Every morning for three months or so he would walk from his own studio in Kensington across Holland Park to Freud's studio. Because Freud painted slowly and always demanded the presence of the sitter, there was plenty of time to exchange ideas and gossip, and for Hockney to fix Freud's face and studio in his memory. The sittings also became a dialogue about painting. He wrote about the experience in a tribute for London's *Evening Standard* the day after Freud's death. Hockney's words reveal his generosity as both an artist and a sitter:

> *Sitting for Lucian was a very memorable and enjoyable experience, and he eventually sat for me for about three hours and fell asleep. He said he would come on an afternoon, the time he usually sleeps. I got one or two things out of it, but I thought this portrait of me very good indeed. All the hours I sat*

(120 hours) were layered into it; he had always added, rarely taken anything away. It really shows: his paintings are remarkable works by a great artist.[5]

Following Freud's death in July 2011, Queen Elizabeth II passed the artist's Order of Merit on to Hockney. Although he had turned down previous honors, including a knighthood, the Order of Merit is offered to only one artist at any one time, and Hockney accepted it graciously.

PORTRAITS FOR THE NEW MILLENNIUM

In 2002 Hockney turned to watercolor. A medium long associated with Sunday painters and Victorian artists on their Grand Tours, it was one that he had not been particularly comfortable with when he tried it earlier. Like the drawings he had made in Paris, this new way of working represented another freeing up, the medium demanding that he work quickly and directly onto paper using a flowing brush. The first portraits were single three-quarter-length figures on a largish scale, all sitting in a functional office chair and painted against a vivid Holbein-green backdrop (see pls. 7-14). The sitters share the same background and furniture, but each exudes a distinct and particularly English character. Although his subjects are not all English, they are certainly anglicized: the art historian and curator Marco Livingstone confronts the artist head-on, I look rather awkward and self-conscious, and George Lawson appears "buttoned-up" in evening dress. Following the single-figure portraits, Hockney went on to produce more than thirty double portraits (see pls. 21–23). The double portrait was particularly challenging—working from life at speed with both models

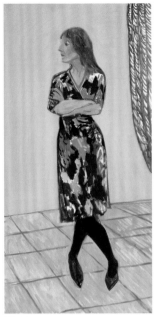

FIG. 67

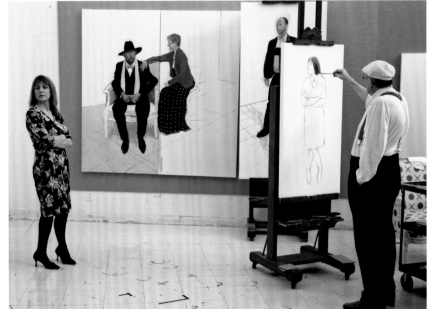

FIG. 68

posed in front of him. This series of double portraits includes a rare commission for the National Portrait Gallery in London to paint a friend, Glyndebourne impresario Sir George Christie, and his wife, Mary. Hockney made this double portrait using four sheets of paper during a single sitting. His concerns in the double portraits are relationships of different kinds, whether lovers, siblings, or artist and assistant, often revealed in the body language of the sitters and accentuated by the simplicity of the backdrop. He described this watercolor series as "portraits for the new millennium," implying that, despite all his work with photography and other technologies, he still believed that the human eye and hand were the best tools for capturing the essential nature of his sitters.

PORTRAITS IN OIL

Three years later, in February 2005, Hockney began painting portraits again in earnest. He had returned to California for the opening of *Hand Eye Heart*, an exhibition of watercolor paintings of the Yorkshire landscape, at L.A. Louver gallery in Venice. In his Los Angeles studio he began producing full-length standing figure paintings, the first since the 1970s. These portraits, a culmination of many things that had gone before, could have been made only in his vast studio there. He worked with oil paint once more, but with a newfound fluidity, delighting in the medium as if discovering it for the first time. In preparation for *David Hockney Portraits*, which was to be shown in 2006 at the National Portrait Gallery in London, he had revisited a series of small portrait heads he had made quickly in oil in his Malibu studio in 1988 and 1989, and these new large-scale oil

paintings had developed out of that direct approach. His palette for these portraits remained vibrant; he retained the Holbein green of the watercolor portraits. But the oils are less intimate in mood than the watercolors; they appear more spacious, more "West Coast" than the half-length portraits he had made back in London. A self-confessed claustrophobic, Hockney celebrates his love of open spaces in these portraits. There is an element of performance, too, which contrasts with the quieter mood of the watercolor portraits. His subjects have a confidence and contemporary swagger: Arthur Lambert (pl. 60) adopts a completely relaxed Californian pose as he sits casually on the corner of a table. His suit is sharp, his shoes shiny. Richard Schmidt, Hockney's studio assistant in Los Angeles, stands in a canary-yellow shirt, with his hands on his hips (pl. 59): "Here I stand, my constitution sound," Hockney quotes from the libretto for the opera *The Rake's Progress*.

In late February of 2005 I stood for one of these oil portraits (figs. 67–68). The day before the session I visited his studio. He told me to put some thought into what I might wear. "No blue jeans," he declared. "Ingres's subjects dressed in their finery." The silk dress I wore presented a challenge—a bold, impressionistic floral print against a black ground. As we walked around the studio, looking at new work, I was unaware that he was observing me, searching out the pose. "There it is," he declared triumphantly as we danced around each other. "She stands like that," he said. "The balance is very good, isn't it?" In the mirror I was confronted by body language of which I was not even aware. A slightly defensive stance—legs crossed, arms folded—my looking-at-pictures pose.

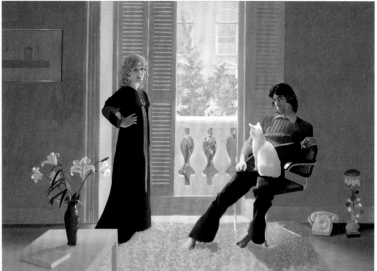
FIG. 69

FIG. 70

David made the portrait against the clock. We had just two hours, as it was the day his exhibition at L.A. Louver opened. By imposing a difficult pose he forced himself to work quickly. "If they stand, I've got to paint faster. Well, to me, I think speed's a part of it." David began by making an outline on the canvas—no preparatory drawing. He draws with paint, a method he learned when making watercolors. The oil is thinned down beforehand with turpentine, and the colors for my dress were premixed. As it had for Turner and Cézanne before him, returning to oils after using watercolor allowed him more subtlety. The application of paint appeared effortless, though the concentration was apparent in his hawklike stare and screwed-up face. In the first hour, with breaks every twenty minutes, a lot of information was put down fast. The easel was only about six feet away from me. We did not speak while he was painting, but when we paused he pointed out that a photographic portrait made at such close quarters would be distorted. Like a magician he juggled with four brushes in his hand at once. In the second hour he spent more time looking from a distance. Unlike working in watercolor, where every mark shows, he enjoyed having the liberty of being able to wipe out and start again. Every time I returned to the pose, my balance had shifted slightly. He repainted the position of my arms and legs several times to reflect this. The sitting took two hours. "In the end you find it," David said. "A camera finds it straight away but with a painting, it is there to be unlocked." In the end he did find an aspect of me—and my reflective mood—that day. I was not expecting flattery and I certainly did not get it, but there is a truth and honesty in that layering of time through paint.[6]

At the same time as the single-figure portraits, Hockney also made some double, and even group, portraits. Some of the double portraits appear more metaphorical, in particular *The Photographer and His Daughter* (pl. 57), which as well as being a portrait of his friend, the Los Angeles photographer Jim McHugh with his teenage daughter, is also a rumination on the status of photography and painting. In *Ann and David, Los Angeles, March 10, 2005* (pl. 58) he painted two old friends from England. Ann had been a life model when Hockney was at the Royal College of Art, and their friendship dates from that time. David Graves ran the London studio and had been instrumental in the research for *Secret Knowledge*. In this beautifully observed painting their body language reveals much about them. David is tall and gangly and here we see him leaning toward Ann to listen, one of his long legs wrapped around the other in characteristic style. Although we do not see Ann's face, she is immediately recognizable from the back by her striking red bob, her arm on the back of the chair, and the way her feet are planted on the floor. A complex composition and portrait of a marriage, it follows in the tradition of *Mr. and Mrs. Clark and Percy* from 1970 (fig. 69), except the Graveses appear to be immersed in their own relationship, whereas Celia and Ossie were separate and very conscious of the artist's presence. Also, Ann and David are not sitting in a domestic space, but in a studio space with vacant chairs in the background awaiting the next sitters.

The double portrait *Self-Portrait with Charlie* (2005, pl. 62), was one of the paintings installed on the final wall of the retrospective exhibition *David Hockney Portraits* at the National Portrait Gallery in London in 2006 and subsequently purchased by the Gallery. As artist and sitter, Hockney

FIG. 71

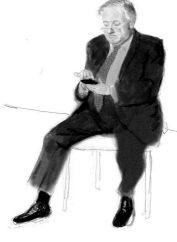

FIG. 72

FIG. 69 David Hockney
Mr. and Mrs. Clark and Percy, 1970
Acrylic on canvas
84 × 120 in. (213.4 × 304.8 cm)
Tate, London, presented by the Friends of the Tate Gallery 1971, T01269

FIG. 70 David Hockney
Henry Geldzahler and Christopher Scott, 1969
Acrylic on canvas
84 × 120 in. (213.4 × 304.8 cm)
Private collection

FIG. 71 David Hockney
Paul & Margaret Hockney (detail), 2009
Inkjet-printed computer drawing on paper
An edition of 12
49 × 33½ in. (124.5 × 85.1 cm)

FIG. 72 David Hockney
Paul Hockney 1, 2009
Inkjet-printed computer drawing on paper
An edition of 12
60 × 41 in. (152.4 × 104.1 cm)

allowed himself to be subjected to the same beady scrutiny as his fellow subjects hanging alongside. Like so many of the artist's double portraits, for example *Henry Geldzahler and Christopher Scott* (1969, fig. 70), *Self-Portrait with Charlie* depicts a triangular relationship between the artist, the subject, and the viewer. The artist looks out at the viewer, at himself, and also at his subject, Charlie Scheips, who is reflected in the mirror (see figs. 96–101). Charlie, a former assistant and a friend, is now a curator living in New York. Although a larger-than-life character, here in the painting he appears diminutive and distant. He too looks out at the viewer as the viewer looks back at Hockney and in turn at Charlie in the background.

DRAWING ON THE COMPUTER, iPHONE, AND iPAD

For the next three years Hockney recorded with zeal the cycle of spring, summer, autumn, and winter in the Yorkshire Wolds in England. His canvases got larger and larger, culminating in some of the largest paintings ever made *en plein air* in the history of art. *Bigger Trees near Warter or/ou Peinture sur le Motif pour le Nouvel Âge Post-Photographique* is made up of fifty canvases and was shown in 2007 at the Royal Academy's annual Summer Exhibition before it was given to the Tate (see fig. 38). Although immense, the painting is still on a human scale. He created two copies made up of computer printouts on the same scale as the original and hung them on the walls of the Royal Academy after the Summer Exhibition had finished. The artist invited friends to join him and photographed them there, looking with a sense of wonder at the created landscape that surrounded them. David had brought the peopleless Yorkshire Wolds to

the center of the metropolis. His preoccupations, as always, were space, light, time, and memory.

This recent exploration of the landscape began with detailed, almost microscopic studies of the hedgerows. At first, he admitted, this complex scene had seemed like a visual jumble, but slowly he had pieced together, bit by bit, each individual frond of grass. (A horticulturist friend of mine, seeing these studies, commented on how botanically accurate they were — each form identifiable.) The grasses and tree trunks became as familiar to him as the landscapes of old friends' faces.

In 2008 Hockney began using the computer program Photoshop as a tool (see pls. 93–99). At the time he wrote:

> *It allows you to draw directly in a printing machine. . . . I used to think the computer was too slow for a draughtsman. You had finished a line, and the computer was 15 seconds later, an absurd position for someone drawing, but things have improved, and it now enables one to draw very freely and fast with color. There are advantages and disadvantages to anything new in mediums for artists, but the speed allowed here with color is something new, swapping brushes in the hand with oil or watercolor takes time.*[7]

He used this technology to make a series of portraits in his vast new Bridlington space. They were reminiscent of the watercolor portraits in format and palette, but the computer allowed him to work more quickly. His subjects included his sister, Margaret, a computer addict who had been using technology for years (see fig. 71). He also made a portrait of his brother Paul, who is seen working on his iPhone (fig. 72). In this portrait David made use

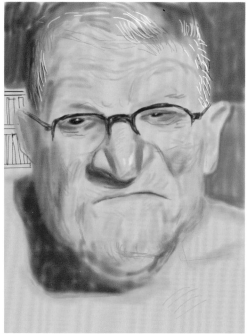

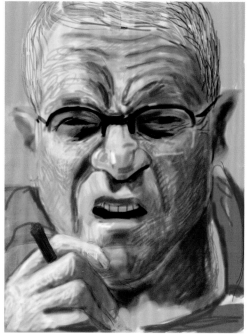

FIG. 73

FIG. 74

FIG. 75

of the variations in line to differentiate between strands of hair and the legs of the chair Paul sits on. His suit is filled in with a soft blue that resembles the texture of cloth.

At the same time as he was making these larger computer works in 2008, Hockney also began using the new technology provided by the iPhone and the iPad to make work (see pls. 106–137 and 138–165). He used them as sketchbooks with infinite possibilities for color and mark making. Among the thousands of drawings he made on screen, twenty iPad self-portraits stand out (see figs. 73–74 and pls. 202–209). He made one each day over a period of twenty days in the same way that he had done back in 1983 using charcoal (see fig. 81). These recent drawings were very different, however. Here he was exploring character types. In this series he grimaces and contorts his face. They are playful, at times caricatures, often confrontational, sometimes a reflection on growing old. They remind us of the heads of the eighteenth-century sculptor Franz Xaver Messerschmidt (see fig. 75).

PORTRAITS IN BURNT WOOD

Hockney began making charcoal portraits in December 2012, after an intense period of activity in that year when he mounted *The Bigger Picture* in London, Bilbao, and Cologne. Alongside the hands-on staging of these exhibitions, he was making movies using up to eighteen cameras and working on multipanel landscape paintings. Inevitably this expansive multidisciplinary action resulted in a period of exhaustion, which was closely followed by a return to the hand and the most ancient of materials—burnt wood.

Having produced thousands of iPhone and iPad drawings, he cast technology aside for a time. The use of charcoal was refreshing for him. He had used it previously to record the hawthorn blossom, but now he began using it in earnest to make portraits (see pls. 221–230). Charcoal, in every conceivable length, dimension, and point, is tantalizingly lined up in wooden cases in his studio. It is all very low-tech. Texture and line can be carefully controlled; its variety is infinite, and the subtlety of the medium is enormous. With charcoal he has found a color, texture, and line that technology cannot replicate.

The drawings share the same format and half-length pose, and were mostly made in the seaside town of Bridlington, far away from the London hubbub. These drawings contrast with the camera lucida portraits made primarily in his Hollywood studio. They are more intimate, more private; many were made in the bedroom of his home in Yorkshire. His subjects, again, are mainly those close to him, whose faces he knows well. He began them over the Christmas period, when traditionally he is visited by old friends. His curator and longtime friend Gregory Evans; his Los Angeles dealer, Peter Goulds; and his friend, printmaker Maurice Payne (see figs. 42–43 and 79–80) became his first subjects. Sitting is a way of just being with the artist, a meditative time. Some sitters, such as Hockney's partner, John Fitzherbert (see fig. 77), look directly at the artist, while others look away. Although Hockney prefers the direct gaze, he does not ask people to do this. He allows his sitters to relax into their poses, and when he finds something that he likes he asks them to keep it. In this recent series of drawings, he gives special attention to the hands. Peter Goulds has the faintest of smiles. Gregory Evans is one of his most consistent models. In

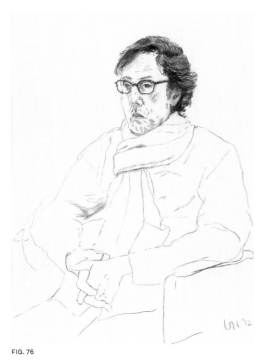

FIG. 76

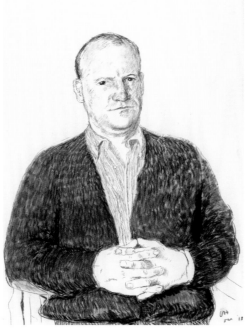

FIG. 77

FIG. 73 David Hockney
1215, 2012
iPad drawing

FIG. 74 David Hockney
1196, 2012
iPad drawing

FIG. 75 Franz Xaver Messerschmidt
Character head, 1770–1783
Lead
Height: 14 15/16 in. (38 cm)
Musée du Louvre, Paris, acquired at auction in
New York with the support of the Société des
Amis du Louvre and the Fonds du Patrimoine
in 2005, R.F. 4724

FIG. 76 David Hockney
Gregory Evans, 24 December, 2012
Charcoal on paper
30 ¼ × 22 ⅝ in. (76.8 × 57.5 cm)

FIG. 77 David Hockney
John Fitzherbert, 28 January, 2013
Charcoal on paper
30 ¼ × 22 ⅝ in. (76.8 × 57.5 cm)

a recent charcoal portrait he appears more internalized and distant than he has in earlier sittings (fig. 76). Gregory often delivers the most insightful of comments about the artist's work, which he is always the first to see, even though he is five thousand miles away, in Los Angeles. When Hockney started making these charcoal portraits, Gregory said he felt a strong sense of mortality in them.

In talking about these portraits Hockney said he believed that the eyes reveal everything about a person, which is particularly true in these portraits. The daylight is important, too, since the drawings are made only in natural light. It is interesting to note that, although in Bridlington he has a studio the size of a football field, he made the portraits there in his modest-sized bedroom because it has northern light. Close attention is paid to the fabrics, patterns, and textures—in particular in the portrait of Sally Marriott (pl. 230). Gregory has spoken about how he finds this drawing and the one of her husband, Richard Marriott (pl. 229), "electrically charged," and how Hockney is "generous with detail." He doesn't "'technique' his way out of it." In this image, Sally is enclosed by the chair, which she appears to cling to for security. Her gaze is distant. She looks like a model from another era—she could be one of Ingres's sitters, or straight out of the pages of Jane Austen. She is, in fact, a local landowner. "I'm the aggressive one," she said when being introduced. However, she appears perfectly passive, even little-girlish, when sitting for the local, world-famous artist. Hockney deals with age very well. Simply sitting for a portrait is an aging process. It is difficult to hold an upright position for long. Some figures are totally at ease; others are awkward. Some figures are

self-assured and confidently fill the space, such as John Fitzherbert; others are enveloped by the chair. Hockney returned to the self-portrait too (see fig. 82), treating himself with unsparing honesty. As an unconscious reflection of old age, he drew himself sitting in the wheelchair that he used to speed around his extensive studio space.

In March 2013 a portrait drawing of Dominic Elliott (pl. 221) appeared on the front cover of the *Guardian*. How rare to see a charcoal drawing of an unknown sitter, or any sitter for that matter, on the front page of a national newspaper. This one had more poignancy and power than any photograph. It was a beautifully observed drawing the artist had made with love of his youngest assistant as part of a series of drawings of all his assistants working out of the Bridlington studio. Dominic was an intelligent local boy working in his dream job. Made from life, the portrait depicts a young intellectual with a sensitive face and a beautifully rendered shock of wild red hair sitting with poise, his long, elegant fingers thoughtfully crisscrossed in an elaborate cat's cradle, and his thumbs pointing to the sky. Sadly, it became a memorial drawing when Dominic died tragically young. A period of mourning for Hockney and his Bridlington assistants followed and put a stop to the very personal art of making portraits. When he did return to the charcoal portraits, they were of a very particular kind: somber, contemplative portraits of close friends, including Charlie Scheips (see fig. 78) and Maurice Payne, who appropriately averted their gazes when sitting. The portraits of Maurice (see pl. 228 and figs. 79–80), were made quickly over successive days in the London studio, where Hockney returned for a while because he could not "see the landscape any more." Now David has

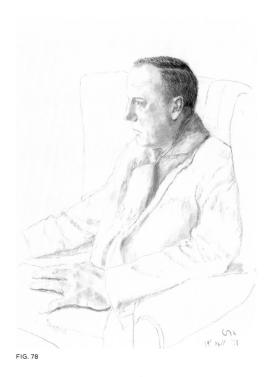

FIG. 78

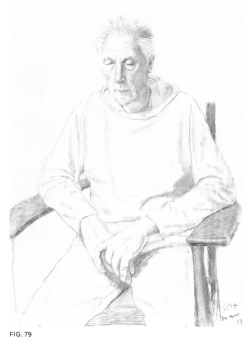

FIG. 79

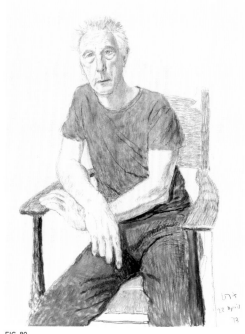

FIG. 80

returned to East Yorkshire to celebrate the return of spring once again on Woldgate after a particularly cruel winter, and to continue to make portraits that record East Yorkshire life.

MAY DAY, 2013

These days David's main means of communication with his friends is via the iPad, and usually in the form of a picture he has just made, "hot off the press." His deafness makes it difficult for him to communicate in other ways. However, he does have a special device on his phone that enables him to overcome this problem. I rang David on May 1, a significant date in the English calendar. First of all, it is a national holiday, a workers' day, but as David loves to reminds us, he is an artist who does not take holidays. It is also a festival of springtime and revelry. Fittingly, David had been out "in the field" recording the onset of spring (see pls. 231–255). He had then returned home, not for a nap, but to complete a portrait of his sister, Margaret, that he had begun the day before.

SH: I wanted to ask you about the setting for your recent charcoal portraits. You said the Bridlington ones had been made in your bedroom—I've been in your bedroom and it's not very big. [David often "tries out" work on the walls there so he can contemplate it while resting from the studio.] Does that mean that you're sitting fairly close to your subjects? Also, it's a private space. How does that affect the mood of the portraits?

DH: I'm drawing them in the bedroom. I'm very close, virtually on top of them.

SH: You mentioned in an earlier conversation that the first charcoal portraits were made in the wintertime, when you only had four hours of light, whereas the more recent ones have been made more quickly.

DH: Yes, the early ones were made over two days. Now there's more daylight I can work six, seven, or eight hours on a portrait. They can be made in a single day.

SH: Some of these recent portraits are of people I don't think you've made portraits of before—the Neaves and Marriotts, for example. They almost seem to be an extension of your camera lucida portraits—although that was ten years ago now. Do you think what you learned from using the camera lucida has helped you map out the face of an unfamiliar subject?

DH: Yes, I think you're right about the camera lucida. I'm drawing people now I've never drawn before.

SH: When you were using the camera lucida you were researching *Secret Knowledge* and looking back at art history and artists' use of optics. I can see the influence of Holbein and Ingres in the earlier camera lucida portraits and the watercolors. Are you still looking at those artists, or are there other artists you've been looking at recently?

DH: Yes, I'm still looking at Holbein and Ingres.

SH: I'm struck with the recent charcoal portraits, as I was by the early watercolor portraits against the green backgrounds, that for the most part the faces seem particularly English or Northern European at least. Would

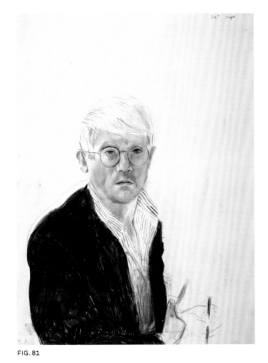

FIG. 81

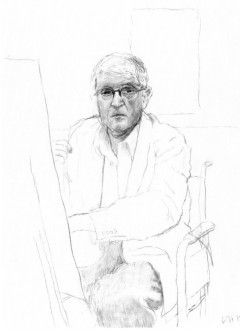

FIG. 82

FIG. 78 David Hockney
Charlie Scheips, 19 April, 2013
Charcoal on paper
30 ¼ × 22 ⅝ in. (76.8 × 57.5 cm)

FIG. 79 David Hockney
Maurice Payne, 20 April, 2013
Charcoal on paper
30 ¼ × 22 ⅝ in. (76.8 × 57.5 cm)

FIG. 80 David Hockney
Maurice Payne, 22 April, 2013
Charcoal on paper
30 ¼ × 22 ⅝ in. (76.8 × 57.5 cm)

FIG. 81 David Hockney
Self-Portrait 26th Sept., 1983
Charcoal on paper
30 × 22 ½ in. (76.2 × 57.2 cm)

FIG. 82 David Hockney
Self-Portrait, 13 December, 2012
Charcoal on paper
30 ¼ × 22 ⅝ in. (76.8 × 57.5 cm)

you agree with that? Oscar Wilde famously said of the English face, "Once seen . . . never remembered." I wouldn't agree with that!

DH: I'll go along with that!

SH: Would you say that making landscapes allows you to be more meditative than when you make portraits because with landscapes you're not distracted by a human presence? With landscapes there is always, at this time of year, a sense of renewal and hope, whereas inevitably when making portraits one is reminded of the aging process, particularly with the subjects you have revisited over the years. Even during the making of a portrait a sitter slumps and grows older. Are you conscious of a different mood in your landscape and portrait work?

DH: Yes, with the landscapes there's always the spring coming, but with portraits you are aware of people getting older. Look at the portraits of Maurice. He's very vain but he's not vain about the portraits. All he cares about is that there's another one done. Over the years they vary and yet they do all look like him.

SH: Among the iPad drawings Gregory has selected for the de Young exhibition you've made some historical portraits—who are they?

DH: They are portraits by Christen Købke, a Danish New Age painter. I made two copies of them from reproductions in books to demonstrate to someone how they were done. I worked on them over a long time. In the San Francisco exhibition you'll be able to see how they were drawn.

NOTES

1 *David Hockney: Travels with Pen, Pencil and Ink*, exh. cat. (London: Tate Gallery; London and New York: Petersburg Press, 1980).

2 David Hockney, *Secret Knowledge: Rediscovering the Lost Techniques of the Old Masters* (London: Thames and Hudson, 2001), 14.

3 Ibid., 23.

4 *David Hockney: Travels with Pen*, n.p.

5 Sarah Howgate, Martin Gayford, and David Hockney, *Lucian Freud: Painting People*, exh. cat. (London: National Portrait Gallery; New Haven, Connecticut: Yale University Press, 2012), 17.

6 Sarah Howgate, "Standing for Hockney," in Sarah Howgate et al., *David Hockney Portraits*, exh. cat. (London: National Portrait Gallery; New Haven, Connecticut: Yale University Press, 2006), 46.

7 *David Hockney: Drawing in a Printing Machine*, exh. cat. (London: Annely Juda Fine Art, 2009), n.p.

to see The Bigger Picture is to see more — has our perspective given us limited vision

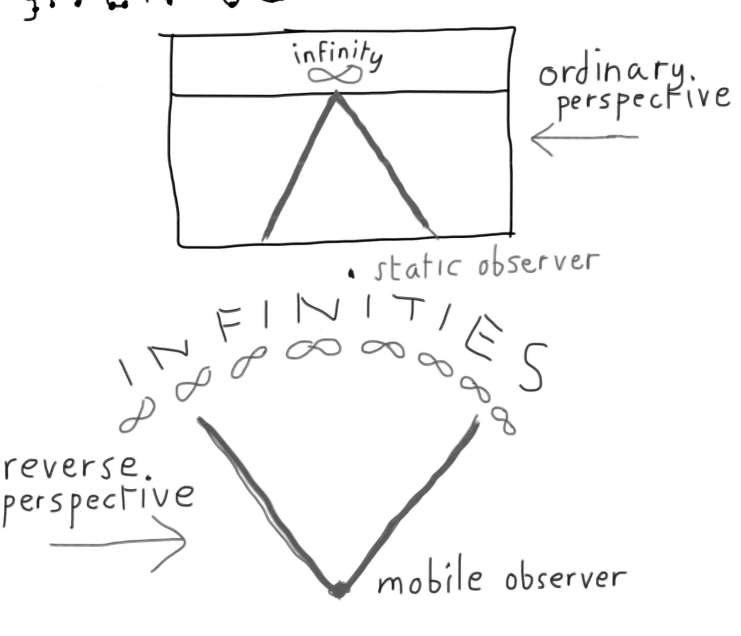

infinity ∞

ordinary. perspective

static observer

INFINITIES

reverse. perspective

mobile observer

Vie

Mort

David Hockney

DAVID HOCKNEY

TO SEE
THE BIGGER PICTURE
IS TO SEE MORE

I AM NOT A HISTORIAN, or even an art historian, but I have an interest in depiction and therefore an interest in the history of pictures.

Twelve years ago I wrote a book—*Secret Knowledge*—about the influence of technology on picture making. Some art historians supported me, a few attacked it, but most ignored it, perhaps hoping it would go away. In the years since, I have become more convinced that we are witnessing a fundamental change in picture making. This has far-reaching consequences for the media and the way we perceive the world. It will mark the end of the old order, which is no bad thing.

Friends tell me how a lot of things—pop music, for instance—are "stuck." But the relentless march of new technology offers hope. For example, the smallness of new video cameras makes it possible to pack several together, generating different lines of vision and creating a new kind of Cubist camera! So now you can create a new television picture that goes way beyond the quaint and ridiculous old notion of "3-D" TV.

Such innovations—there are countless others, just look around you—are not only changing pictures, but also the traditional mass media, which after decades of immense power are now under siege or simply falling apart. Broadcasting giants are fighting to hold on to their audiences and their reputations; long-established publications, such as *Newsweek*, are abandoning print. This is certainly bewildering, but it is not necessarily a bad thing. It may even be liberating, as it might deliver a break from the way in which we in the West have, for centuries, been conditioned to see the world, in pictures and, later, in the mass media—namely through "correct" perspective.

Art history tells us that Brunelleschi "invented" perspective in Florence in 1420. His perspective picture does not exist, but very good descriptions of it do—the size of the panel and its subject, the Baptistry in Florence. He stood seven *bracci* inside the Duomo and made the first perspective picture. It was not an "invention" but a discovery of a law of optics.

Fast-forward half a millennium and this perspective now dominates the visual world. It is the way we have come to expect the world to be mediated for us.

This was not always universal. It is often assumed that non-Western picture making got perspective "wrong." But the non-Westerners didn't get it wrong—it's just that they didn't use optics. Chinese scroll painters had a very sophisticated perspective, without the vanishing point that had reduced the viewer to a static mathematical point. (If we are alive, we move!)

In my book, I argued that the camera obscura was involved in European picture making long before the invention of photography. Most people seem to think the camera is a nineteenth-century invention, including "serious" people such as Susan Sontag, who wrote that the camera was "invented in 1839." No editor asked her for the name of the inventor. There isn't one, of course: the camera is a natural phenomenon, requiring little more than a pinhole. It was the chemical process to fix the image made by a camera that was the invention in the 1830s.

I would say that what a camera does is to make an optical projection of nature. This can be made simply with an eyeglass lens or a concave mirror—a shaving mirror, say. To make a good one, you quickly discover that you need

FIG. 83 David Hockney
1311, 2012
iPad drawing

strong light; and strong light casts the deepest shadows. So to make a good projection you need deep shadows.

Art historians have never really explained the appearance of shadows in European art. No art made outside of Europe used shadows. Chinese, Japanese, Persian, and Indian—all highly sophisticated image makers—ignored shadows. Yet they occur in a big way in European art, and in a very big way in the likes of Caravaggio. Whether they offer an accurate reflection is another matter. There is a story about one of the Jesuits who went to China and painted a portrait of the empress. Her comment on it was, "I can assure you that the right side of my face is the same color as the left side of my face."

Vermeer made no drawings, neither did Caravaggio nor Frans Hals; Velázquez made only a handful. So how were those pictures constructed, if not with a camera? Art historians have never asked the question, obviously considering it of little importance. Art history seems to have trouble with technology; it has trouble with photography, often ignoring it altogether. Yet it was the photography of paintings that made art history possible.

There is far more of a continuum than is typically conveyed in art history—photography came out of painting and, because of Photoshop, is returning to it. All comprehensive collections of photography have "collages" in them. The Metropolitan Museum of Art in New York recently held an exhibition called *Faking It* about photographic manipulation before Photoshop.

This began almost as soon as chemical photography was invented. Very elaborate photographs were made using the same techniques as painters. Sontag, in *Regarding the Pain of Others*, refers to Mathew Brady moving corpses around in his photographs of the American Civil War as a form of "cheating." But this is to impose a kind of Leica mentality on photography sixty years before small cameras. He was really just doing what a painter would, moving things because the camera was fixed or too heavy.

Human beings are interested in pictures. They can have powerful effects on us, always did and still do. As I thought about what is a correct perspective, I began to see other things—beyond how this was applied just in the art world.

In Europe, for almost five hundred years, the Church was the main image supplier. If you wanted to see pictures, you went to a church. There you were not looking at "art" but at vivid depictions of life that would have been just as powerful—if not more so—as film or TV today. In all of this time the Church had social control. When did it begin to lose it? I would say it started in the nineteenth century and that, by the start of the turn of the new century, social control had followed images into what we would call "the media": photography, films, and then TV.

The age of the mass media is also the age of mass murder. That is probably no accident. The terrors of the twentieth century—Nazi Germany, Soviet Russia, and Mao's China—needed control of the mass media.

It is this age that is ending. What I would call the old media—TV, film, and newspapers—are dying. But so too is a lot we thought would always be with us: the culture of stars and celebrity. The age of the mass media made, and perhaps needed, stars. One thinks of Charlie Chaplin, the first world star of films, and then those stars created by Hollywood.

The revolution in painting of the early twentieth century—Cubism—was really an attack on depiction based on perspective. But in truth that old perspective did not die. The radical nature of Cubism was overshadowed by what seemed even more radical: moving pictures. And yet, in essence, the moving picture was still the old perspective—it used just one camera!

This was not really noticed until the depictive problems of today. These are now being addressed by the triumph of the animated film and new technology that is changing photography.

Technology brought in the mass media and technology is now taking it away. Perhaps our celebrity culture is the last gasp of the mass media "star period." The power of the old media barons is in decline—I am sure Rupert Murdoch knows this—and seems to be passing to the masses themselves, whether they want it or not.

The old media needed stars. In the new media your friends are the stars. Without the old media, how will you get famous on YouTube? Perhaps the corollary to Andy Warhol's quip about how "in the future everyone will be famous for fifteen minutes" is that in the future nobody will be famous, or only locally.

Images will continue to play a big part, but we are definitely entering a very different age. Can it be worse than the age of the mass media? Goebbels "marketed" Hitler with new media that few understood better than he did. He knew film created better propaganda than radio. In film everyone saw the same image, whereas with radio everyone forms their own images.

That kind of power is not possible now. Can governments maintain control when they know the street has a new power that they are forced to accept? It might look like chaos, but new forms of representation will arise. Could they be better?

What all of this has to do with the present world crisis, I don't know. I simply offer a slightly different view of the history usually ignored by economists, historians, and politicians.

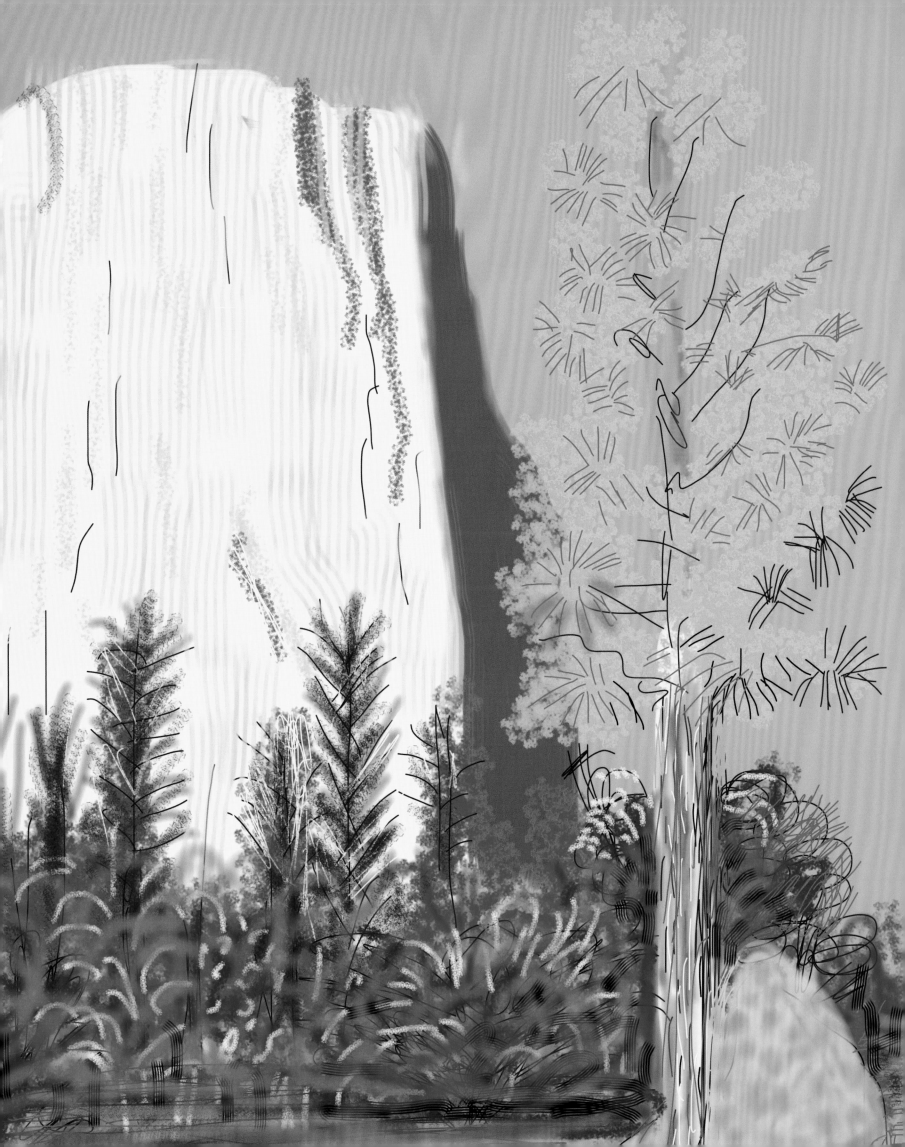

PLATES

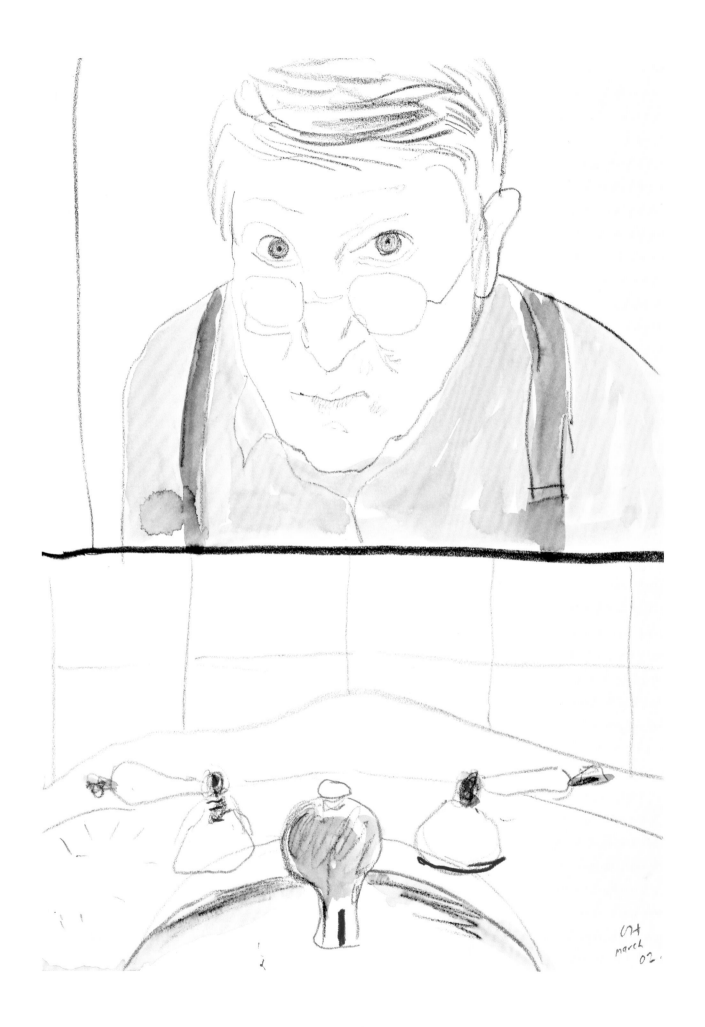

1 | SELF-PORTRAIT IN BATHROOM MIRROR WITH SINK,
NEW YORK, 2002
Watercolor and crayon on paper, 20 × 14 in. (50.8 × 35.6 cm)

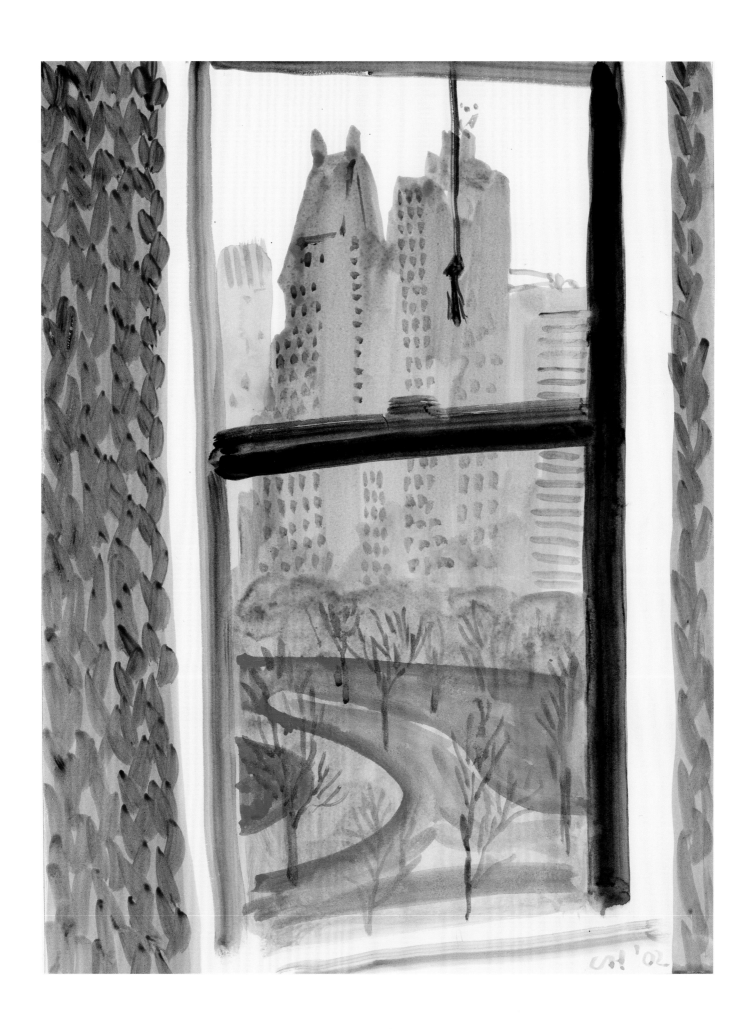

2 | VIEW FROM MAYFLOWER HOTEL, NEW YORK (MORNING), 2002

Watercolor on paper, 24 × 18 in. (61 × 45.7 cm)

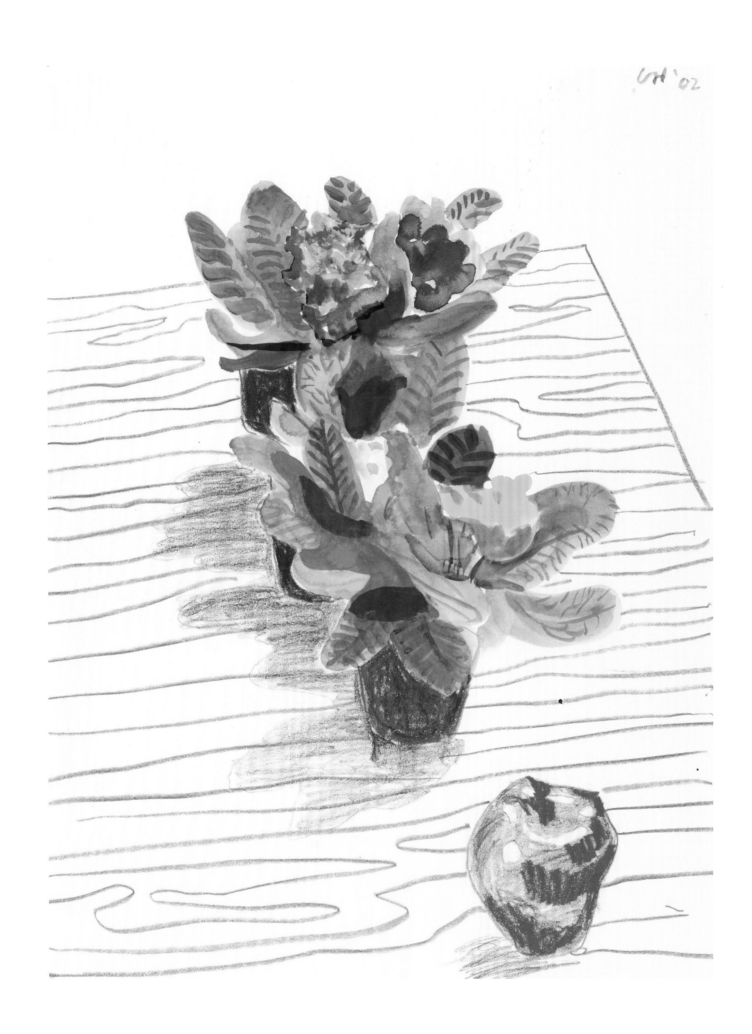

3 | POTTED VIOLETS AND AN APPLE, NEW YORK, 2002
Watercolor and crayon on paper, 24 × 18 in. (61 × 45.7 cm)

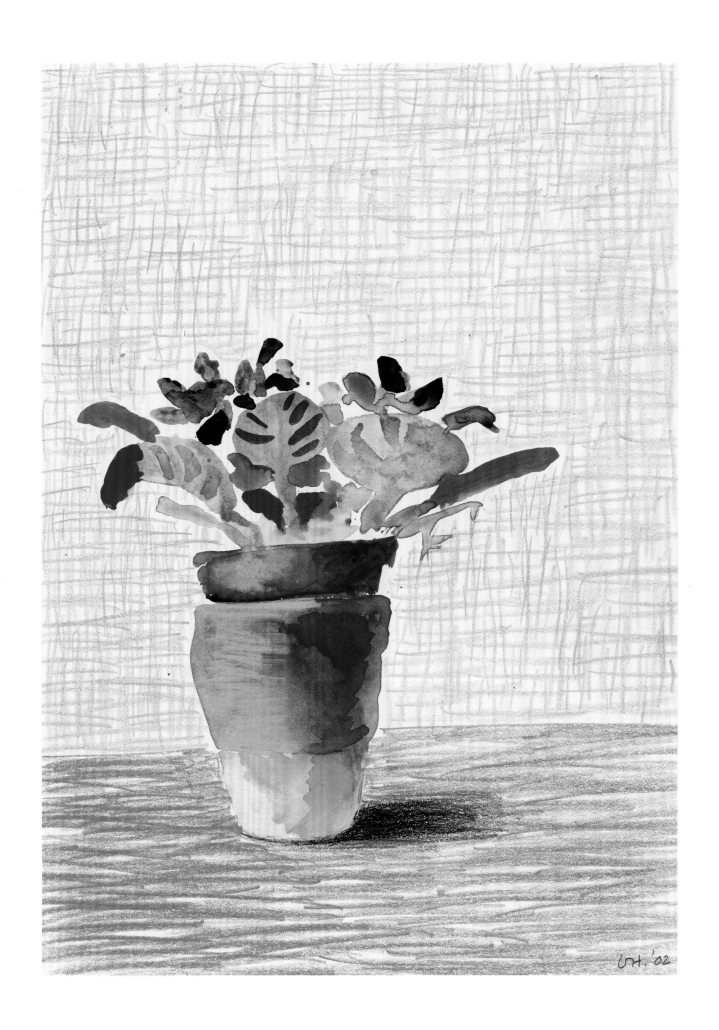

4 | A POT OF VIOLETS, 2002
Watercolor and crayon on paper, 14 ¼ × 10 ¼ in. (36.2 × 26 cm)

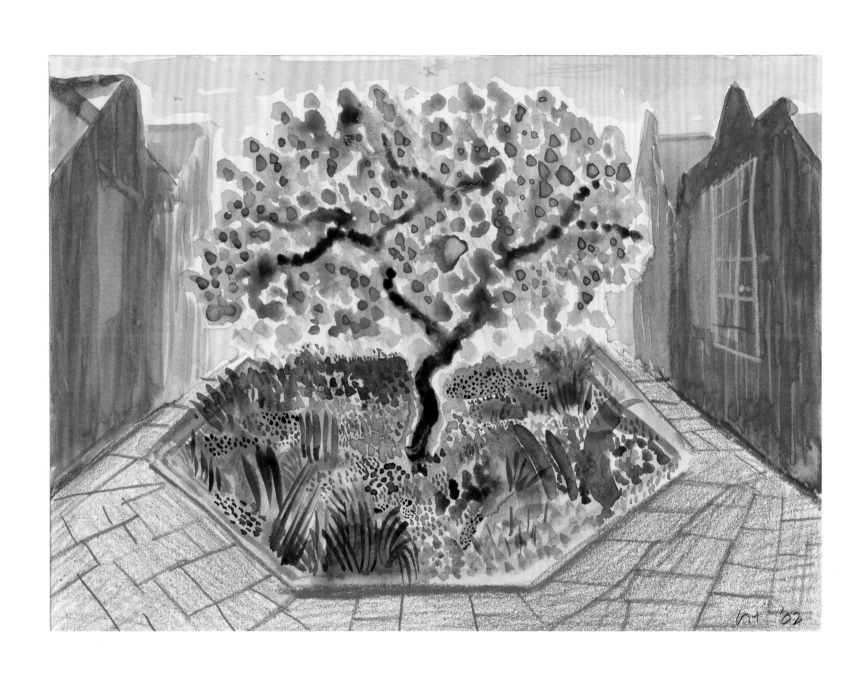

5 | STUDY FOR CHERRY BLOSSOM, 2002

Watercolor and crayon on paper, 10 ¼ × 14 ¼ in. (26 × 36.2 cm)

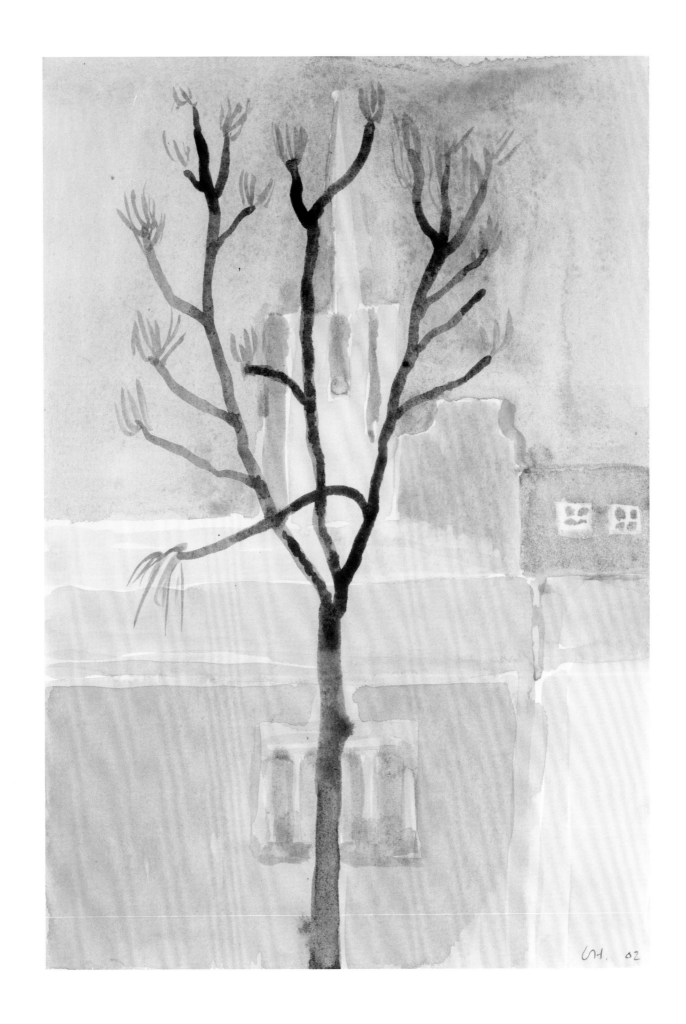

6 | ST. JOHN'S SPIRE & TREE, 2002

Watercolor on paper, 10 ½ × 7 in. (26.7 × 17.8 cm)

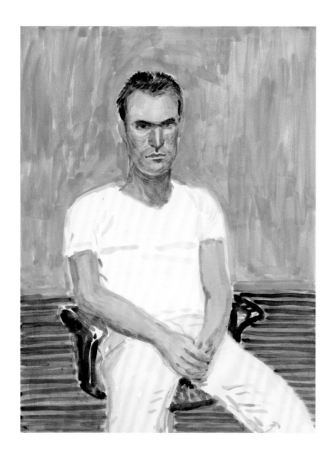

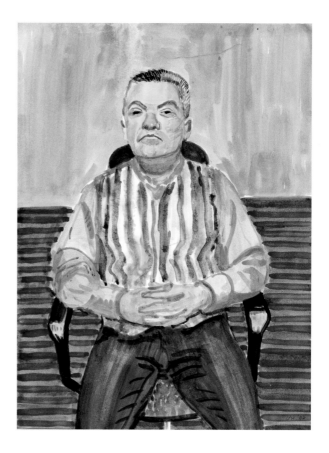

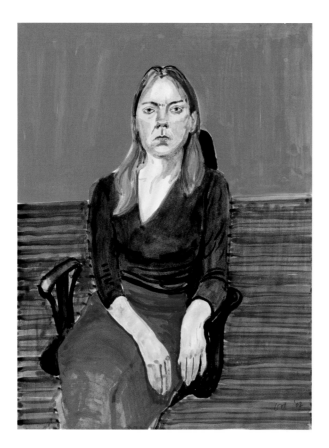

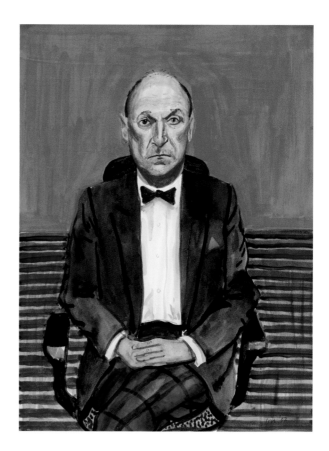

7 | MICHAEL SMITH, 2002
Watercolor on paper, 24 × 18 in. (61 × 45.7 cm)

8 | MARCO LIVINGSTONE, 2002
Watercolor on paper, 24 × 18⅛ in. (61 × 46 cm)

9 | SARAH HOWGATE, 2002
Watercolor on paper, 24 × 18⅛ in. (61 × 46 cm)

10 | GEORGE LAWSON, 2002
Watercolor on paper, 24 × 18⅛ in. (61 × 46 cm)

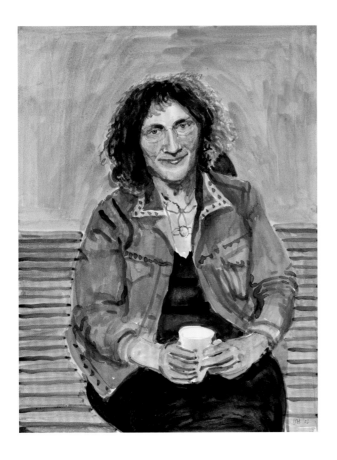

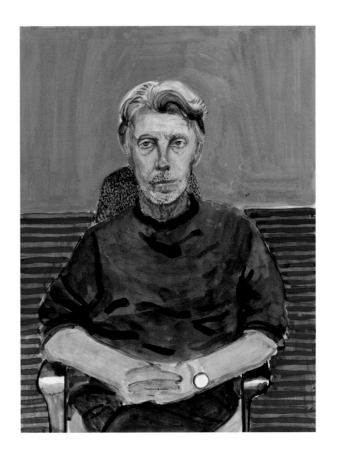

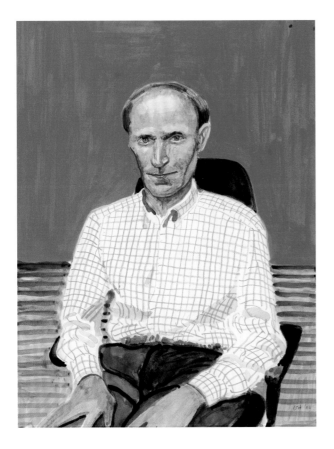

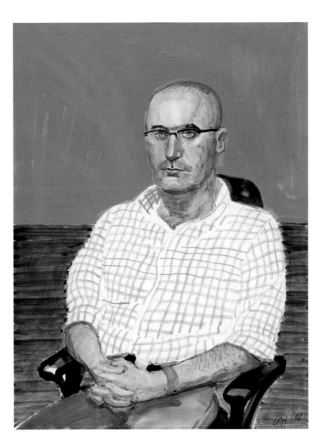

11 | KAREN WRIGHT, 2002
Watercolor on paper, 24 × 18 ⅛ in. (61 × 46 cm)

12 | ANGUS STEWART II, 2002
Watercolor on paper, 24 × 18 in. (61 × 45.7 cm)

13 | STEPHEN STUART-SMITH, 2002
Watercolor and crayon on paper, 24 × 18 ⅛ in. (61 × 46 cm)

14 | PAUL MELIA, 2002
Watercolor and crayon on paper, 24 × 18 ⅛ in. (61 × 46 cm)

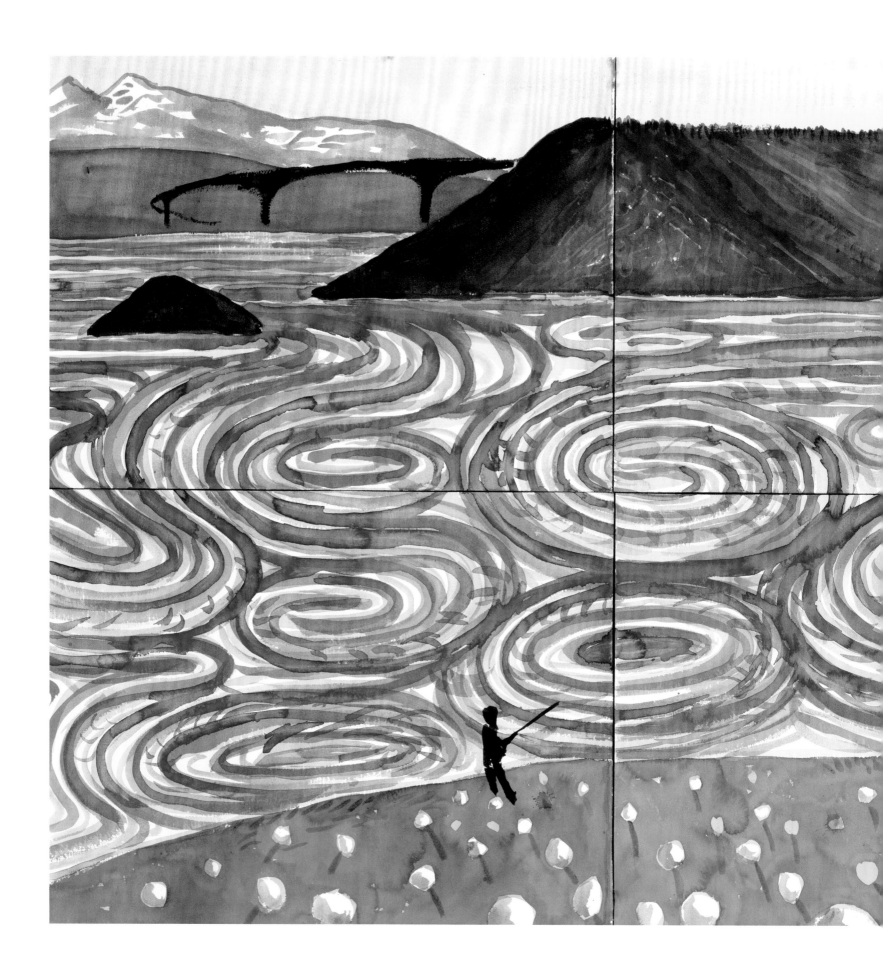

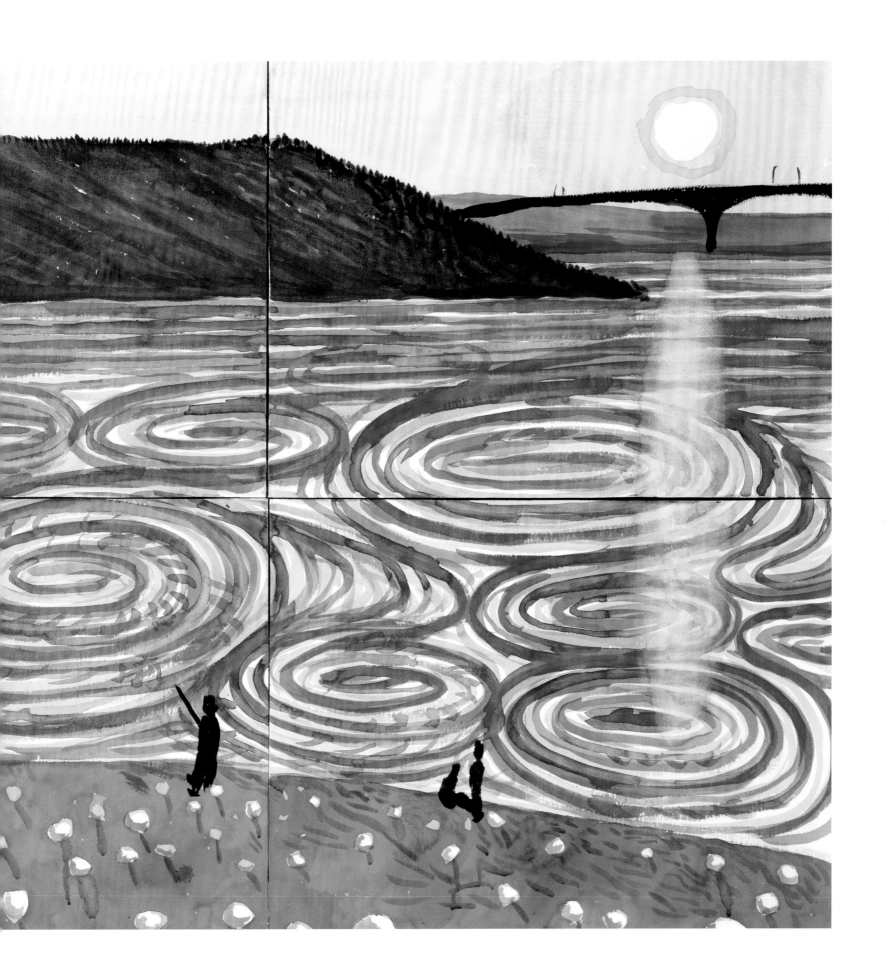

15 | THE MAELSTROM. BODØ, 2002

Watercolor on 6 sheets of paper, 36 × 72 in. (91.4 × 182.9 cm)

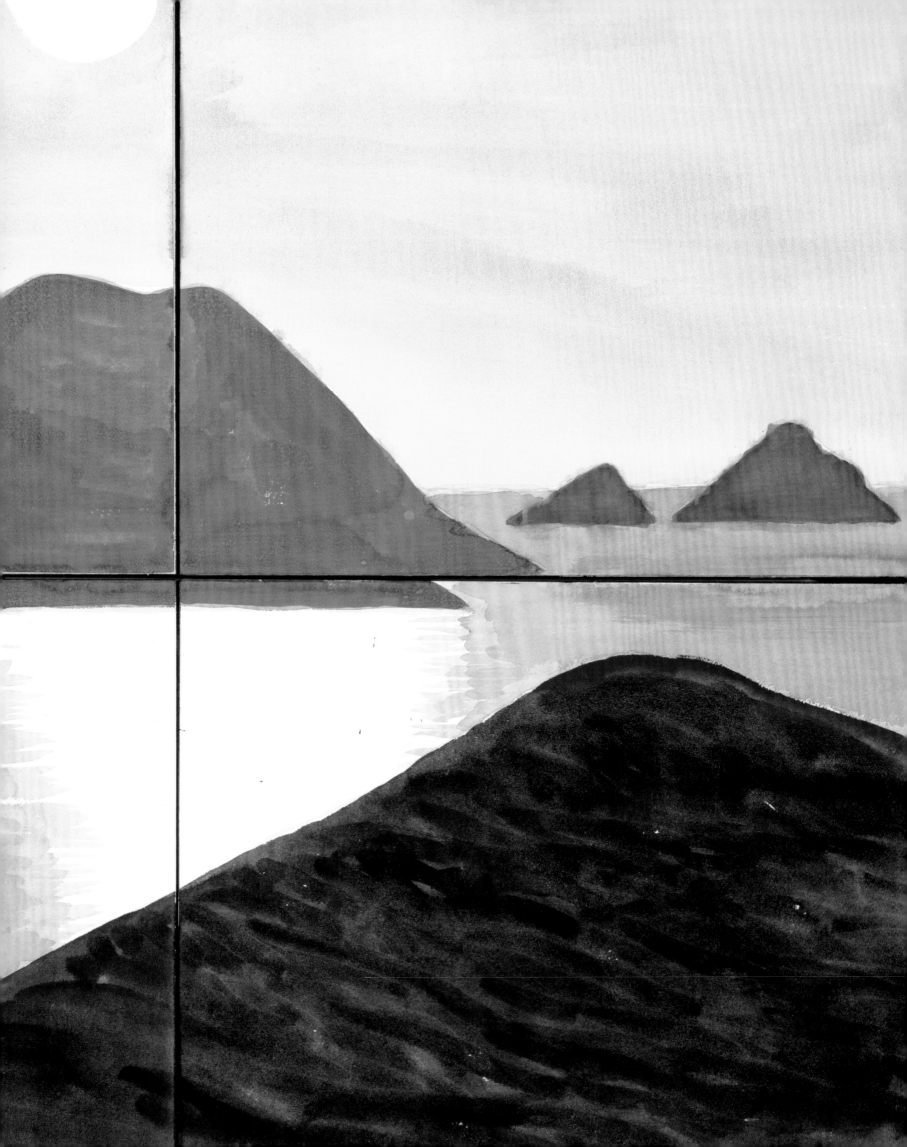

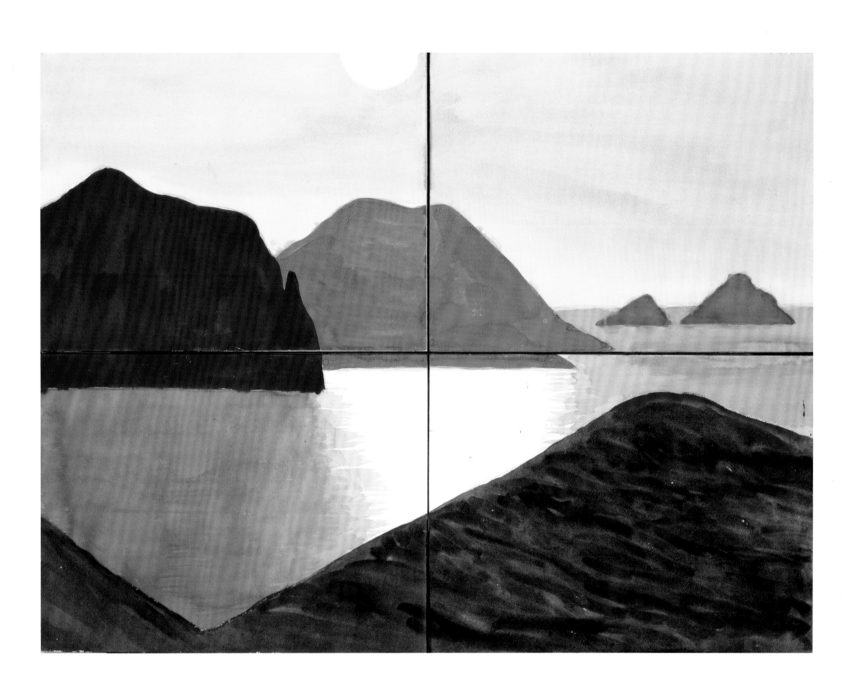

16 | NEAR NORDKAPP, 2002

Watercolor on 4 sheets of paper, 36 × 48 in. (91.4 × 121.9 cm)

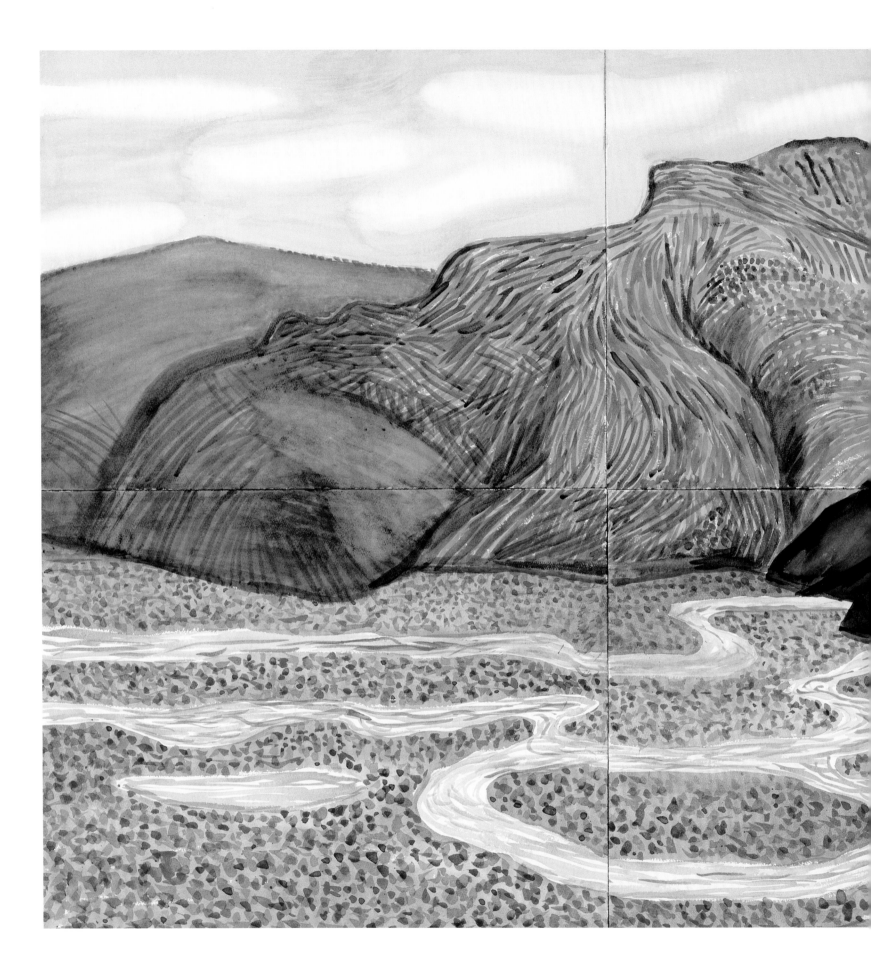

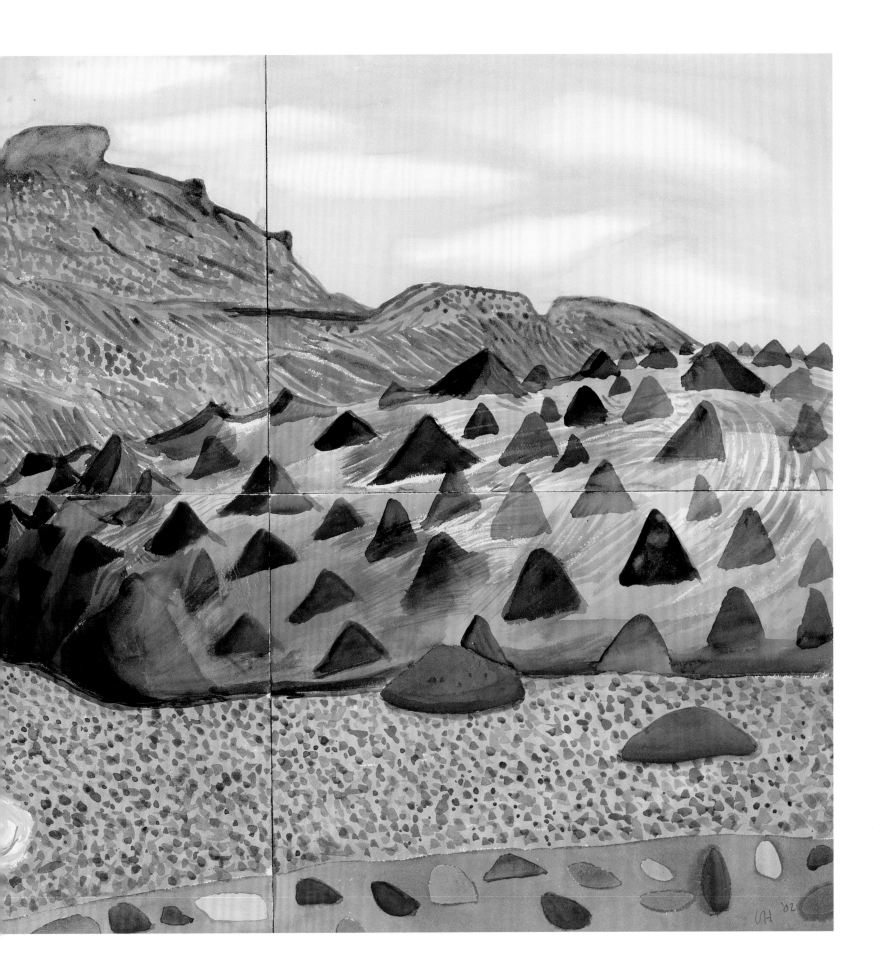

17 | THE BLACK GLACIER, 2002
Watercolor on 6 sheets of paper, 36 × 72 in. (91.4 × 182.9 cm)

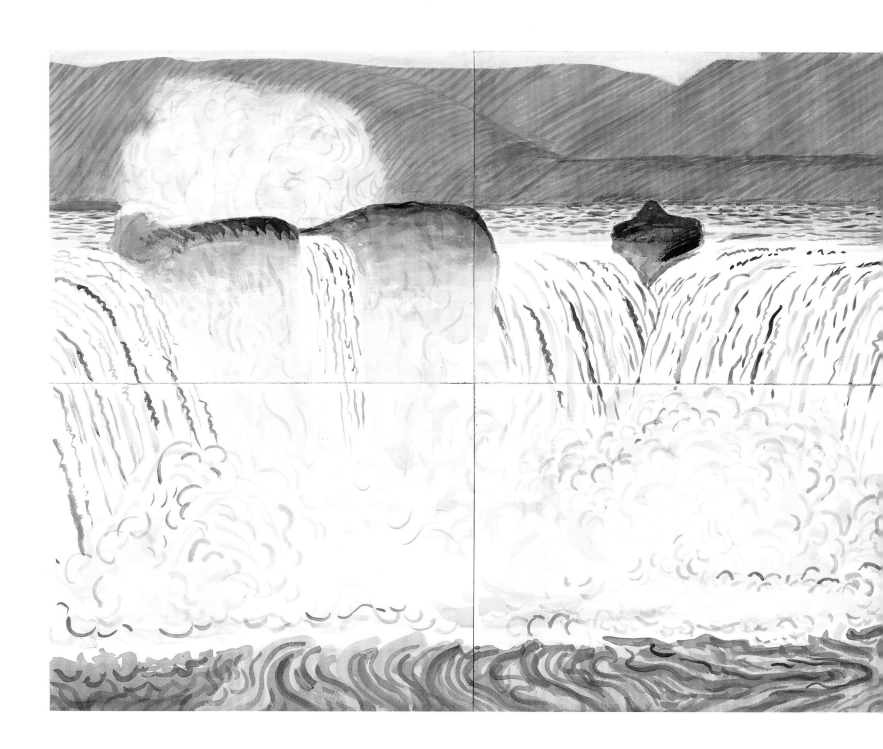

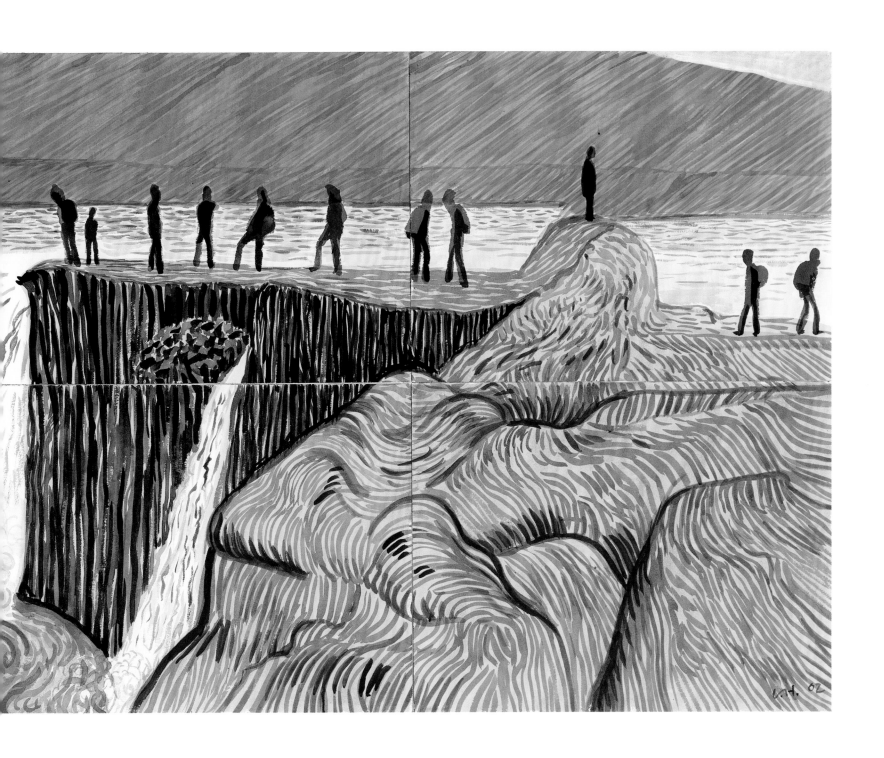

18 | GOÐAFOSS. ICELAND, 2002
Watercolor on 8 sheets of paper, 36 × 96 in. (91.4 × 243.8 cm)

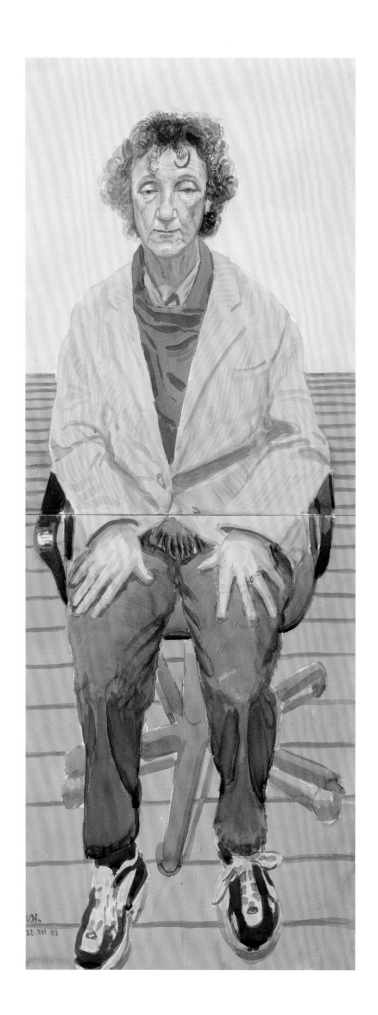

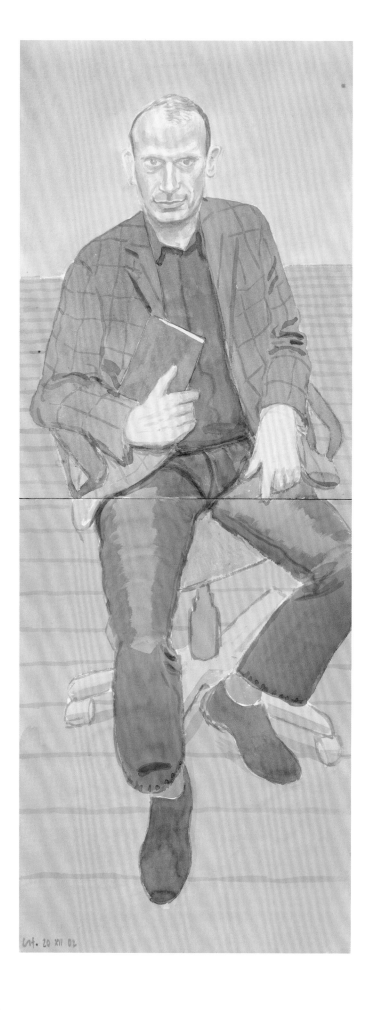

19 | LINDY DUFFERIN I, 2002
Watercolor on 2 sheets of paper, 48 × 18 in. (121.9 × 45.7 cm)

20 | ANDREW MARR, 2002
Watercolor on 2 sheets of paper, 48 × 18 in. (121.9 × 45.7 cm)

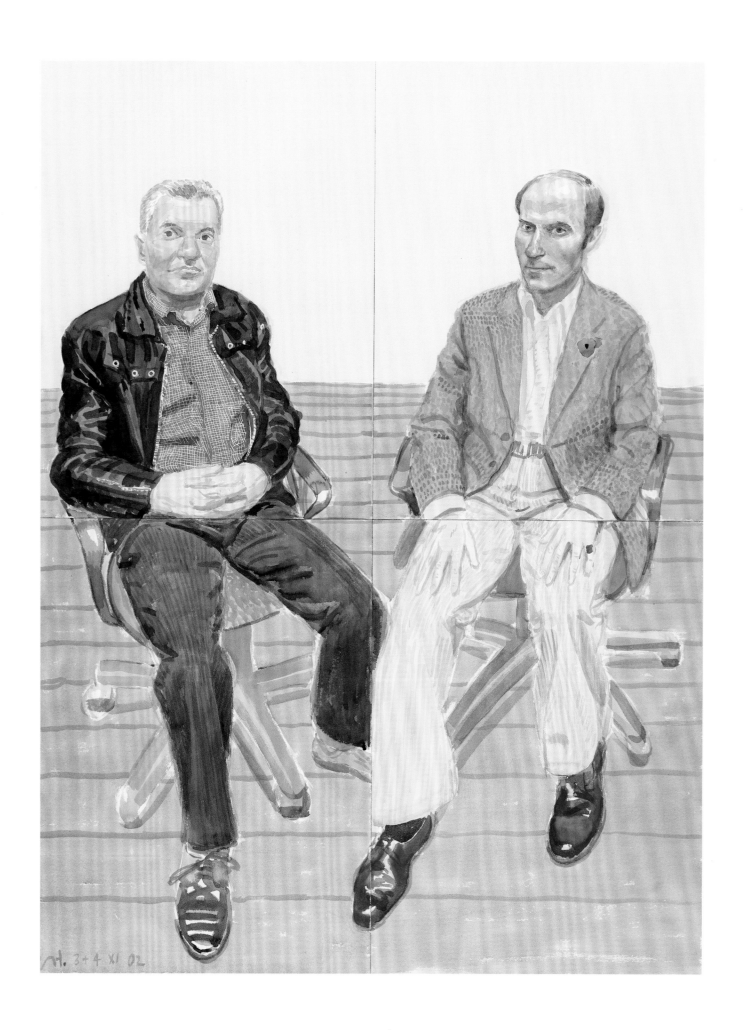

21 | MARCO LIVINGSTONE AND STEPHEN STUART-SMITH, 2002
Watercolor on 4 sheets of paper, 48 × 36 in. (121.9 × 91.4 cm)

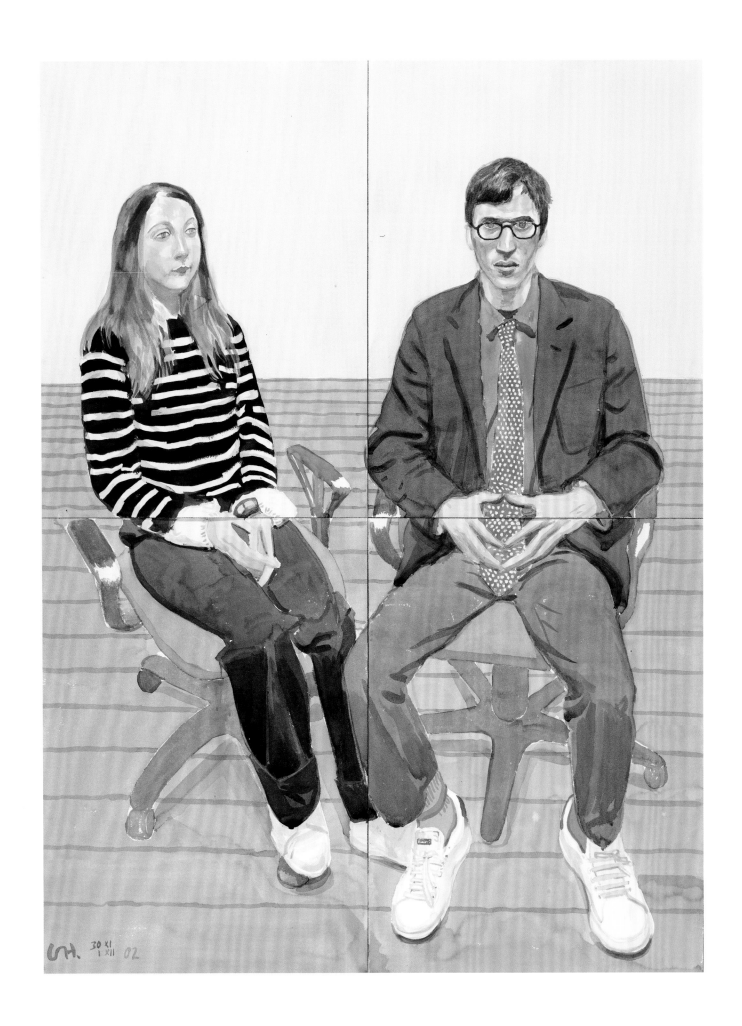

22 | ARCADIA FLETCHER AND ROBIN KATZ, 2002
Watercolor on 4 sheets of paper, 48 × 36 in. (121.9 × 91.4 cm)

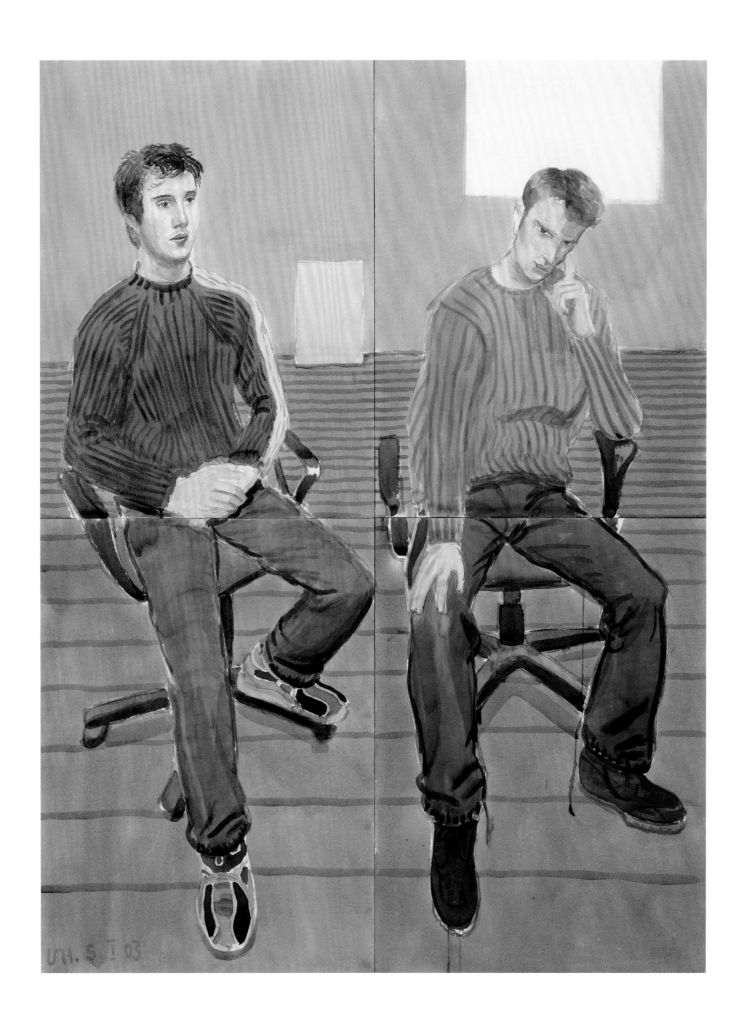

23 | NATHAN AND SAM JOYCE, 2003

Watercolor on 4 sheets of paper, 48 × 36 ¼ in. (121.9 × 92.1 cm)

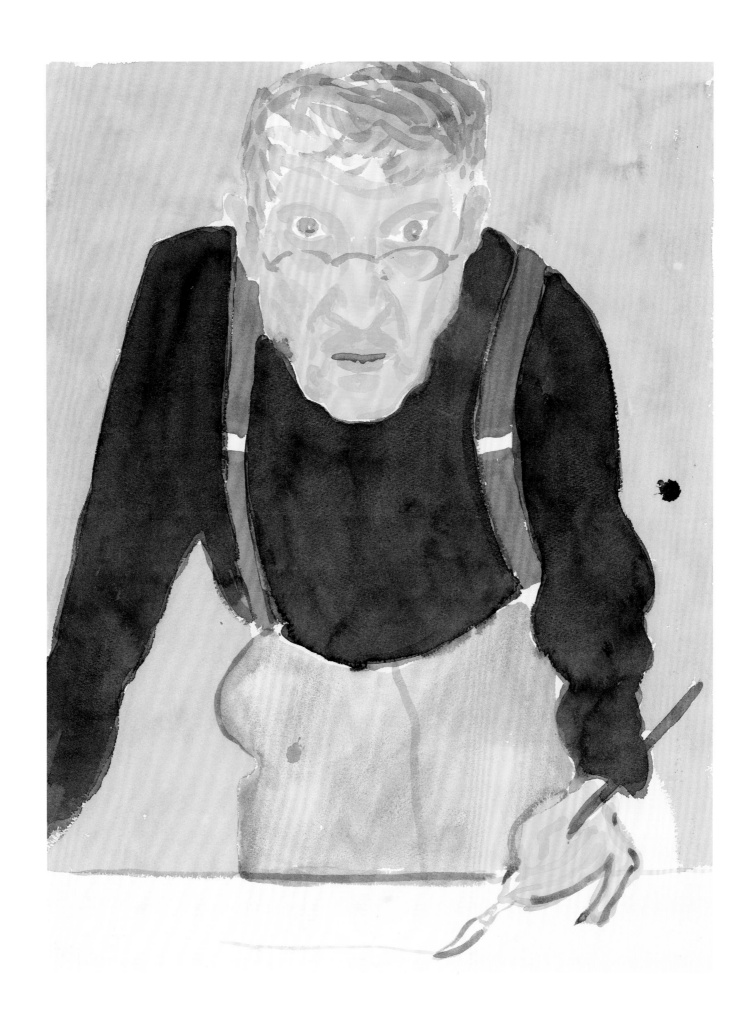

Watercolor on paper, 24 × 18 ⅛ in. (61 × 46 cm)

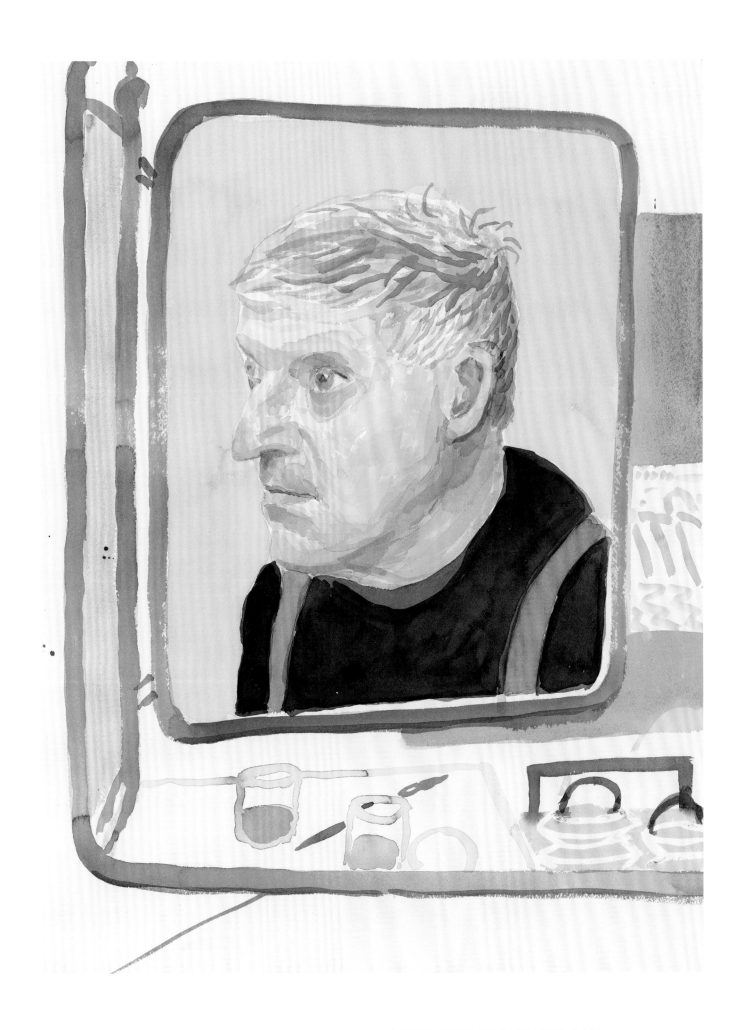

25 | SELF-PORTRAIT IN MIRROR, 2003

Watercolor on paper, 24 × 18 ⅛ in. (61 × 46 cm)

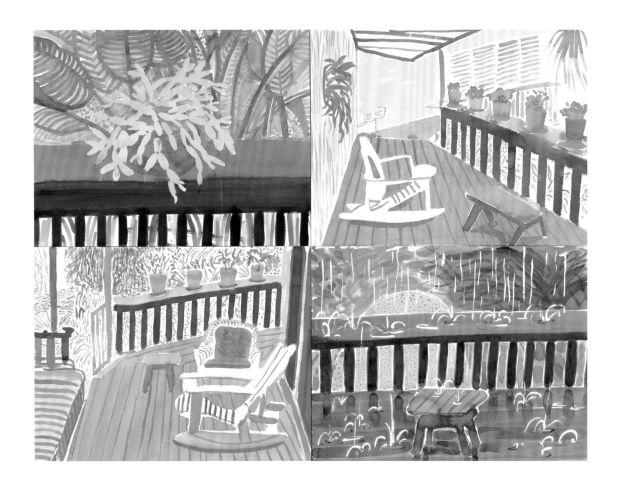

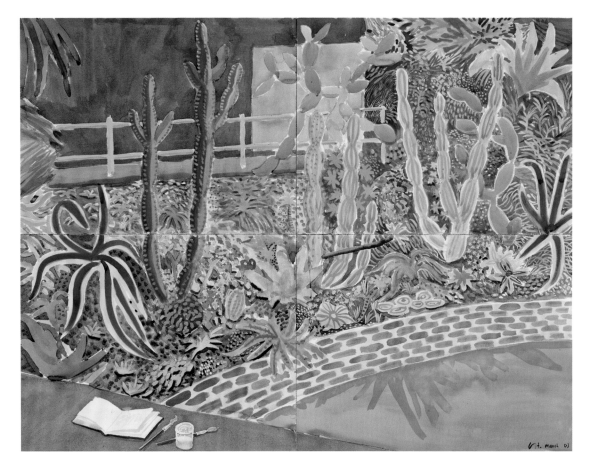

26 | FOUR VIEWS OF MONTCALM TERRACE, 2003
Watercolor on 4 sheets of paper, 34 ¼ × 48 in. (87 × 121.9 cm)

27 | CACTUS GARDEN III, 2003
Watercolor on 4 sheets of paper, 36 ¼ × 48 in. (92.1 × 121.9 cm)

28 | THE MASSACRE AND THE PROBLEMS OF DEPICTION, 2003
Watercolor on 7 sheets of paper, 56 ½ × 72 ¼ in. (143.5 × 183.5 cm)

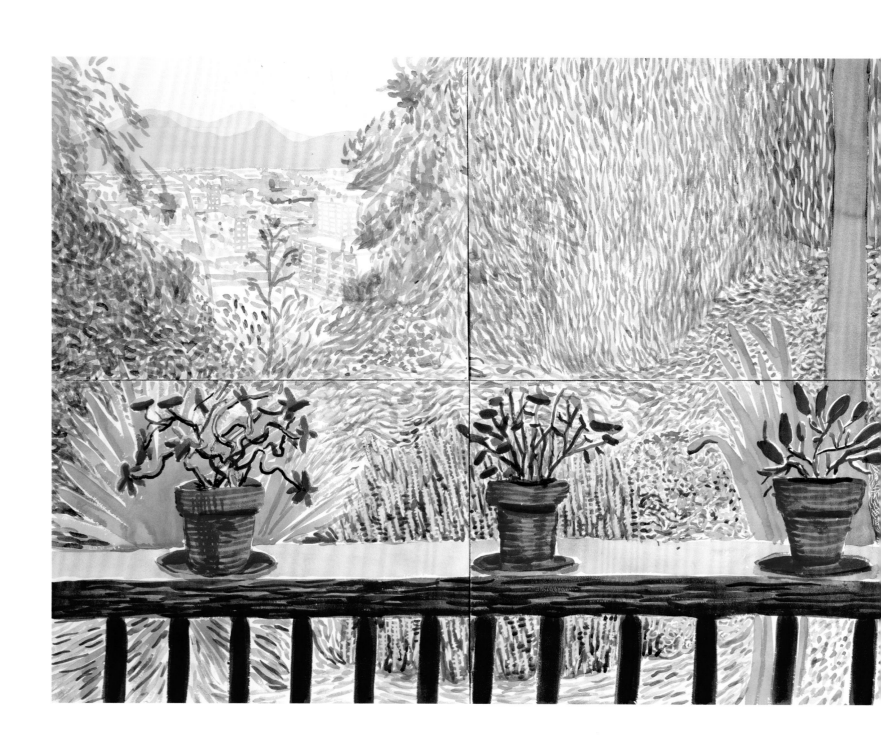

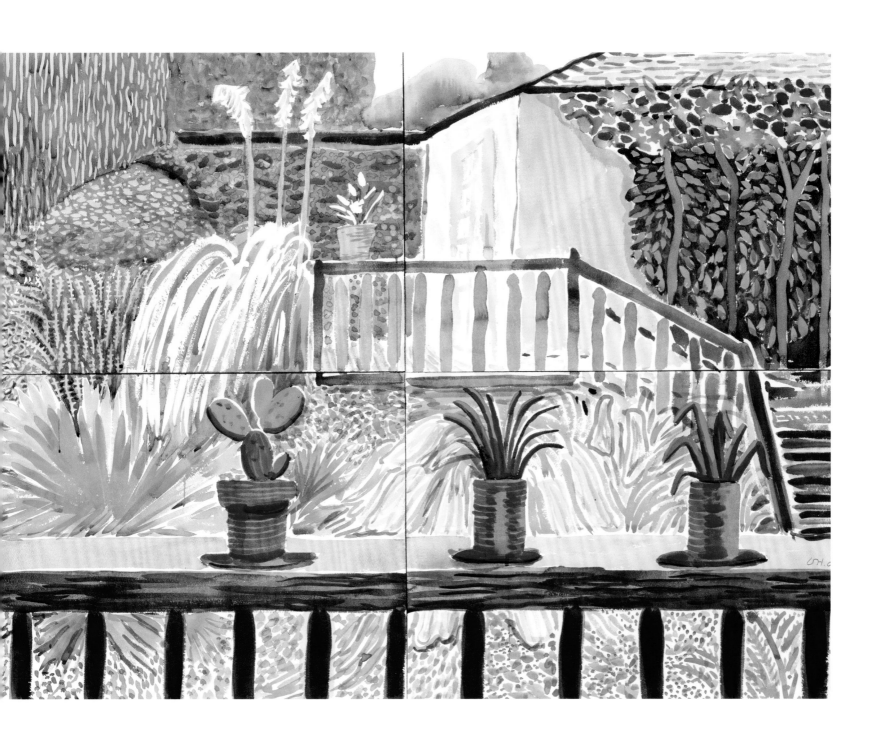

29 | VIEW FROM TERRACE II, 2003
Watercolor on 8 sheets of paper, 36 ¼ × 96 ⅛ in. (92.1 × 244.2 cm)

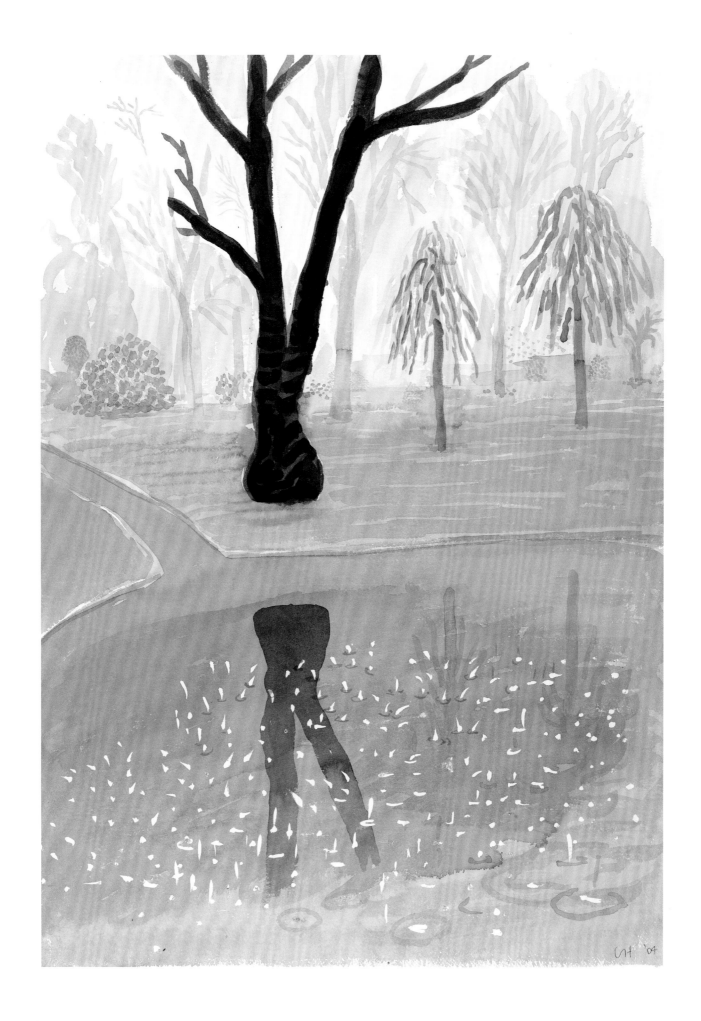

30 | RAINY MORNING. HOLLAND PARK, 2004
Watercolor on paper, 41 ½ × 29 ½ in. (105.4 × 74.9 cm)

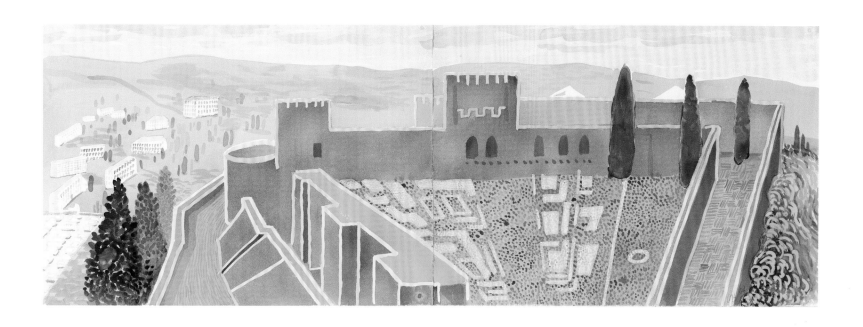

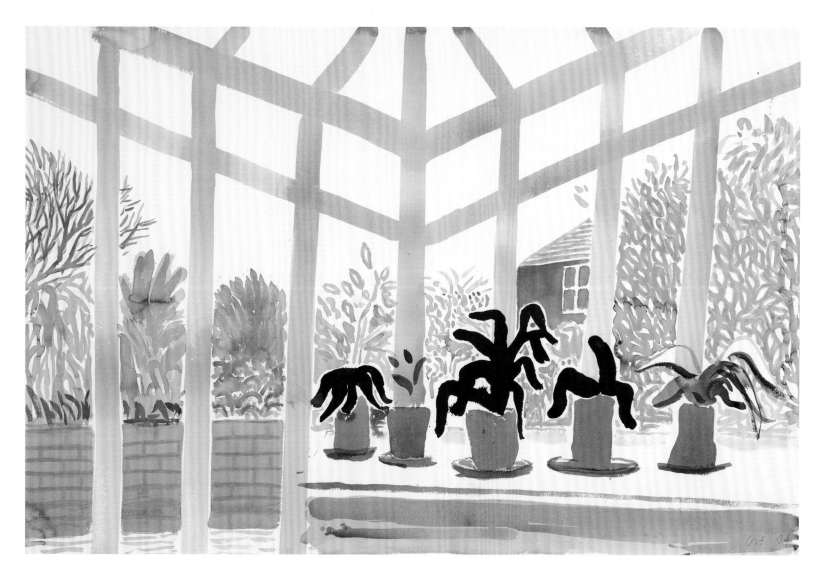

31 | ANDALUCIA. ALCAZABA, GRANADA, 2004
Watercolor on 2 sheets of paper, 29 ½ × 83 in. (74.9 × 210.8 cm)

32 | A BIGGER CONSERVATORY I, 2004
Watercolor on paper, 40 × 60 ½ in. (101.6 × 153.7 cm)

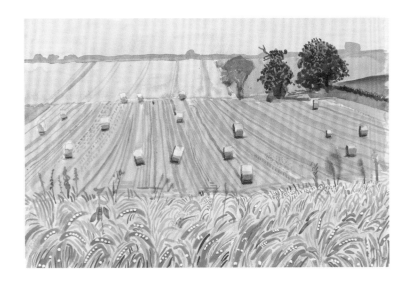
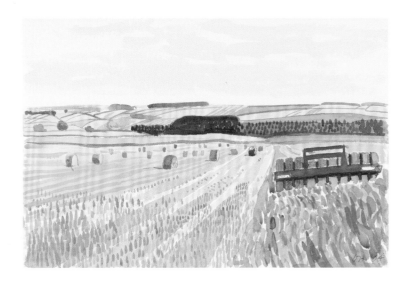
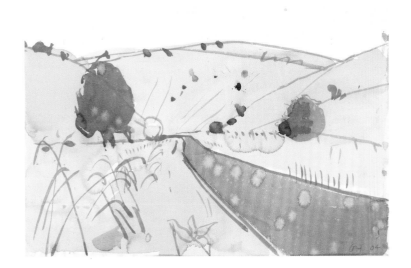
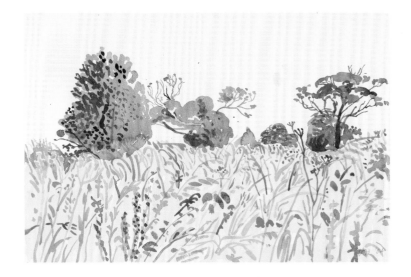
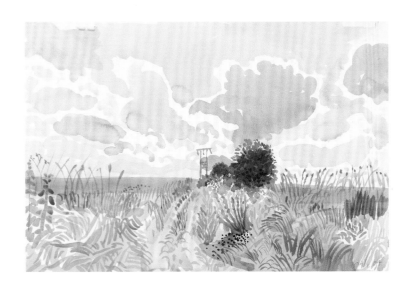
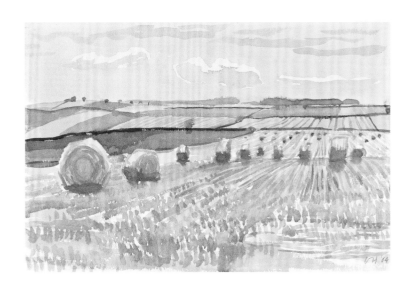

33–56 | WATERCOLORS FROM THE SERIES MIDSUMMER: EAST YORKSHIRE, 2004
Watercolor on paper, each 15 × 22 ½ in. (38.1 × 57.2 cm)

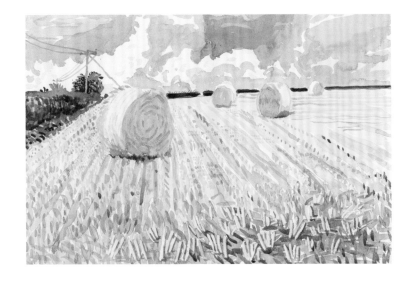 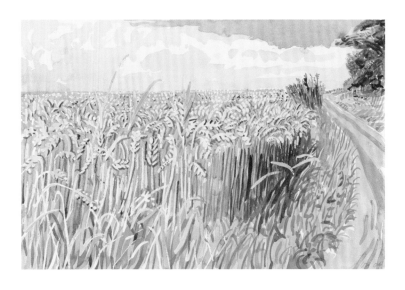

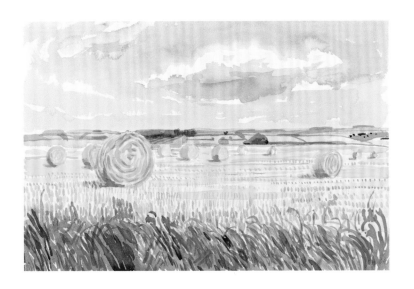 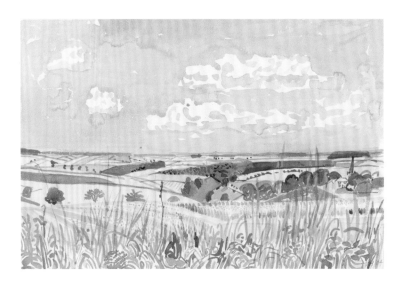

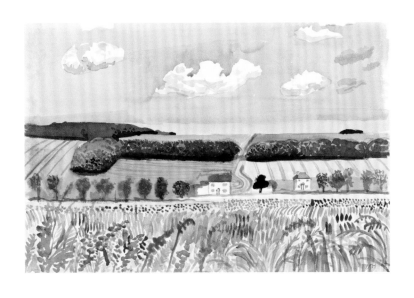 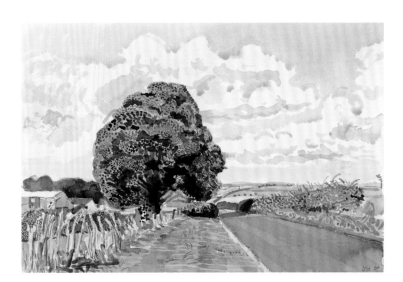

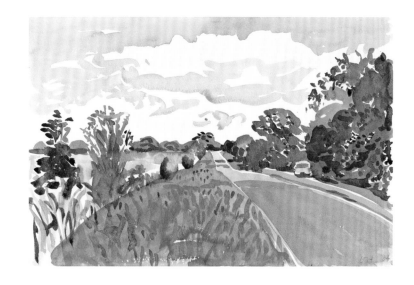

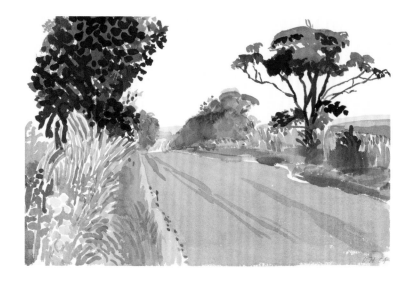

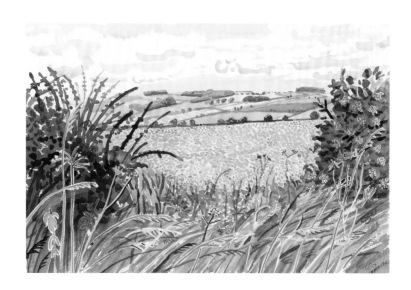

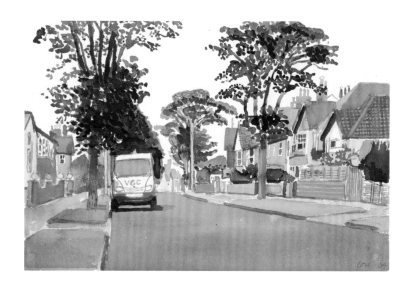

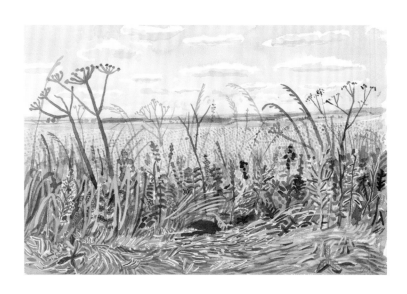

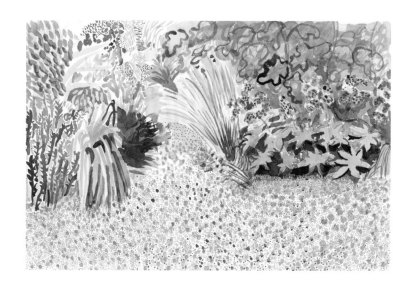

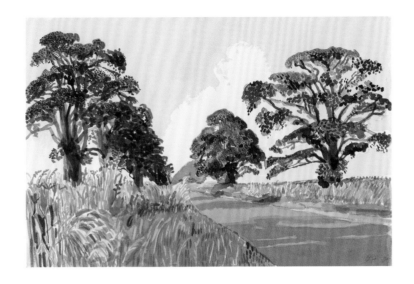

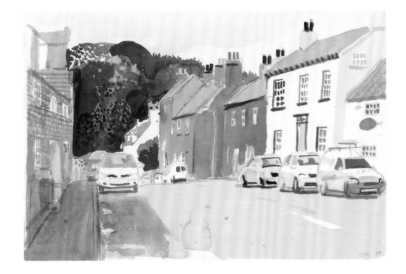

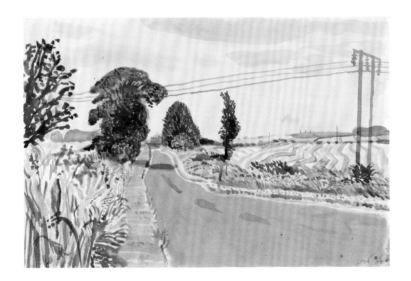

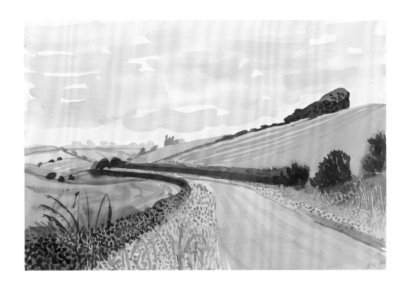

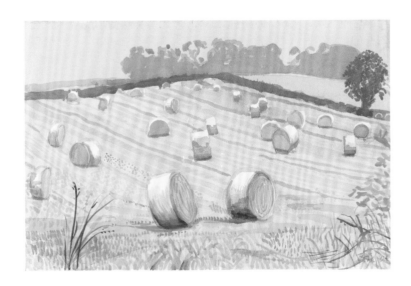

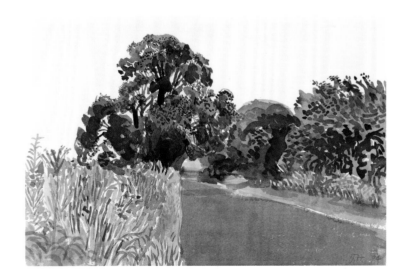

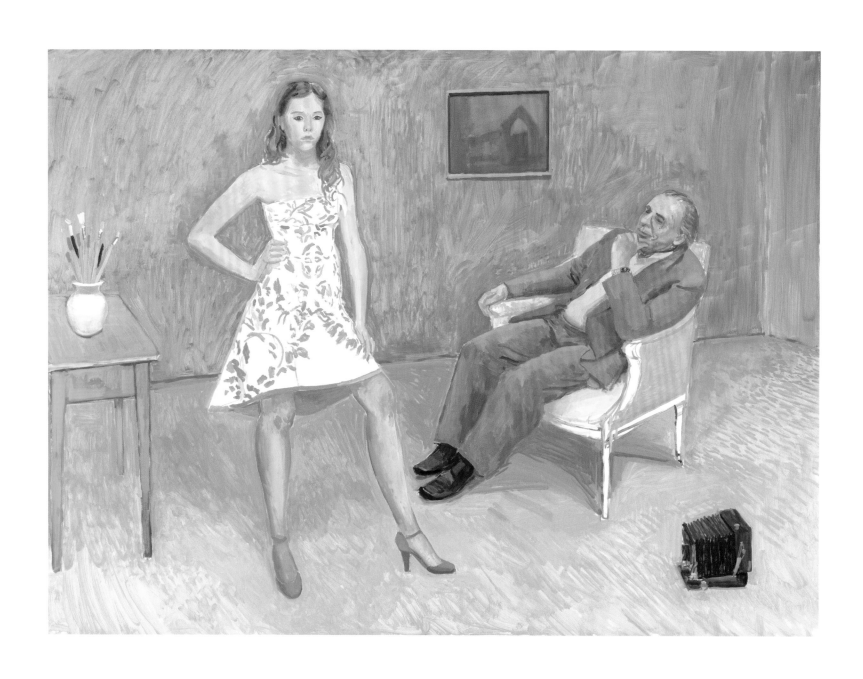

57 | THE PHOTOGRAPHER AND HIS DAUGHTER, 2005
Oil on canvas, 56 × 76 in. (142.2 × 193 cm)

100

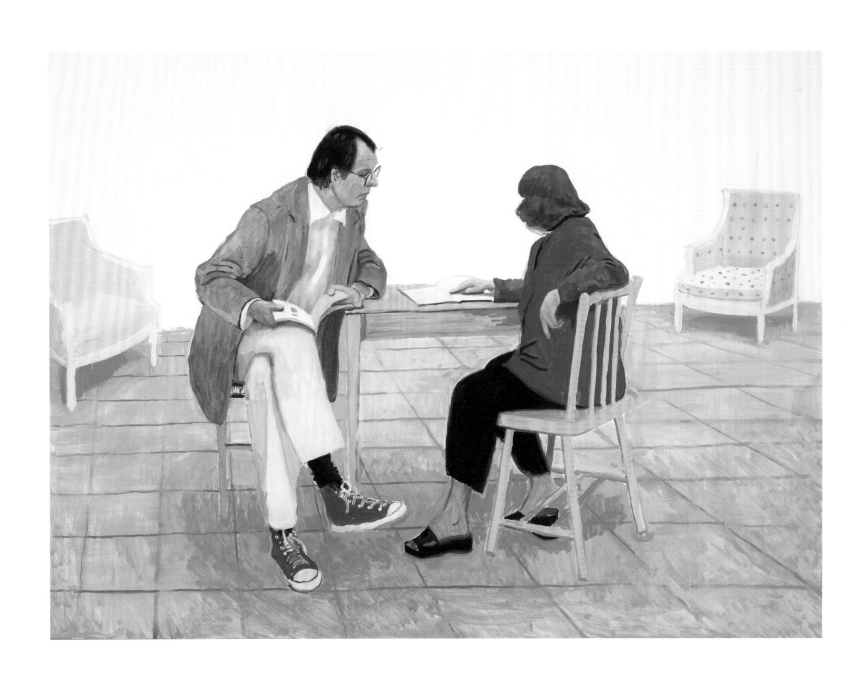

| ANN AND DAVID, LOS ANGELES, MARCH 10, 2005
Oil on canvas, 56 × 76 in. (142.2 × 193 cm)

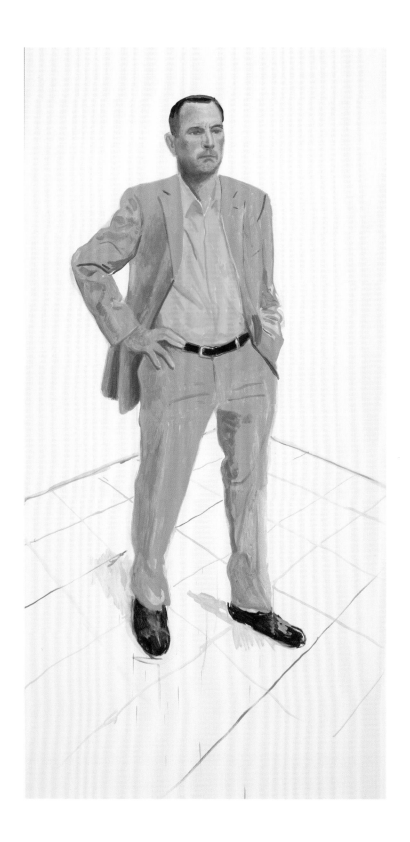

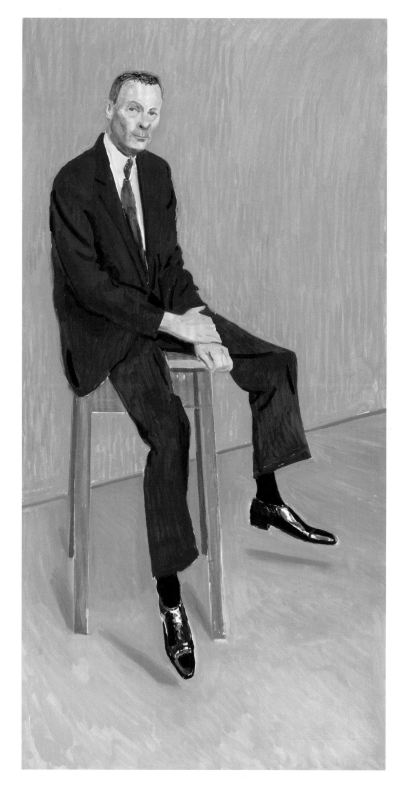

59 | RICHARD SCHMIDT, 2005
Oil on canvas, 72 × 36 in. (182.9 × 91.4 cm)

60 | ARTHUR LAMBERT, 2005
Oil on canvas, 72 × 36 in. (182.9 × 91.4 cm)

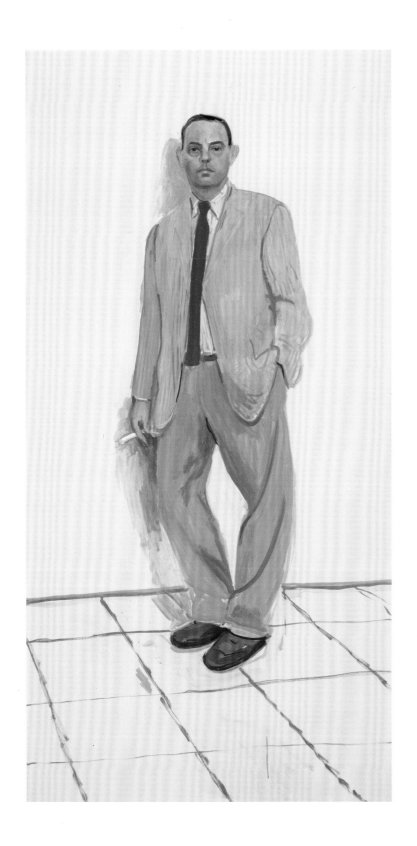

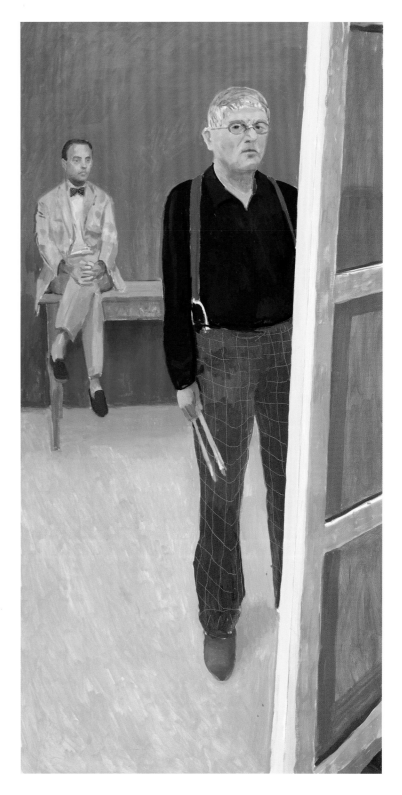

61 | CHARLIE SCHEIPS, 2005
Oil on canvas, 72 × 36 in. (182.9 × 91.4 cm)

62 | SELF-PORTRAIT WITH CHARLIE, 2005
Oil on canvas, 72 × 36 in. (182.9 × 91.4 cm)

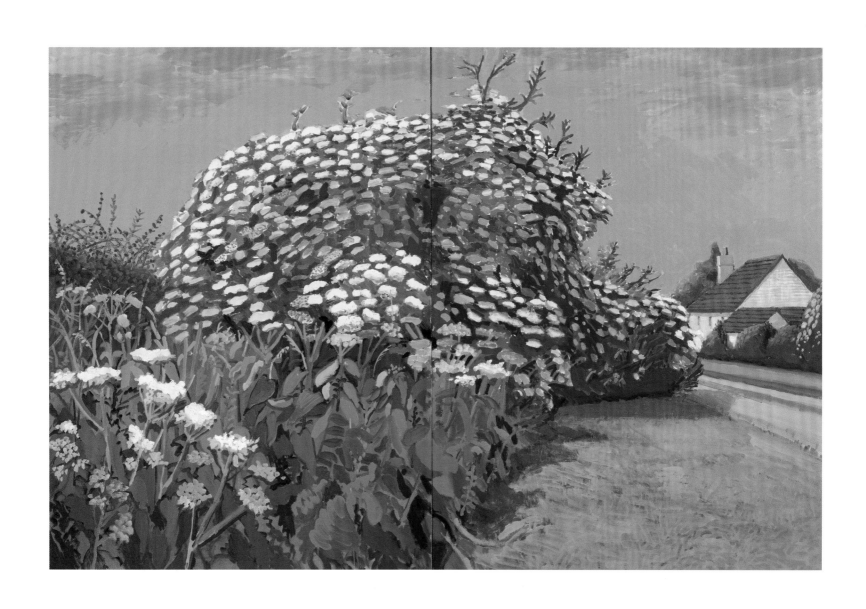

63 | ELDERFLOWER BLOSSOM, KILHAM, JULY, 2006
Oil on 2 canvases, 48 × 72 in. (121.9 × 182.9 cm)

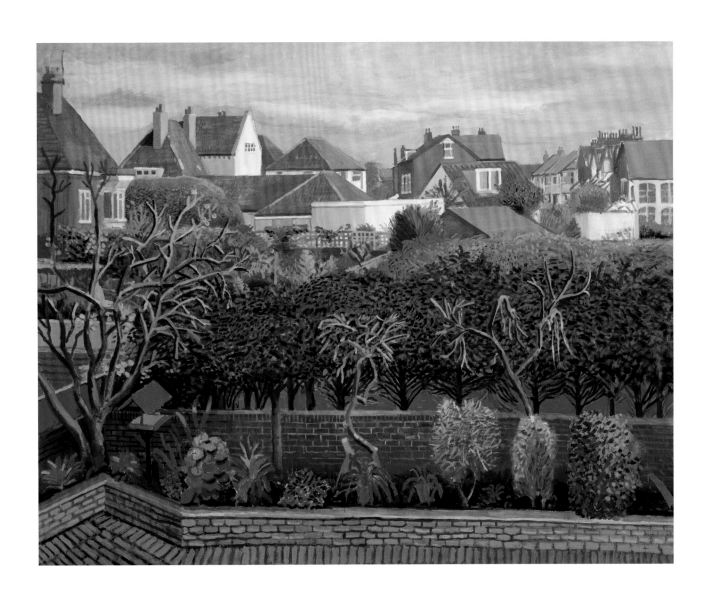

64 | BRIDLINGTON ROOFTOPS, OCTOBER, NOVEMBER,
DECEMBER, 2005
Oil on canvas, 48 × 60 in. (121.9 × 152.4 cm)

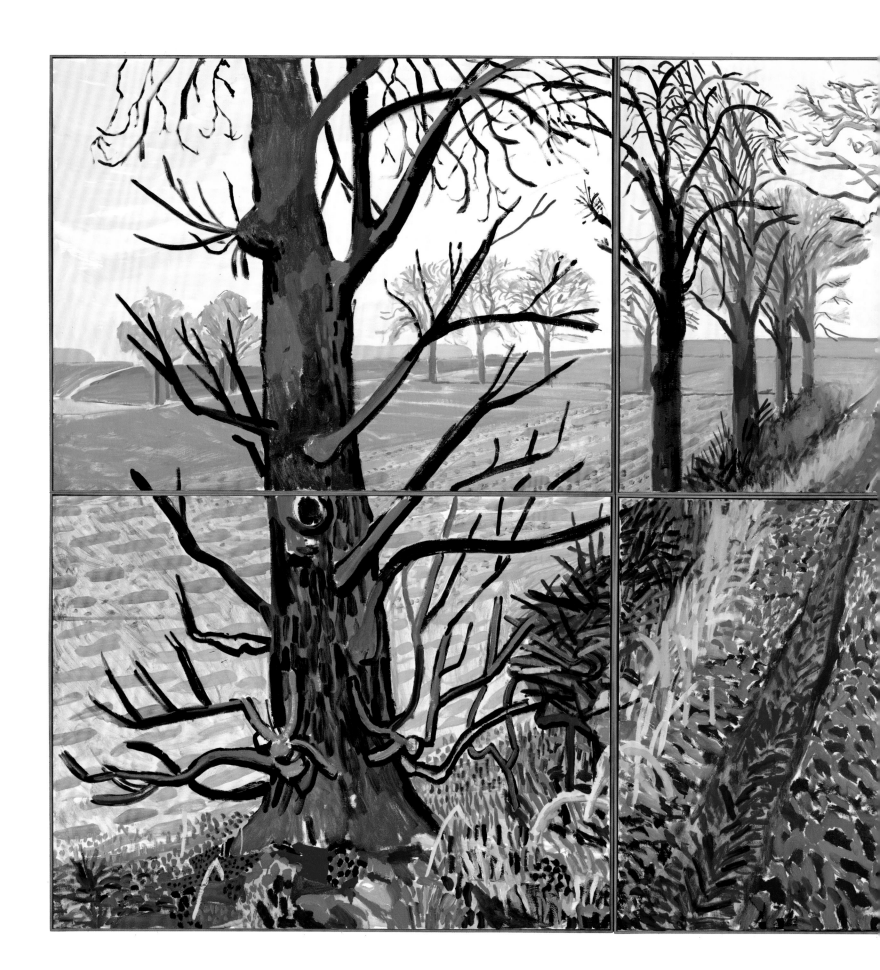

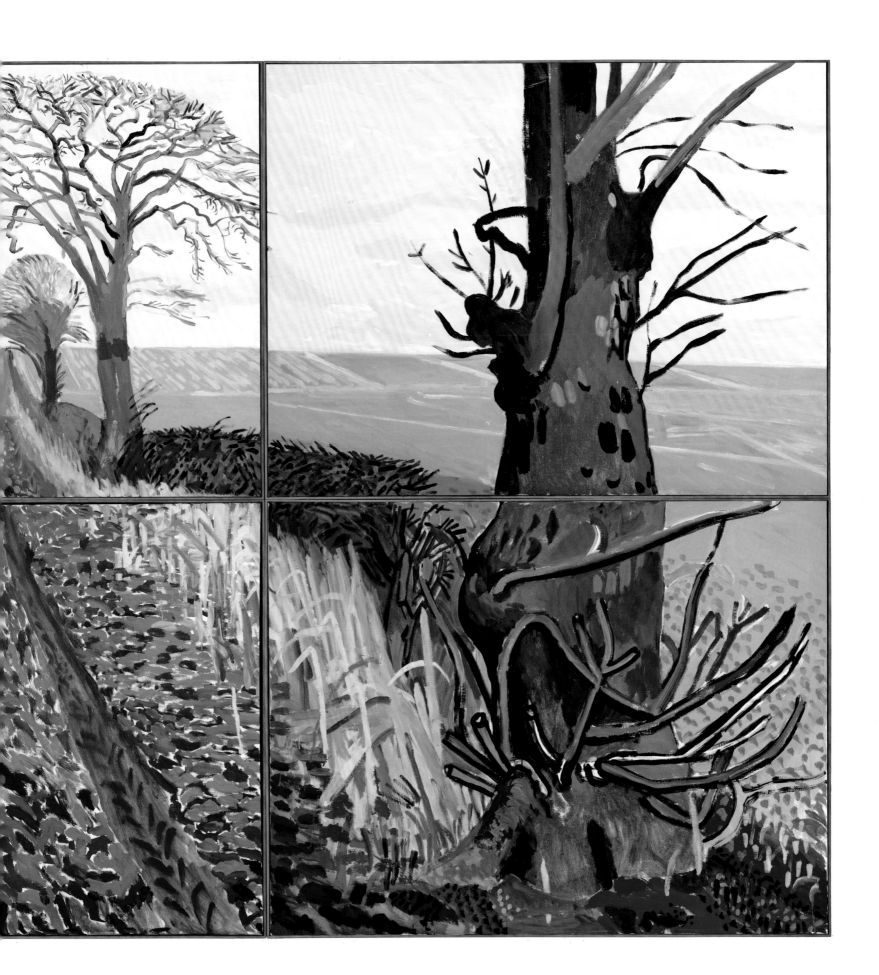

65 | A CLOSER WINTER TUNNEL, FEBRUARY–MARCH, 2006
Oil on 6 canvases, 72 × 144 in. (182.9 × 365.8 cm)

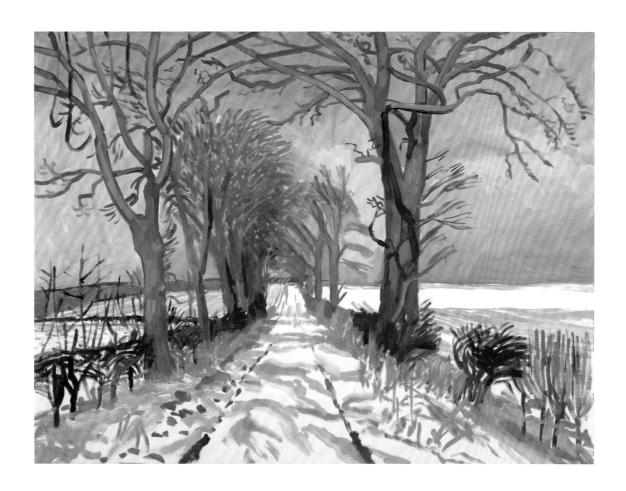

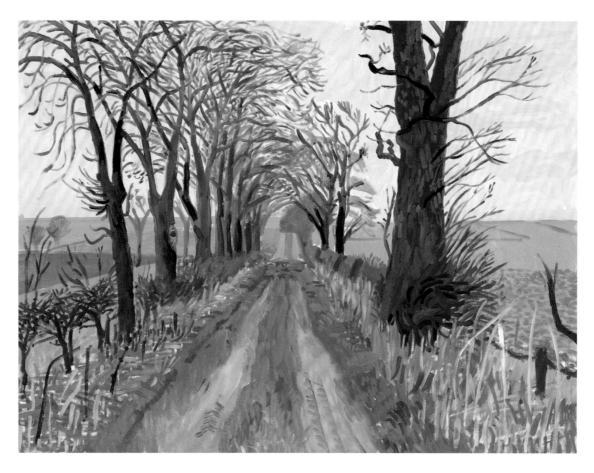

66 | WINTER TUNNEL WITH SNOW, MARCH, 2006
Oil on canvas, 36 × 48 in. (91.4 × 121.9 cm)

67 | WINTER TUNNEL, FEBRUARY, 2006
Oil on canvas, 36 × 48 in. (91.4 × 121.9 cm)

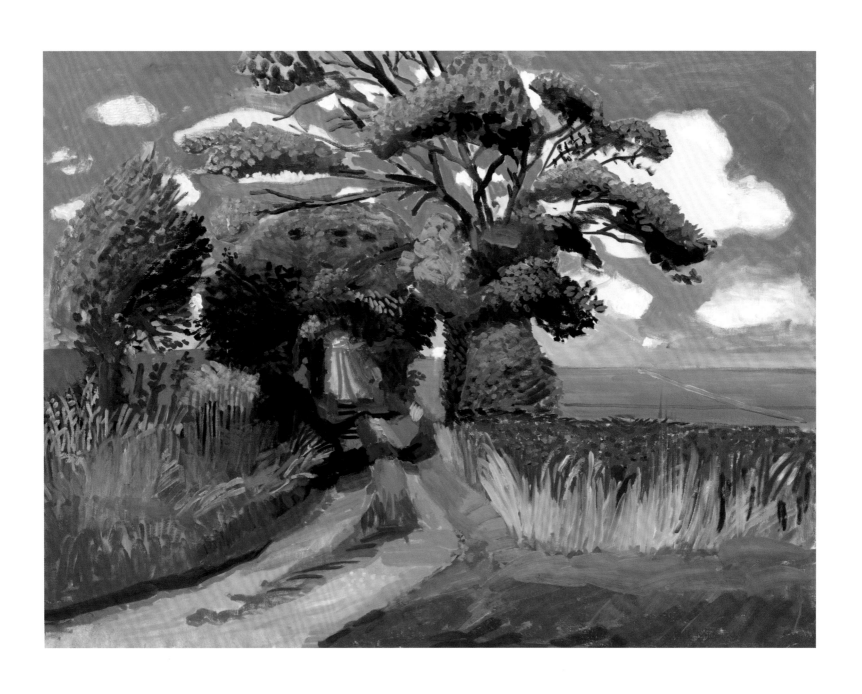

68 | THE TUNNEL EARLY AUTUMN, OCTOBER, 2005
Oil on canvas, 36 × 48 in. (91.4 × 121.9 cm)

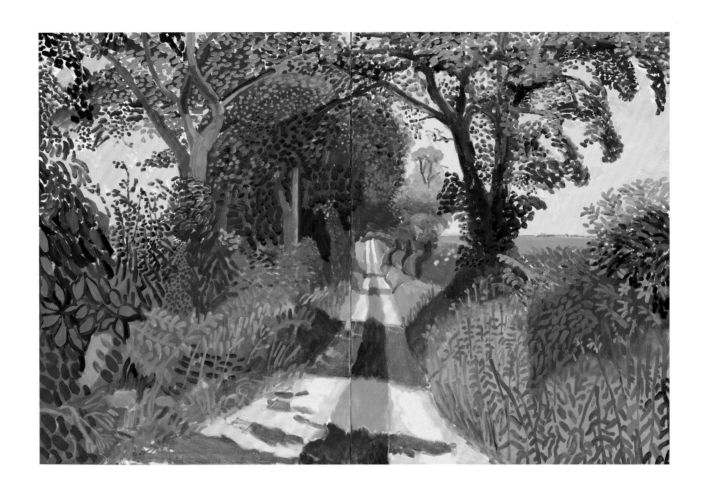

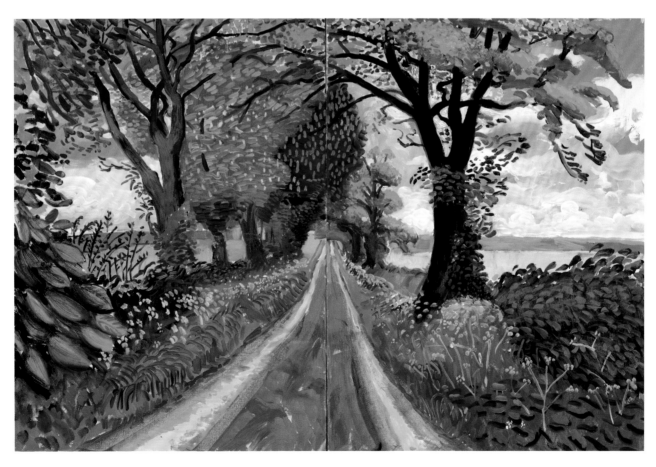

69 | EARLY JULY TUNNEL, 2006
Oil on 2 canvases, 48 × 72 in. (121.9 × 182.9 cm)

70 | LATE SPRING TUNNEL, MAY, 2006
Oil on 2 canvases, 48 × 72 in. (121.9 × 182.9 cm)

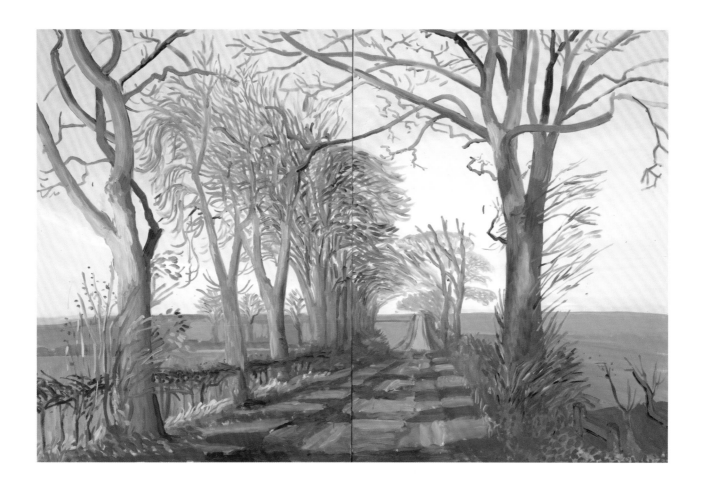

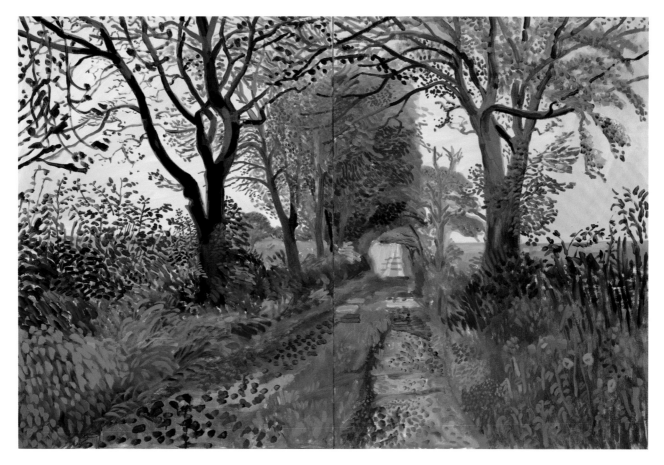

71 | LATE NOVEMBER TUNNEL, 2006
Oil on 2 canvases, 48 × 72 in. (121.9 × 182.9 cm)

72 | EARLY NOVEMBER TUNNEL, 2006
Oil on 2 canvases, 48 × 72 in. (121.9 × 182.9 cm)

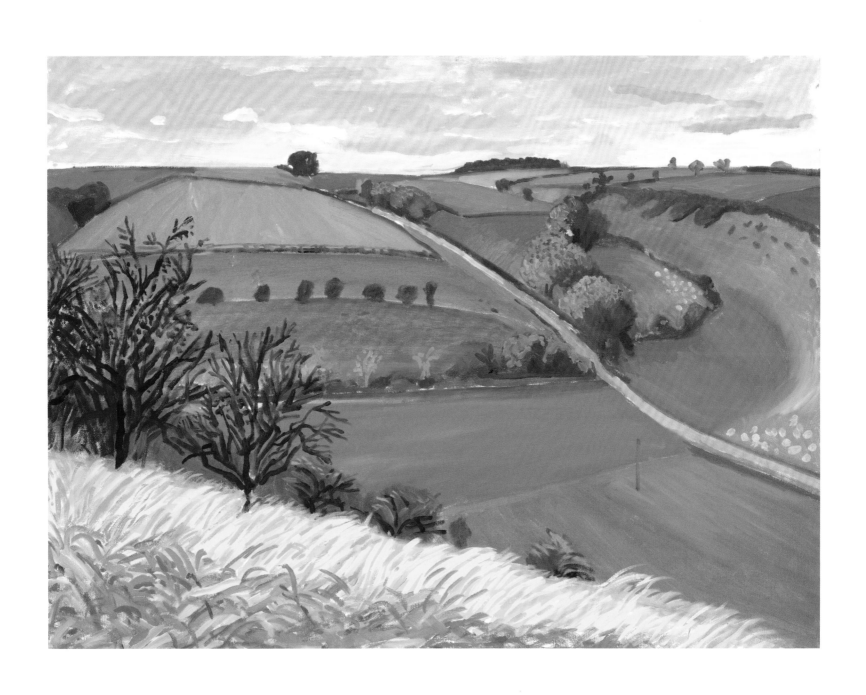

73 | FRIDAYTHORPE VALLEY, 25 OCTOBER 2005
Oil on canvas, 36 × 48 in. (91.4 × 121.9 cm)

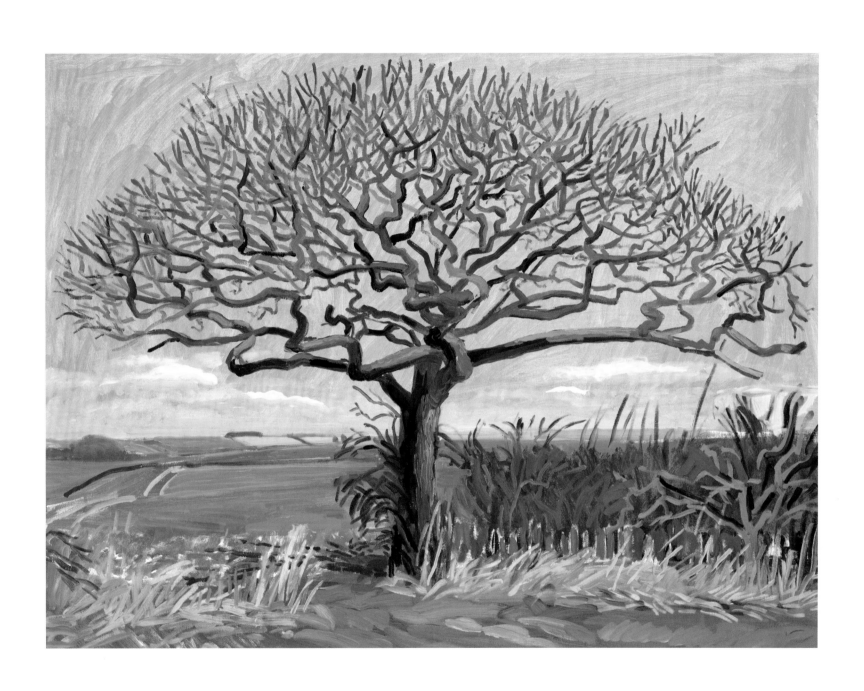

| TREE ON WOLDGATE, 6 MARCH, 2006
Oil on canvas, 36 × 48 in. (91.4 × 121.9 cm)

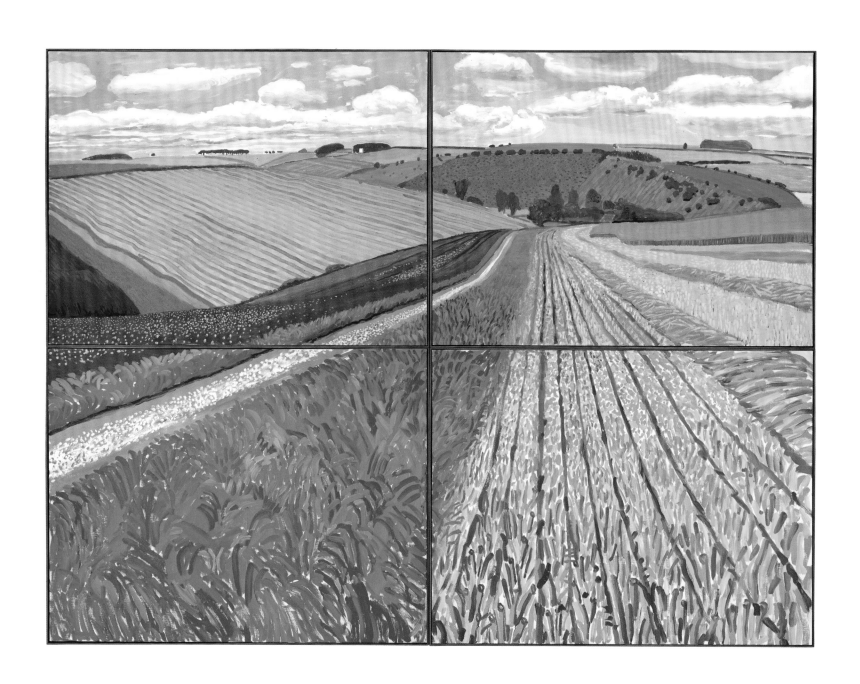

75 | VISTA NEAR FRIDAYTHORPE, AUG, SEPT 2006
Oil on 4 canvases, 72 × 96 in. (182.9 × 243.8 cm)

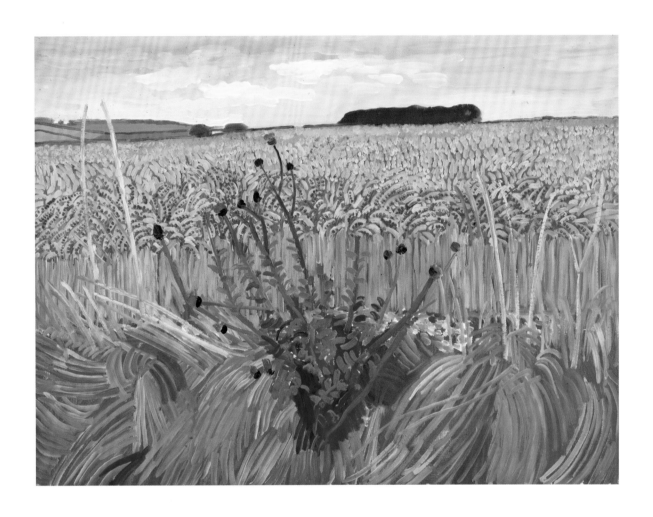

WHEAT FIELD BEYOND THE TUNNEL, 16 AUGUST 2006
Oil on canvas, 36 × 48 in. (91.4 × 121.9 cm)

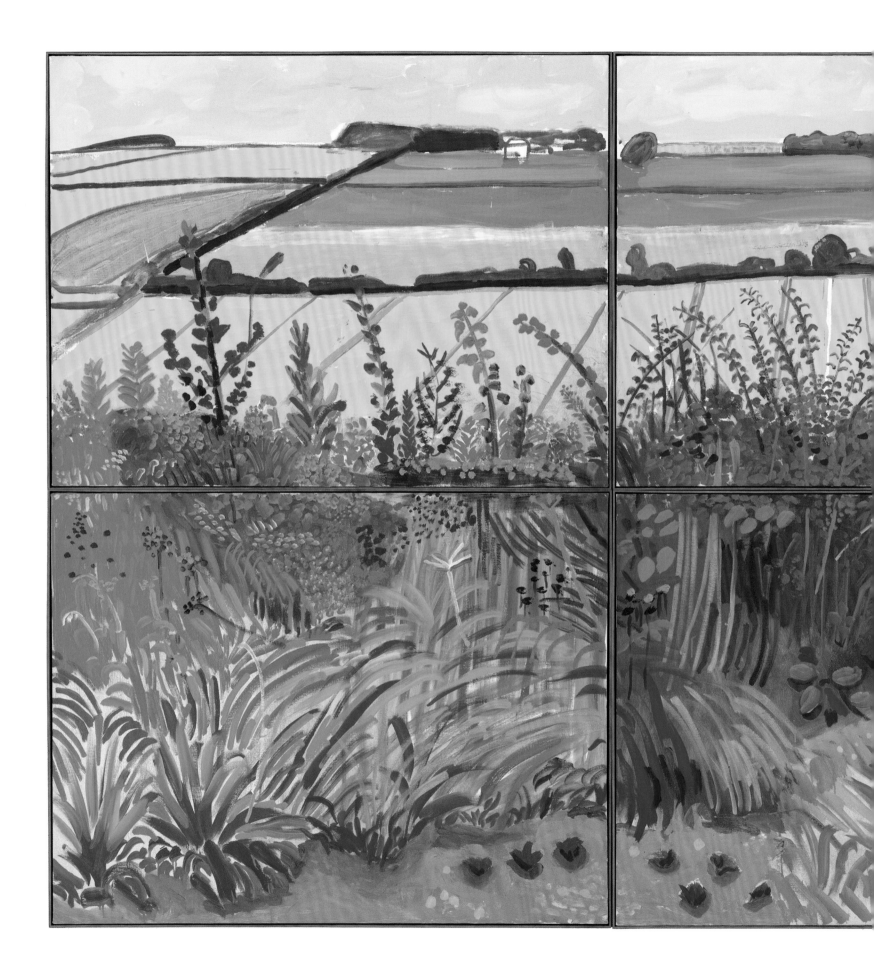

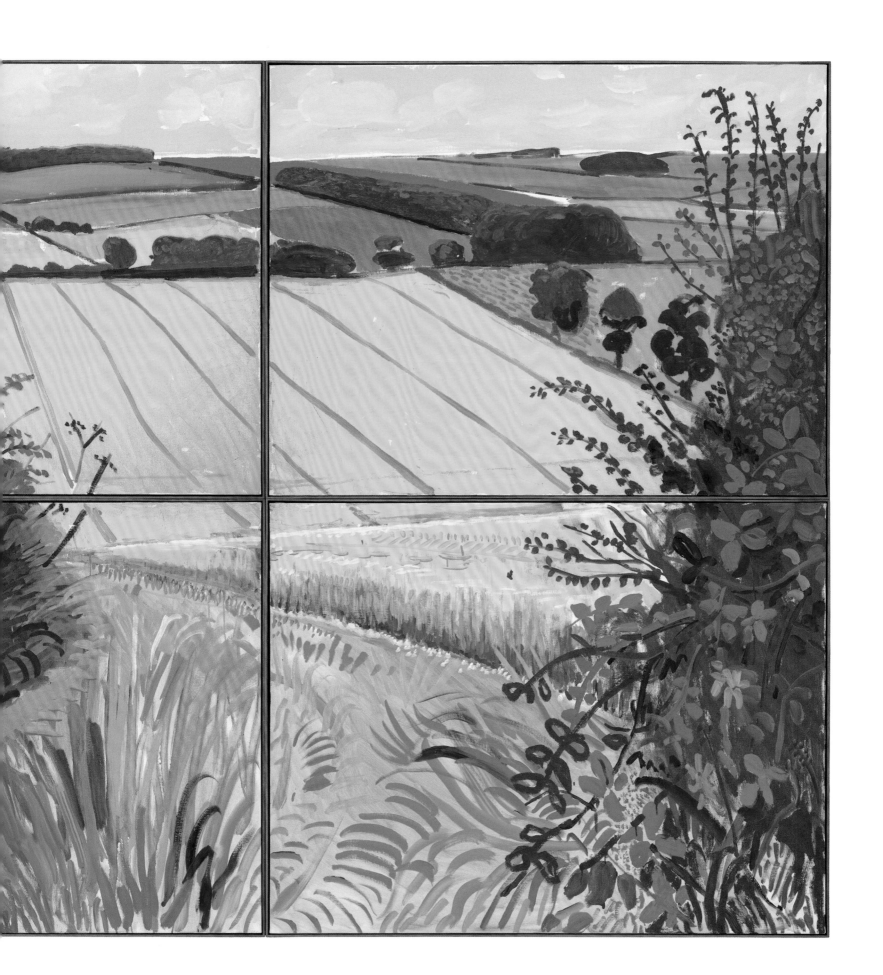

77 | THE ROAD TO THWING, JULY, 2006

Oil on 6 canvases, 72 × 144 in. (182.9 × 365.8 cm)

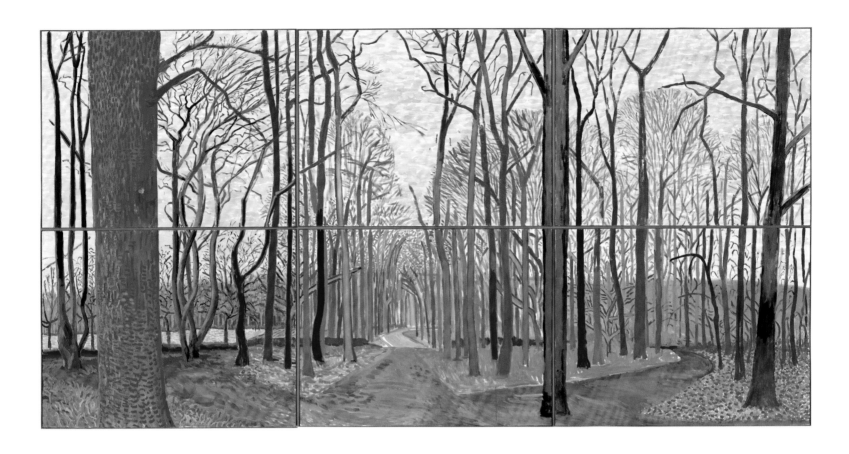

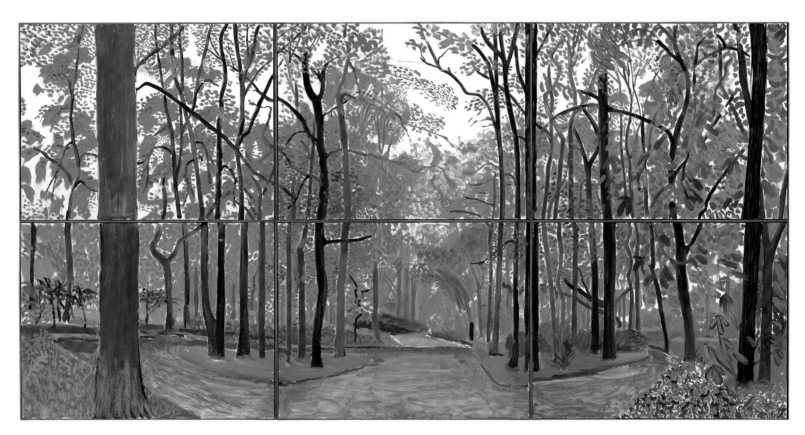

78 | WOLDGATE WOODS, 30 MARCH–21 APRIL 2006
Oil on 6 canvases, 72 × 144 in. (182.9 × 365.8 cm)

79 | WOLDGATE WOODS III, 20 & 21 MAY 2006
Oil on 6 canvases, 72 × 144 in. (182.9 × 365.8 cm)

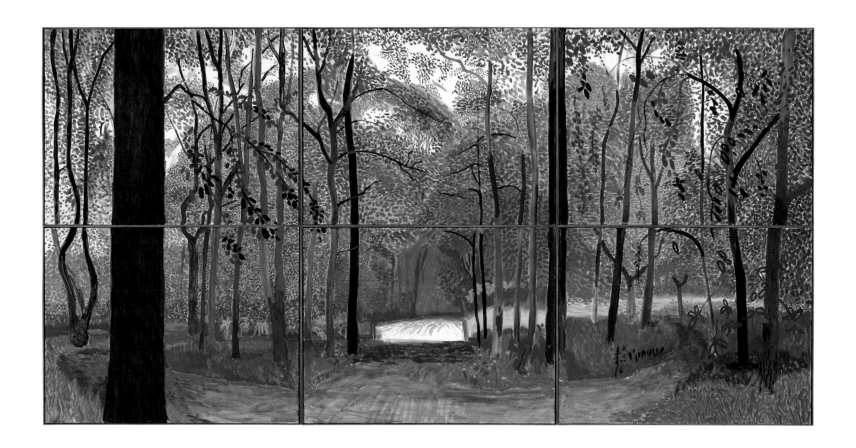

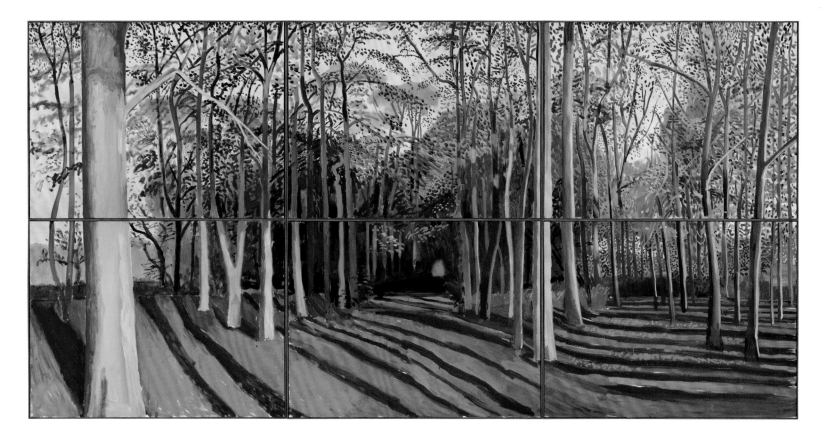

80 | WOLDGATE WOODS, 26, 27 & 30 JULY 2006
Oil on 6 canvases, 72 × 144 in. (182.9 × 365.8 cm)

81 | WOLDGATE WOODS, 6 & 9 NOVEMBER 2006
Oil on 6 canvases, 72 × 144 in. (182.9 × 365.8 cm)

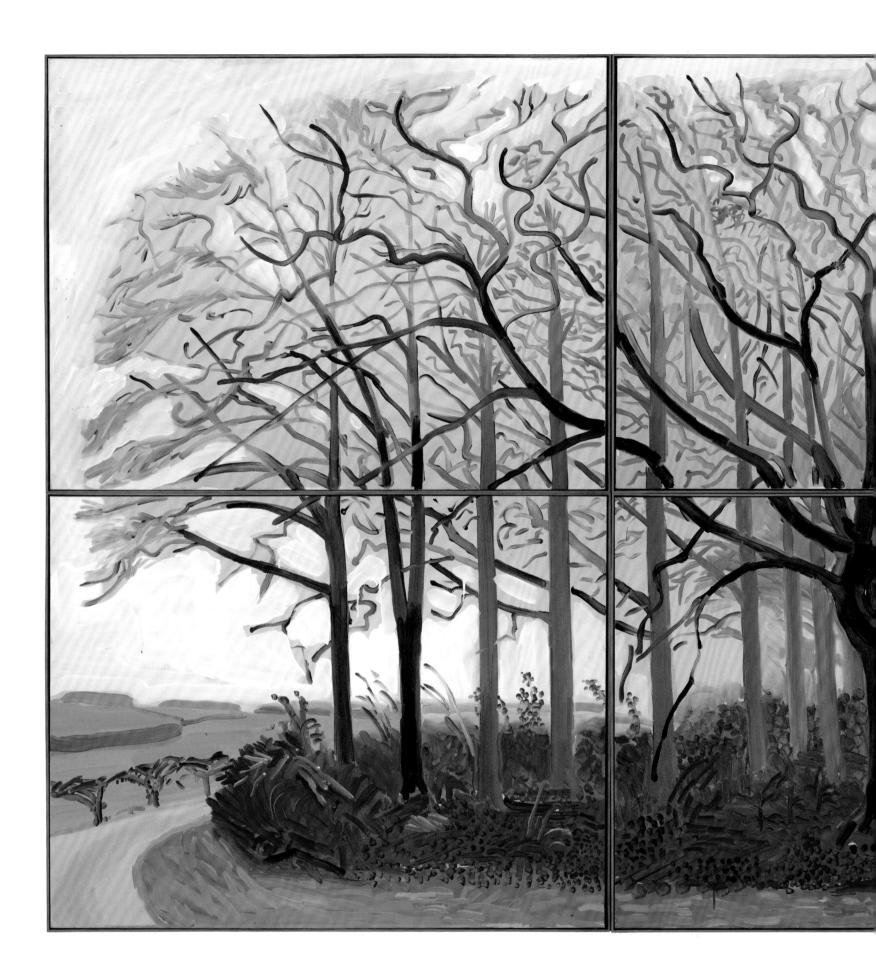

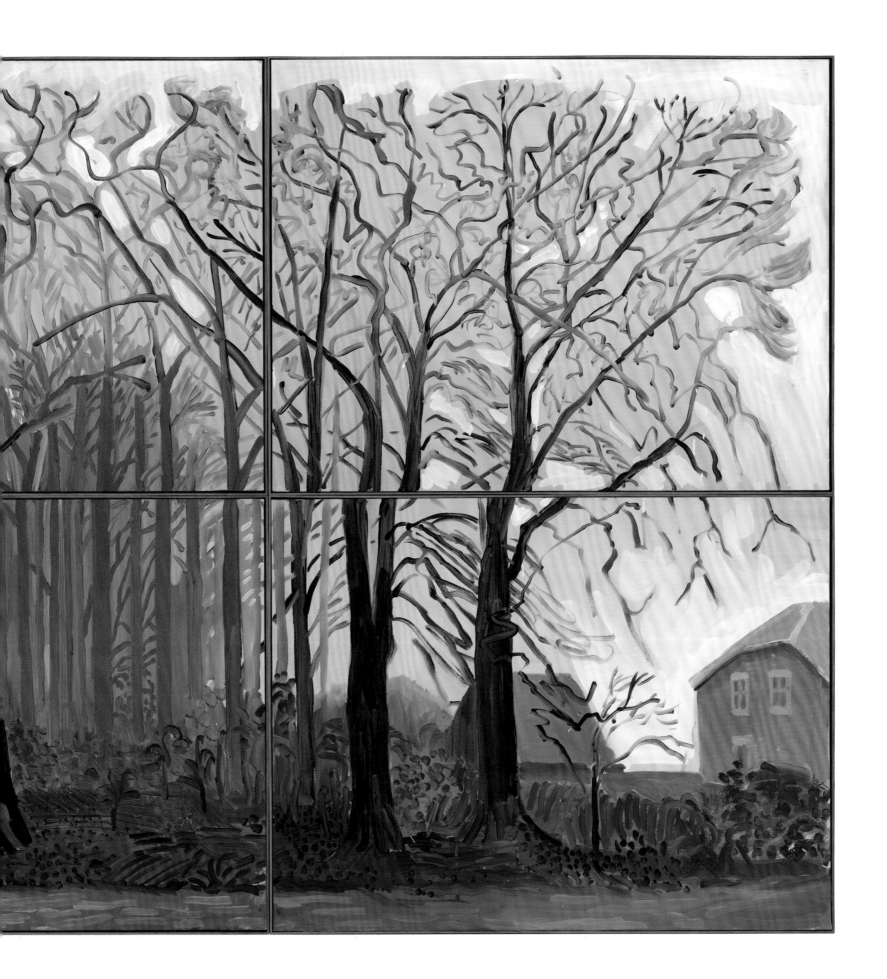

SIX-PART STUDY FOR "BIGGER TREES," 2007
Oil on 6 canvases, 72 × 144 in. (182.9 × 365.8 cm)

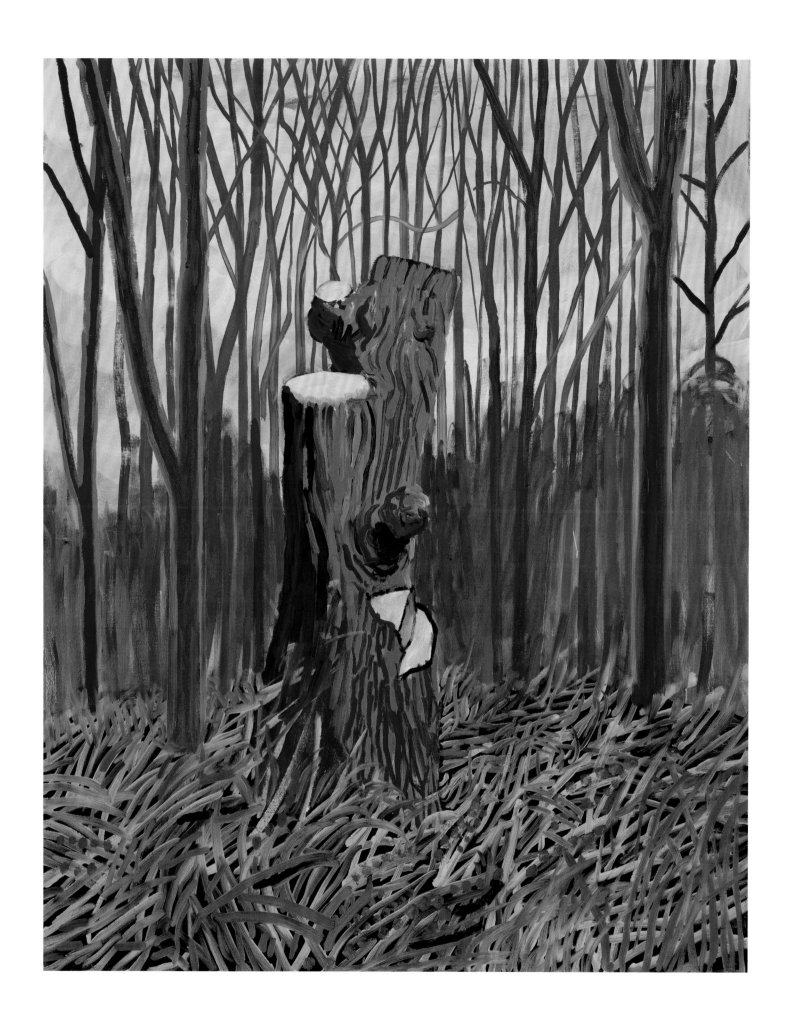

83 | THE SECOND TOTEM TREE, 2008
Oil on canvas, 60 × 48 in. (152.4 × 121.9 cm)

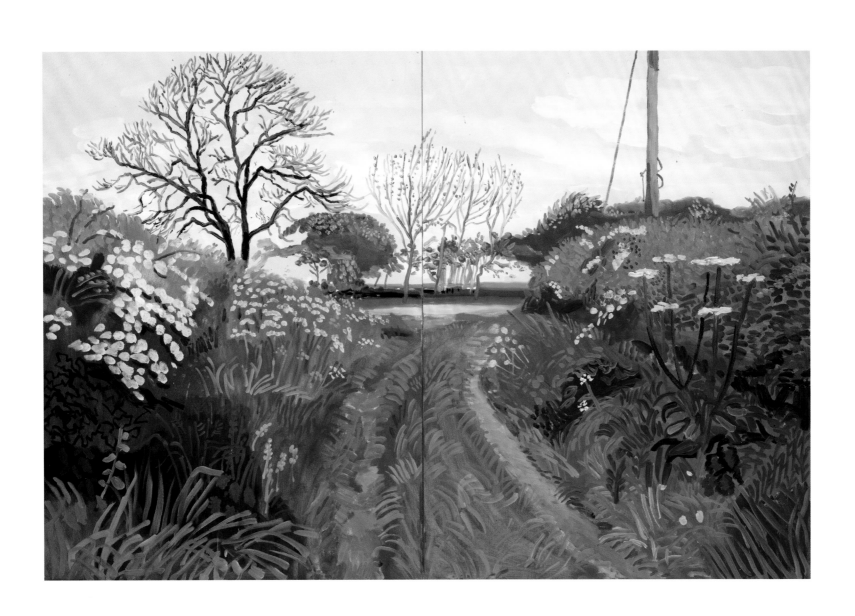

84 | WOLDGATE LANE TO BURTON AGNES, 2007
Oil on 2 canvases, 48 × 72 in. (121.9 × 182.9 cm)

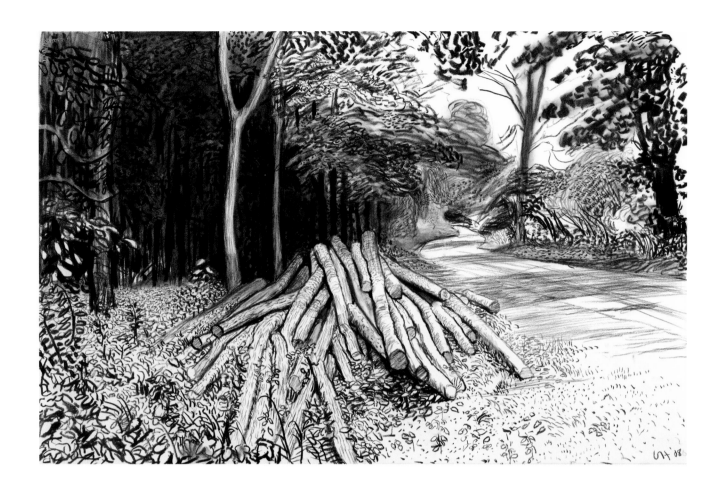

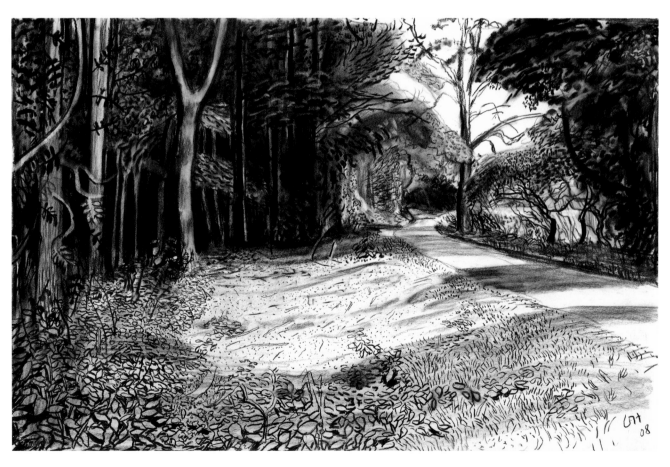

85 | CUT TREES—TIMBER, 2008
Charcoal on paper, 26 × 40¼ in. (66 × 102.2 cm)

86 | TIMBER GONE, 2008
Charcoal on paper, 26 × 40¼ in. (66 × 102.2 cm)

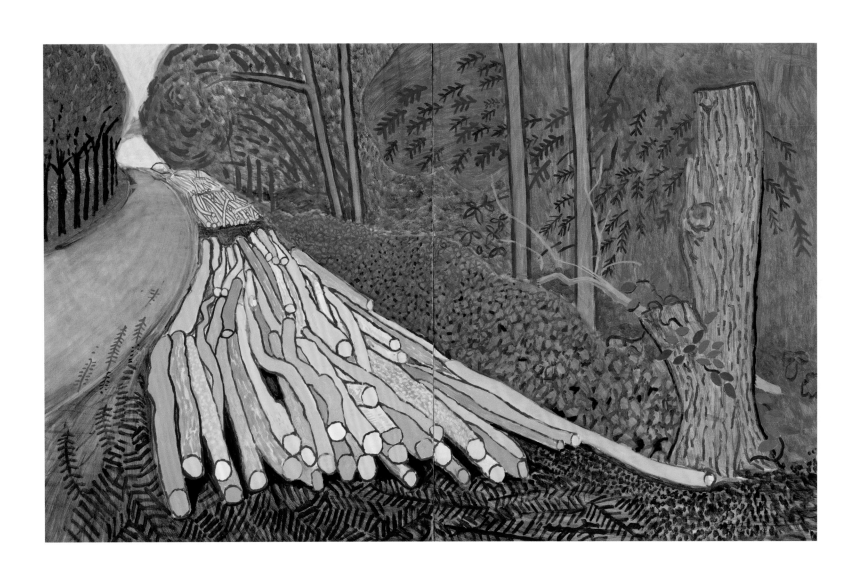

Oil on 2 canvases, 60 × 96 in. (152.4 × 243.8 cm)

88 | HAWTHORN BLOSSOM ON THE B1253, 31 MAY 08, 2008
Oil on canvas, 30 × 96 in. (76.2 × 243.8 cm)

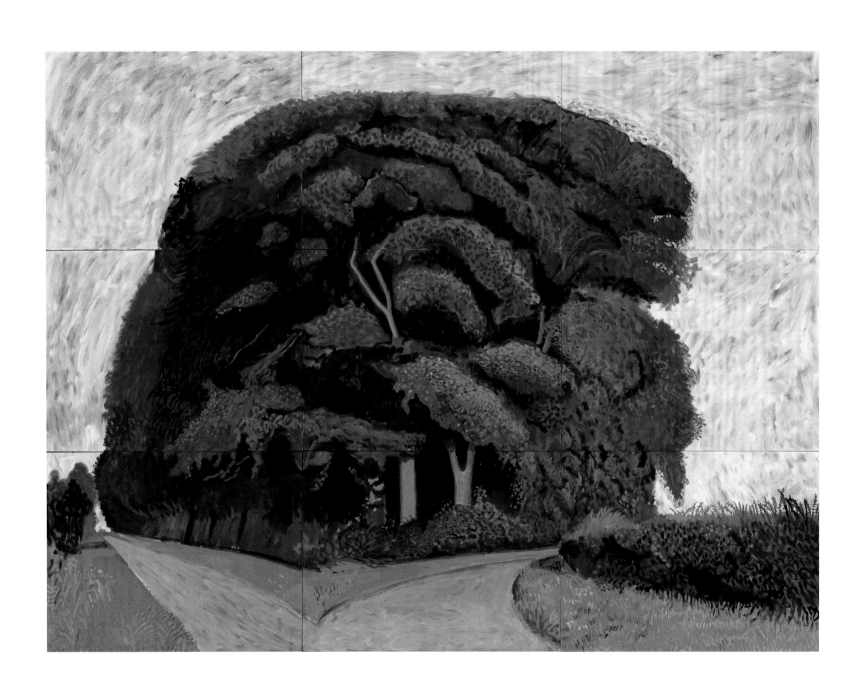

89 | BIGGER TREES NEARER WARTER, SUMMER 2008
Oil on 9 canvases, 108 × 144 in. (274.3 × 365.8 cm)

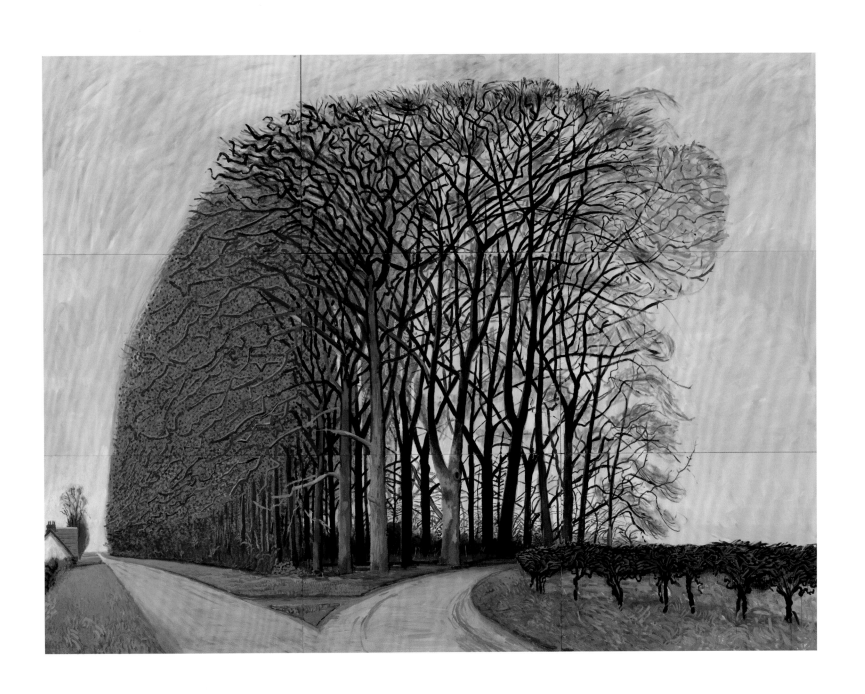

90 | BIGGER TREES NEARER WARTER, WINTER 2008

Oil on 9 canvases, 108 × 144 in. (274.3 × 365.8 cm)

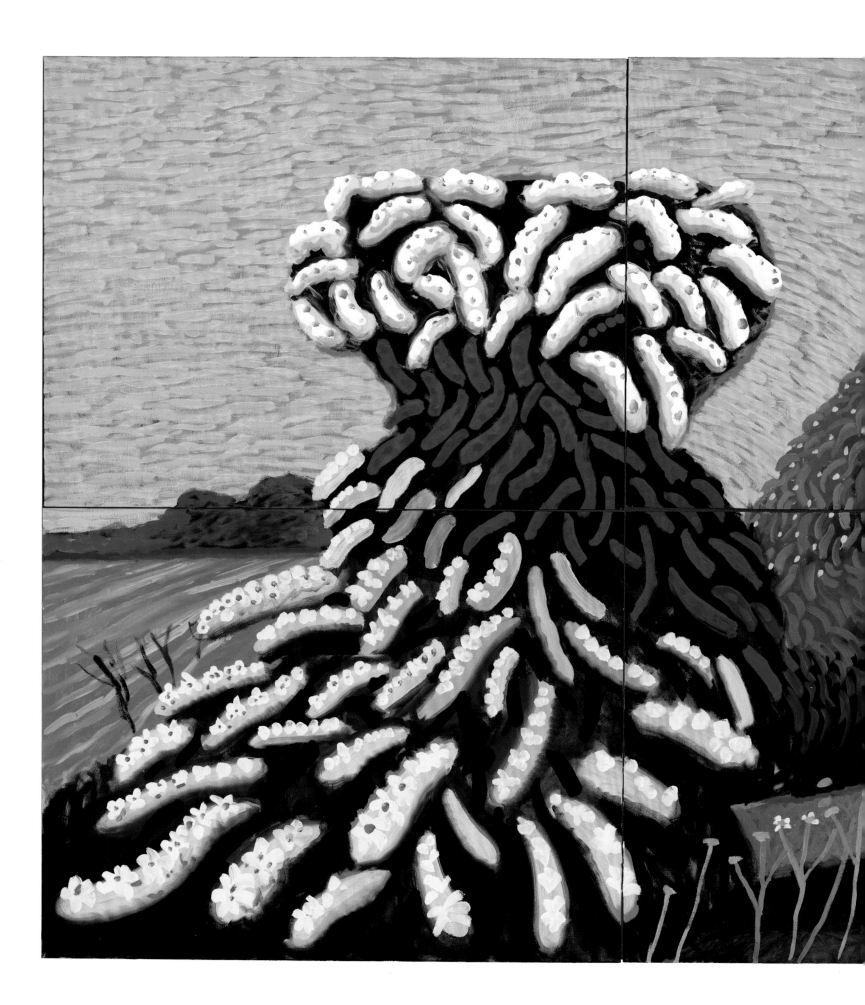

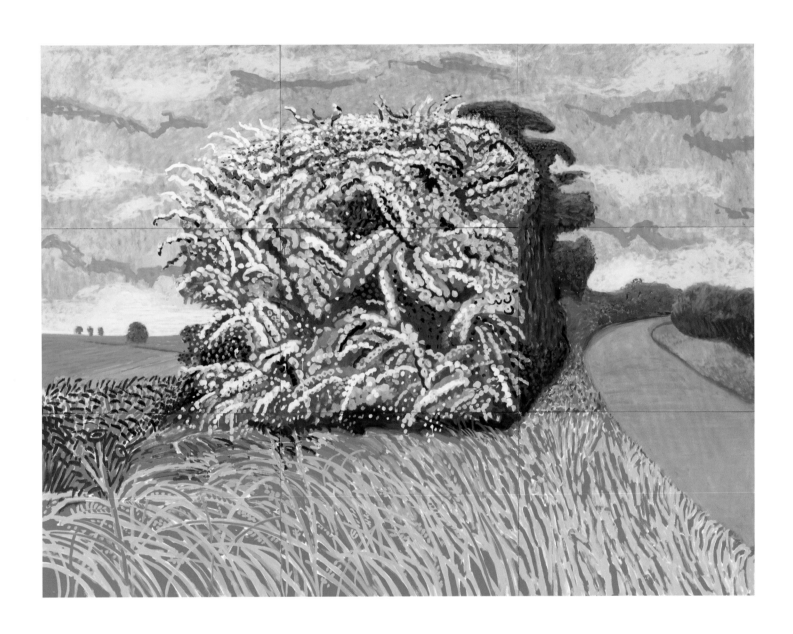

92 | THE BIG HAWTHORN, 2008
Oil on 9 canvases, 108 × 144 in. (274.3 × 365.8 cm)

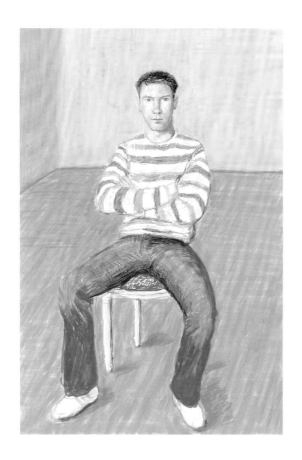

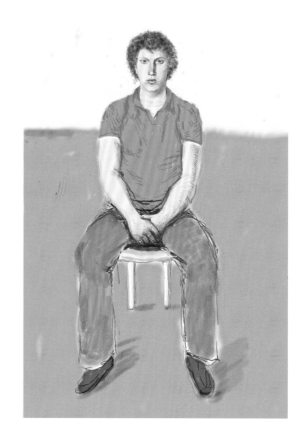

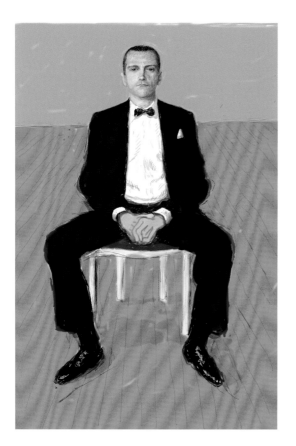

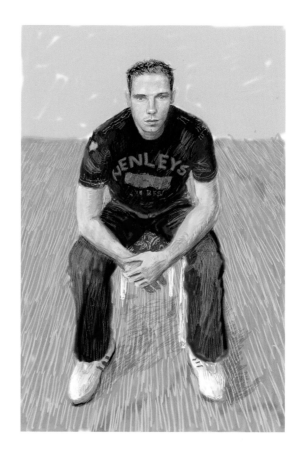

93 | A BIGGER JAMIE McHALE 1, 2008
Inkjet-printed computer drawing on paper, mounted on Dibond,
63 ⅞ × 42 ⅞ in. (162.2 × 108.9 cm)

94 | A BIGGER DOMINIC ELLIOTT, 2008
Inkjet-printed computer drawing on paper, mounted on Dibond,
63 ⅞ × 42 ⅞ in. (162.2 × 108.9 cm)

95 | A BIGGER JEAN-PIERRE GONÇALVES DE LIMA, 2008
Inkjet-printed computer drawing on paper, mounted on Dibond,
63 ⅞ × 42 ⅞ in. (162.2 × 108.9 cm)

96 | A BIGGER JAMIE McHALE 2, 2008
Inkjet-printed computer drawing on paper, mounted on Dibond,
63 ⅞ × 42 ⅞ in. (162.2 × 108.9 cm)

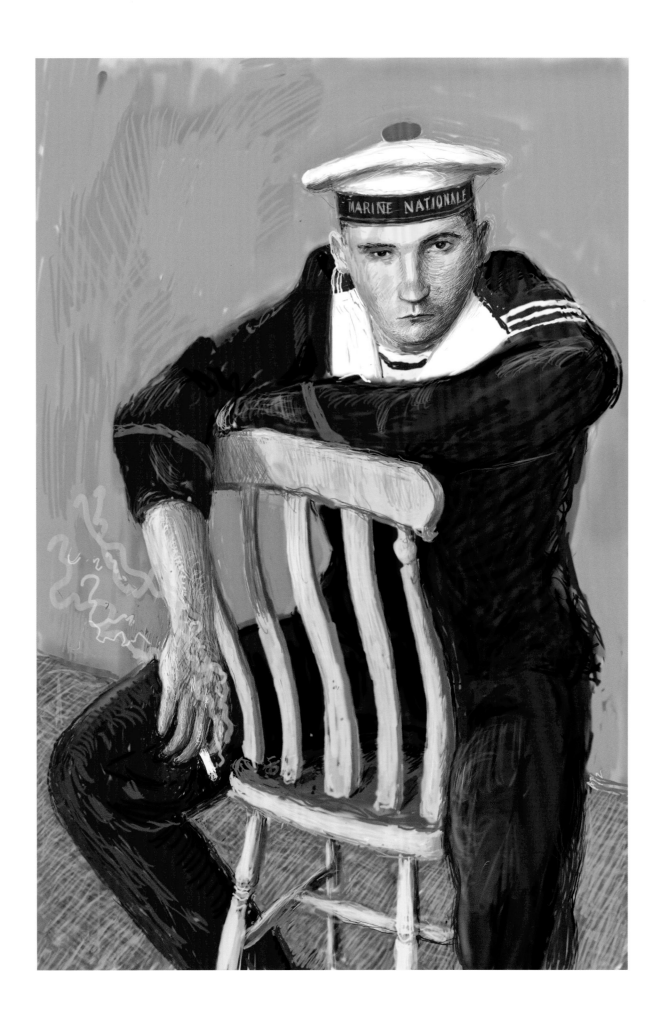

97 | A BIGGER MATELOT KEVIN DRUEZ 2, 2009

Inkjet-printed computer drawing on paper, mounted on Dibond, 63 ⅞ × 42 ⅞ in. (162.2 × 108.9 cm)

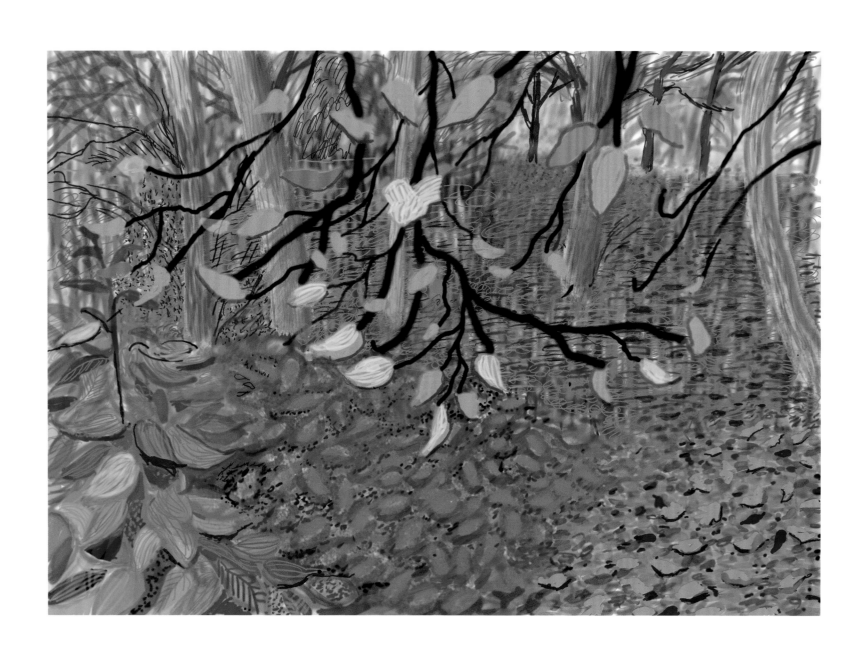

98 | AUTUMN LEAVES, 2008
Inkjet-printed computer drawing on 2 sheets of paper, mounted on Dibond,
60 ¾ × 85 ½ in. (154.3 × 217.2 cm)

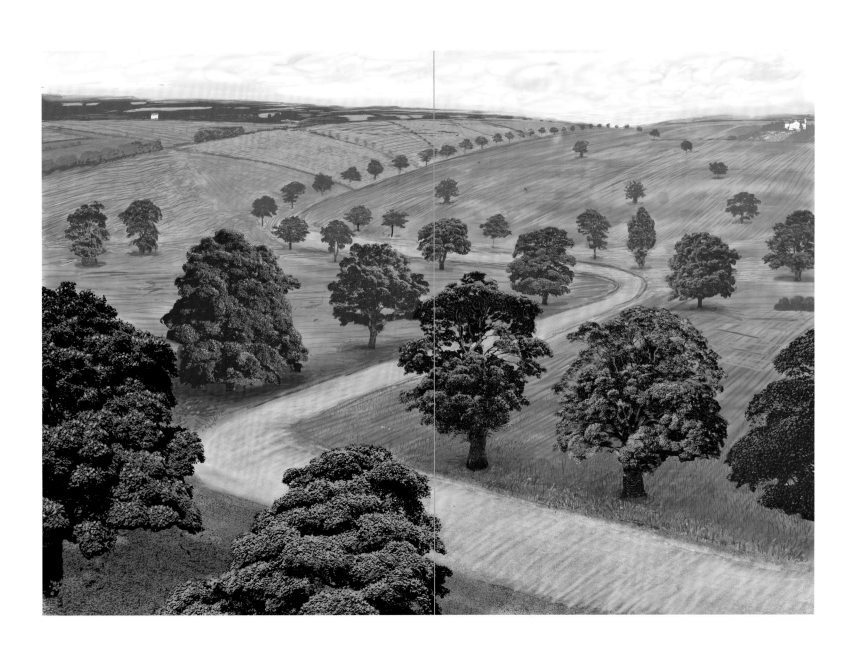

99 | A BIGGER GREEN VALLEY, 2008

Inkjet-printed computer drawing on 2 sheets of paper, mounted on Dibond,
60¾ × 85½ in. (154.3 × 217.2 cm)

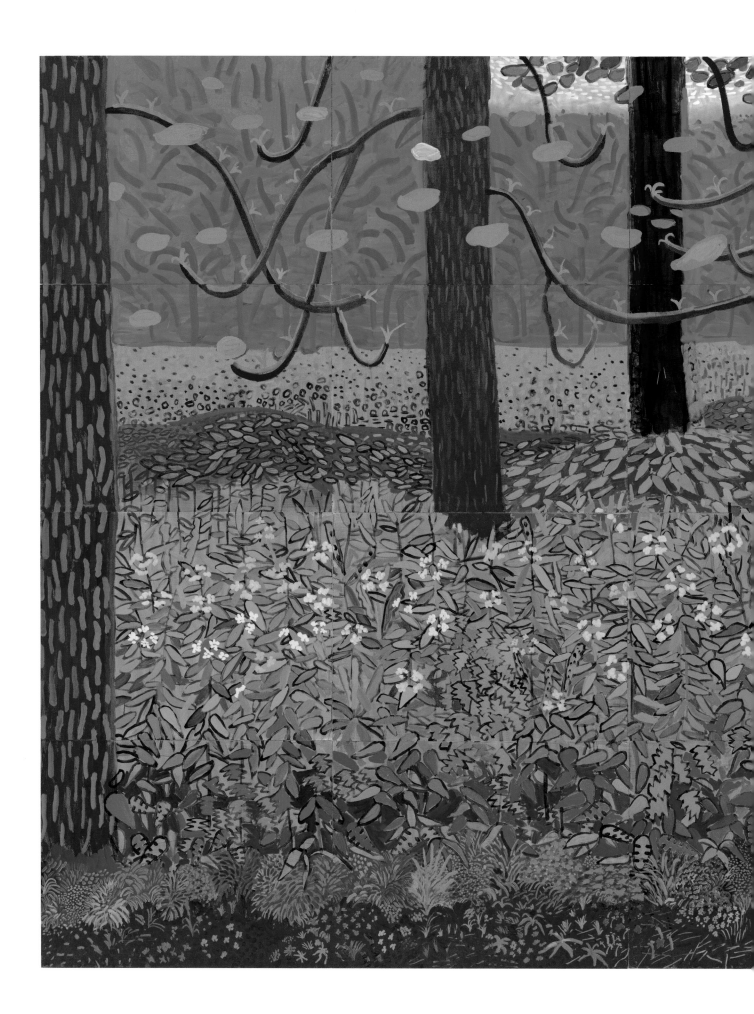

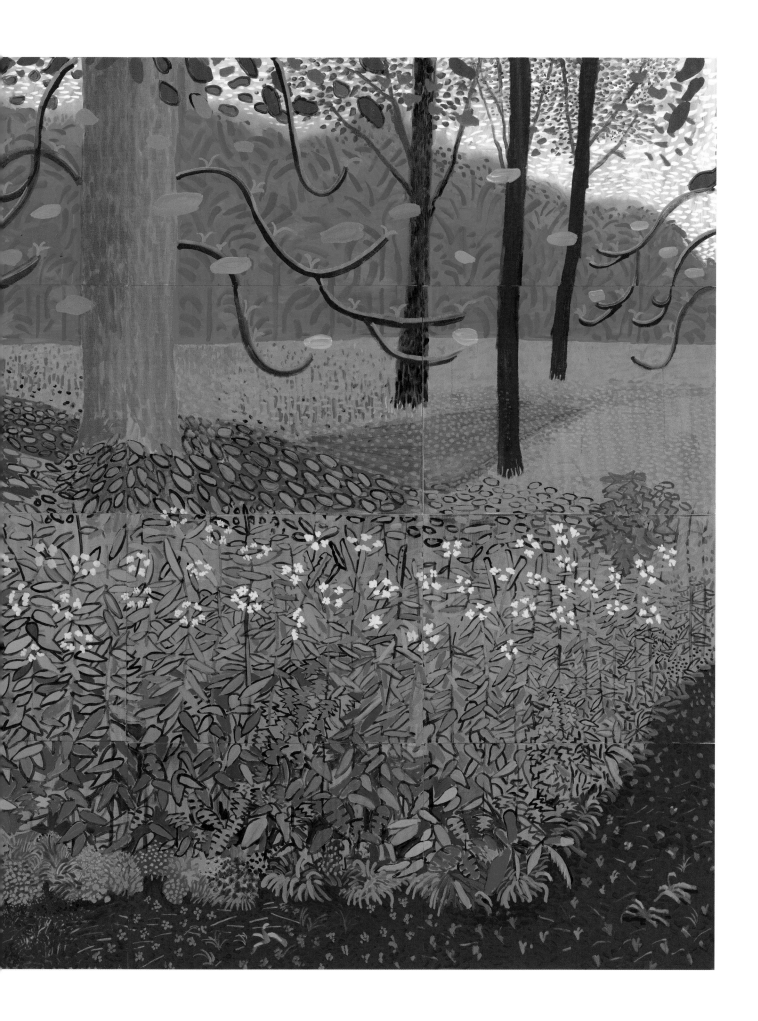

100 | UNDER THE TREES, BIGGER, 2010–2011

Oil on 20 canvases, 144 × 240 in. (365.8 × 609.6 cm)

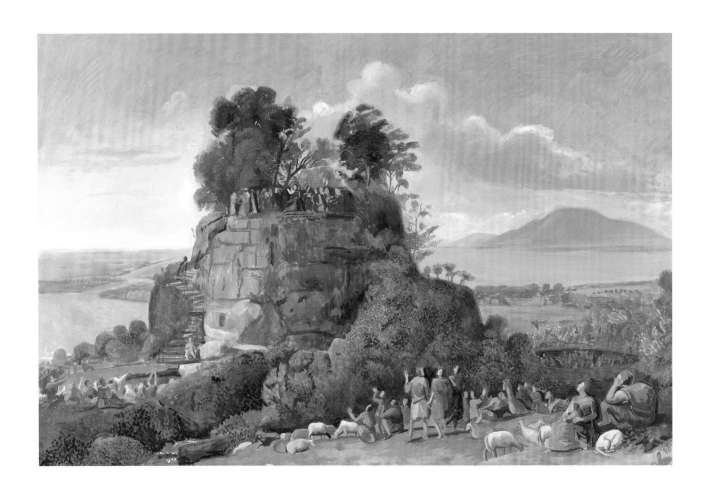

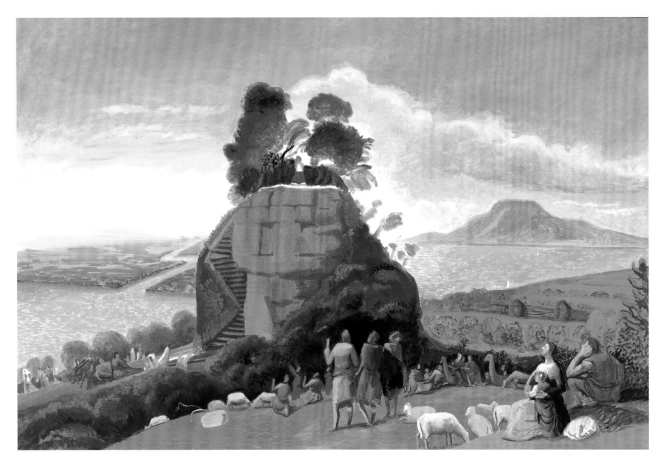

101 | THE SERMON ON THE MOUNT II (AFTER CLAUDE), 2010
Oil on canvas, 67½ × 102¼ in. (171.5 × 259.7 cm)

102 | THE SERMON ON THE MOUNT XI (AFTER CLAUDE), 2010
Oil on canvas, 67½ × 102¼ in. (171.5 × 259.7 cm)

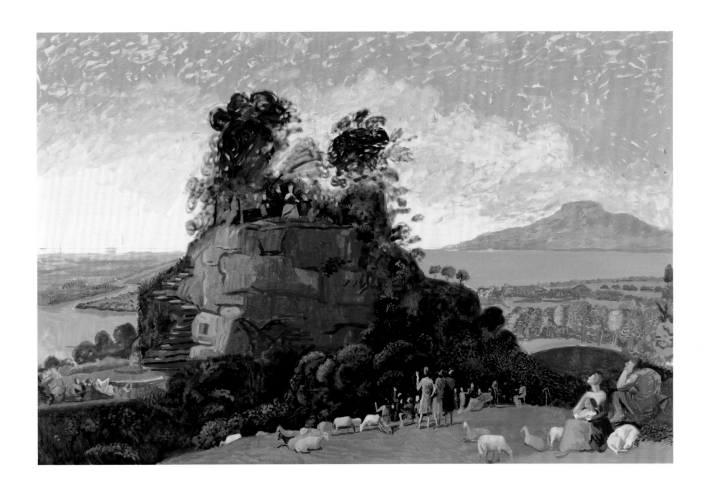

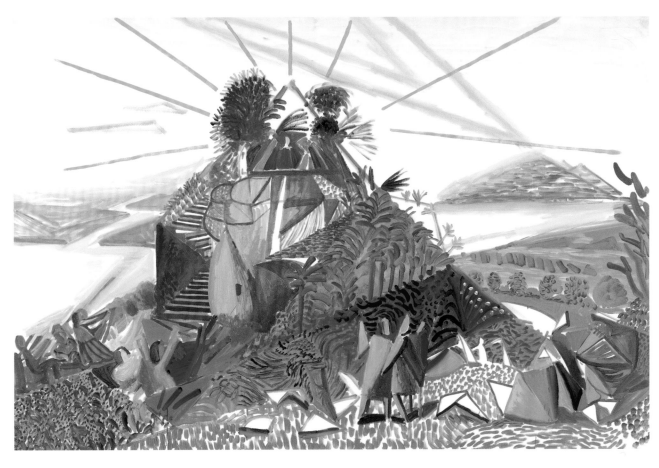

103 | THE SERMON ON THE MOUNT VI (AFTER CLAUDE), 2010 104 | THE SERMON ON THE MOUNT X (AFTER CLAUDE), 2010
Oil on canvas, 67 ½ × 102 ¼ in. (171.5 × 259.7 cm) Oil on canvas, 67 ½ × 102 ¼ in. (171.5 × 259.7 cm)

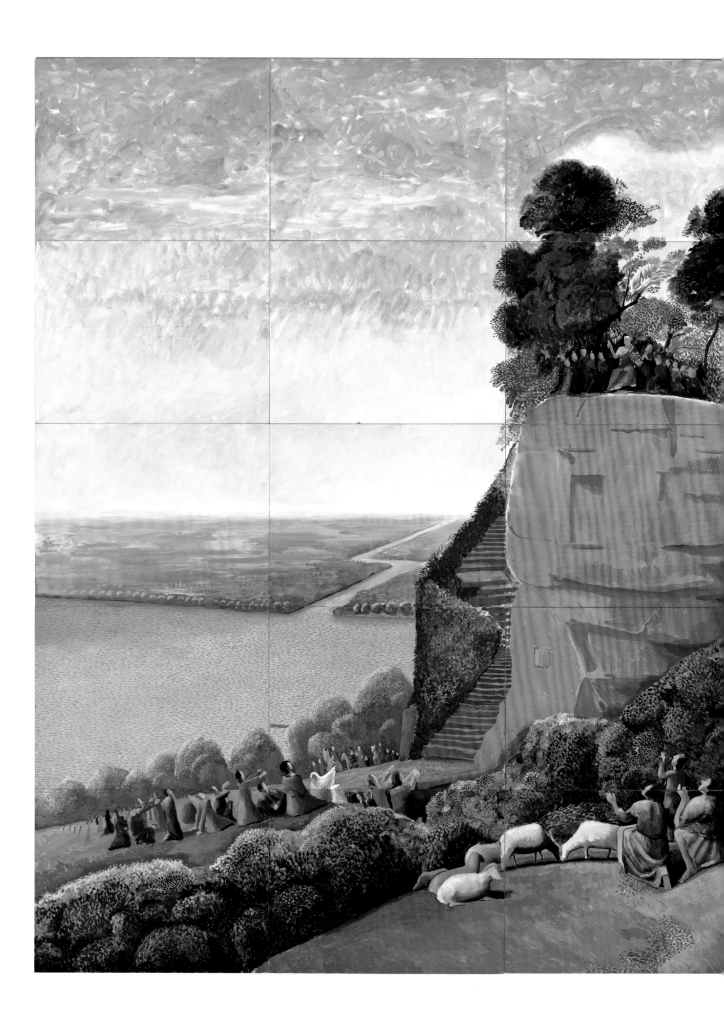

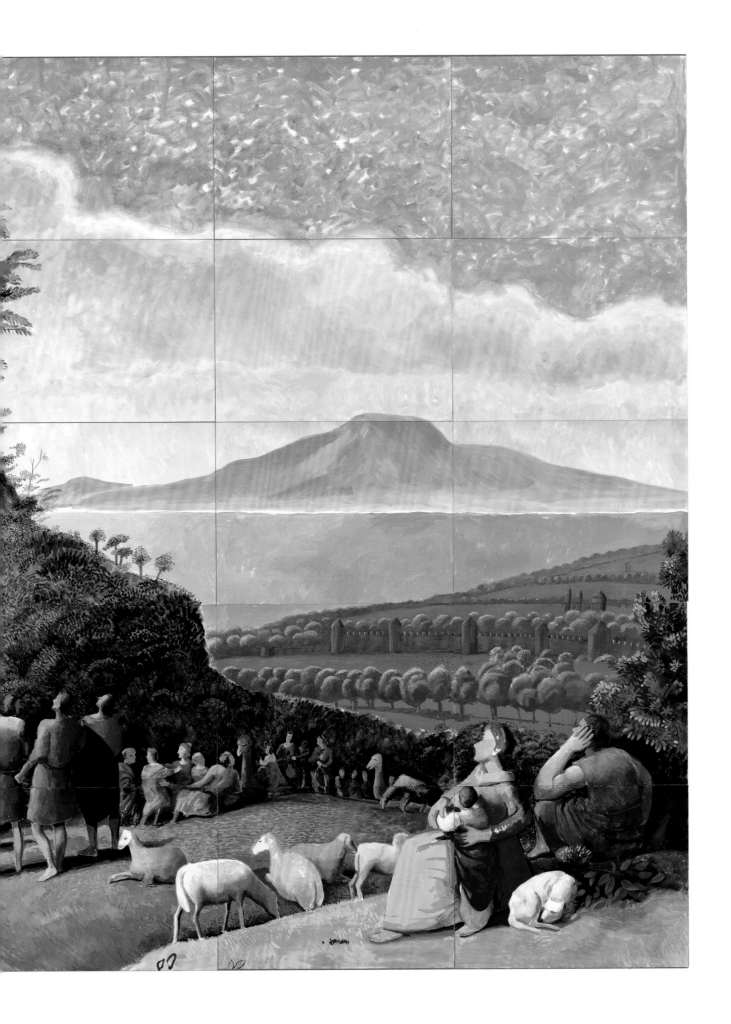

105 | A BIGGER MESSAGE, 2010

Oil on 30 canvases, 180 × 288 in. (457.2 × 731.5 cm)

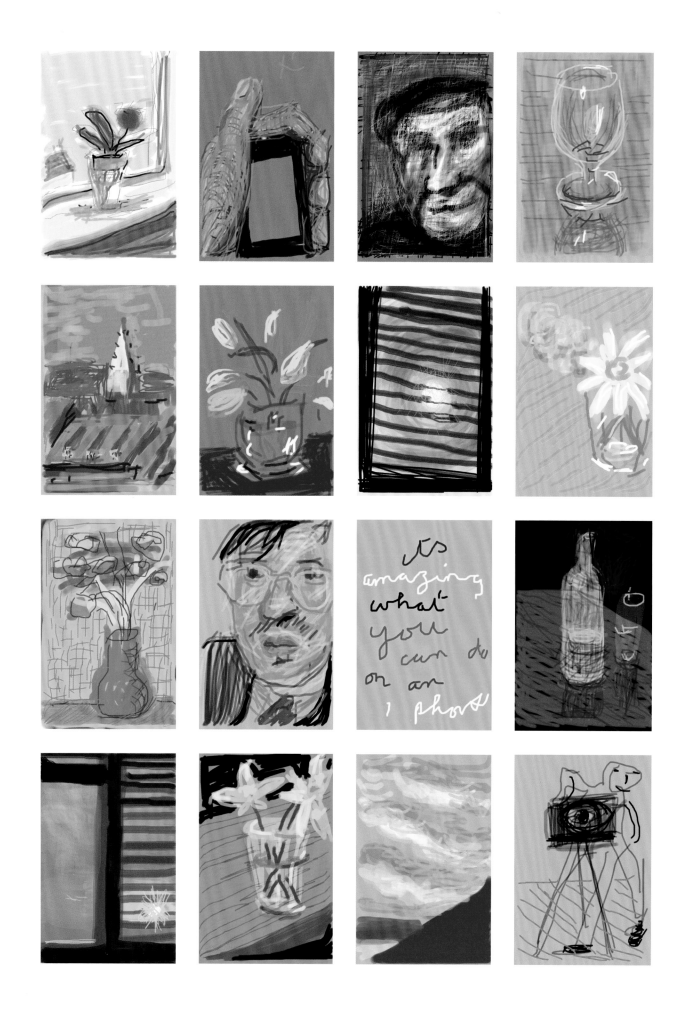

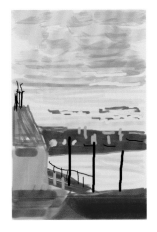

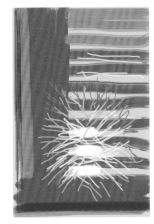
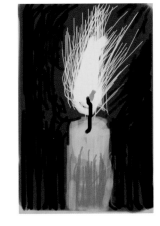

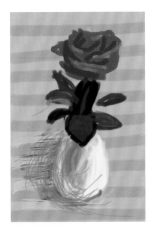

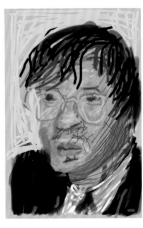
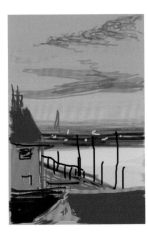
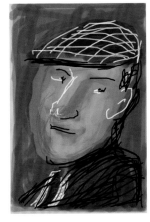

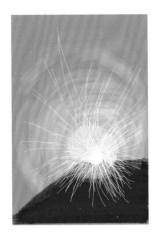
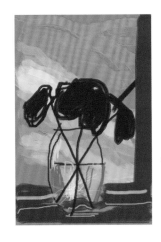
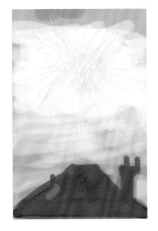
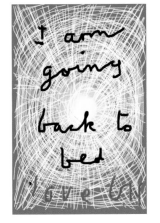

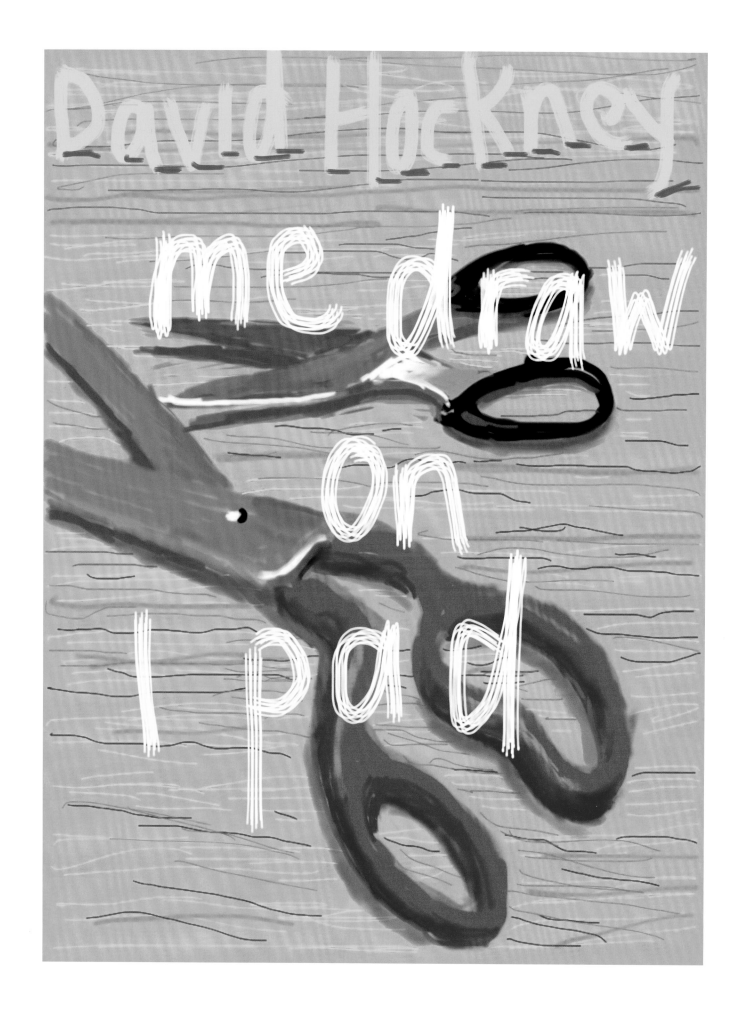

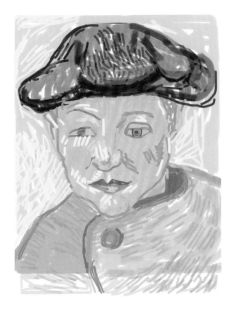

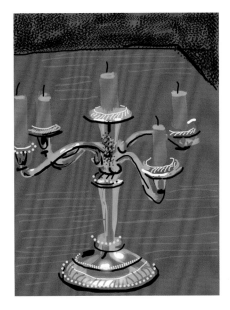

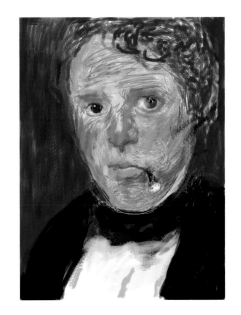

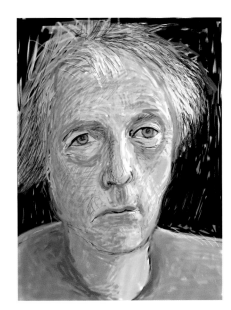

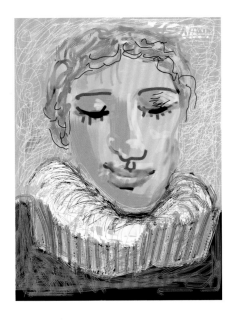

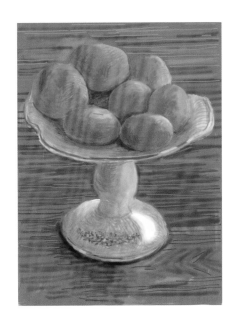

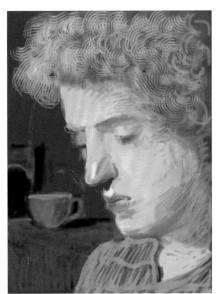

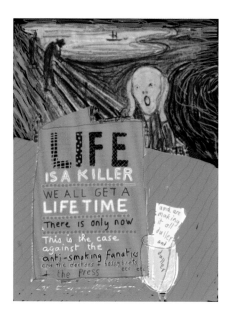

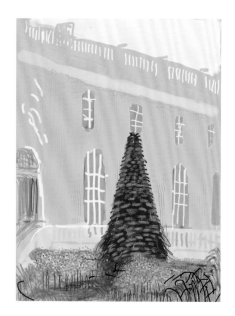

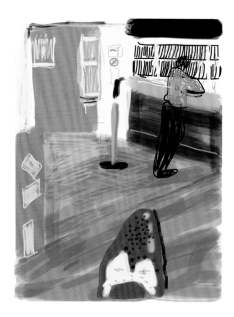

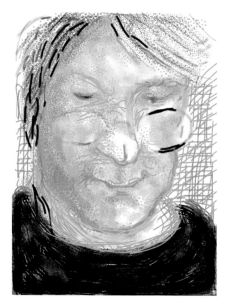

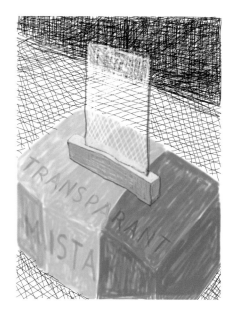

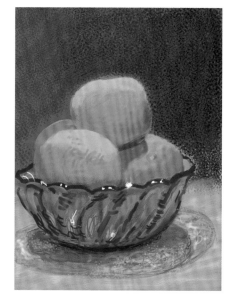

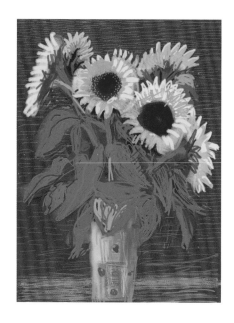

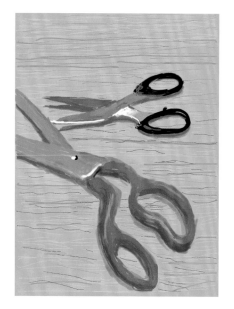

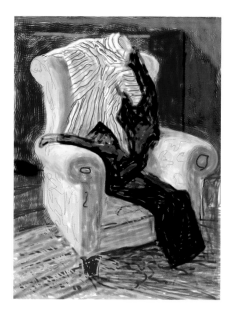

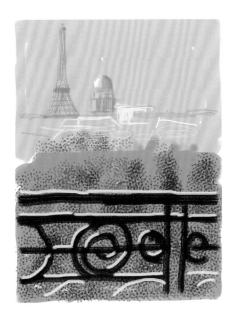

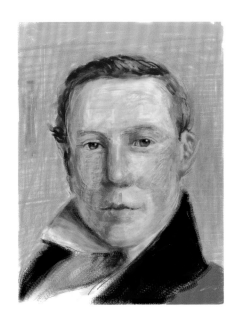

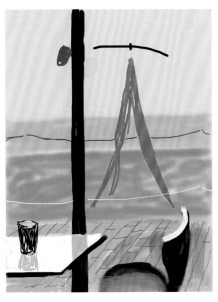

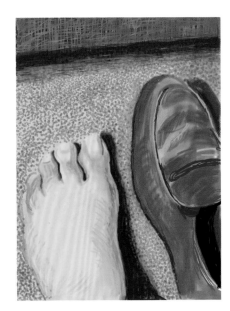

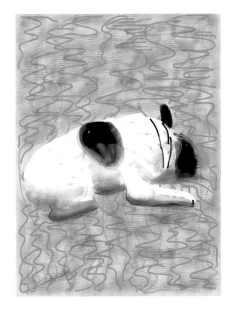

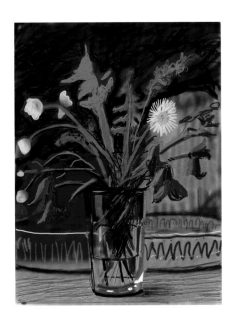

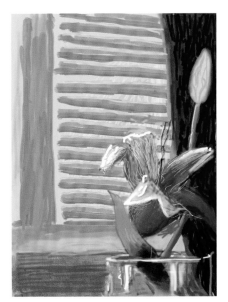

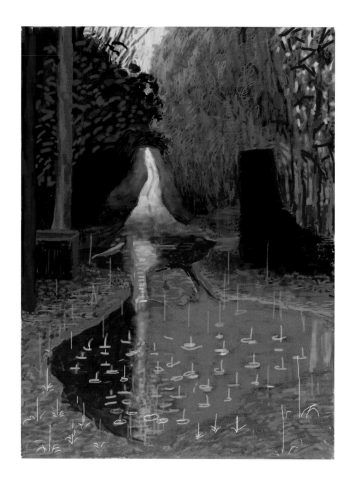

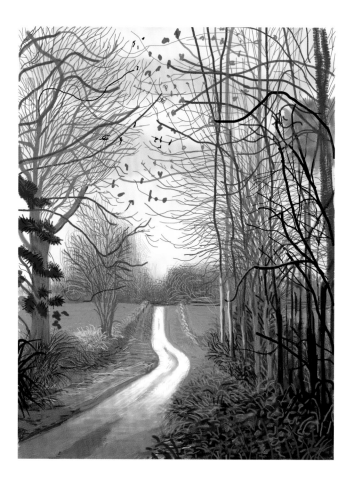

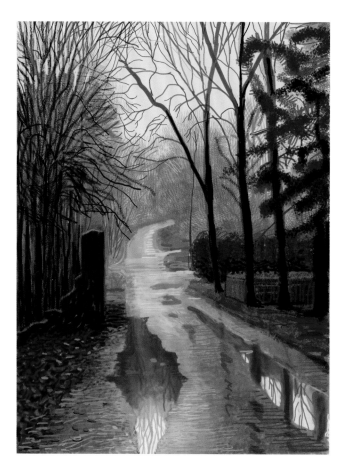

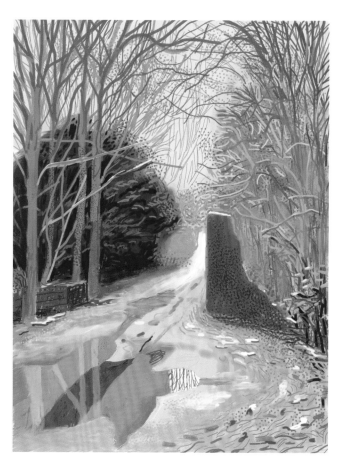

166 | 18 DECEMBER 167 | 29 DECEMBER 168 | 29 DECEMBER 169 | 2 JANUARY

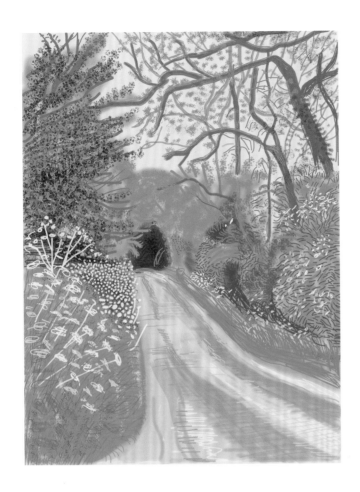

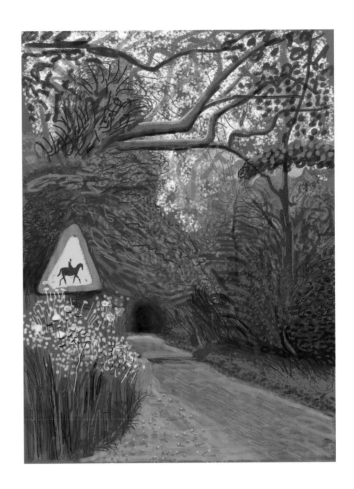

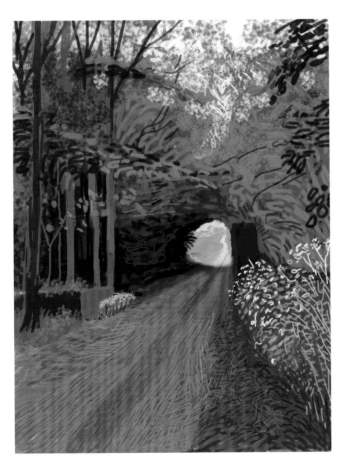

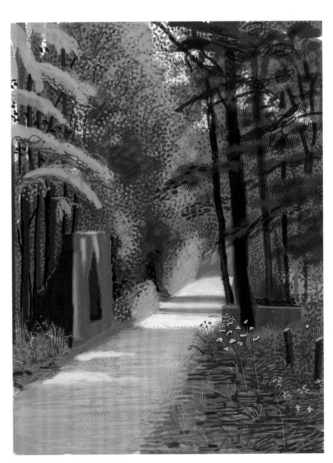

174 | **16 MAY** 175 | **30 MAY** 176 | **31 MAY** 177 | **2 JUNE**

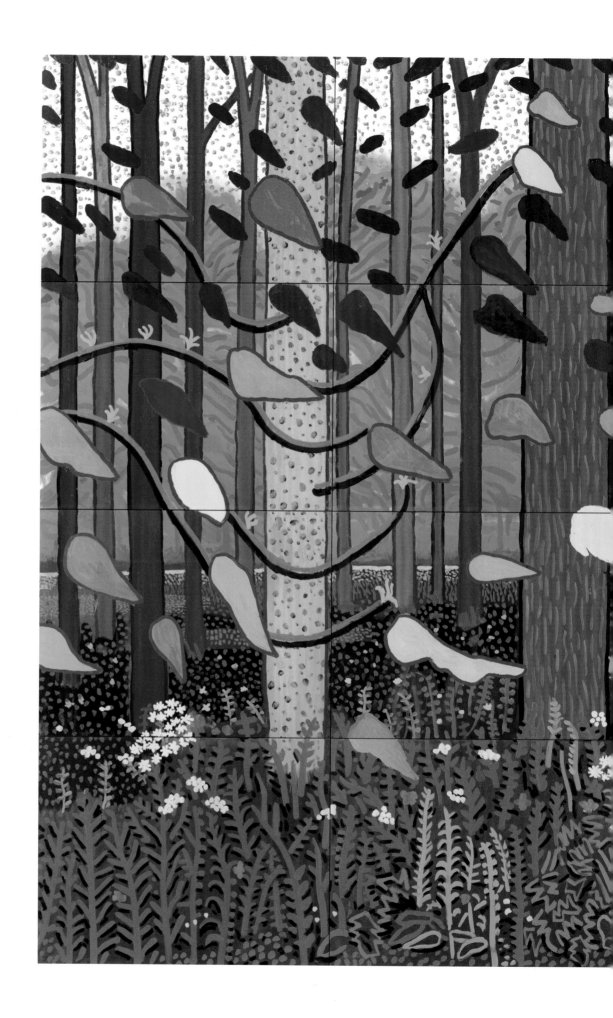

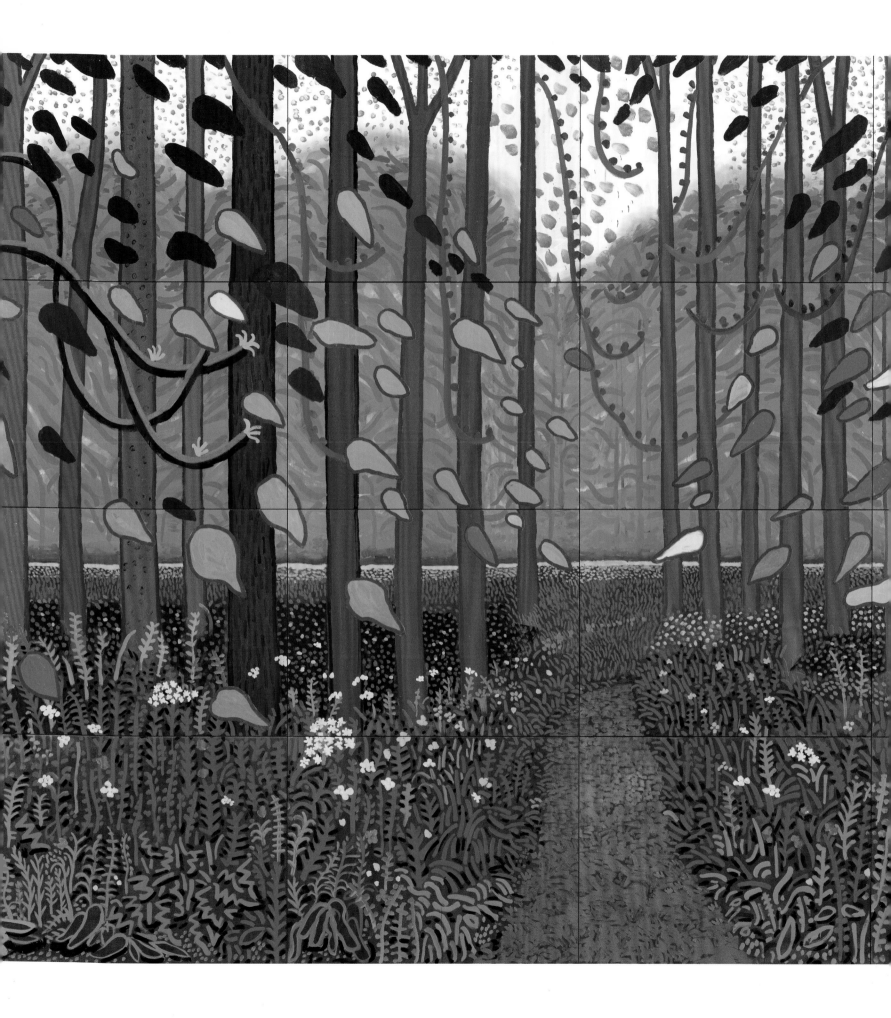

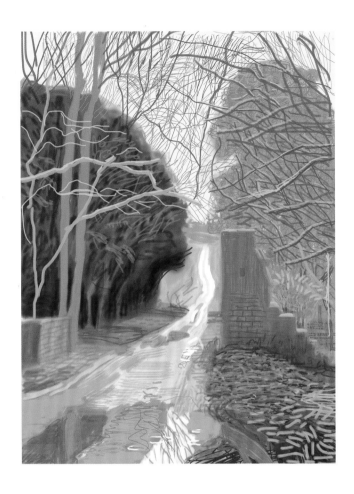

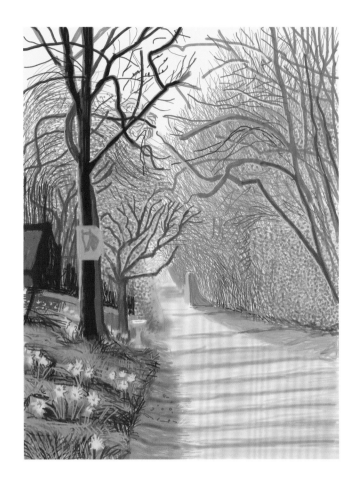

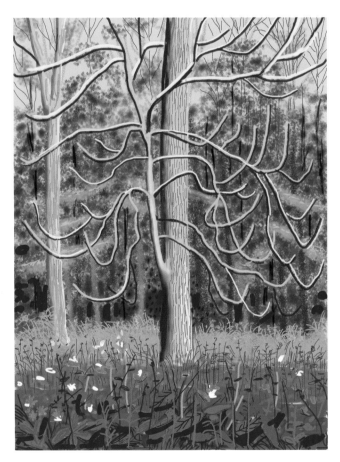

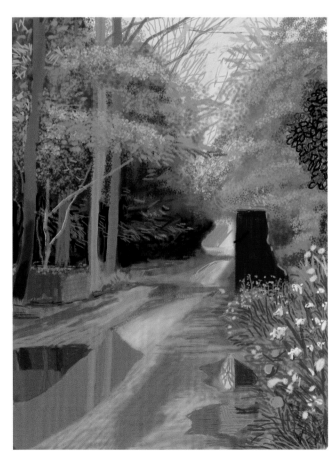

170 | **29 JANUARY** 171 | **25 MARCH** 172 | **4 MAY** 173 | **11 MAY**

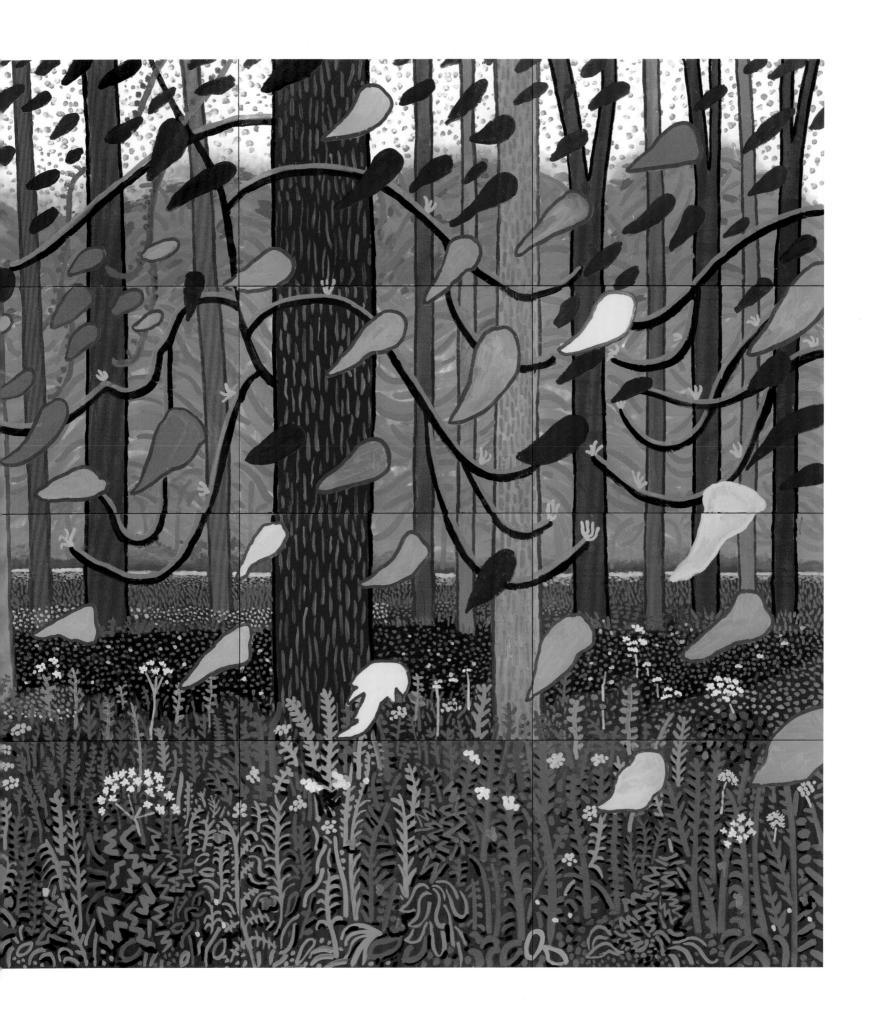

166-178 | THE ARRIVAL OF SPRING IN WOLDGATE, EAST YORKSHIRE IN 2011 (TWENTY ELEVEN), VERSION 3, 2011-2013
13 parts: oil on 32 canvases and 12 iPad drawings each printed on 4 sheets of paper, mounted on Dibond, 144 × 384 in. (365.8 × 975.4 cm) (painting),
93 × 70 in. (236.2 × 177.8 cm) (drawings)

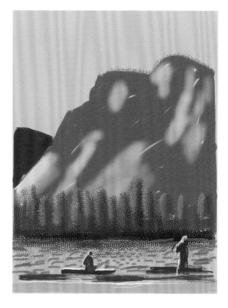
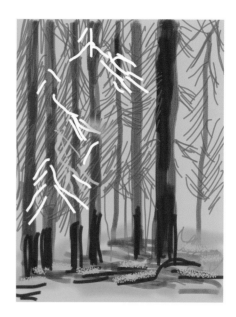
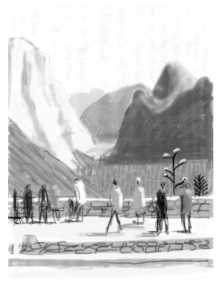
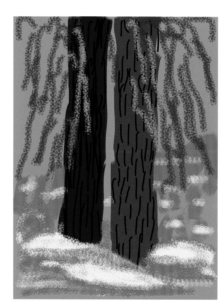
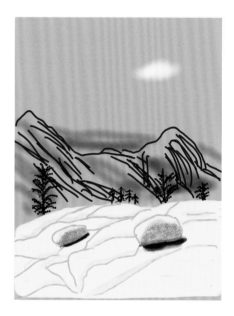
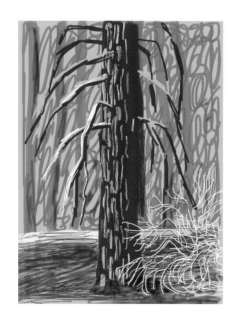
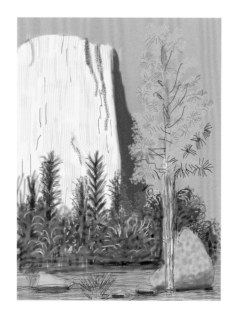
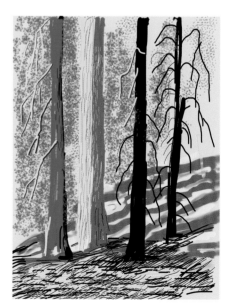

179–196 | iPAD DRAWINGS FROM THE YOSEMITE SUITE, 2010

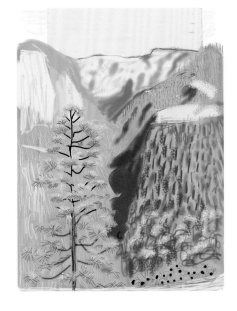 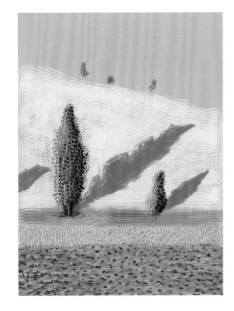 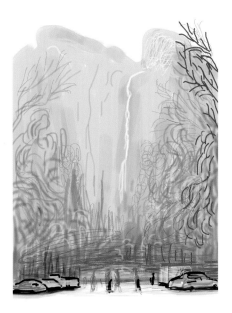

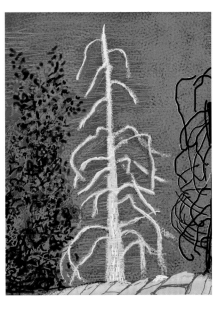 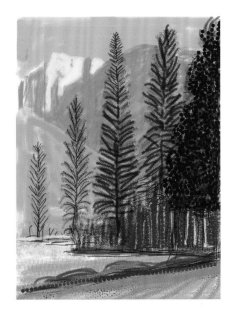 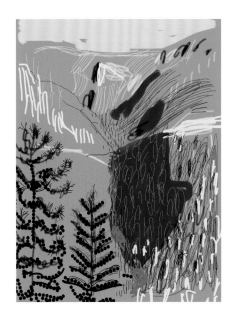

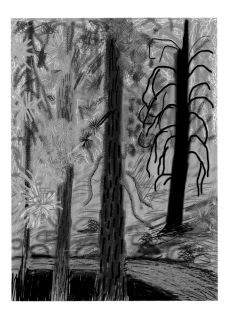 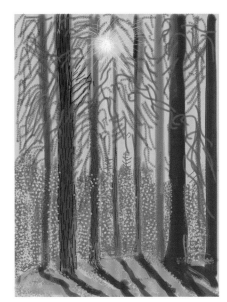

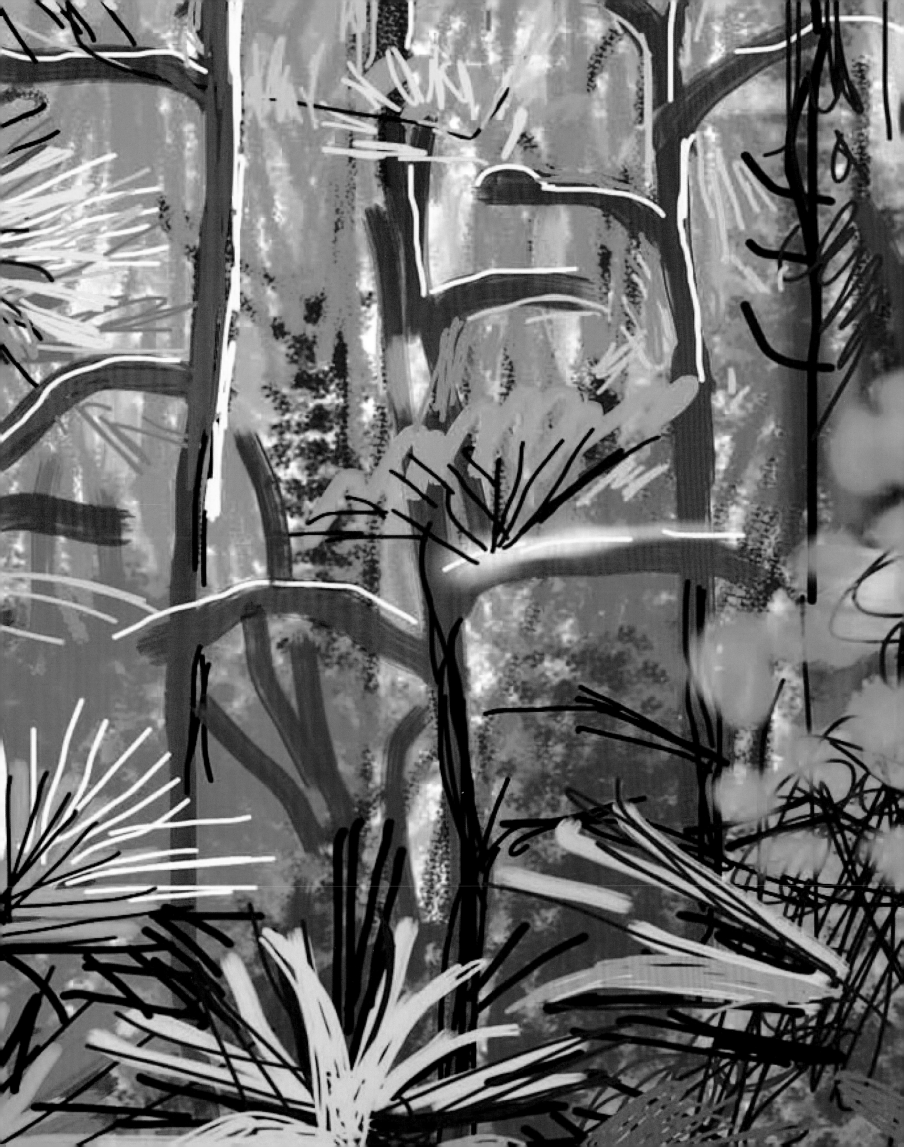

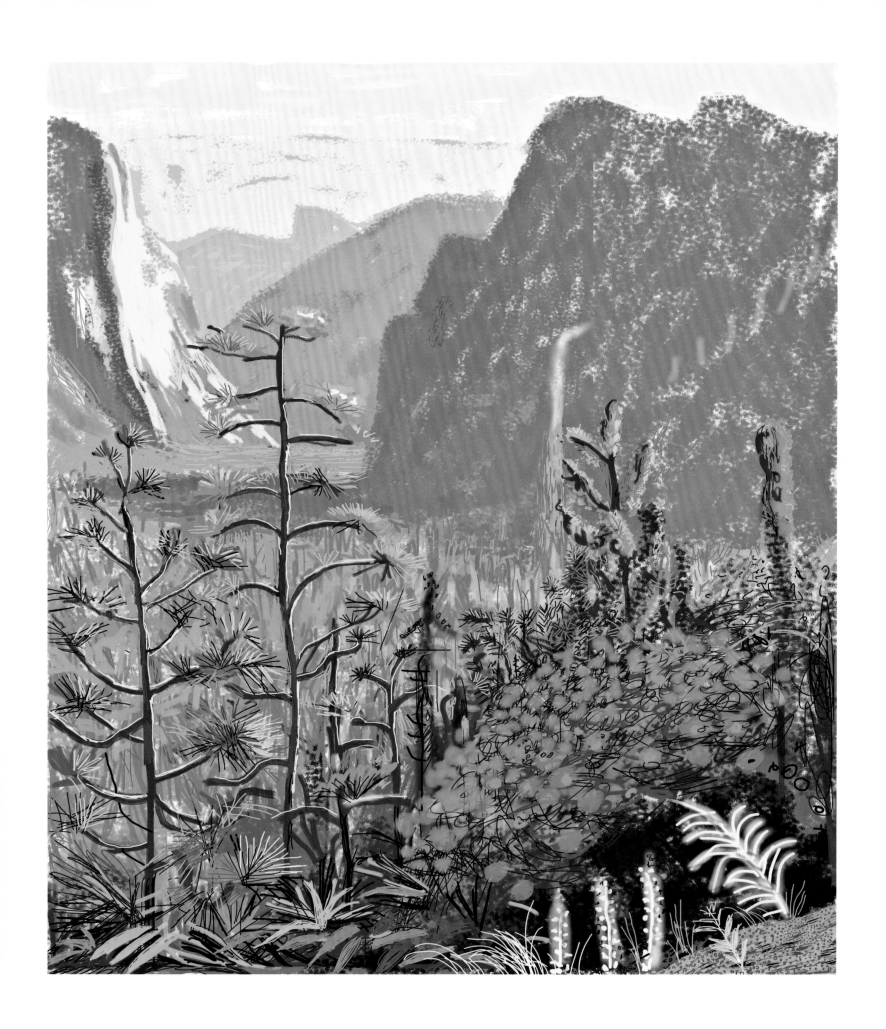

197 | YOSEMITE I, OCTOBER 16TH 2011
iPad drawing printed on 6 sheets of paper, mounted on Dibond,
143 ½ × 128 ¼ in. (364.5 × 325.8 cm)

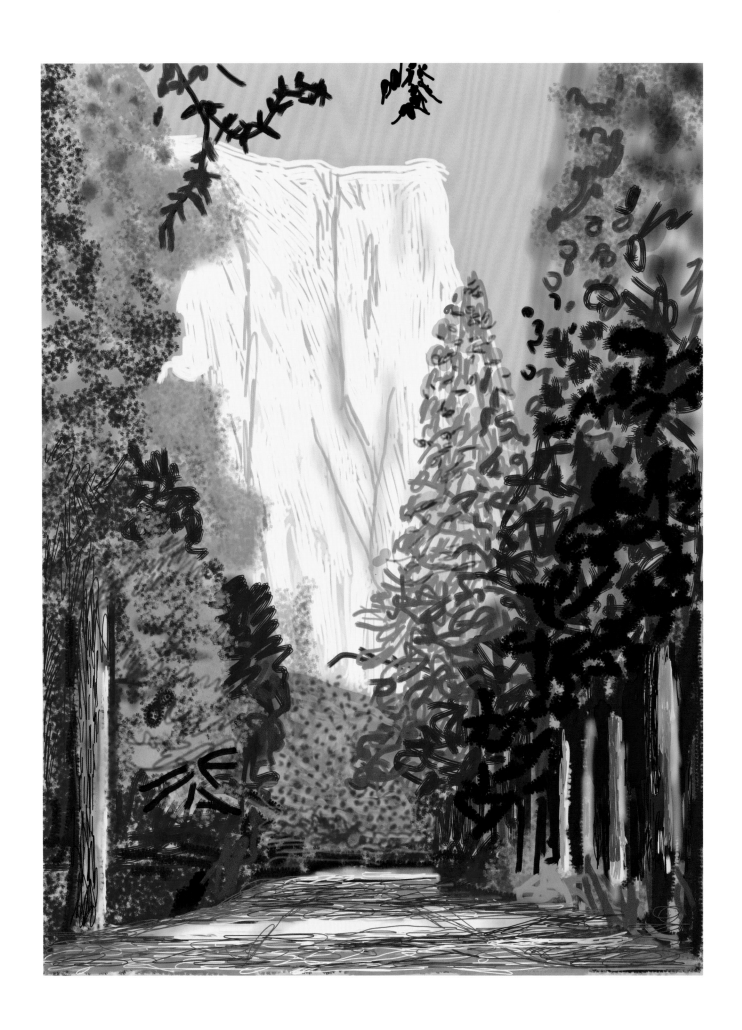

198 | YOSEMITE II, OCTOBER 16TH 2011
iPad drawing printed on 6 sheets of paper, mounted on Dibond,
143½ × 107¼ in. (364.5 × 272.4 cm)

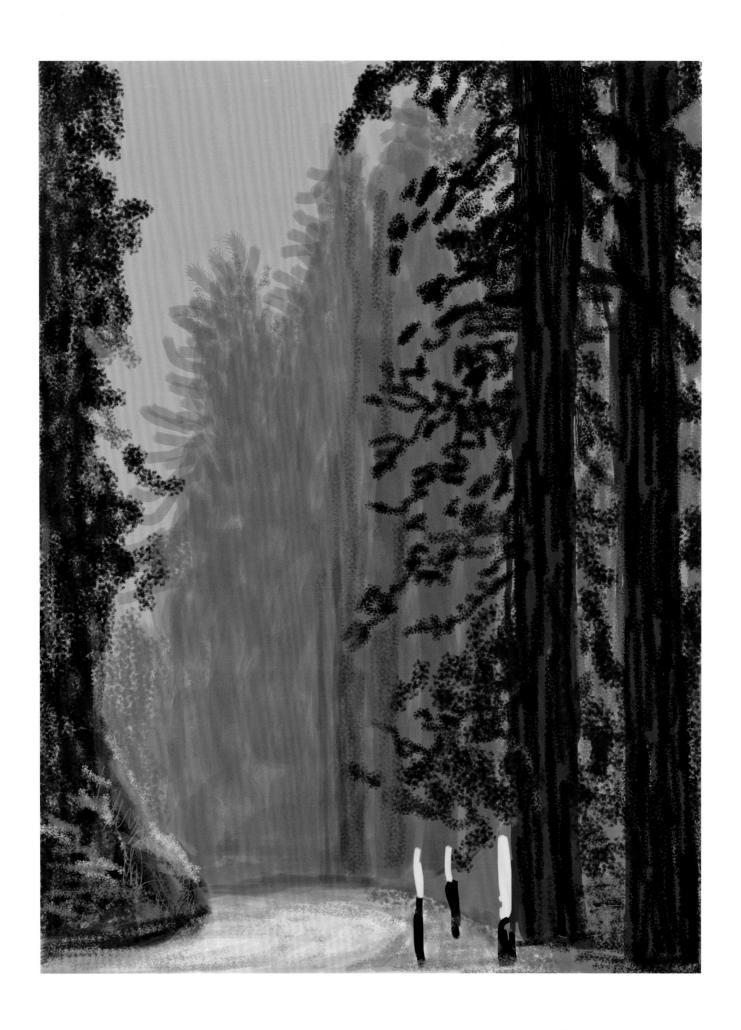

199 | YOSEMITE III, OCTOBER 5TH 2011
iPad drawing printed on 6 sheets of paper, mounted on Dibond,
143½ × 107¼ in. (364.5 × 272.4 cm)

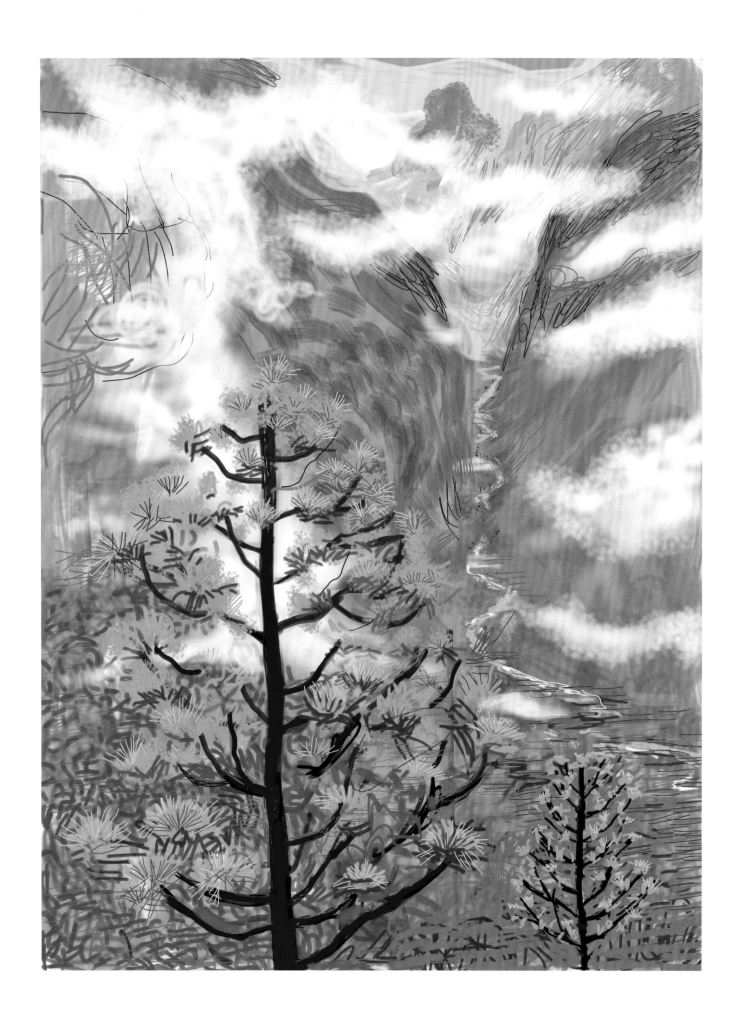

200 | YOSEMITE I, OCTOBER 5TH 2011
iPad drawing printed on 6 sheets of paper, mounted on Dibond,
143 ½ × 107 ¼ in. (364.5 × 272.4 cm)

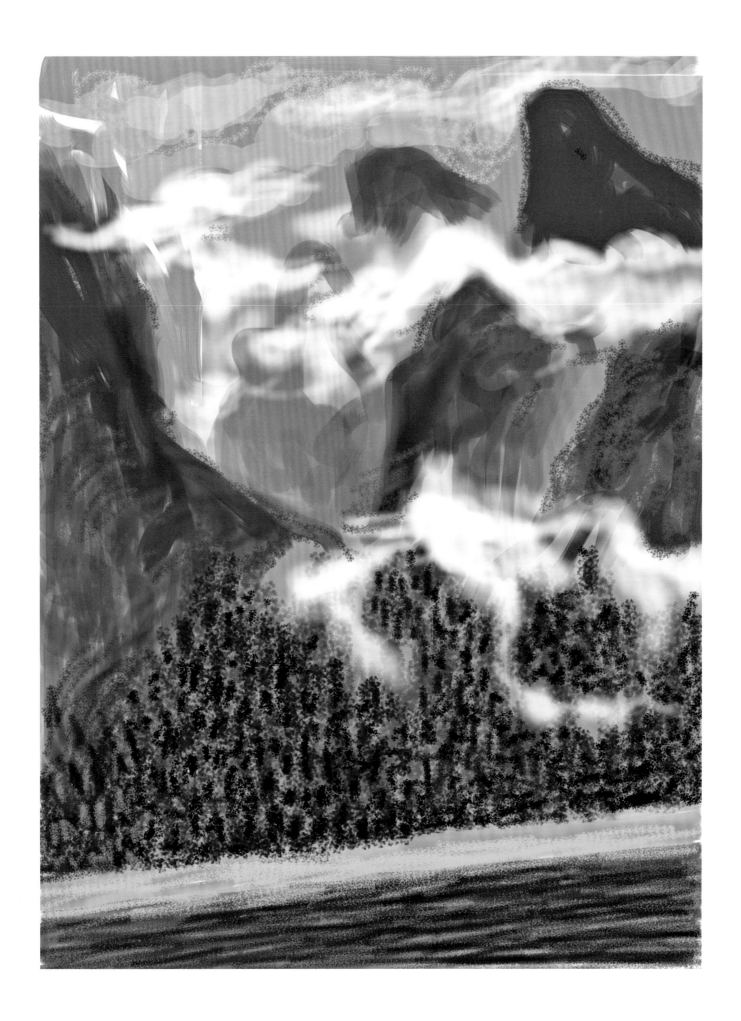

201 | YOSEMITE II, OCTOBER 5TH 2011
iPad drawing printed on 6 sheets of paper, mounted on Dibond,
143½ × 107¼ in. (364.5 × 272.4 cm)

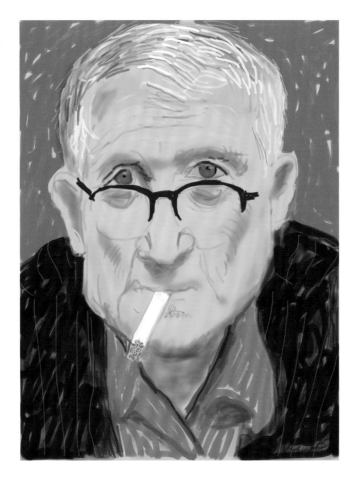
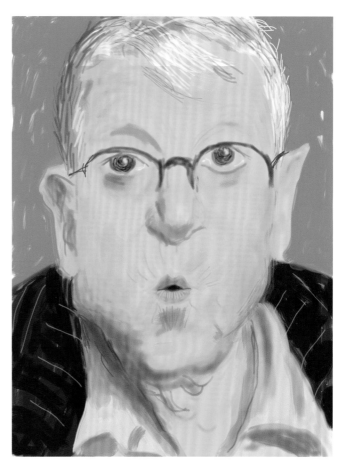
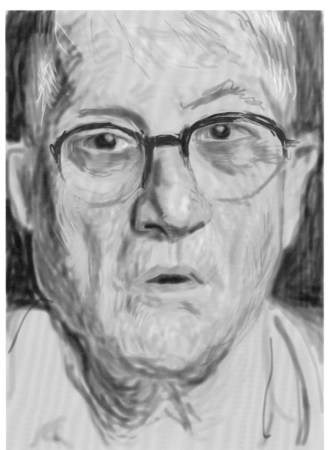
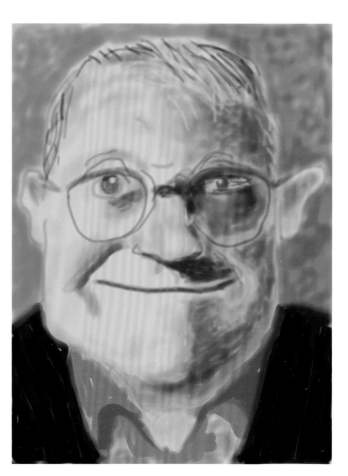

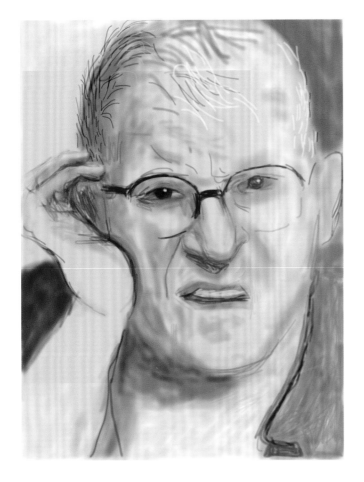

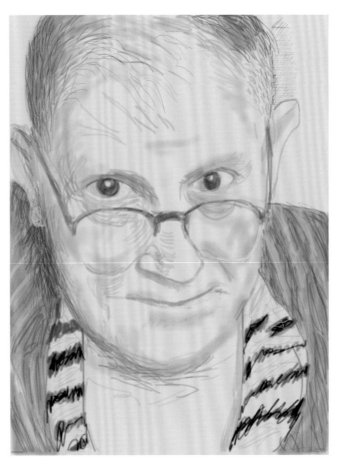

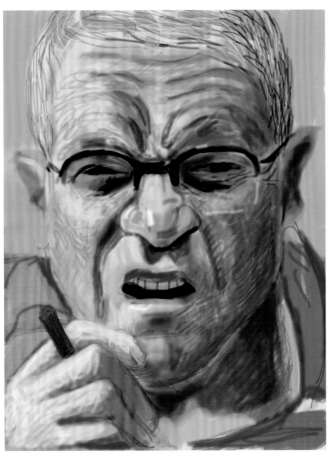

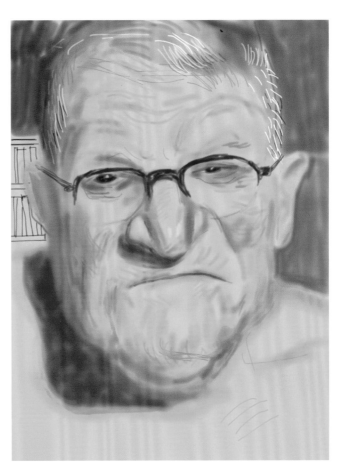

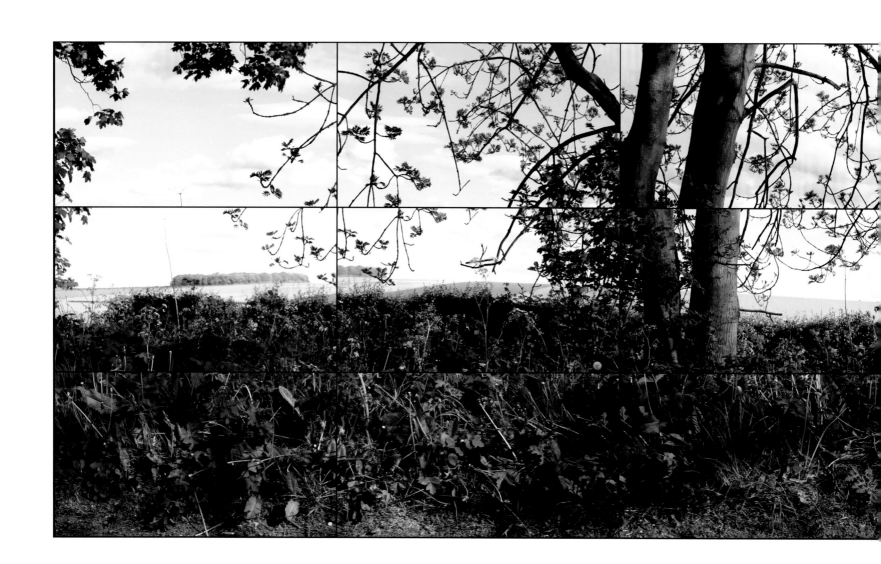

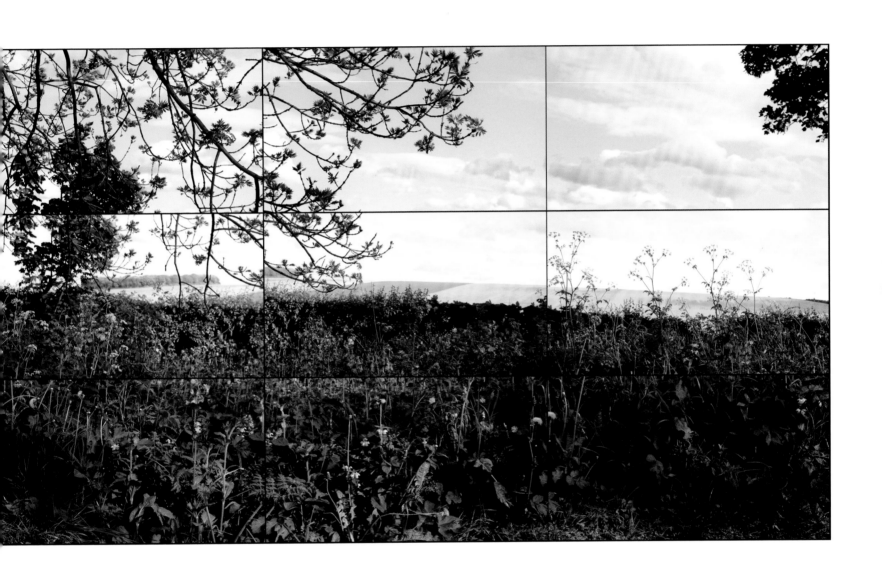

210 | STILL FROM MAY 12TH 2011, RUDSTON TO KILHAM ROAD, 5PM
18 digital videos synchronized and presented on 18 55-inch NEC screens to comprise a single artwork

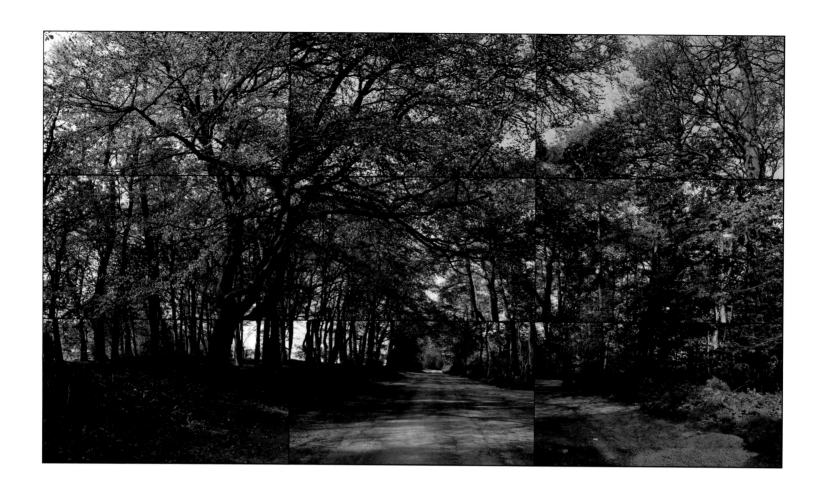

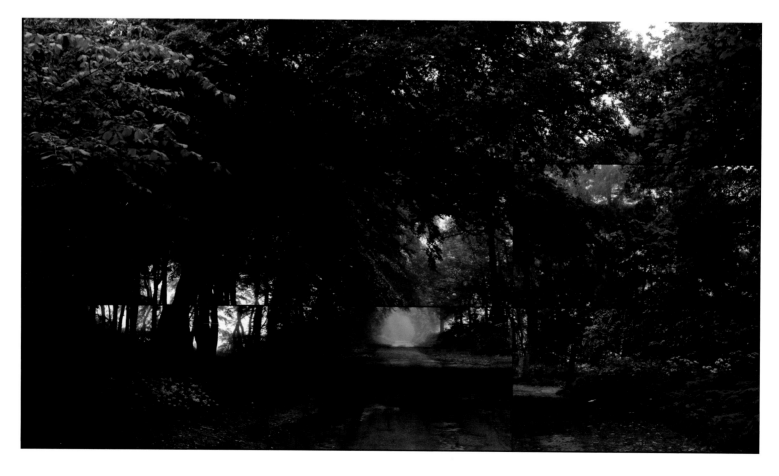

211 | STILL FROM WOLDGATE WOODS, APRIL 18TH 2011
9 digital videos synchronized and presented on 9 55-inch NEC screens to comprise a single artwork

212 | STILL FROM WOLDGATE WOODS, JUNE 2ND 2010
9 digital videos synchronized and presented on 9 55-inch NEC screens to comprise a single artwork

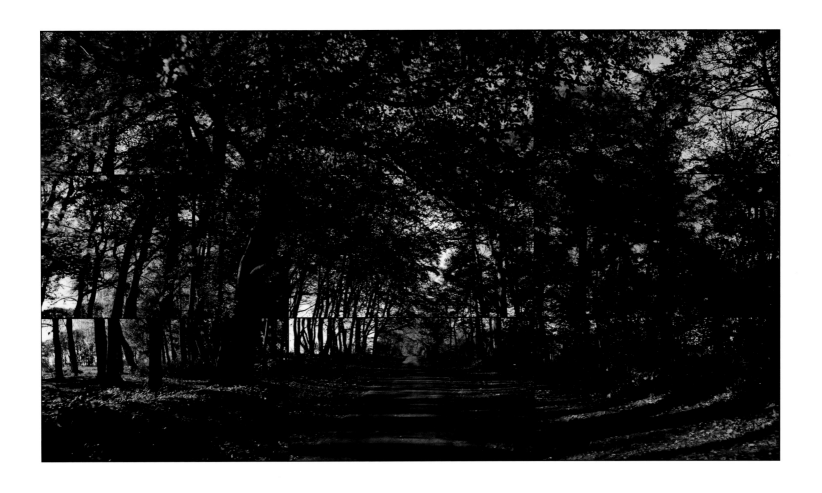

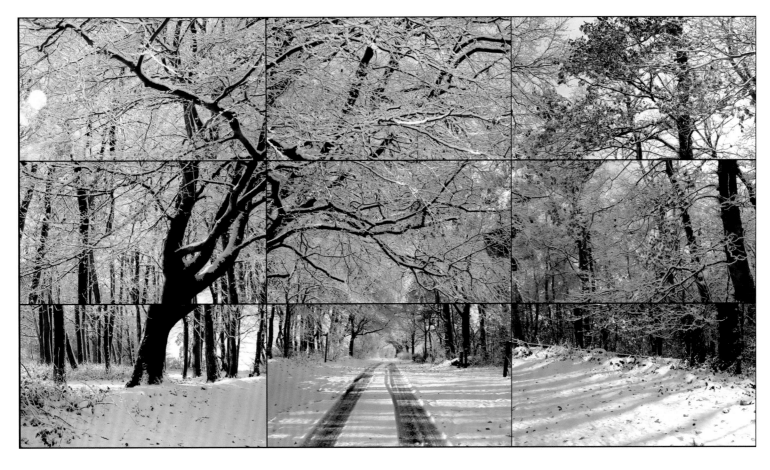

213 | STILL FROM WOLDGATE WOODS, NOVEMBER 7TH 2010
9 digital videos synchronized and presented on 9 55-inch NEC screens to comprise a single artwork

214 | STILL FROM WOLDGATE WOODS, NOVEMBER 26TH 2010
9 digital videos synchronized and presented on 9 55-inch NEC screens to comprise a single artwork

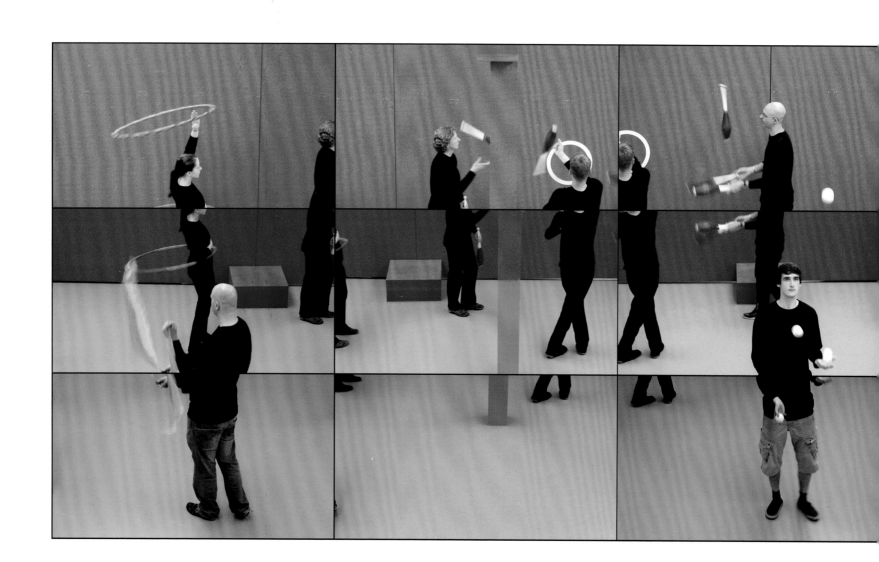

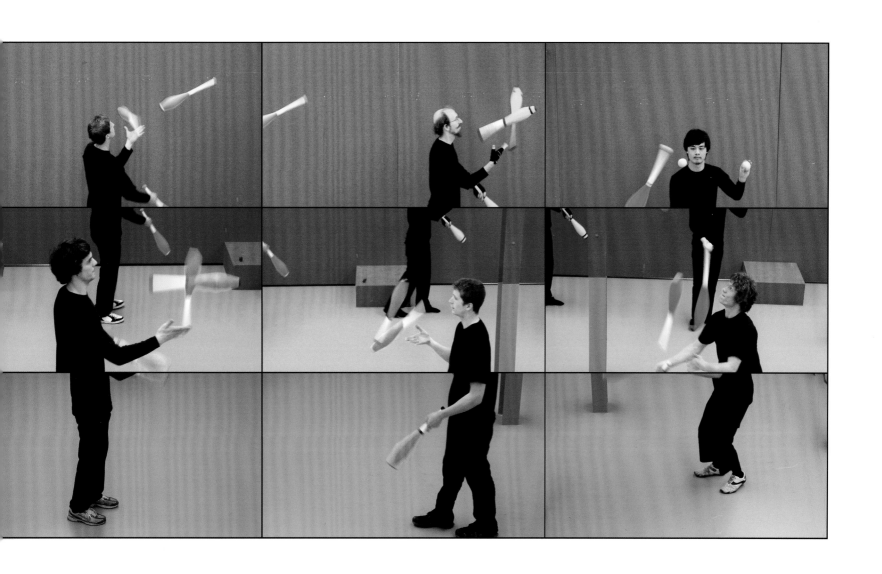

215 | STILL FROM THE JUGGLERS, 2012
 18 digital videos synchronized and presented on 18 55-inch NEC screens to comprise a single artwork

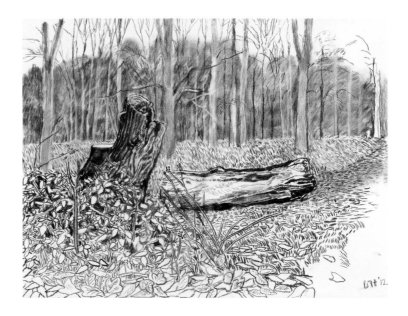

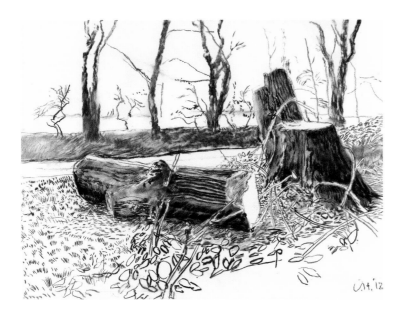

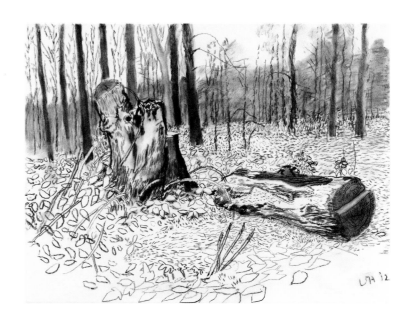

216 | VANDALIZED TOTEM, 16–17 NOVEMBER, 2012
Charcoal on paper, 22 ⅜ × 30 ¼ in. (57.5 × 76.8 cm)

217 | VANDALIZED TOTEM, 19–20 NOVEMBER, 2012
Charcoal on paper, 22 ⅝ × 30 ¼ in. (57.5 × 76.8 cm)

218 | VANDALIZED TOTEM, 22 NOVEMBER, 2012
Charcoal on paper, 22 ⅝ × 30 ¼ in. (57.5 × 76.8 cm)

219 | VANDALIZED TOTEM, 25 NOVEMBER, 2012
Charcoal on paper, 22 ⅝ × 30 ¼ in. (57.5 × 76.8 cm)

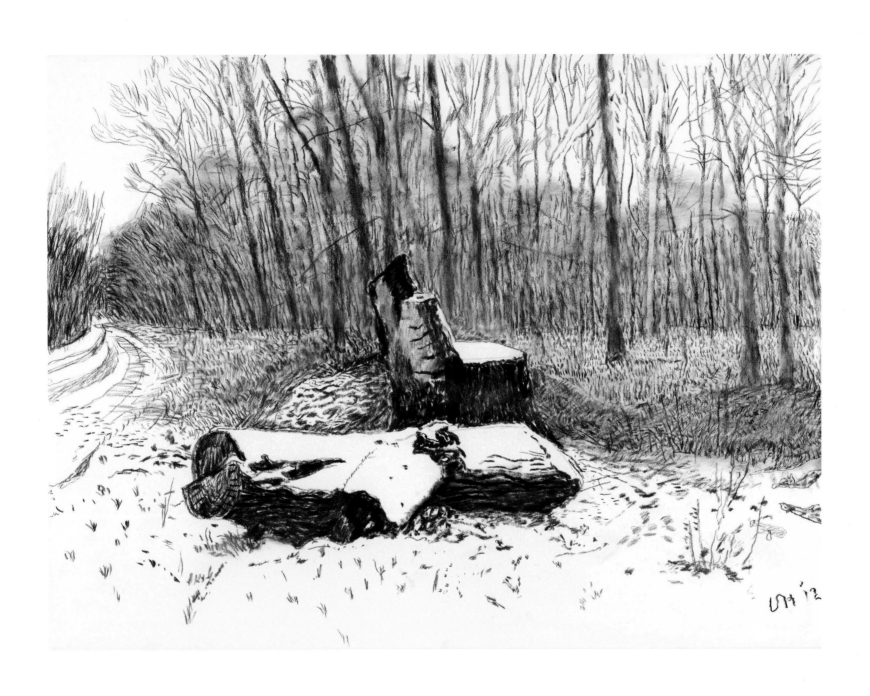

220 | VANDALIZED TOTEM IN SNOW, 5 DECEMBER, 2012

Charcoal on paper, 22 ⅝ × 30 ¼ in. (57.5 × 76.8 cm)

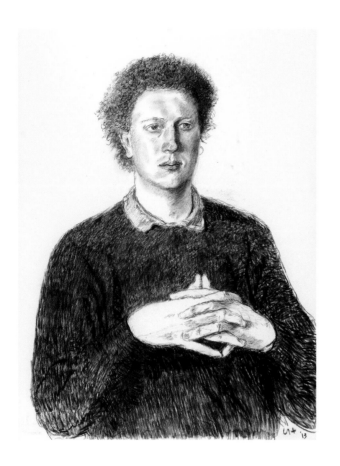

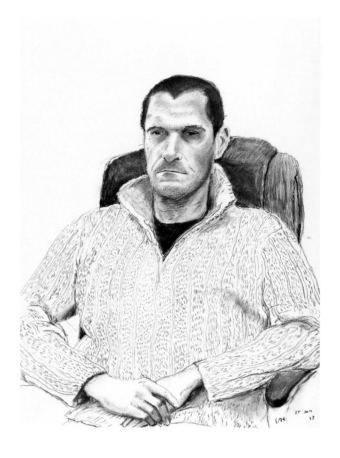

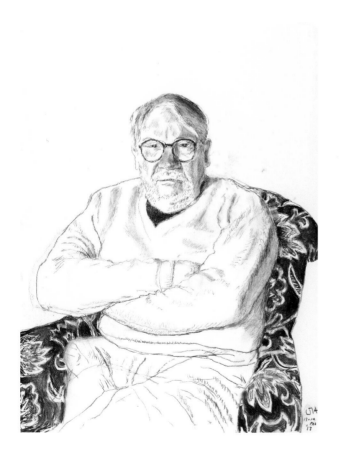

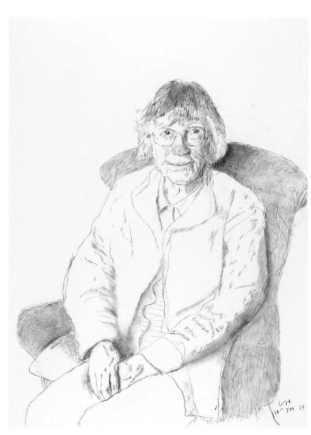

221 | DOMINIC ELLIOTT, 30–31 JANUARY, 2013
Charcoal on paper, 30 ¼ × 22 ⅝ in. (76.8 × 57.5 cm)

222 | JEAN-PIERRE GONÇALVES DE LIMA, 25 JANUARY, 2013
Charcoal on paper, 30 ¼ × 22 ⅝ in. (76.8 × 57.5 cm)

223 | JOHN HOCKNEY, 13–14 FEBRUARY, 2013
Charcoal on paper, 30 ¼ × 22 ⅝ in. (76.8 × 57.5 cm)

224 | MARGARET HOCKNEY, 14 FEBRUARY, 2013
Charcoal on paper, 30 ¼ × 22 ⅝ in. (76.8 × 57.5 cm)

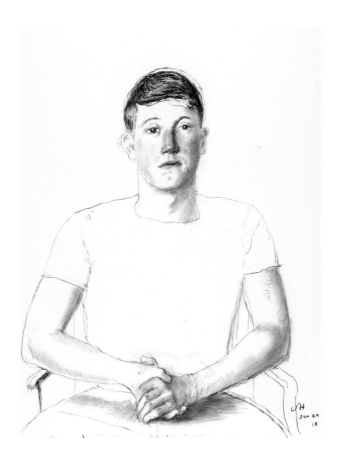

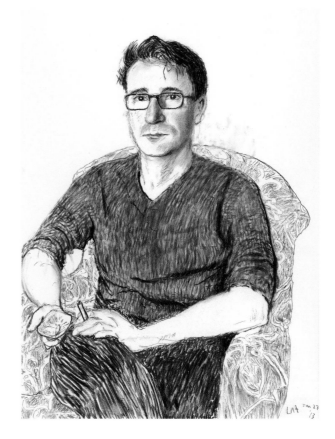

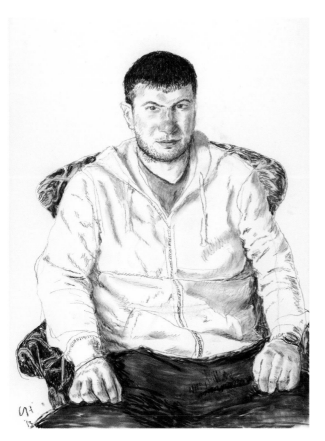

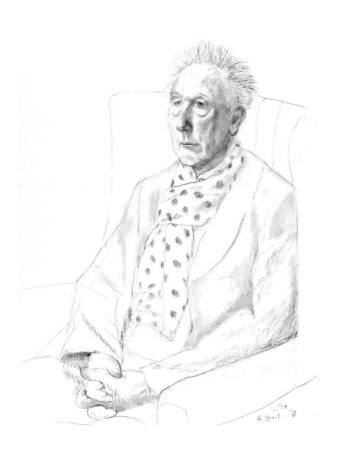

225 | RICHARD TODD, 29 JANUARY, 2013
Charcoal on paper, 30 ¼ × 22 ⅝ in. (76.8 × 57.5 cm)

226 | ROBBIE STARK, 27 JANUARY, 2013
Charcoal on paper, 30 ¼ × 22 ⅝ in. (76.8 × 57.5 cm)

227 | MARK SHEPHARD, 28 FEBRUARY, 2013
Charcoal on paper, 30 ¼ × 22 ⅝ in. (76.8 × 57.5 cm)

228 | MAURICE PAYNE, 16 APRIL, 2013
Charcoal on paper, 30 ¼ × 22 ⅝ in. (76.8 × 57.5 cm)

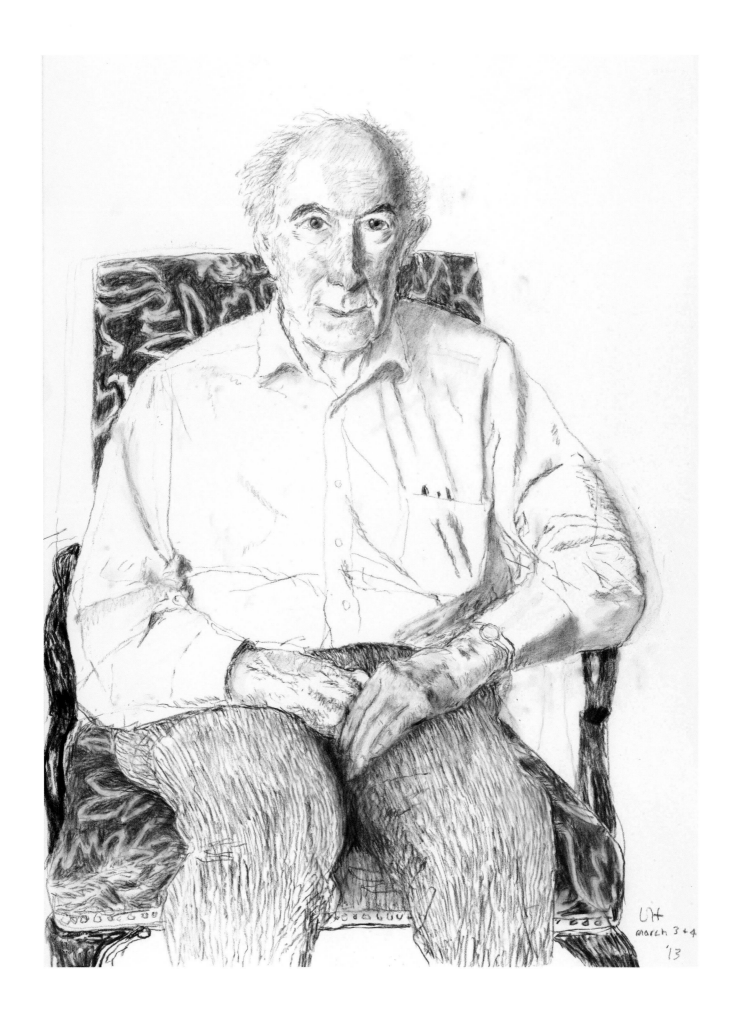

229 | RICHARD MARRIOTT, 3–4 MARCH, 2013
Charcoal on paper, 30 ¼ × 22 ⅝ in. (76.8 × 57.5 cm)

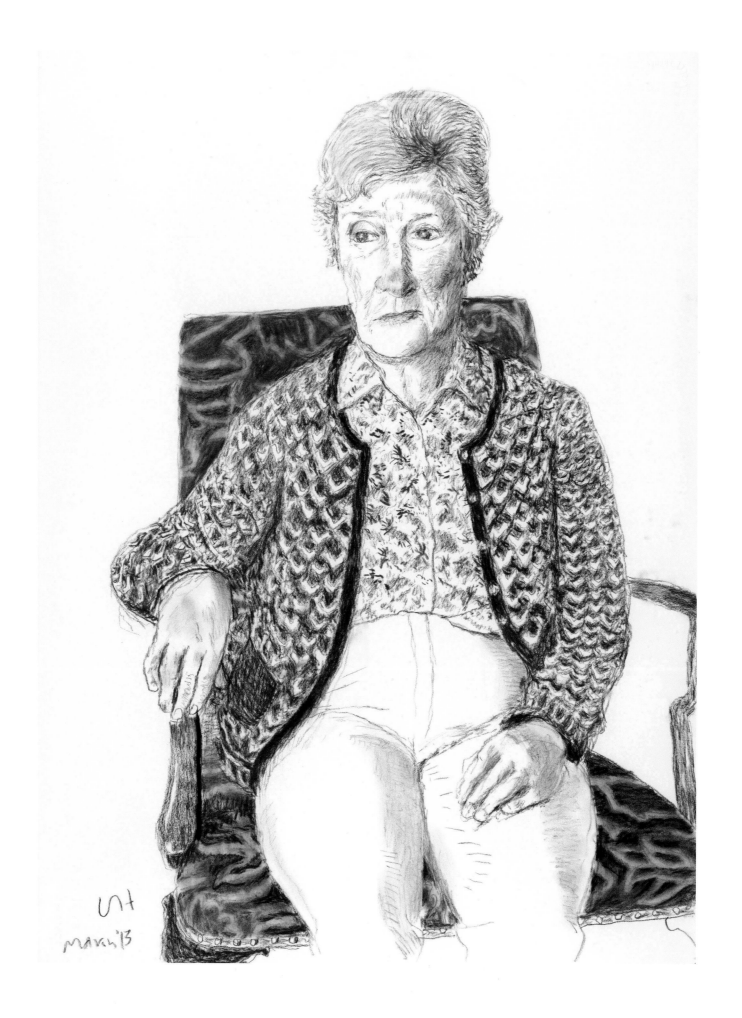

230 | SALLY MARRIOTT, 5, 7 & 11 MARCH, 2013
Charcoal on paper, 30 ¼ × 22 ⅝ in. (76.8 × 57.5 cm)

THE ARRIVAL OF SPRING IN 2013 (TWENTY THIRTEEN)

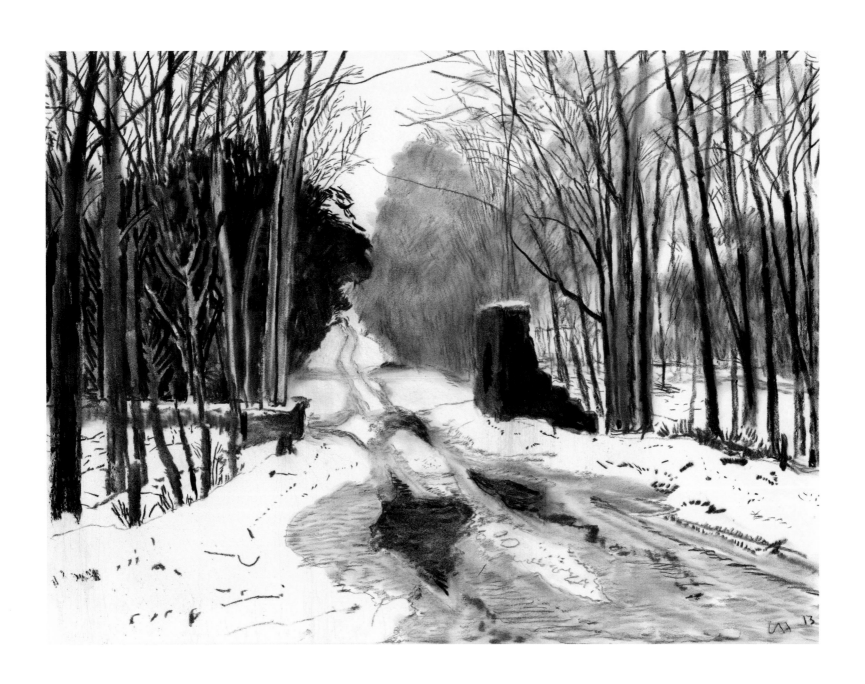

231 | WOLDGATE, 22–23 JANUARY, 2013
Charcoal on paper, 22 ⅝ × 30 ¼ in. (57.5 × 76.8 cm)

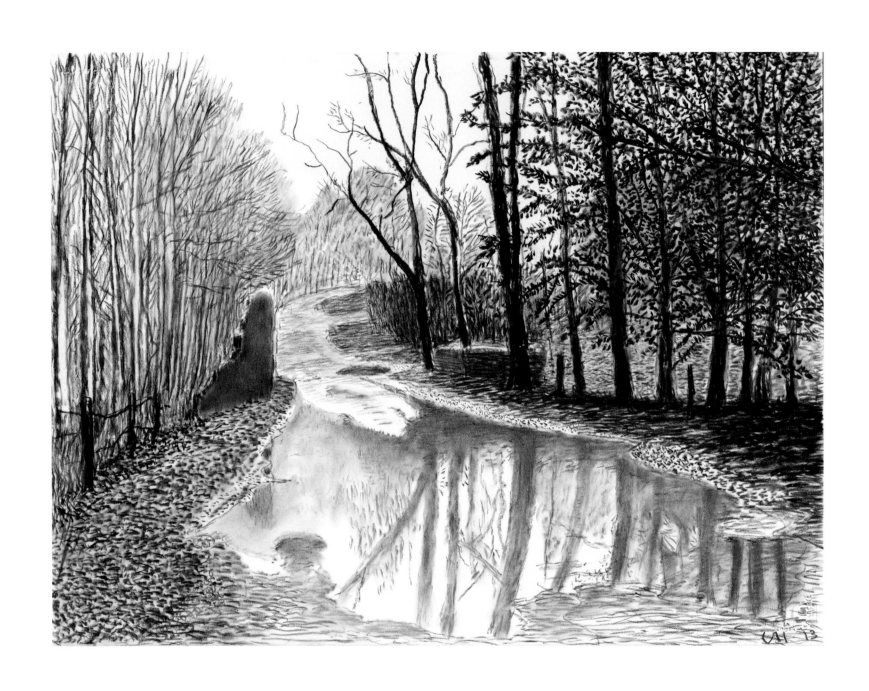

232 | WOLDGATE, 6–7 FEBRUARY, 2013
Charcoal on paper, 22 ⅝ × 30 ¼ in. (57.5 × 76.8 cm)

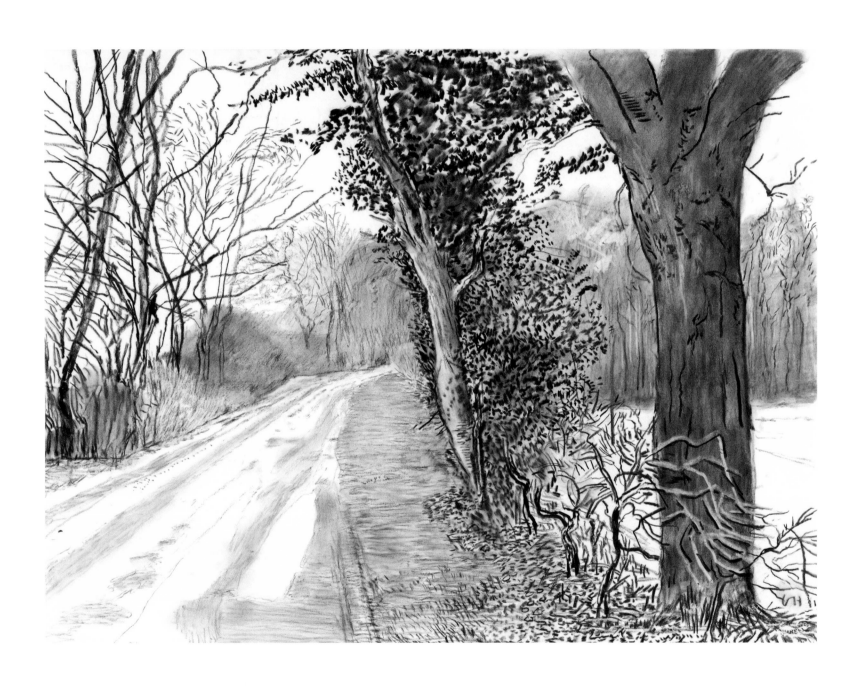

Charcoal on paper, 22 ⅝ × 30 ¼ in. (57.5 × 76.8 cm)

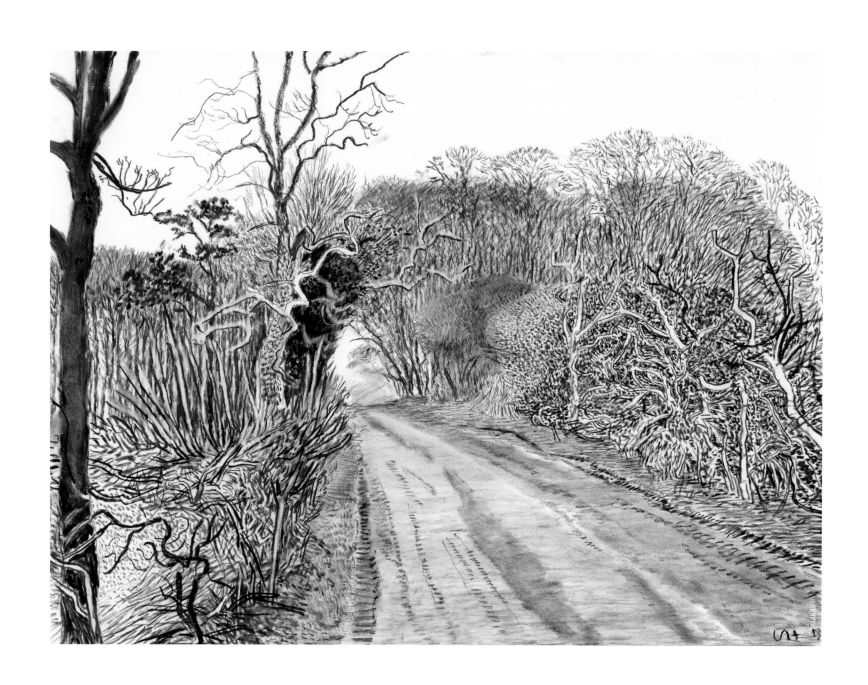

234 | WOLDGATE, 25–27 FEBRUARY, 2013
Charcoal on paper, 22 ⅝ × 30 ¼ in. (57.5 × 76.8 cm)

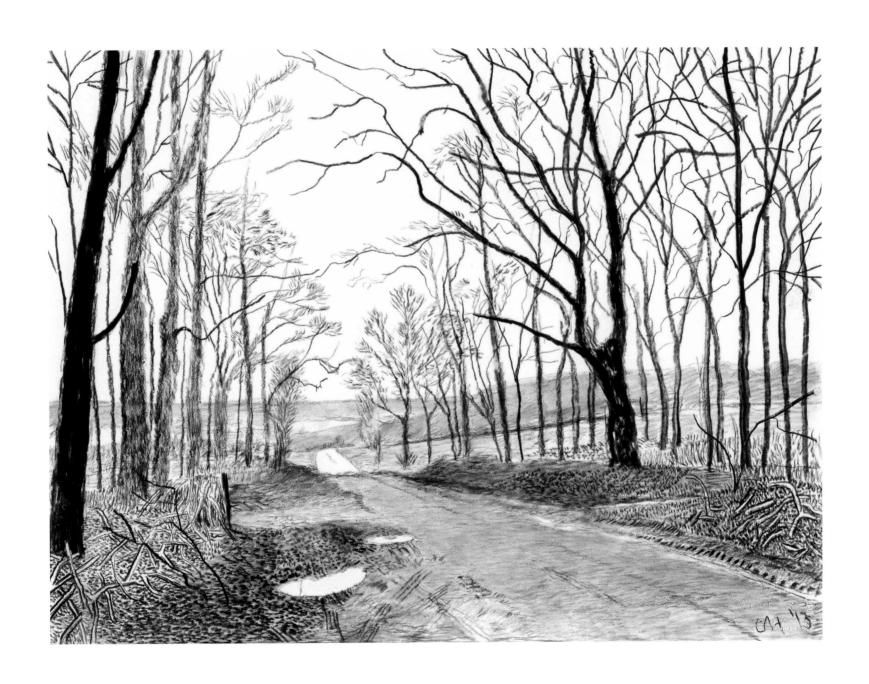

235 | WOLDGATE, 16 & 26 MARCH, 2013

Charcoal on paper, 22 ⅜ × 30 ¼ in. (57.5 × 76.8 cm)

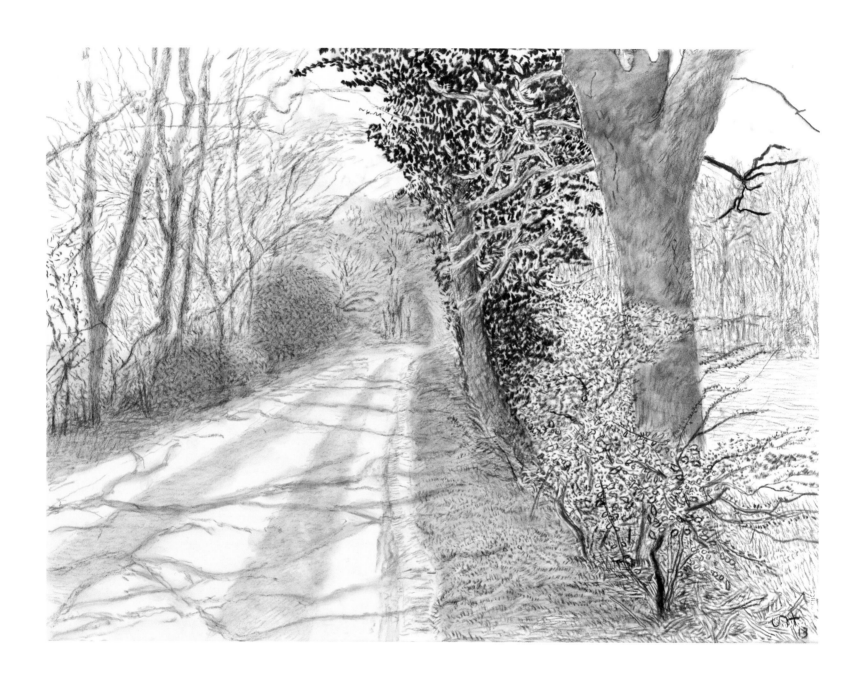

236 | WOLDGATE, 30 APRIL, 1 & 5 MAY, 2013
Charcoal on paper, 22 ⅝ × 30 ¼ in. (57.5 × 76.8 cm)

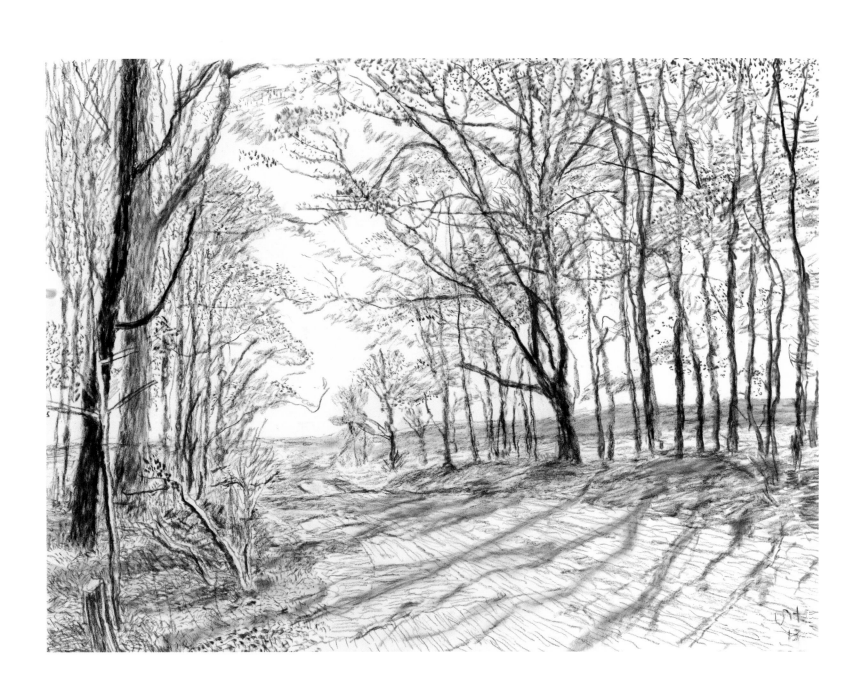

237 | WOLDGATE, 3 MAY, 2013

Charcoal on paper, 22 ⅝ × 30 ¼ in. (57.5 × 76.8 cm)

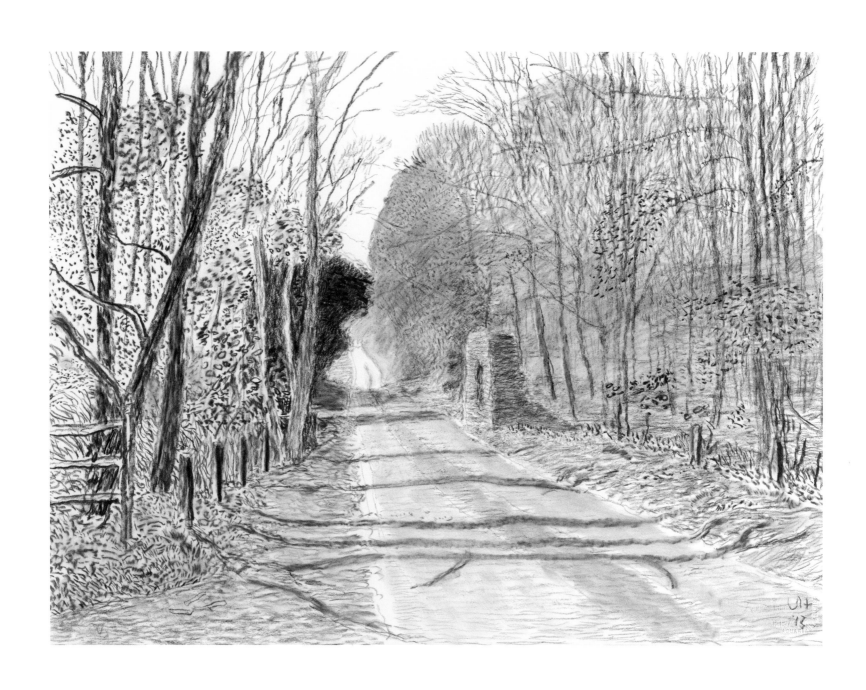

Charcoal on paper, 22 ⅝ × 30 ¼ in. (57.5 × 76.8 cm)

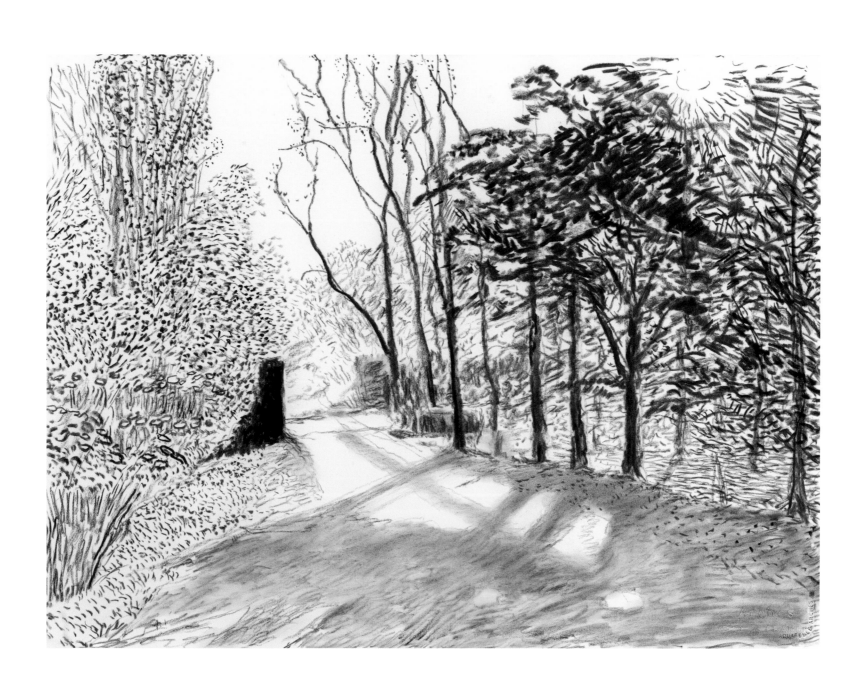

239 | WOLDGATE, 6 MAY, 2013

Charcoal on paper, 22 ⅝ × 30 ¼ in. (57.5 × 76.8 cm)

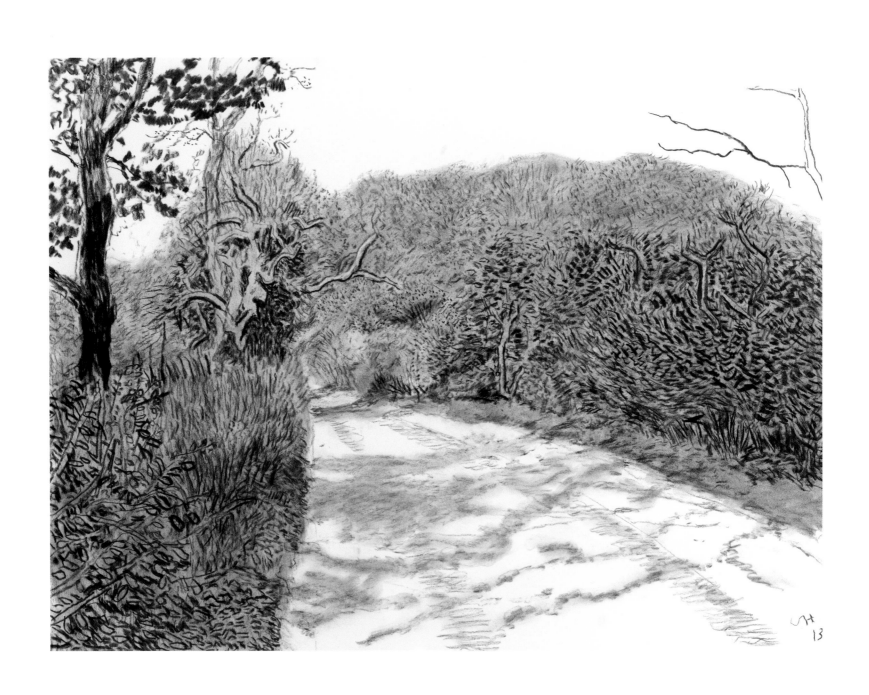

240 | WOLDGATE, 6–7 MAY, 2013
Charcoal on paper, 22 ⅝ × 30 ¼ in. (57.5 × 76.8 cm)

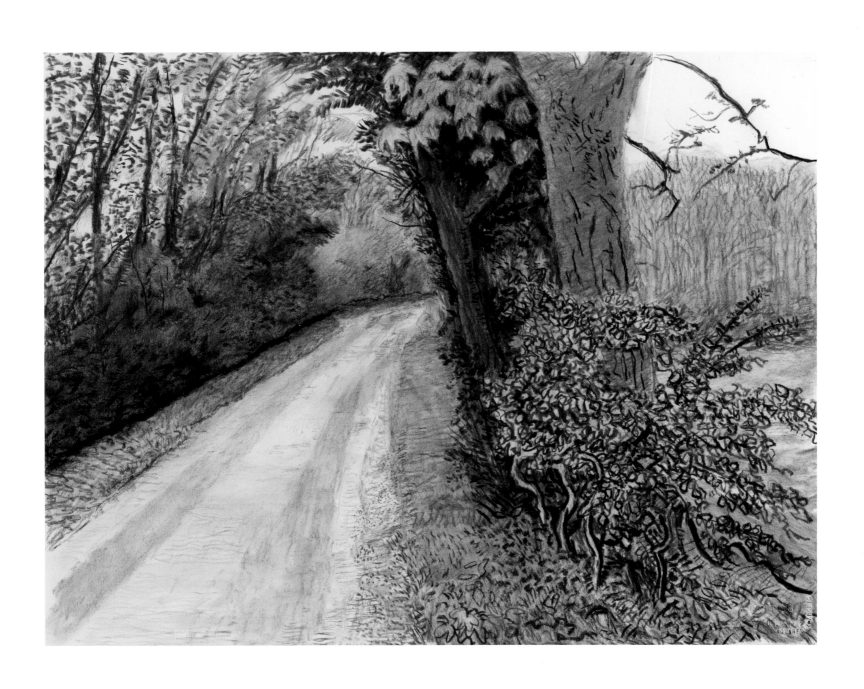

241 | WOLDGATE, 8 MAY, 2013

Charcoal on paper, 22 ⅝ × 30 ¼ in. (57.5 × 76.8 cm)

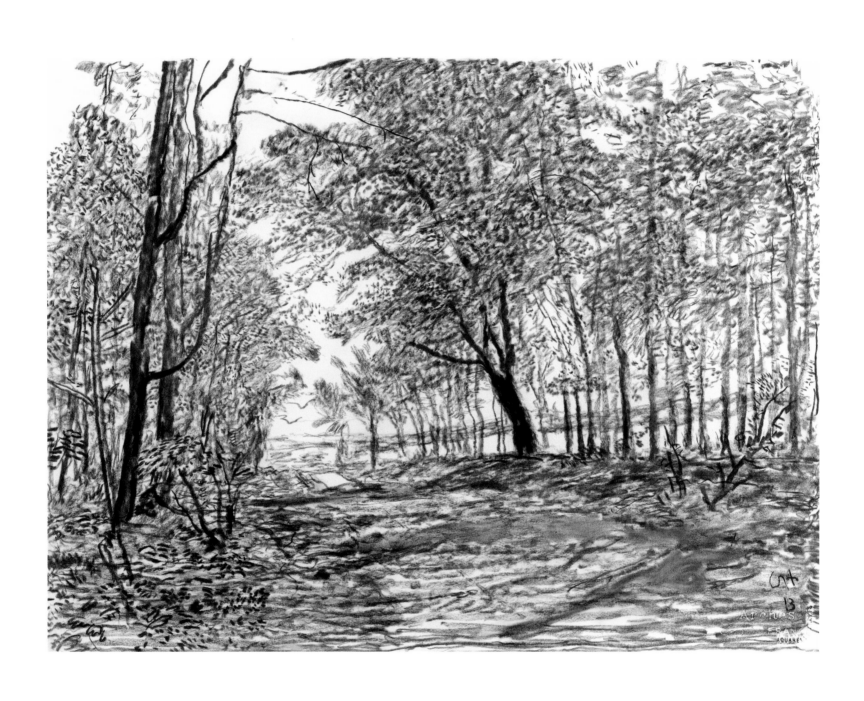

242 | WOLDGATE, 9 & 12 MAY, 2013

Charcoal on paper, 22 ⅝ × 30 ¼ in. (57.5 × 76.8 cm)

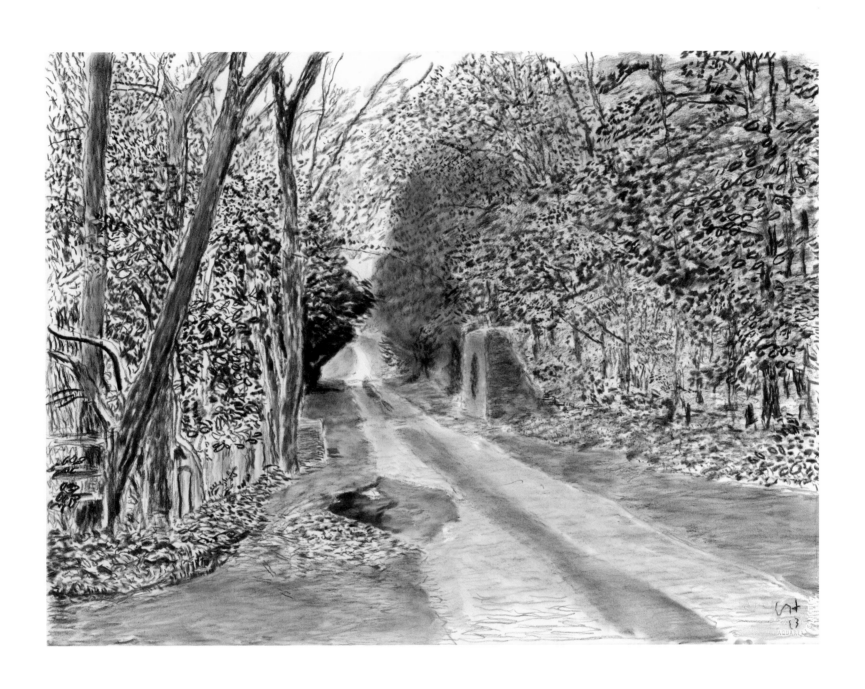

243 | WOLDGATE, 10–11 MAY, 2013

Charcoal on paper, 22 ⅝ × 30 ¼ in. (57.5 × 76.8 cm)

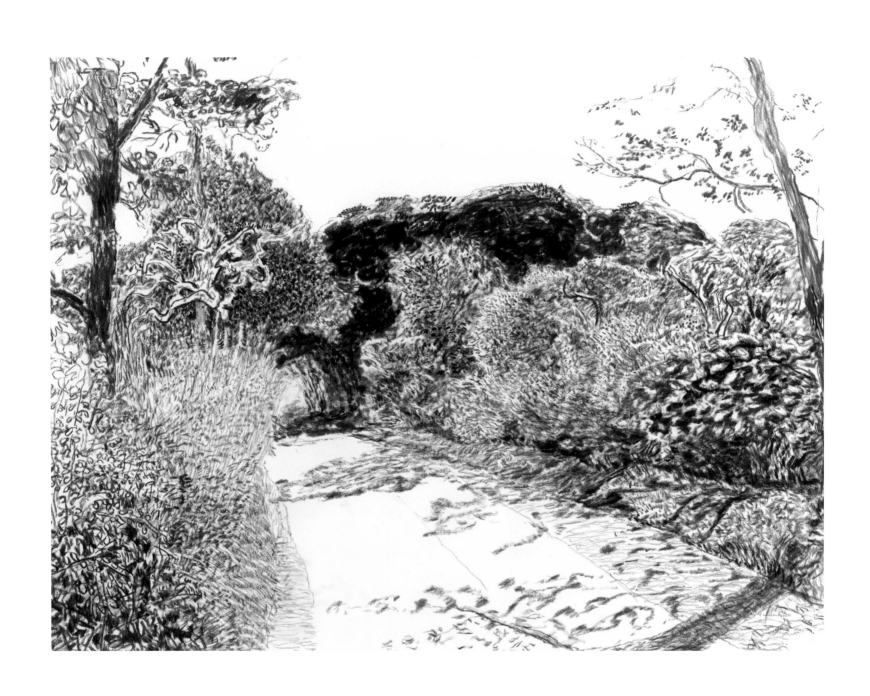

Charcoal on paper, 22 ⅝ × 30 ¼ in. (57.5 × 76.8 cm)

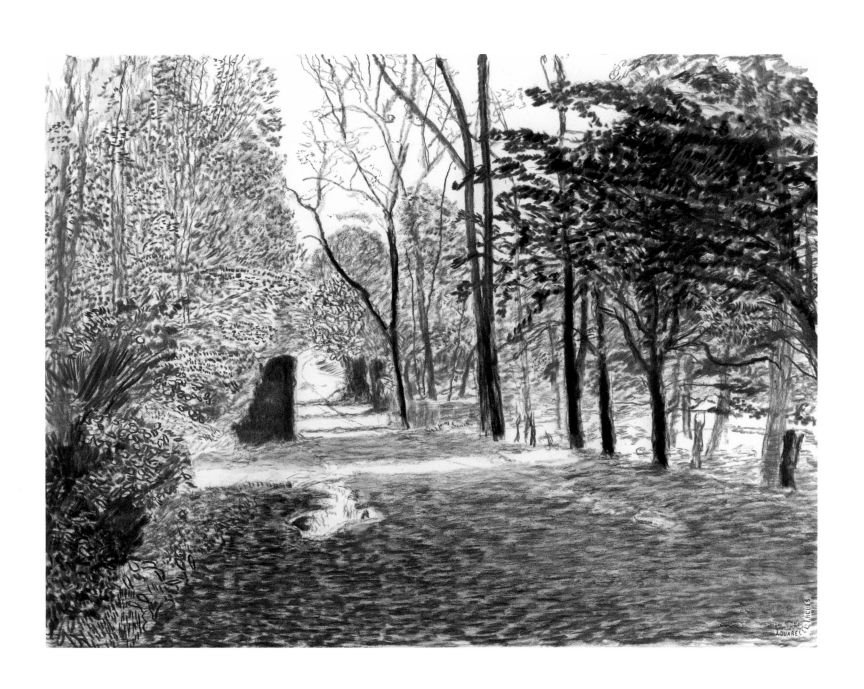

245 | WOLDGATE, 12–13 MAY, 2013

Charcoal on paper, 22 ⅝ × 30 ¼ in. (57.5 × 76.8 cm)

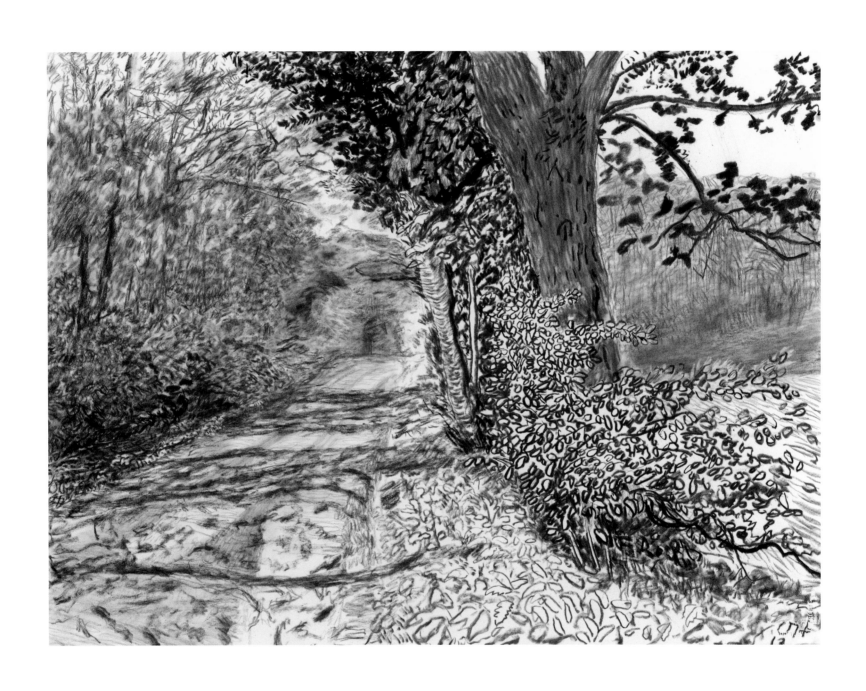

Charcoal on paper, 22 ⅝ × 30 ¼ in. (57.5 × 76.8 cm)

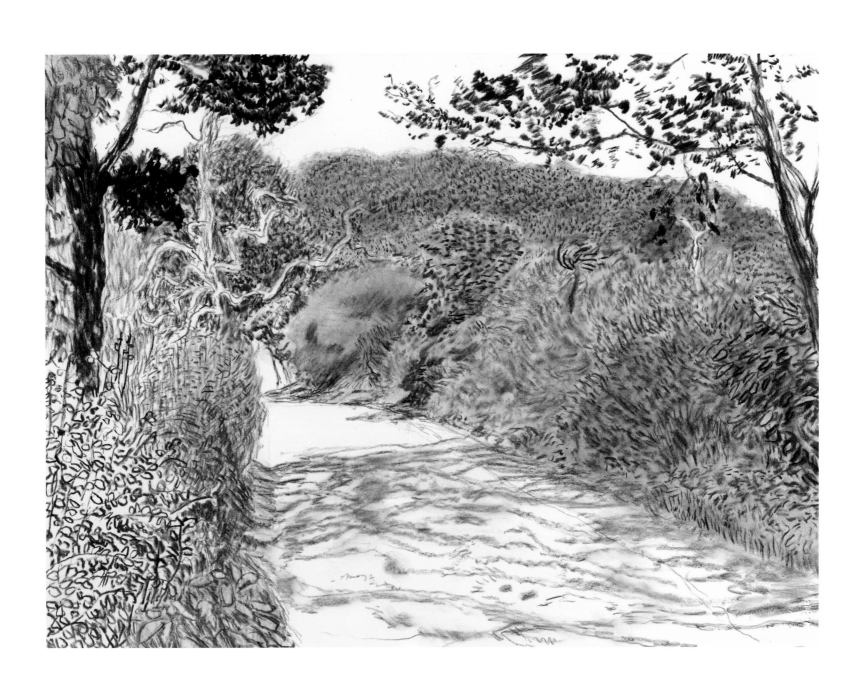

247 | WOLDGATE, 16 MAY, 2013

Charcoal on paper, 22 ⅝ × 30 ¼ in. (57.5 × 76.8 cm)

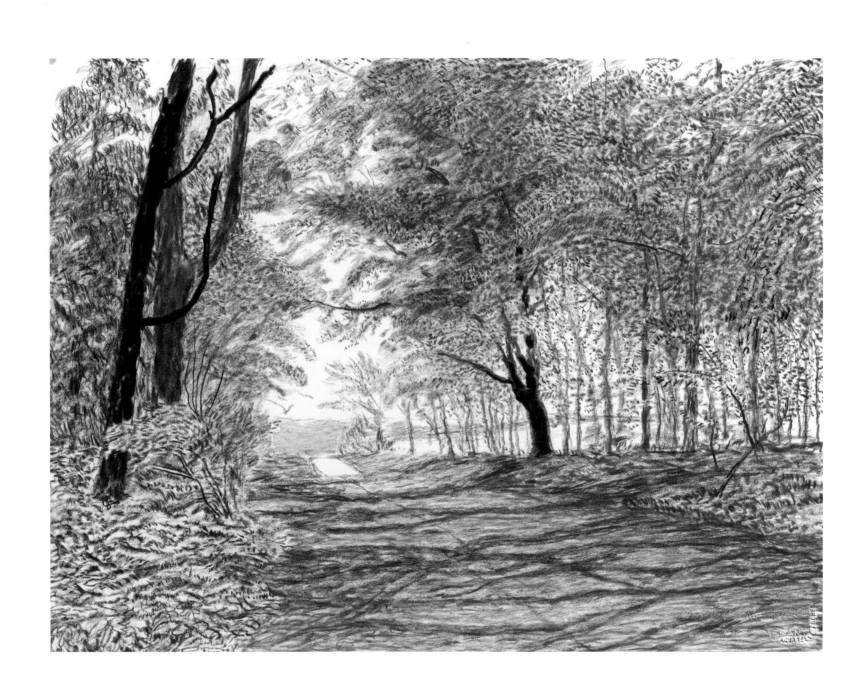

248 | WOLDGATE, 17 MAY, 2013
Charcoal on paper, 22 ⅝ × 30 ¼ in. (57.5 × 76.8 cm)

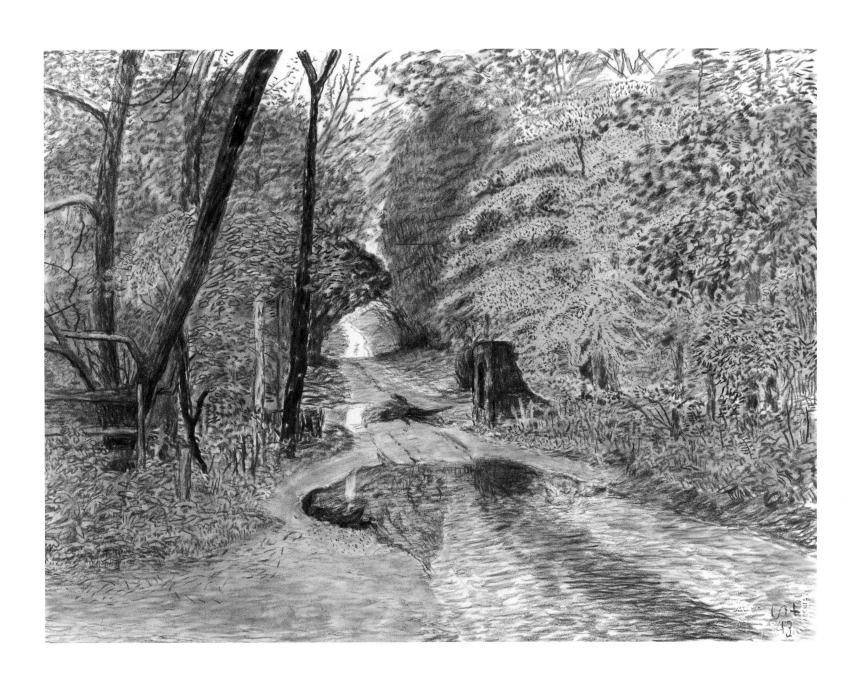

249 | WOLDGATE, 18–19 MAY, 2013
Charcoal on paper, 22 ⅝ × 30 ¼ in. (57.5 × 76.8 cm)

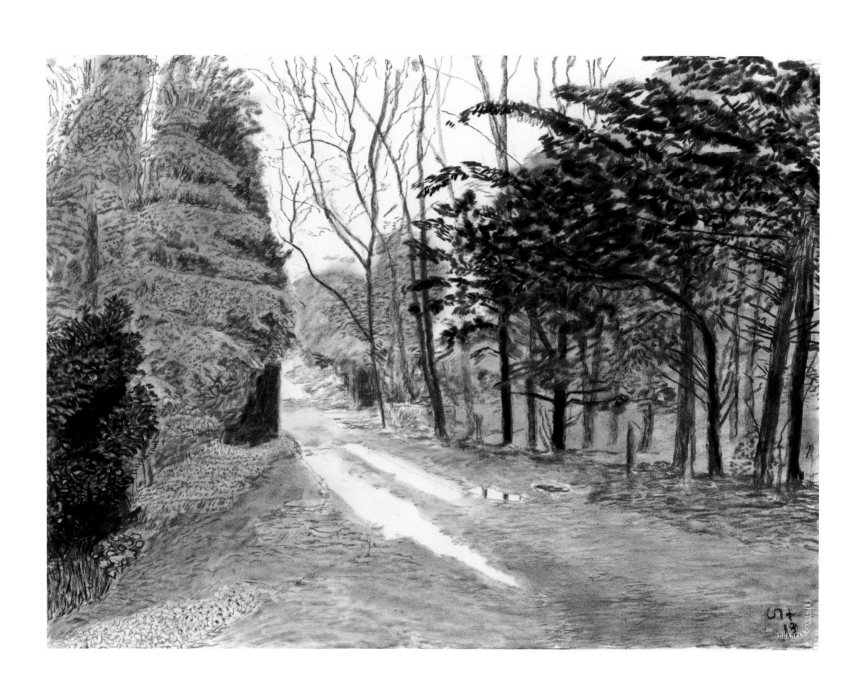

250 | WOLDGATE, 20–21 MAY, 2013
Charcoal on paper, 22 ⅝ × 30 ¼ in. (57.5 × 76.8 cm)

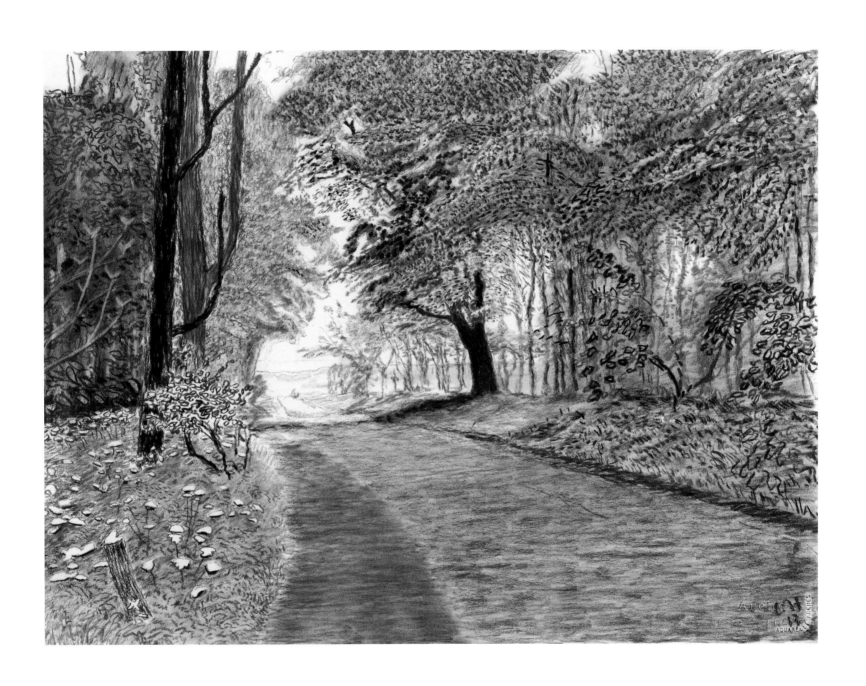

251 | WOLDGATE, 21–22 MAY, 2013

Charcoal on paper, 22 ⅝ × 30 ¼ in. (57.5 × 76.8 cm)

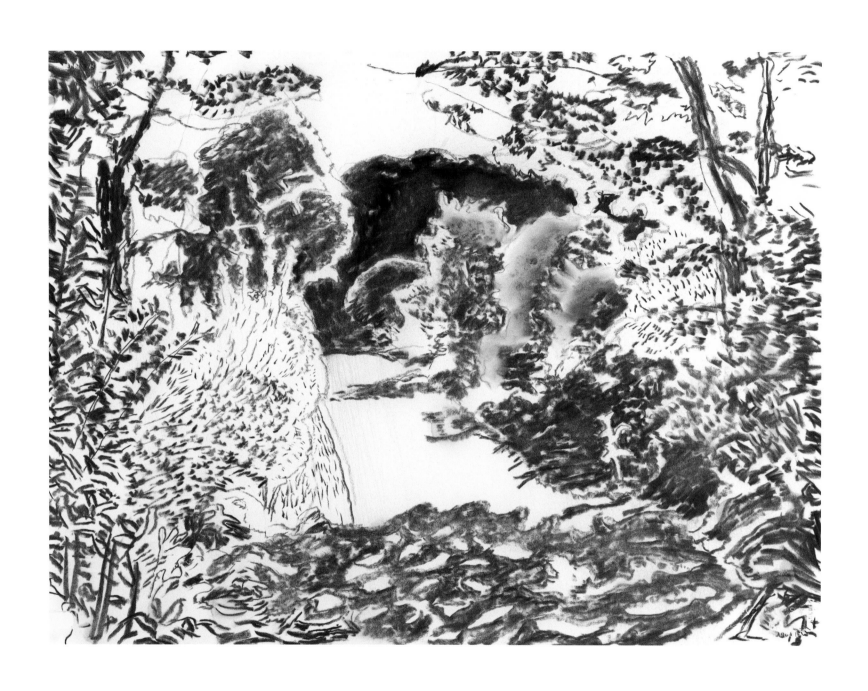

252 | WOLDGATE, 25 MAY, 2013
Charcoal on paper, 22 ⅝ × 30 ¼ in. (57.5 × 76.8 cm)

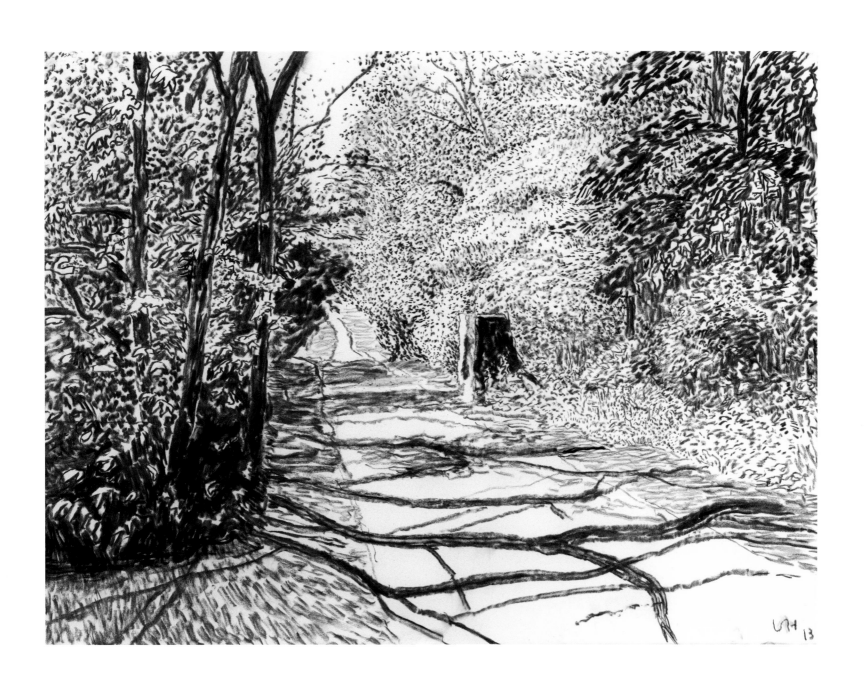

253 | WOLDGATE, 26 MAY, 2013

Charcoal on paper, 22 ⅝ × 30 ¼ in. (57.5 × 76.8 cm)

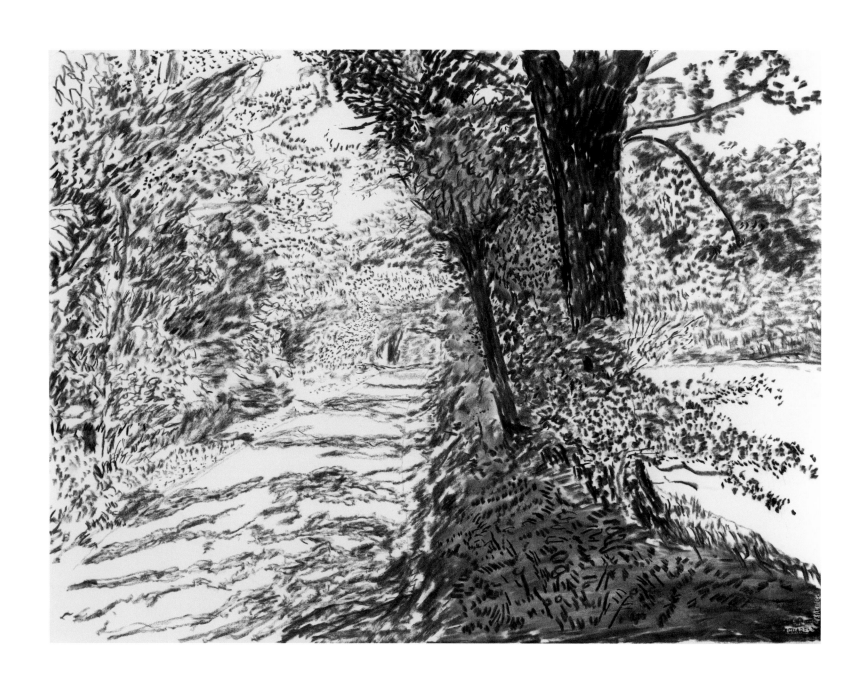

254 | WOLDGATE, 26 MAY, 2013

Charcoal on paper, 22 ⅝ × 30 ¼ in. (57.5 × 76.8 cm)

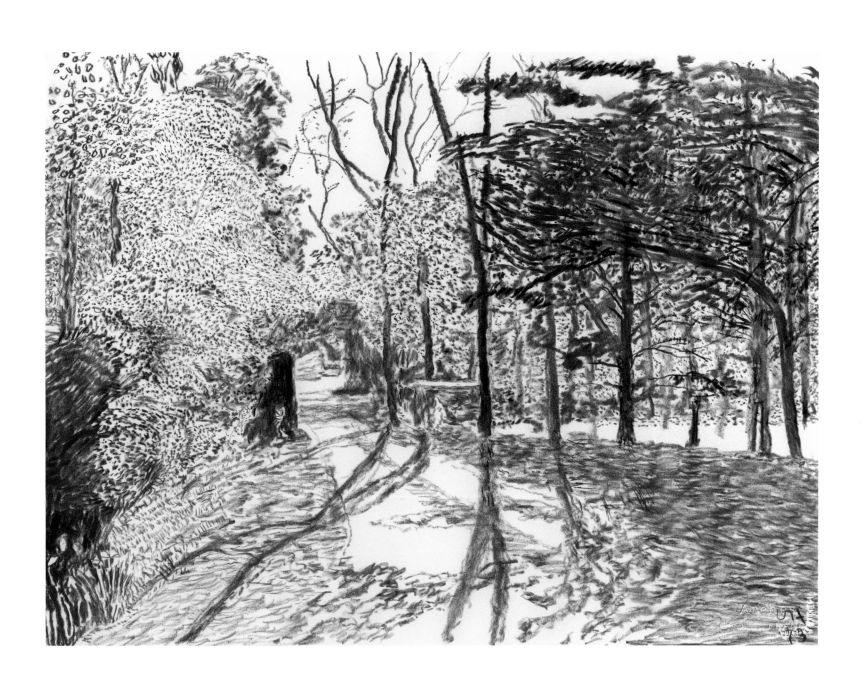

255 | WOLDGATE, 27 MAY, 2013

Charcoal on paper, 22 ⅝ × 30 ¼ in. (57.5 × 76.8 cm)

THE ARRIVAL OF SPRING IN 2013 (TWENTY THIRTEEN)

A SELECTION OF PHOTOGRAPHS

On May 27, 2013, David Hockney finished a new sequence of charcoal drawings, *The Arrival of Spring in 2013 (twenty thirteen)* (pls. 231–255), which depicts a five-stage transformation of the passing of winter through five separate views in Woldgate, East Yorkshire, England (see fig. 84). Hockney realized he had the opportunity to chronicle, in charcoal and paper, spring's arrival in 2013 — just as he had done with twelve iPad drawings and a monumental thirty-two-canvas oil painting in 2011. The painting in that thirteen-part work, *The Arrival of Spring in Woldgate, East Yorkshire in 2011 (twenty eleven), Version 3* (2011–2013; pls. 166–178), fantasizes a colorful spring arrived. The new work lends another means of seeing a seasonal passage through a different artistic vocabulary. These detailed renderings, which utilize some of the most fundamental materials and themes, convey the artist's intention to show the bleakness of winter — and its transformation into spring.

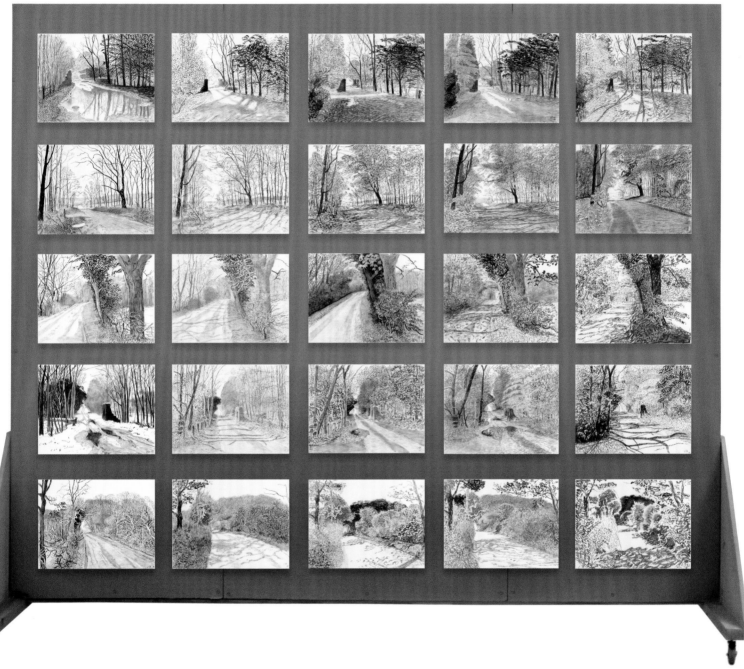

FIG. 84

FIG. 84 The artist's studio wall showing the five transforming
views of *The Arrival of Spring in 2013 (twenty thirteen)*, 2013

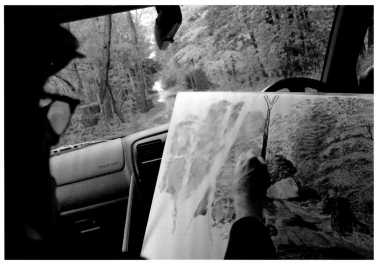

FIG. 85

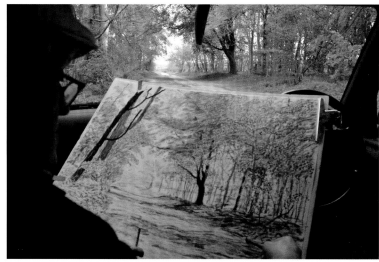

FIG. 86

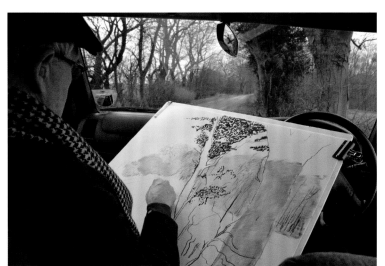

FIG. 87

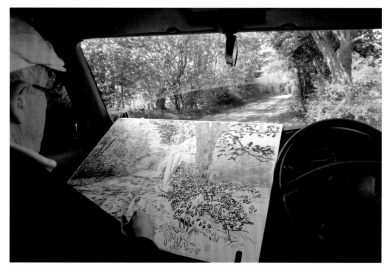

FIG. 88

FIGS. 85–92 David Hockney working on *The Arrival of Spring in 2013 (twenty thirteen)* in his "mobile studio" in Woldgate, East Yorkshire, England, 2013

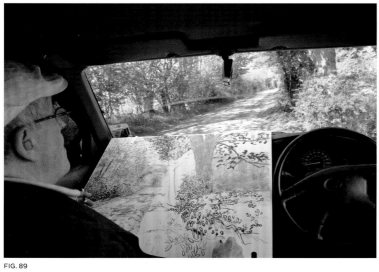

FIG. 89

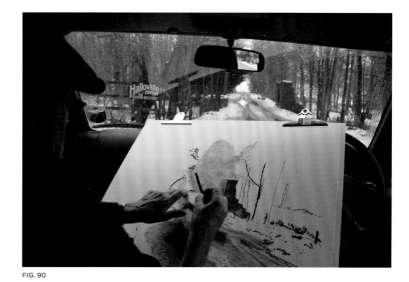

FIG. 90

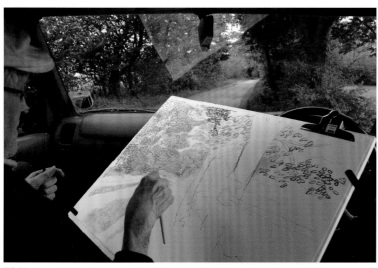

FIG. 91

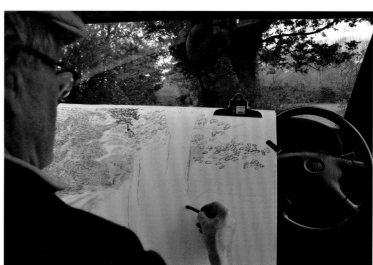

FIG. 92

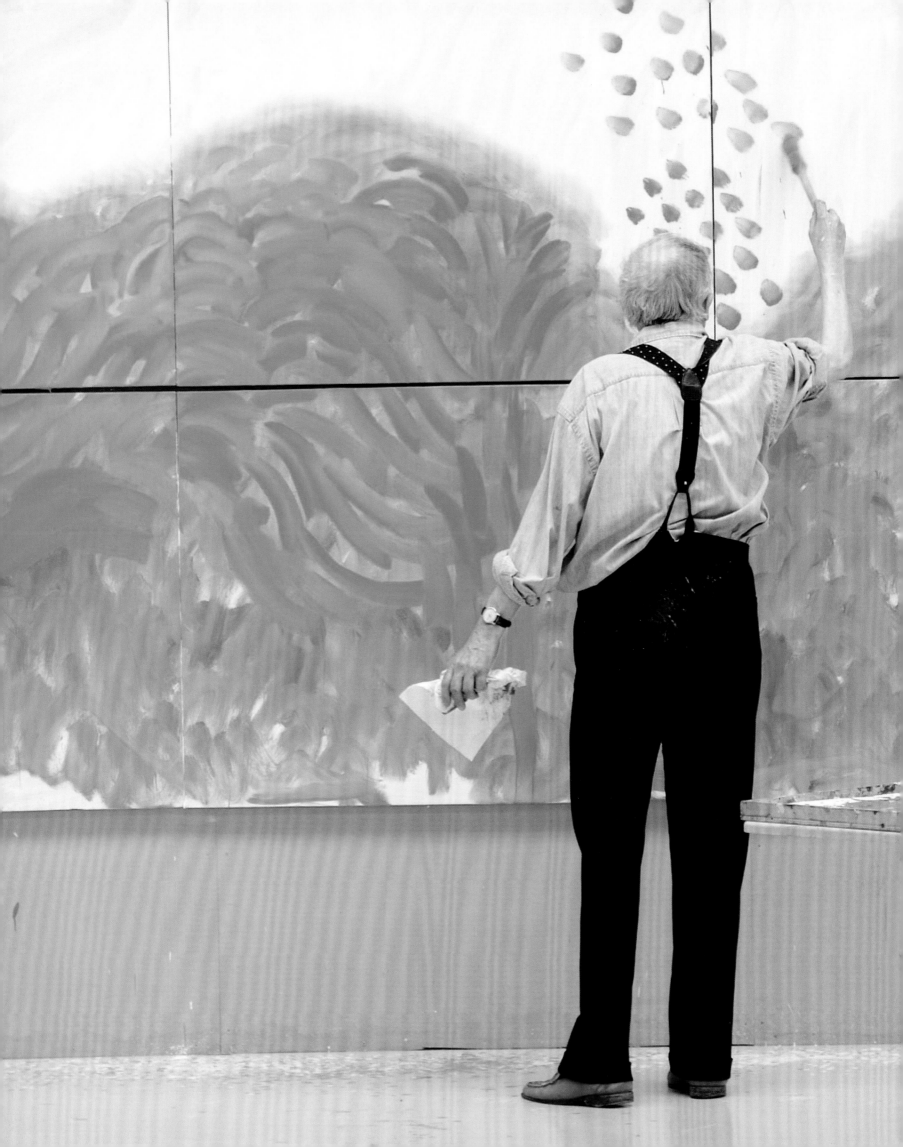

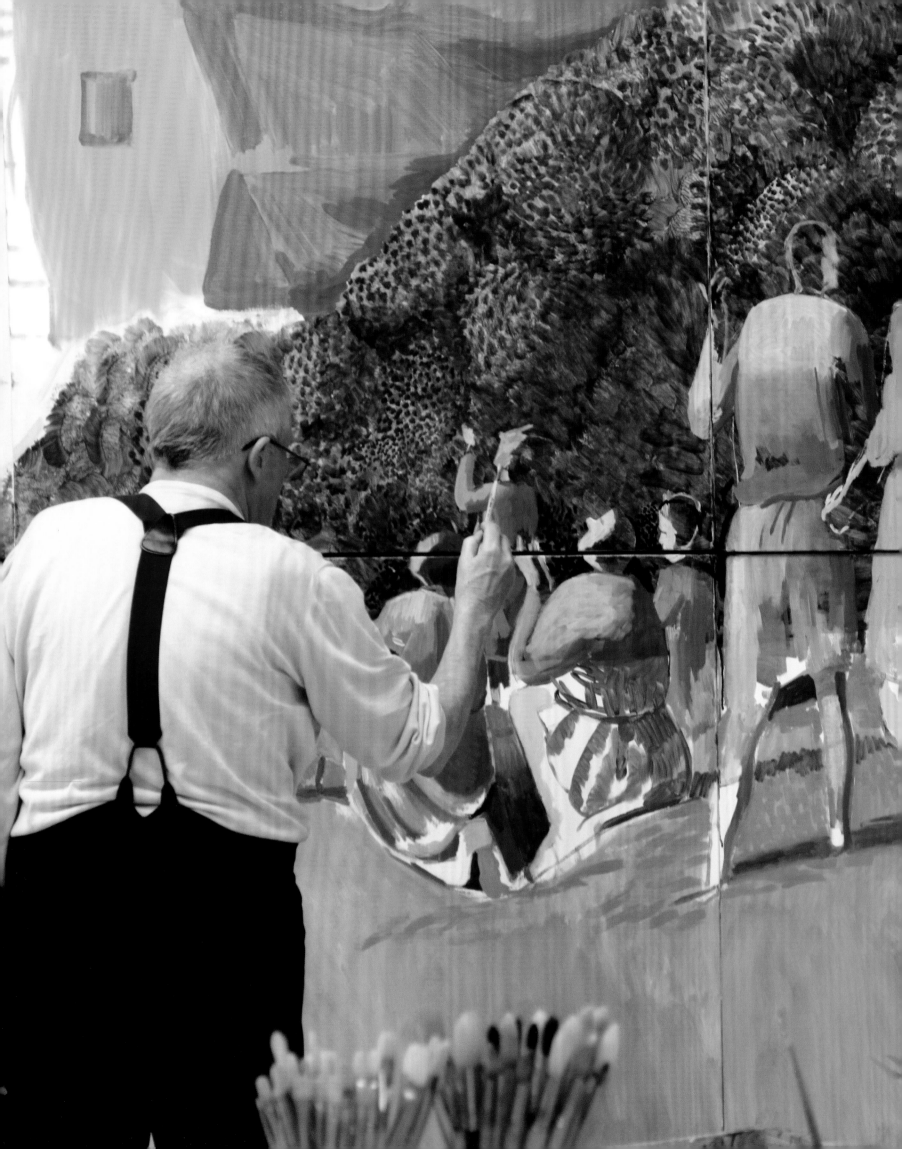

CHECKLIST OF THE EXHIBITION

COMPILED BY **GREGORY EVANS**, CURATOR OF THE EXHIBITION

This checklist documents the exhibition as presented at the de Young Museum in San Francisco. It reflects the order of the plate illustrations and represents the most complete information available at the time of publication. All works are from the collection of David Hockney, unless otherwise noted.

1. *Self-Portrait in Bathroom Mirror with Sink, New York*, 2002
 Watercolor and crayon on paper
 20 × 14 in. (50.8 × 35.6 cm)
 Collection of the David Hockney Foundation

2. *View from Mayflower Hotel, New York (Morning)*, 2002
 Watercolor on paper
 24 × 18 in. (61 × 45.7 cm)

3. *Potted Violets and an Apple, New York*, 2002
 Watercolor and crayon on paper
 24 × 18 in. (61 × 45.7 cm)

4. *A Pot of Violets*, 2002
 Watercolor and crayon on paper
 14 ¼ × 10 ¼ in. (36.2 × 26 cm)
 Private collection

5. *Study for Cherry Blossom*, 2002
 Watercolor and crayon on paper
 10 ¼ × 14 ¼ in. (26 × 36.2 cm)
 Private collection

6. *St. John's Spire & Tree*, 2002
 Watercolor on paper
 10 ½ × 7 in. (26.7 × 17.8 cm)

7. *Michael Smith*, 2002
 Watercolor on paper
 24 × 18 in. (61 × 45.7 cm)

8. *Marco Livingstone*, 2002
 Watercolor on paper
 24 × 18 ⅛ in. (61 × 46 cm)

9. *Sarah Howgate*, 2002
 Watercolor on paper
 24 × 18 ⅛ in. (61 × 46 cm)

10. *George Lawson*, 2002
 Watercolor on paper
 24 × 18 ⅛ in. (61 × 46 cm)

11. *Karen Wright*, 2002
 Watercolor on paper
 24 × 18 ⅛ in. (61 × 46 cm)

12. *Angus Stewart II*, 2002
 Watercolor on paper
 24 × 18 in. (61 × 45.7 cm)

13. *Stephen Stuart-Smith*, 2002
 Watercolor and crayon on paper
 24 × 18 ⅛ in. (61 × 46 cm)

14. *Paul Melia*, 2002
 Watercolor and crayon on paper
 24 × 18 ⅛ in. (61 × 46 cm)

15. *The Maelstrom. Bodø*, 2002
 Watercolor on 6 sheets of paper
 Each: 18 × 24 in. (45.7 × 61 cm)
 Overall: 36 × 72 in. (91.4 × 182.9 cm)
 Private collection, courtesy of L.A. Louver

16. *Near Nordkapp*, 2002
 Watercolor on 4 sheets of paper
 Each: 18 × 24 in. (45.7 × 61 cm)
 Overall: 36 × 48 in. (91.4 × 121.9 cm)
 Private collection

17. *The Black Glacier*, 2002
 Watercolor on 6 sheets of paper
 Each: 18 × 24 in. (45.7 × 61 cm)
 Overall: 36 × 72 in. (91.4 × 182.9 cm)

18. *Goðafoss. Iceland*, 2002
 Watercolor on 8 sheets of paper
 Each: 18 × 24 in. (45.7 × 61 cm)
 Overall: 36 × 96 in. (91.4 × 243.8 cm)

19. *Lindy Dufferin I*, 2002
 Watercolor on 2 sheets of paper
 Each: 24 × 18 in. (61 × 45.7 cm)
 Overall: 48 × 18 in. (121.9 × 45.7 cm)

20. *Andrew Marr*, 2002
 Watercolor on 2 sheets of paper
 Each: 24 × 18 in. (61 × 45.7 cm)
 Overall: 48 × 18 in. (121.9 × 45.7 cm)

FIGS. 93-95 Sketching and watercolor painting in Iceland (see pls. 15–18), 2002

21. *Marco Livingstone and Stephen Stuart-Smith*, 2002
Watercolor on 4 sheets of paper
Each: 24 × 18 in. (61 × 45.7 cm)
Overall: 48 × 36 in. (121.9 × 91.4 cm)

22. *Arcadia Fletcher and Robin Katz*, 2002
Watercolor on 4 sheets of paper
Each: 24 × 18 in. (61 × 45.7 cm)
Overall: 48 × 36 in. (121.9 × 91.4 cm)

23. *Nathan and Sam Joyce*, 2003
Watercolor on 4 sheets of paper
Each: 24 × 18 in. (61 × 45.7 cm)
Overall: 48 × 36 ¼ in. (121.9 × 92.1 cm)

24. *Self-Portrait with Red Braces*, 2003
Watercolor on paper
24 × 18 ⅛ in. (61 × 46 cm)
Private collection

25. *Self-Portrait in Mirror*, 2003
Watercolor on paper
24 × 18 ⅛ in. (61 × 46 cm)
Collection of the David Hockney Foundation

26. *Four Views of Montcalm Terrace*, 2003
Watercolor on 4 sheets of paper
Each: 17 ⅛ × 24 in. (43.5 × 61 cm)
Overall: 34 ¼ × 48 in. (87 × 121.9 cm)

27. *Cactus Garden III*, 2003
Watercolor on 4 sheets of paper
Each: 18 × 24 in. (45.7 × 61 cm)
Overall: 36 ¼ × 48 in. (92.1 × 121.9 cm)
Collection of the David Hockney Foundation

28. *The Massacre and the Problems of Depiction*, 2003
Watercolor on 7 sheets of paper
Each: 18 × 24 in. (45.7 × 61 cm)
Overall: 56 ½ × 72 ¼ in. (143.5 × 183.5 cm)
Collection of the David Hockney Foundation

29. *View from Terrace II*, 2003
Watercolor on 8 sheets of paper
Each: 18 × 24 in. (45.7 × 61 cm)
Overall: 36 ¼ × 96 ⅛ in. (92.1 × 244.2 cm)
Würth GmbH and Co., Germany

30. *Rainy Morning. Holland Park*, 2004
Watercolor on paper
41 ½ × 29 ½ in. (105.4 × 74.9 cm)
Private collection

31. *Andalucia. Alcazaba, Granada*, 2004
Watercolor on 2 sheets of paper
Each: 29 ½ × 41 ½ in. (74.9 × 105.4 cm)
Overall: 29 ½ × 83 in. (74.9 × 210.8 cm)

32. *A Bigger Conservatory I*, 2004
Watercolor on paper
40 × 60 ½ in. (101.6 × 153.7 cm)

33-56 **WATERCOLORS FROM THE SERIES MIDSUMMER: EAST YORKSHIRE, 2004**
(ordered left to right and top to bottom on each page)

33. *Field of Bales. East Yorkshire. Grey Day*, 2004
Watercolor on Paper
15 × 22 ½ in. (38.1 × 57.2 cm)
Collection of the David Hockney Foundation

34. *Harvest, with Farm Equipment*, 2004
Watercolor on Paper
15 × 22 ½ in. (38.1 × 57.2 cm)
Collection of the David Hockney Foundation

35. *Valley, Millington. E. Yorks*, 2004
Watercolor on Paper
15 × 22 ½ in. (38.1 × 57.2 cm)
Collection of the David Hockney Foundation

36. *Tangled Bank and Trees. East Yorkshire*, 2004
Watercolor on Paper
15 × 22 ½ in. (38.1 × 57.2 cm)
Collection of the David Hockney Foundation

37. *Cart Track and Pylon. East Yorkshire*, 2004
Watercolor on Paper
15 × 22 ½ in. (38.1 × 57.2 cm)
Collection of the David Hockney Foundation

38. *Harvest Landscape. East Yorkshire*, 2004
Watercolor on Paper
15 × 22 ½ in. (38.1 × 57.2 cm)
Collection of the David Hockney Foundation

39. *Straw Bales and Stubble. East Yorkshire*, 2004
Watercolor on Paper
15 × 22 ½ in. (38.1 × 57.2 cm)
Collection of the David Hockney Foundation

40. *Ripe Corn on the Roman Road. East Yorkshire*, 2004
Watercolor on Paper
15 × 22 ½ in. (38.1 × 57.2 cm)
Collection of the David Hockney Foundation

41. *Harvested Wheat. East Yorkshire*, 2004
Watercolor on Paper
15 × 22 ½ in. (38.1 × 57.2 cm)
Collection of the David Hockney Foundation

42. *Looking towards Huggate. Late Summer*, 2004
Watercolor on Paper
15 × 22 ½ in. (38.1 × 57.2 cm)
Collection of the David Hockney Foundation

43. *Road with Two Houses. East Yorkshire*, 2004
Watercolor on Paper
15 × 22 ½ in. (38.1 × 57.2 cm)
Collection of the David Hockney Foundation

44. *Road and Tree, near Wetwang*, 2004
Watercolor on Paper
15 × 22 ½ in. (38.1 × 57.2 cm)
Collection of the David Hockney Foundation

45. *Rudston Road, East Yorkshire. Late Summer*, 2004
Watercolor on Paper
15 × 22 ½ in. (38.1 × 57.2 cm)
Collection of the David Hockney Foundation

46. *Trees near Kilham*, 2004
Watercolor on Paper
15 × 22 ½ in. (38.1 × 57.2 cm)
Collection of the David Hockney Foundation

47. *A Gap in the Hedgerow*, 2004
Watercolor on Paper
15 × 22 ½ in. (38.1 × 57.2 cm)
Collection of the David Hockney Foundation

48. *Street Scene. Bridlington*, 2004
Watercolor on Paper
15 × 22 ½ in. (38.1 × 57.2 cm)
Collection of the David Hockney Foundation

49. *Roadside Plants and Landscape. East Yorkshire*, 2004
Watercolor on Paper
15 × 22 ½ in. (38.1 × 57.2 cm)
Collection of the David Hockney Foundation

50. *Jungle Garden, Burton Agnes Hall I*, 2004
Watercolor on Paper
15 × 22 ½ in. (38.1 × 57.2 cm)
Collection of the David Hockney Foundation

51. *Trees near Rudston*, 2004
Watercolor on Paper
15 × 22 ½ in. (38.1 × 57.2 cm)
Collection of the David Hockney Foundation

52. *Kilham. July 2004*
Watercolor on Paper
15 × 22 ½ in. (38.1 × 57.2 cm)
Collection of the David Hockney Foundation

53. *Yorkshire, Summer, with Power Line*, 2004
Watercolor on Paper
15 × 22 ½ in. (38.1 × 57.2 cm)
Collection of the David Hockney Foundation

54. *Road and Farmhouse. East Yorkshire. July 2004*
Watercolor on Paper
15 × 22 ½ in. (38.1 × 57.2 cm)
Collection of the David Hockney Foundation

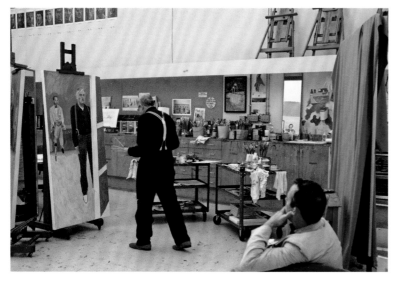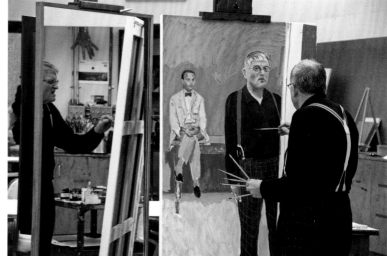

FIGS. 96-101 The artist (with Charlie Scheips) painting *Self-Portrait with Charlie* (2005, pl. 62), 2005

55. *Harvested Field. East Yorkshire*, 2004
Watercolor on Paper
15 × 22 ½ in. (38.1 × 57.2 cm)
Collection of the David Hockney Foundation

56. *Roadside Trees. East Yorkshire*, 2004
Watercolor on Paper
15 × 22 ½ in. (38.1 × 57.2 cm)
Collection of the David Hockney Foundation

57. *The Photographer and His Daughter*, 2005
Oil on canvas
56 × 76 in. (142.2 × 193 cm)

58. *Ann and David, Los Angeles, March 10, 2005*
Oil on canvas
56 × 76 in. (142.2 × 193 cm)

59. *Richard Schmidt*, 2005
Oil on canvas
72 × 36 in. (182.9 × 91.4 cm)

60. *Arthur Lambert*, 2005
Oil on canvas
72 × 36 in. (182.9 × 91.4 cm)

61. *Charlie Scheips*, 2005
Oil on canvas
72 × 36 in. (182.9 × 91.4 cm)

62. *Self-Portrait with Charlie*, 2005
Oil on canvas
72 × 36 in. (182.9 × 91.4 cm)
National Portrait Gallery, London, purchased with help
from the proceeds of the 150th anniversary gala and
Gift Aid visitor ticket donations, 2007, NPG 6819

63. *Elderflower Blossom, Kilham, July*, 2006
Oil on 2 canvases
Each: 48 × 36 in. (121.9 × 91.4 cm)
Overall: 48 × 72 in. (121.9 × 182.9 cm)
Private collection

64. *Bridlington Rooftops, October, November, December*, 2005
Oil on canvas
48 × 60 in. (121.9 × 152.4 cm)
Private collection

65. *A Closer Winter Tunnel, February–March*, 2006
Oil on 6 canvases
Each: 36 × 48 in. (91.4 × 121.9 cm)
Overall: 72 × 144 in. (182.9 × 365.8 cm)
Collection of the Art Gallery of New South Wales, Sydney,
Australia, purchased with funds provided by Geoff and Vicki
Ainsworth, the Florence and William Crosby Bequest, and
the Art Gallery of New South Wales Foundation 2007

66. *Winter Tunnel with Snow, March*, 2006
Oil on canvas
36 × 48 in. (91.4 × 121.9 cm)

67. *Winter Tunnel, February*, 2006
Oil on canvas
36 × 48 in. (91.4 × 121.9 cm)

68. *The Tunnel Early Autumn, October*, 2005
Oil on canvas
36 × 48 in. (91.4 × 121.9 cm)

69. *Early July Tunnel*, 2006
Oil on 2 canvases
Each: 48 × 36 in. (121.9 × 91.4 cm)
Overall: 48 × 72 in. (121.9 × 182.9 cm)

70. *Late Spring Tunnel, May*, 2006
Oil on 2 canvases
Each: 48 × 36 in. (121.9 × 91.4 cm)
Overall: 48 × 72 in. (121.9 × 182.9 cm)

71. *Late November Tunnel*, 2006
Oil on 2 canvases
Each: 48 × 36 in. (121.9 × 91.4 cm)
Overall: 48 × 72 in. (121.9 × 182.9 cm)

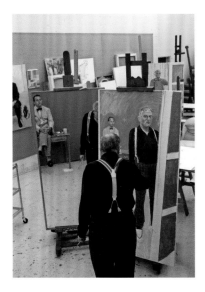 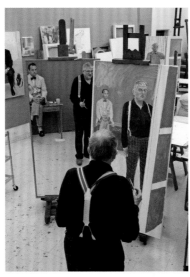 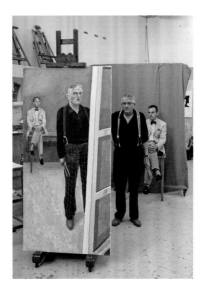

72. *Early November Tunnel*, 2006
Oil on 2 canvases
Each: 48 × 36 in. (121.9 × 91.4 cm)
Overall: 48 × 72 in. (121.9 × 182.9 cm)

73. *Fridaythorpe Valley, 25 October 2005*
Oil on canvas
36 × 48 in. (91.4 × 121.9 cm)

74. *Tree on Woldgate, 6 March*, 2006
Oil on canvas
36 × 48 in. (91.4 × 121.9 cm)

75. *Vista near Fridaythorpe, Aug, Sept 2006*
Oil on 4 canvases
Each: 36 × 48 in. (91.4 × 121.9 cm)
Overall: 72 × 96 in. (182.9 × 243.8 cm)

76. *Wheat Field beyond the Tunnel, 16 August 2006*
Oil on canvas
36 × 48 in. (91.4 × 121.9 cm)

77. *The Road to Thwing, July*, 2006
Oil on 6 canvases
Each: 36 × 48 in. (91.4 × 121.9 cm)
Overall: 72 × 144 in. (182.9 × 365.8 cm)

78. *Woldgate Woods, 30 March–21 April 2006*
Oil on 6 canvases
Each: 36 × 48 in. (91.4 × 121.9 cm)
Overall: 72 × 144 in. (182.9 × 365.8 cm)

79. *Woldgate Woods III, 20 & 21 May 2006*
Oil on 6 canvases
Each: 36 × 48 in. (91.4 × 121.9 cm)
Overall: 72 × 144 in. (182.9 × 365.8 cm)

80. *Woldgate Woods, 26, 27 & 30 July 2006*
Oil on 6 canvases
Each: 36 × 48 in. (91.4 × 121.9 cm)
Overall: 72 × 144 in. (182.9 × 365.8 cm)

81. *Woldgate Woods, 6 & 9 November 2006*
Oil on 6 canvases
Each: 36 × 48 in. (91.4 × 121.9 cm)
Overall: 72 × 144 in. (182.9 × 365.8 cm)

82. *Six-Part Study for "Bigger Trees,"* 2007
Oil on 6 canvases
Each: 36 × 48 in. (91.4 × 121.9 cm)
Overall: 72 × 144 in. (182.9 × 365.8 cm)

83. *The Second Totem Tree*, 2008
Oil on canvas
60 × 48 in. (152.4 × 121.9 cm)

84. *Woldgate Lane to Burton Agnes*, 2007
Oil on 2 canvases
Each: 48 × 36 in. (121.9 × 91.4 cm)
Overall: 48 × 72 in. (121.9 × 182.9 cm)
Collection of the David Hockney Foundation

85. *Cut Trees—Timber*, 2008
Charcoal on paper
26 × 40 ¼ in. (66 × 102.2 cm)

86. *Timber Gone*, 2008
Charcoal on paper
26 × 40 ¼ in. (66 × 102.2 cm)

87. *More Felled Trees on Woldgate*, 2008
Oil on 2 canvases
Each: 60 × 48 in. (152.4 × 121.9 cm)
Overall: 60 × 96 in. (152.4 × 243.8 cm)

88. *Hawthorn Blossom on the B1253, 31 May 08*, 2008
Oil on canvas
30 × 96 in. (76.2 × 243.8 cm)

89. *Bigger Trees nearer Warter, Summer 2008*
Oil on 9 canvases
Each: 36 × 48 in. (91.4 × 121.9 cm)
Overall: 108 × 144 in. (274.3 × 365.8 cm)

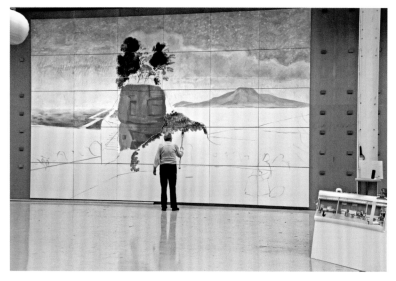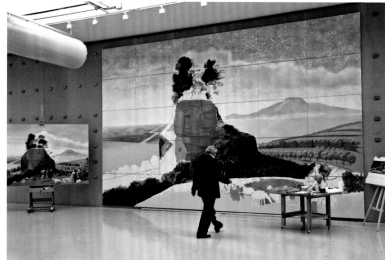

<small>FIGS. 102-105</small> David Hockney at work on *A Bigger Message* (2010, pl. 105), 2010

90. *Bigger Trees nearer Warter, Winter 2008*
Oil on 9 canvases
Each: 36 × 48 in. (91.4 × 121.9 cm)
Overall: 108 × 144 in. (274.3 × 365.8 cm)

91. *May Blossom on the Roman Road*, 2009
Oil on 8 canvases
Each: 36 × 48 in. (91.4 × 121.9 cm)
Overall: 72 × 192 in. (182.9 × 487.7 cm)

92. *The Big Hawthorn*, 2008
Oil on 9 canvases
Each: 36 × 48 in. (91.4 × 121.9 cm)
Overall: 108 × 144 in. (274.3 × 365.8 cm)

93. *A Bigger Jamie McHale 1*, 2008
Inkjet-printed computer drawing on paper,
mounted on Dibond
An edition of 12
63 ⅞ × 42 ⅞ in. (162.2 × 108.9 cm)

94. *A Bigger Dominic Elliott*, 2008
Inkjet-printed computer drawing on paper,
mounted on Dibond
An edition of 12
63 ⅞ × 42 ⅞ in. (162.2 × 108.9 cm)

95. *A Bigger Jean-Pierre Gonçalves de Lima*, 2008
Inkjet-printed computer drawing on paper,
mounted on Dibond
An edition of 12
63 ⅞ × 42 ⅞ in. (162.2 × 108.9 cm)

96. *A Bigger Jamie McHale 2*, 2008
Inkjet-printed computer drawing on paper,
mounted on Dibond
An edition of 12
63 ⅞ × 42 ⅞ in. (162.2 × 108.9 cm)

97. *A Bigger Matelot Kevin Druez 2*, 2009
Inkjet-printed computer drawing on paper,
mounted on Dibond
63 ⅞ × 42 ⅞ in. (162.2 × 108.9 cm)

98. *Autumn Leaves*, 2008
Inkjet-printed computer drawing on 2 sheets of paper,
mounted on Dibond
An edition of 7
Each: 60 ¾ × 42 ¾ in. (154.3 × 108.6 cm)
Overall: 60 ¾ × 85 ½ in. (154.3 × 217.2 cm)

99. *A Bigger Green Valley*, 2008
Inkjet-printed computer drawing on 2 sheets of paper,
mounted on Dibond
An edition of 15
Each: 60 ¾ × 42 ¾ in. (154.3 × 108.6 cm)
Overall: 60 ¾ × 85 ½ in. (154.3 × 217.2 cm)

100. *Under the Trees, Bigger*, 2010–2011
Oil on 20 canvases
Each: 36 × 48 in. (91.4 × 121.9 cm)
Overall: 144 × 240 in. (365.8 × 609.6 cm)

101. *The Sermon on the Mount II (after Claude)*, 2010
Oil on canvas
67 ½ × 102 ¼ in. (171.5 × 259.7 cm)

102. *The Sermon on the Mount XI (after Claude)*, 2010
Oil on canvas
67 ½ × 102 ¼ in. (171.5 × 259.7 cm)

103. *The Sermon on the Mount VI (after Claude)*, 2010
Oil on canvas
67 ½ × 102 ¼ in. (171.5 × 259.7 cm)

104. *The Sermon on the Mount X (after Claude)*, 2010
Oil on canvas
67 ½ × 102 ¼ in. (171.5 × 259.7 cm)

105. *A Bigger Message*, 2010
Oil on 30 canvases
Each: 36 × 48 in. (91.4 × 121.9 cm)
Overall: 180 × 288 in. (457.2 × 731.5 cm)

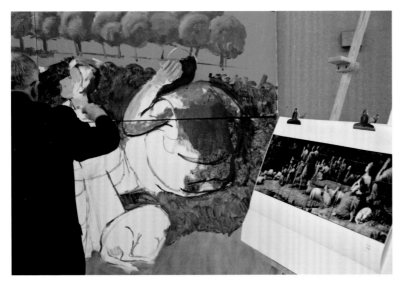 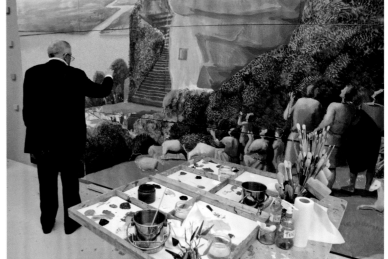

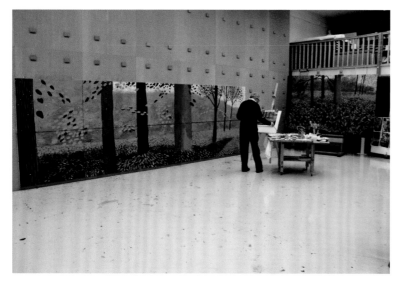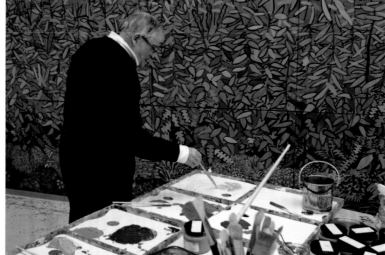

FIGS. 106-109 The artist working on *Under the Trees, Bigger* (2010–2011, pl. 100), 2010–2011

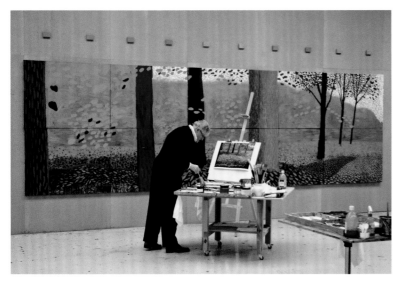 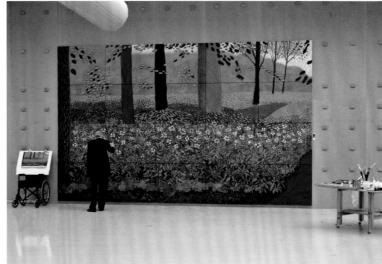

166. *The Arrival of Spring in Woldgate, East Yorkshire in 2011*
 (twenty eleven), Version 3—18 December, 2011
 iPad drawing printed on 4 sheets of paper,
 mounted on Dibond
 Each: 46 ½ × 35 in. (118.1 × 88.9 cm)
 Overall: 93 × 70 in. (236.2 × 177.8 cm)

167. *The Arrival of Spring in Woldgate, East Yorkshire in 2011*
 (twenty eleven), Version 3—29 December, No. 1, 2011
 iPad drawing printed on 4 sheets of paper,
 mounted on Dibond
 Each: 46 ½ × 35 in. (118.1 × 88.9 cm)
 Overall: 93 × 70 in. (236.2 × 177.8 cm)

168. *The Arrival of Spring in Woldgate, East Yorkshire in 2011*
 (twenty eleven), Version 3—29 December, No. 2, 2011
 iPad drawing printed on 4 sheets of paper,
 mounted on Dibond
 Each: 46 ½ × 35 in. (118.1 × 88.9 cm)
 Overall: 93 × 70 in. (236.2 × 177.8 cm)

169. *The Arrival of Spring in Woldgate, East Yorkshire in 2011*
 (twenty eleven), Version 3—2 January, 2011
 iPad drawing printed on 4 sheets of paper,
 mounted on Dibond
 Each: 46 ½ × 35 in. (118.1 × 88.9 cm)
 Overall: 93 × 70 in. (236.2 × 177.8 cm)

170. *The Arrival of Spring in Woldgate, East Yorkshire in 2011*
 (twenty eleven), Version 3—29 January, 2011
 iPad drawing printed on 4 sheets of paper,
 mounted on Dibond
 Each: 46 ½ × 35 in. (118.1 × 88.9 cm)
 Overall: 93 × 70 in. (236.2 × 177.8 cm)

171. *The Arrival of Spring in Woldgate, East Yorkshire in 2011*
 (twenty eleven), Version 3—25 March, 2011
 iPad drawing printed on 4 sheets of paper,
 mounted on Dibond
 Each: 46 ½ × 35 in. (118.1 × 88.9 cm)
 Overall: 93 × 70 in. (236.2 × 177.8 cm)

172. *The Arrival of Spring in Woldgate, East Yorkshire in 2011*
 (twenty eleven), Version 3—4 May, 2011
 iPad drawing printed on 4 sheets of paper,
 mounted on Dibond
 Each: 46 ½ × 35 in. (118.1 × 88.9 cm)
 Overall: 93 × 70 in. (236.2 × 177.8 cm)

173. *The Arrival of Spring in Woldgate, East Yorkshire in 2011*
 (twenty eleven), Version 3—11 May, 2011
 iPad drawing printed on 4 sheets of paper,
 mounted on Dibond
 Each: 46 ½ × 35 in. (118.1 × 88.9 cm)
 Overall: 93 × 70 in. (236.2 × 177.8 cm)

174. *The Arrival of Spring in Woldgate, East Yorkshire in 2011*
 (twenty eleven), Version 3—16 May, 2011
 iPad drawing printed on 4 sheets of paper,
 mounted on Dibond
 Each: 46 ½ × 35 in. (118.1 × 88.9 cm)
 Overall: 93 × 70 in. (236.2 × 177.8 cm)

175. *The Arrival of Spring in Woldgate, East Yorkshire in 2011*
 (twenty eleven), Version 3—30 May, 2011
 iPad drawing printed on 4 sheets of paper,
 mounted on Dibond
 Each: 46 ½ × 35 in. (118.1 × 88.9 cm)
 Overall: 93 × 70 in. (236.2 × 177.8 cm)

176. *The Arrival of Spring in Woldgate, East Yorkshire in 2011*
 (twenty eleven), Version 3—31 May, No. 1, 2011
 iPad drawing printed on 4 sheets of paper,
 mounted on Dibond
 Each: 46 ½ × 35 in. (118.1 × 88.9 cm)
 Overall: 93 × 70 in. (236.2 × 177.8 cm)

177. *The Arrival of Spring in Woldgate, East Yorkshire in 2011*
 (twenty eleven), Version 3—2 June, 2011
 iPad drawing printed on 4 sheets of paper,
 mounted on Dibond
 Each: 46 ½ × 35 in. (118.1 × 88.9 cm)
 Overall: 93 × 70 in. (236.2 × 177.8 cm)

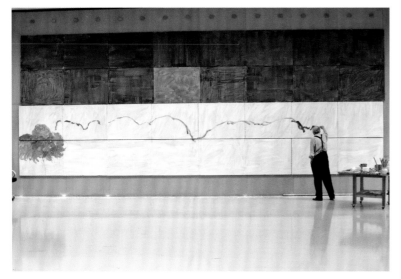
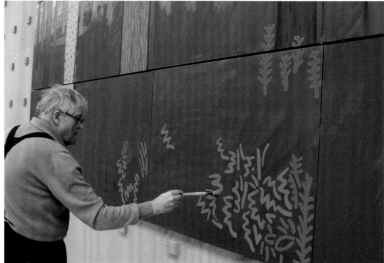

FIGS. 110-113 David Hockney painting *The Arrival of Spring in Woldgate, East Yorkshire in 2011 (twenty eleven), Version 3* (2011–2013, pl. 178), 2011

178. *The Arrival of Spring in Woldgate, East Yorkshire in 2011 (twenty eleven), Version 3*, 2011–2013
13 parts: oil on 32 canvases; 12 iPad drawings each printed on 4 sheets of paper, mounted on Dibond
Each panel: 36 × 48 in. (91.4 × 121.9 cm)
Overall (canvas): 144 × 384 in. (365.8 × 975.4 cm)
Each sheet: 46 ½ × 35 in. (118.1 × 88.9 cm)
Overall (drawings): 93 × 70 in. (236.2 × 177.8 cm)

179–196 **iPAD DRAWINGS FROM THE YOSEMITE SUITE, 2010**
(ordered left to right and top to bottom on each page)

179. *410*, 2010
iPad drawing

180. *437*, 2010
iPad drawing

181. *398*, 2010
iPad drawing

182. *420*, 2010
iPad drawing

183. *402*, 2010
iPad drawing

184. *440*, 2010
iPad drawing

185. *428*, 2010
iPad drawing

186. *435*, 2010
iPad drawing

187. *409*, 2010
iPad drawing

188. *430*, 2010
iPad drawing

189. *413*, 2010
iPad drawing

190. *418*, 2010
iPad drawing

191. *419*, 2010
iPad drawing

192. *416*, 2010
iPad drawing

193. *434*, 2010
iPad drawing

194. *408*, 2010
iPad drawing

195. *436*, 2010
iPad drawing

196. *399*, 2010
iPad drawing

197–201 **BIGGER YOSEMITE iPAD DRAWINGS, 2011**

197. *Yosemite I, October 16th 2011*
iPad drawing printed on 6 sheets of paper, mounted on 6 sheets of Dibond
Each: 71 ¾ × 42 ¾ in. (182.3 × 108.6 cm)
Overall: 143 ½ × 128 ¼ in. (364.5 × 325.8 cm)

198. *Yosemite II, October 16th 2011*
iPad drawing printed on 6 sheets of paper, mounted on 6 sheets of Dibond
Each: 71 ¾ × 35 ¾ in. (182.3 × 90.8 cm)
Overall: 143 ½ × 107 ¼ in. (364.5 × 272.4 cm)

199. *Yosemite III, October 5th 2011*
iPad drawing printed on 6 sheets of paper, mounted on 6 sheets of Dibond
Each: 71 ¾ × 35 ¾ in. (182.3 × 90.8 cm)
Overall: 143 ½ × 107 ¼ in. (364.5 × 272.4 cm)

200. *Yosemite I, October 5th 2011*
iPad drawing printed on 6 sheets of paper, mounted on 6 sheets of Dibond
Each: 71 ¾ × 35 ¾ in. (182.3 × 90.8 cm)
Overall: 143 ½ × 107 ¼ in. (364.5 × 272.4 cm)

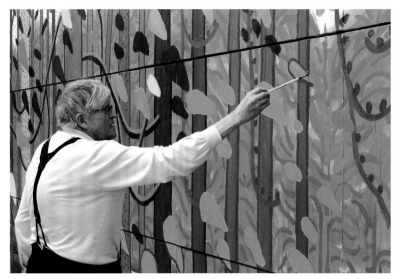 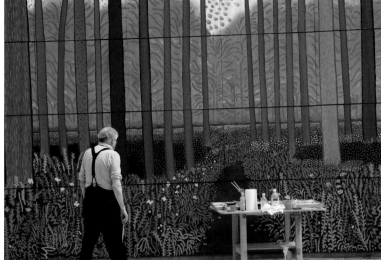

201. *Yosemite II, October 5th 2011*
iPad drawing printed on 6 sheets of paper,
mounted on 6 sheets of Dibond
Each: 71¾ × 35¾ in. (182.3 × 90.8 cm)
Overall: 143½ × 107¼ in. (364.5 × 272.4 cm)

202–209 iPAD SELF-PORTRAITS, 2012
(ordered left to right and top to bottom on each page)

202. *1219*, 2012
iPad drawing

203. *1233*, 2012
iPad drawing

204. *1216*, 2012
iPad drawing

205. *1200*, 2012
iPad drawing

206. *1190*, 2012
iPad drawing

207. *1187*, 2012
iPad drawing

208. *1196*, 2012
iPad drawing

209. *1215*, 2012
iPad drawing

210. Still from *May 12th 2011, Rudston to Kilham Road, 5pm*
18 digital videos synchronized and presented on
18 55-inch NEC screens to comprise a single artwork
Each: 27 × 47⅞ in. (68.6 × 121.6 cm)
Overall: 81 × 287 in. (205.7 × 729 cm)
Duration: 1:50 min.

211. Still from *Woldgate Woods, April 18th 2011*
9 digital videos synchronized and presented on
9 55-inch NEC screens to comprise a single artwork
Each: 27 × 47⅞ in. (68.6 × 121.6 cm)
Overall: 81 × 143½ in. (205.7 × 364.49 cm)
Duration: 4:18 min.

212. Still from *Woldgate Woods, June 2nd 2010*
9 digital videos synchronized and presented on
9 55-inch NEC screens to comprise a single artwork
Each: 27 × 47⅞ in. (68.6 × 121.6 cm)
Overall: 81 × 143½ in. (205.7 × 364.49 cm)
Duration: 4:18 min.

213. Still from *Woldgate Woods, November 7th 2010*
9 digital videos synchronized and presented on
9 55-inch NEC screens to comprise a single artwork
Each: 27 × 47⅞ in. (68.6 × 121.6 cm)
Overall: 81 × 143½ in. (205.7 × 364.49 cm)
Duration: 4:18 min.

214. Still from *Woldgate Woods, November 26th 2010*
9 digital videos synchronized and presented on
9 55-inch NEC screens to comprise a single artwork
Each: 27 × 47⅞ in. (68.6 × 121.6 cm)
Overall: 81 × 143½ in. (205.7 × 364.49 cm)
Duration: 4:18 min.

215. Still from *The Jugglers*, 2012
18 digital videos synchronized and presented on
18 55-inch NEC screens to comprise a single artwork
Each: 27 × 47⅞ in. (68.6 × 121.6 cm)
Overall: 81 × 287 in. (205.7 × 729 cm)
Duration: 22:13 min.

216. *Vandalized Totem, 16–17 November*, 2012
Charcoal on paper
22⅝ × 30¼ in. (57.5 × 76.8 cm)

217. *Vandalized Totem, 19–20 November*, 2012
Charcoal on paper
22⅝ × 30¼ in. (57.5 × 76.8 cm)

218. *Vandalized Totem, 22 November*, 2012
Charcoal on paper
22⅝ × 30¼ in. (57.5 × 76.8 cm)

219. *Vandalized Totem, 25 November*, 2012
Charcoal on paper
22⅝ × 30¼ in. (57.5 × 76.8 cm)

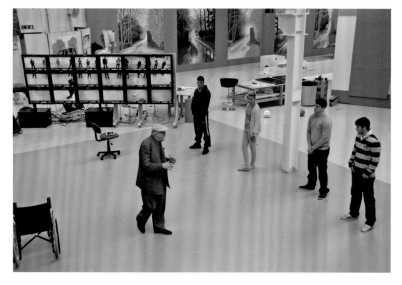 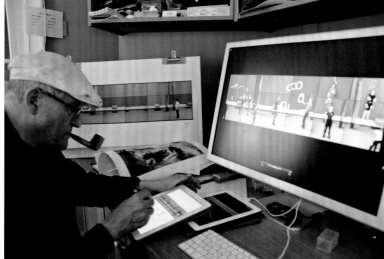

FIGS. 114–117 David Hockney (with assistants) making *The Jugglers* (2012, pl. 215), 2012

220. *Vandalized Totem in Snow, 5 December*, 2012
Charcoal on paper
22 ⅝ × 30 ¼ in. (57.5 × 76.8 cm)

221. *Dominic Elliott, 30–31 January*, 2013
Charcoal on paper
30 ¼ × 22 ⅝ in. (76.8 × 57.5 cm)

222. *Jean-Pierre Gonçalves de Lima, 25 January*, 2013
Charcoal on paper
30 ¼ × 22 ⅝ in. (76.8 × 57.5 cm)

223. *John Hockney, 13–14 February*, 2013
Charcoal on paper
30 ¼ × 22 ⅝ in. (76.8 × 57.5 cm)

224. *Margaret Hockney, 14 February, 2013*
Charcoal on paper
30 ¼ × 22 ⅝ in. (76.8 × 57.5 cm)

225. *Richard Todd, 29 January*, 2013
Charcoal on paper
30 ¼ × 22 ⅝ in. (76.8 × 57.5 cm)

226. *Robbie Stark, 27 January*, 2013
Charcoal on paper
30 ¼ × 22 ⅝ in. (76.8 × 57.5 cm)

227. *Mark Shephard, 28 February*, 2013
Charcoal on paper
30 ¼ × 22 ⅝ in. (76.8 × 57.5 cm)

228. *Maurice Payne, 16 April*, 2013
Charcoal on paper
30 ¼ × 22 ⅝ in. (76.8 × 57.5 cm)

229. *Richard Marriott, 3–4 March*, 2013
Charcoal on paper
30 ¼ × 22 ⅝ in. (76.8 × 57.5 cm)

230. *Sally Marriott, 5, 7 & 11 March*, 2013
Charcoal on paper
30 ¼ × 22 ⅝ in. (76.8 × 57.5 cm)

231–255 **THE ARRIVAL OF SPRING IN 2013**
(TWENTY THIRTEEN)

231. *Woldgate, 22–23 January*, 2013
Charcoal on paper
22 ⅝ × 30 ¼ in. (57.5 × 76.8 cm)

232. *Woldgate, 6–7 February*, 2013
Charcoal on paper
22 ⅝ × 30 ¼ in. (57.5 × 76.8 cm)

233. *Woldgate, 6–7 February*, 2013
Charcoal on paper
22 ⅝ × 30 ¼ in. (57.5 × 76.8 cm)

234. *Woldgate, 25–27 February*, 2013
Charcoal on paper
22 ⅝ × 30 ¼ in. (57.5 × 76.8 cm)

235. *Woldgate, 16 & 26 March*, 2013
Charcoal on paper
22 ⅝ × 30 ¼ in. (57.5 × 76.8 cm)

236. *Woldgate, 30 April, 1 & 5 May*, 2013
Charcoal on paper
22 ⅝ × 30 ¼ in. (57.5 × 76.8 cm)

237. *Woldgate, 3 May*, 2013
Charcoal on paper
22 ⅝ × 30 ¼ in. (57.5 × 76.8 cm)

238. *Woldgate, 3 May*, 2013
Charcoal on paper
22 ⅝ × 30 ¼ in. (57.5 × 76.8 cm)

239. *Woldgate, 6 May*, 2013
Charcoal on paper
22 ⅝ × 30 ¼ in. (57.5 × 76.8 cm)

240. *Woldgate, 6–7 May*, 2013
Charcoal on paper
22 ⅝ × 30 ¼ in. (57.5 × 76.8 cm)

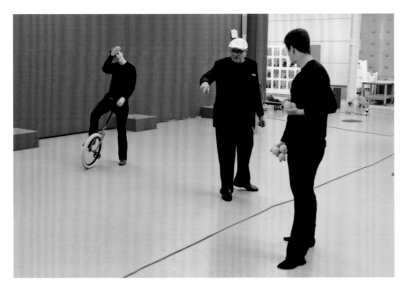 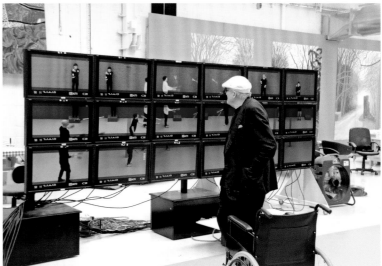

241. *Woldgate, 8 May*, 2013
Charcoal on paper
22 ⅝ × 30 ¼ in. (57.5 × 76.8 cm)

242. *Woldgate, 9 & 12 May*, 2013
Charcoal on paper
22 ⅝ × 30 ¼ in. (57.5 × 76.8 cm)

243. *Woldgate, 10–11 May*, 2013
Charcoal on paper
22 ⅝ × 30 ¼ in. (57.5 × 76.8 cm)

244. *Woldgate, 11–12 May*, 2013
Charcoal on paper
22 ⅝ × 30 ¼ in. (57.5 × 76.8 cm)

245. *Woldgate, 12–13 May*, 2013
Charcoal on paper
22 ⅝ × 30 ¼ in. (57.5 × 76.8 cm)

246. *Woldgate, 15–16 May*, 2013
Charcoal on paper
22 ⅝ × 30 ¼ in. (57.5 × 76.8 cm)

247. *Woldgate, 16 May*, 2013
Charcoal on paper
22 ⅝ × 30 ¼ in. (57.5 × 76.8 cm)

248. *Woldgate, 17 May*, 2013
Charcoal on paper
22 ⅝ × 30 ¼ in. (57.5 × 76.8 cm)

249. *Woldgate, 18–19 May*, 2013
Charcoal on paper
22 ⅝ × 30 ¼ in. (57.5 × 76.8 cm)

250. *Woldgate, 20–21 May*, 2013
Charcoal on paper
22 ⅝ × 30 ¼ in. (57.5 × 76.8 cm)

251. *Woldgate, 21–22 May*, 2013
Charcoal on paper
22 ⅝ × 30 ¼ in. (57.5 × 76.8 cm)

252. *Woldgate, 25 May*, 2013
Charcoal on paper
22 ⅝ × 30 ¼ in. (57.5 × 76.8 cm)

253. *Woldgate, 26 May*, 2013
Charcoal on paper
22 ⅝ × 30 ¼ in. (57.5 × 76.8 cm)

254. *Woldgate, 26 May*, 2013
Charcoal on paper
22 ⅝ × 30 ¼ in. (57.5 × 76.8 cm)

255. *Woldgate, 27 May*, 2013
Charcoal on paper
22 ⅝ × 30 ¼ in. (57.5 × 76.8 cm)

SELECTED BIBLIOGRAPHY

Barringer, Tim, Edith Devaney, Margaret Drabble, Martin Gayford, Marco Livingstone, David Hockney, and Xavier F. Salomon. *David Hockney: A Bigger Picture*. Exh. cat. London: Royal Academy of Arts; Thames and Hudson, 2012.

Bohm, David. *Wholeness and the Implicate Order*. London: Routledge, 1980, x–xi.

David Hockney: Travels with Pen, Pencil and Ink. Exh. cat. London: Tate Gallery; London and New York: Petersburg Press, 1980.

Edgerton, Samuel Y., Jr. *The Renaissance Rediscovery of Linear Perspective*. New York: Basic Books, 1975, 164–165.

Falco, Charles M. "The Hockney-Falco Thesis" (regularly updated). http://fp.optics.arizona.edu/SSD/art-optics/index.html.

Friedman, Martin L. *Hockney Paints the Stage*. Exh. cat. Minneapolis: Walker Art Center; New York: Abbeville Press, 1983.

Gayford, Martin. *A Bigger Message: Conversations with David Hockney*. London: Thames and Hudson, 2011.

Haas, Philip (director), and David Hockney. *A Day on the Grand Canal with the Emperor of China, or, Surface Is Illusion but So Is Depth*. Harrington Park, New Jersey: Milestone Film & Video, 1991. DVD, 46 min.

Hockney, David, and Lawrence Weschler. *Cameraworks*. New York: Knopf, 1984.

Hockney, David. *Hockney's Pictures: The Definitive Retrospective*. New York: Bulfinch Press, 2004.

Hockney, David. *Secret Knowledge: Rediscovering the Lost Techniques of the Old Masters*. Rev. ed. London: Thames and Hudson, 2006. First published in 2001.

Hockney, David, and Nikos Stangos. *That's the Way I See It*. 1993. Reprint, London: Thames and Hudson, 2002.

Howgate, Sarah, Martin Gayford, and David Hockney. *Lucian Freud: Painting People*. Exh. cat. London: National Portrait Gallery; New Haven, Connecticut: Yale University Press, 2012.

Howgate, Sarah, and Barbara Stern Shapiro, with Mark Glazebrook, Marco Livingstone, and Edmund White. *David Hockney Portraits*. Exh. cat. London: National Portrait Gallery; New Haven, Connecticut: Yale University Press, 2006.

Livingstone, Marco. *David Hockney: My Yorkshire*. London: Enitharmon Editions, 2011.

Livingstone, Marco. "Faces Lit with Life: Hockney's Camera Lucida Portraits," in *Likeness: Recent Portrait Drawings by David Hockney*. Exh. cat. Los Angeles: Hammer Museum, University of California, 2000.

Livingstone, Marco. "12 Portraits after Ingres in a Uniform Style," in *Encounters: New Art from Old*. Exh. cat. London: National Gallery, 2000.

Livingstone, Marco, and Kay Heymer. *Hockney's Portraits and People*. London: Thames and Hudson, 2003.

Piper, David. *The English Face*. 1957. Reprint, London: National Portrait Gallery, 1978.

Rowley, George. *Principles of Chinese Painting*. Princeton: Princeton University Press, 1947, 61.

Stangos, Nikos, ed. *David Hockney by David Hockney: My Early Years*. London: Thames and Hudson, 1976.

Sykes, Christopher Simon. *David Hockney: The Biography, 1937–1975: A Rake's Progress*. New York: Nan A. Talese / Doubleday, 2012.

Weschler, Lawrence. *True to Life: Twenty-Five Years of Conversations with David Hockney*. Berkeley: University of California Press, 2008.

INDEX

This index contains all the works in the catalogue. The works listed for David Hockney are those referenced in this catalogue and do not constitute the entire body of his work. Some titles have been grouped together under their relevant headings in the index; the headings may be found in the Checklist of the Exhibition, pp. 211–223. All works are by David Hockney unless otherwise indicated. Page numbers in *italics* refer to illustrations.

Published by the Fine Arts Museums of San Francisco and DelMonico Books | Prestel, on the occasion of the exhibition *David Hockney: A Bigger Exhibition*, de Young Museum, San Francisco, October 26, 2013–January 20, 2014

This exhibition is organized by the Fine Arts Museums of San Francisco in collaboration with David Hockney, Inc. The exhibition is designed and curated by Gregory Evans.

Director's Circle:
David Davies and Jack Weeden
Bequest of Dr. Charles L. Dibble
The Michael Taylor Trust
Diane B. Wilsey

Curator's Circle:
Ray and Dagmar Dolby
Marissa Mayer and Zachary Bogue

This catalogue is published with the assistance of the Andrew W. Mellon Foundation Endowment for Publications.

A version of David Hockney's essay "To See the Bigger Picture Is to See More" was first published in the *Financial Times*, October 27, 2012, on the occasion of the opening of *David Hockney: A Bigger Picture* at the Ludwig Museum in Cologne, Germany.

Lawrence Weschler's essay "David Hockney's New iPhone Passion" is expanded from an article originally published in the *New York Review of Books*, October 23, 2009.

Library of Congress Cataloging-in-Publication Data

David Hockney (San Francisco, Calif.)
David Hockney : a bigger exhibition / by Richard Benefield, Lawrence Weschler, Sarah Howgate, and David Hockney.
 pages cm
Includes bibliographical references and index.
1. Hockney, David--Exhibitions. I. Benefield, Richard. David Hockney in San Francisco. II. Weschler, Lawrence. Love life. III. Weschler, Lawrence. David Hockney's new iPhone passion. IV. Howgate, Sarah. Exploring the landscape of the face. V. Hockney, David. To see the bigger picture is to see more. VI. M.H. de Young Memorial Museum. VII. Title.
N6797.H57A4 2013
740.92--dc23

2013019957

Fine Arts Museums of San Francisco
Golden Gate Park
50 Hagiwara Tea Garden Drive
San Francisco, CA 94118–4502
www.famsf.org

Leslie Dutcher, Director of Publications
Danica Michels Hodge, Editor
Lucy Medrich, Associate Editor

Edited by Ann Heath Karlstrom
Proofread by Susan Richmond
Index by Susan G. Burke
Designed and typeset by Bob Aufuldish, Aufuldish & Warinner
Separations, printing, and binding by Conti Tipocolor, Italy

DelMonico Books is an imprint of Prestel,
a member of Verlagsgruppe Random House GmbH

Prestel Verlag
Neumarkter Strasse 28
81673 Munich
Germany
TEL: 49 89 4136 0
FAX: 49 89 4136 2335
www.prestel.de

Prestel Publishing Ltd.
14–17 Wells Street
London W1T 3PD
United Kingdom
TEL: 44 20 7323 5004
FAX: 44 20 7323 0271

Prestel Publishing
900 Broadway, Suite 603
New York, NY 10003
TEL: 212 995 2720
FAX: 212 995 2733
EMAIL: sales@prestel-usa.com
www.prestel.com

ISBN 978-3-7913-5334-0 (hardcover)
ISBN 978-3-7913-6509-1 (paperback)

Second printing 2013